GW00775894

THE
EIGHTEEN NINETIES

A REVIEW OF ART AND IDEAS AT THE
CLOSE OF THE NINETEENTH
CENTURY

BY

HOLBROOK JACKSON
AUTHOR OF "ROMANCE AND REALITY," ETC.

LONDON
GRANT RICHARDS LTD.
MDCCCCXXII

First Edition . . 1913
Reprinted . . . 1922

PRINTED IN GREAT BRITAIN BY THE RIVERSIDE PRESS LIMITED
EDINBURGH

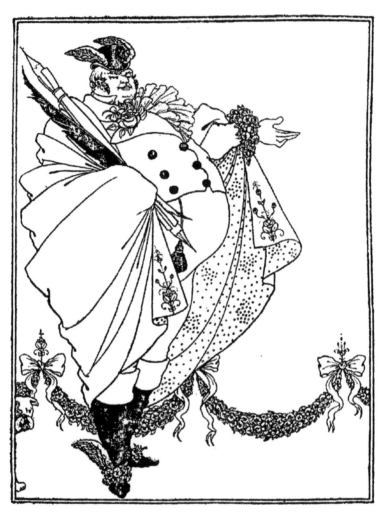

Design by Aubrey Beardsley for the Contents Page of *The Savoy*, Vol. I.

CONTENTS

		PAGE
INTRODUCTION		13

CHAPTER

I. FIN DE SIÈCLE—1890–1900 . . .		17
II. PERSONALITIES AND TENDENCIES . .		33
III. THE DECADENCE		55
IV. OSCAR WILDE : THE LAST PHASE . .		72
V. AUBREY BEARDSLEY		91
VI. THE NEW DANDYISM		105
VII. THE INCOMPARABLE MAX . . .		117
VIII. SHOCKING AS A FINE ART . . .		126
IX. PURPLE PATCHES AND FINE PHRASES . .		135
X. THE DISCOVERY OF THE CELT . . .		147
XI. THE MINOR POET . . .		157
XII. FRANCIS THOMPSON . . .		166
XIII. JOHN DAVIDSON		177
XIV. ENTER—G.B.S.		193
XV. THE HIGHER DRAMA . . .		205
XVI. THE NEW FICTION . . .		216
XVII. RUDYARD KIPLING . . .		231
XVIII. ART AND LIFE		244
XIX. THE REVIVAL OF PRINTING . . .		255
XX. BRITISH IMPRESSIONISTS . . .		267
XXI. IN BLACK AND WHITE . . .		279
INDEX		293

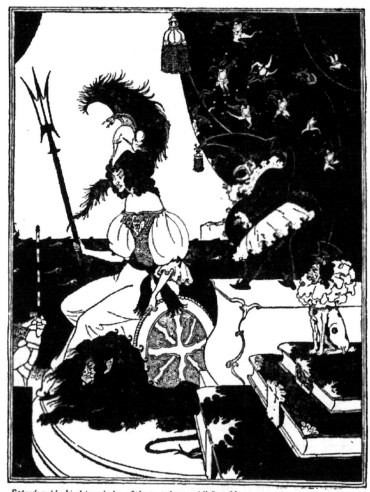

Britannia à la Beardsley
By our "Yellow" Decadent
(E. T. Reed)

LIST OF PLATES

Aubrey Beardsley *Frontispiece*
From a Photograph by Frederick H. Evans

TO FACE PAGE

Cover Design of *The Yellow Book*, Volume I . . 18
By Aubrey Beardsley

Cover Design of *The Saturday Review*, Christmas Supple-
ment (1896) 34
By William Rothenstein

Cover Design of *The Savoy*, Volume I . . . 38
By Aubrey Beardsley

Oscar Wilde (1895) 72

Aubrey Beardsley 92
By Max Beerbohm

The Rape of the Lock 98
By Aubrey Beardsley

Page Decoration from the *Morte d'Arthur* . . . 100
By Aubrey Beardsley

Tail-piece from *Salomé* 104
By Aubrey Beardsley

"Mr W. B. Yeats introducing Mr George Moore to the
Queen of the Fairies" 120
By Max Beerbohm

A. E. Housman 164
From a Drawing by William Rothenstein

Francis Thompson (Life Mask, 1905) . . . 166

Rudyard Kipling 232
By William Nicholson

A Garland for May Day 1895 244
By Walter Crane

9

TO FACE PAGE

Page Decoration from the Kelmscott *Coleridge* . . 258
 By William Morris

Page Decoration from John Gray's *Spiritual Poems* . 262
 By Charles Ricketts

Frontispiece and Title-Page of *The House of Joy* . 266
 By Laurence Housman

The Peacock Fan 268
 By Charles Conder

The Arrival of Prince Charming 274
 By Charles Conder

A Voluptuary 280
 By L. Raven Hill

Illustration from *The Faerie Queene* 282
 By Walter Crane

Phil May 286
 By Spy

A Lecture in Store 288
 By Phil May

The Banks of the Styx 290
 By S. H. Sime

PREFACE

This new edition of " The Eighteen Nineties " has been revised and corrected. Here and there notes and sentences have been added for purposes of clarity. In all other respects it resembles the 1913 edition. Through the courtesy of the Proprietors of " Punch " it has been possible to add to the illustrations Mr E. T. Reed's admirable caricature, " Britannia à la Beardsley."

<div align="right">

H. J.

</div>

LONDON, 1922

INTRODUCTION

THERE is little to say by way of introduction to this study, as the title, I imagine, explains the subject, with the possible exception that it does not, for reasons of space, indicate that I have reviewed only certain tendencies in art and ideas in this country. I have had, of course, to refer, incidentally, to the work of foreign writers and painters, but only as part of the process of tracing origins and lines of development. This is said not as excuse but in explanation of omissions which might otherwise be questioned. The movement which I have described in the British Islands was, to be sure, but one phase of a literary and artistic awakening which had its counterparts in many countries, particularly in France and Germany, and to some extent in Italy and Russia. Mr Arthur Symons, in the *Symbolist Movement in Literature*, has given us a valuable interpretation of one of its important phases in France, and Mr W. G. Blaikie Murdoch, in *The Renaissance of the Nineties*, has dealt eloquently, but all too briefly, with certain manifestations of the awakening in our own country, whilst Mr J. M. Kennedy in *English Literature, 1880-1905*, has made the literary history of the quarter century he reviews the basis of an argument in defence of the classical as against the romantic idea. My intention has been to co-ordinate the various movements of the period, and avoiding sectional or specialised argument, to interpret them not only in relation to one another, but in relation to their foreign influences and the main trend of our national art and life. Thus my aim may be described as interpretative rather than critical, although criticism is not easily avoided by one who engages to select examples and instances from a great body of work.

No excuse need be made by me for confining my review to so limited a period as the last decade of the nineteenth

century, for once having decided to write about the art and ideas of the closing years of that century, the final ten years insisted upon definite recognition by the coincidence of position in time and appropriate happenings in literature, painting, and other arts and crafts. But, as a matter of fact, I have not confined myself strictly to a single decade, for it will be seen that my Nineties trespass upon the adjoining territory of the Eighties and the Nineteen Hundreds, and, to protect myself as far as possible against extraneous argument, I have adopted in the initial chapter the dates " 1890-1900 " as a kind of symbol for the period. The compromise is defensible, as I have not wilfully singled out a decade for review ; that decade had singled itself out, the Eighteen Nineties having already become a distinctive epoch in the minds of those who concern themselves with art and ideas.

Anybody who studies the moods and thoughts of the Eighteen Nineties cannot fail to observe their central characteristic in a widespread concern for the correct—that is, the most effective, the most powerful, the most righteous— mode of living. For myself, however, the awakening of the Nineties does not appear to be the realisation of a purpose, but the realisation of a possibility. Life aroused curiosity. People became enthusiastic about the way it should be used. And in proof of sincerity there were opinionated battles— most of them inconclusive. But they were not wasteful on that account, for the very circumstance of idea pitting itself against idea, vision against vision, mood against mood, and, indeed, whim against whim, cleared the way for more definite action when the time ripened. It was an epoch of experiment, with some achievement and some remorse. The former is to be seen in certain lasting works of art and in the acceptance of new, and sometimes revolutionary, social ideas ; the latter in the repentant attitude of so many poets and other artists of the time who, after tasting more life than was good for them, reluctantly sought peace in an escape from material concerns. The decade began with a dash for life and ended with a retreat—but not defeat. It was the

old battle between heterodoxy and orthodoxy, materialist and mystic, Christian and Pagan, but fought from a great variety of positions. Arthur Symons summed up the situation very effectively in the conclusion to *Studies in Prose and Verse*, where he discusses the conversion of Huysmans. "He has realised," Mr Symons wrote, "the great choice between the world and something which is not the visible world, but out of which the visible world has been made, does not lie in the mere contrast of the subtler and grosser senses. He has come to realise what the choice really is, and he has chosen. Yet the choice is not quite so narrow as Barbey D'Aurevilly thought; perhaps it is a choice between actualising this dream or actualising that dream. In his escape from the world, one man chooses religion, and seems to find himself; another choosing love may seem also to find himself; and may not another, coming to art as to a religion and as to a woman, seem to find himself not less effectively? The one certainty is that society is the enemy of man, and that formal art is the enemy of the artist. We shall not find ourselves in drawing-rooms or in museums. A man who goes through a day without some fine emotion has wasted his day, whatever he has gained by it. And it is so easy to go through day after day, busily and agreeably, without ever really living for a single instant. Art begins when a man wishes to immortalise the most vivid moment he has ever lived. Life has already, to one not an artist, become art in that moment. And the making of one's life into art is after all the first duty and privilege of every man. It is to escape from material reality into whatever form of ecstasy is our own form of spiritual existence." There we have the attitude of the Eighteen Nineties from which most pilgrimages into life began. In the following pages I have endeavoured to expound the attitude and to indicate its victories and defeats.

Finally, I have to thank all those who have so willingly given me their aid by permitting me to quote from their works and to use the illustrations written and pictorial which add so much to the grace and value of this book. Particularly

I must thank Mr John Lane for permission to use the following designs by Aubrey Beardsley :—"The Rape of the Lock," "Tail-piece from *Salomé*," and the cover designs from *The Yellow Book* and *The Savoy*; Mr William Heinemann, for the study of Rudyard Kipling from *Twelve Portraits* by William Nicholson; Messrs J. M. Dent & Sons Ltd., for Aubrey Beardsley's page decoration from the *Morte d'Arthur*; Messrs George Routledge & Sons Ltd., for the frontispiece and title-page of *The House of Joy*, by Laurence Housman; the proprietors of *Punch*, for "A Lecture in Store," by Phil May; the editor of *Vanity Fair*, for the caricature of Phil May by Spy; the editor of *The Saturday Review*, for William Rothenstein's cover design of the Christmas Supplement, 1896; Mr Walter Crane and Messrs George Allen & Co. Ltd., for the illustration from the decorated edition of the *Faerie Queene*; Mr Walter Crane, for the Socialist cartoon, "A Garland for May Day"; Mr Francis Meynell, for the photograph of the life mask of Francis Thompson; Mr Raven Hill, for "A Voluptuary," from *Pick-me-up*; Mr Charles Ricketts, for the decorated pages from the Vale Press edition of John Gray's *Spiritual Poems*; the executors of William Morris, for the page from the Kelmscott *Coleridge*; Mr Max Beerbohm, for his caricature of Aubrey Beardsley and "Mr W. B. Yeats introducing Mr George Moore to the Queen of the Fairies"; and my friends, Mr Frederick H. Evans, for his portrait study of Beardsley; Mr William Rothenstein, for his drawing of A. E. Housman; Mr S. H. Sime, for "The Banks of the Styx"; Mr Grant Richards, for the "Arrival of Prince Charming," and "The Peacock Fan," by Charles Conder; and Mr Frederick Richardson, for untiring help and many suggestions during the making of the book in all its stages.

HOLBROOK JACKSON.

LONDON, *October*, 1913.

CHAPTER I

FIN DE SIÈCLE—1890–1900

IN the year 1895 Max Beerbohm announced, how whimsically and how ironically it is not necessary to consider, that he felt himself a trifle out-moded. "I belong to the Beardsley period," he said. The Eighteen Nineties were then at their meridian; but it was already the afternoon of the Beardsley period. That very year Aubrey Beardsley's strange black and white masses and strong delicate lines disappeared from *The Yellow Book*, and he only contributed to the first few numbers of *The Savoy*, which began in 1896. Fatal disease was overtaking him, and remorse. Aubrey Beardsley actually abandoned his period in the evening of its brief day, and when he died, in 1898, the Beardsley period had almost become a memory. But, after all, Aubrey Beardsley was but an incident of the Eighteen Nineties, and only relatively a significant incident. He was but one expression of *fin de siècle* daring, of a bizarre and often exotic courage, prevalent at the time and connected but indirectly, and often negatively, with some of the most vital movements of a decade which was singularly rich in ideas, personal genius and social will. Aubrey Beardsley crowded the vision of the period by the peculiarity of his art rather than by any need there was of that art to make the period complete. He was, therefore, not a necessity of the Eighteen Nineties, although his appearance in the decade was inevitable; indeed he was so essentially *fin de siècle* that one can say of him with more confidence than of any other artist of the decade that his appearance at any other time would have been inopportune.

The Eighteen Nineties were so tolerant of novelty in art and ideas that it would seem as though the declining century

wished to make amends for several decades of intellectual and artistic monotony. It may indeed be something more than coincidence that placed this decade at the close of a century, and *fin de siècle* may have been at one and the same time a swan song and a death-bed repentance. As a matter of fact, a quickening of life during the last years of a century is not without parallel. The preceding century closed with the French Revolution and the First Consulate of Napoleon, and the sixteenth century closed with the destruction of the Armada and the appearance of Shakespeare, Ben Jonson, Spenser, Christopher Marlowe and Francis Bacon; whilst the close of the fifteenth century saw the Revival of Learning, and the discovery of America by Columbus and of Newfoundland by Cabot. One cannot avoid the temptation to speculate on the meaning of such *fin de siècle* occurrences, for we are actually made more conscious of our standing towards time by the approaching demise of a century, just as we are made conscious of our own ages on birthday anniversaries and New Year's Eve. And it is at least thinkable that as we are certainly moved in the latter circumstances to pull ourselves together, as it were, even if the effort be only an instinctive attempt to find in action forgetfulness of the flight of time ; so it is equally thinkable that a similar but racial instinct towards unique activity may come about at so impressive a period as the close of a century. But, whatever the cause, the last decade of the last century was, in spite of its many extravagances, a renascent period, characterised by much mental activity and a quickening of the imagination, combined with pride of material prosperity, conquest and imperial expansion, as well as the desire for social service and a fuller communal and personal life.

Max Nordau, the Jeremiah of the period, linked up his famous attack on what were called "*fin de siècle* tendencies " with certain traditional beliefs in the evil destiny of the closure of centuries. "The disposition of the times is curiously confused," he said ; "a compound of feverish restlessness and blunted discouragement, of fearful presage and hang-dog renunciation. The prevalent feeling is that of

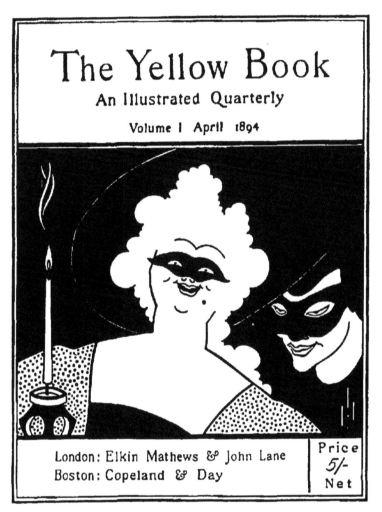

COVER DESIGN OF *THE YELLOW BOOK*, VOLUME I
By Aubrey Beardsley

imminent perdition and extinction. *Fin de siècle* is at once a confession and a complaint. The old northern faith contained the fearsome doctrine of the Dusk of the Gods. In our days there have arisen in more highly developed minds vague qualms of the Dusk of the Nations, in which all suns and all stars are gradually waning, and mankind with all its institutions and creations is perishing in the midst of a dying world." All of which sounds very hectic and hysterical now, nearly twenty years after it was first written, when many of the writers and artists he condemned have become harmless classics, and some almost forgotten. But it is interesting to remember Nordau's words, because they are an example of the very liveliness of a period which was equally lively in making or marring itself. The Eighteen Nineties, however, were not entirely decadent and hopeless ; and even their decadence was often decadence only in name, for much of the genius denounced by Max Nordau as degeneration was a sane and healthy expression of a vitality which, as it is not difficult to show, would have been better named regeneration.

At the same time the fact must not be overlooked that much of the vitality of the period, much even of its effective vitality, was destructive of ideas and conventions which we had come to look upon as more or less permanent ; and one cannot help feeling, at this distance, that not a little of *fin de siècle* attractiveness was the result of abandonment due to internal chaos. But this is no cause for condemnation on our part, still less for self-complacency ; for, as we have been told by Friedrich Nietzsche, himself a half-felt motive force, in this country at least, behind the tendencies of the times : "Unless you have chaos within you cannot give birth to a dancing star." More than one dancing star swam into our ken in the last decade of the nineteenth century, and the proof of the regenerative powers of the period are to be found most obviously, but perhaps even more certainly, if not quite so plainly, in the fact that those who were most allied with its moods and whims were not only conscious of the fact, but in some cases capable of looking at themselves and laughing. *Fin de siècle* was a pose as well as a fact, a point not realised

by Nordau. John Davidson, among others, was able to smile at its extravagances, and in *Earl Lavender*, his burlesque novel of the decadence, one of the characters, a garrulous Cockney dame with a smattering of French, reveals the existence of power to cast what Meredith would have called " the oblique ray " upon the doings of the time. " It's *fang-de-seeaycle* that does it, my dear," says this lady, "and education, and reading French."

It is obvious, then, that people felt they were living amid changes and struggles, intellectual, social and spiritual, and the interpreters of the hour—the publicists, journalists and popular purveyors of ideas of all kinds—did not fail to make a sort of traffic in the spirit of the times. Anything strange or uncanny, anything which savoured of freak and perversity, was swiftly labelled *fin de siècle*, and given a certain topical prominence. The term became a fashion, and writers vied one with another as to which should apply it most aptly. At least one writer emphasised the phrase in an attempt to stigmatise it. "Observe," wrote Max Beerbohm, "that I write no fool's prattle about *le fin de siècle*." And Max Nordau gives a useful list illustrating the manner in which the term was used in the country of its birth. A king who abdicates but retains by agreement certain political rights, which he afterwards sells to his country to provide means for the liquidation of debts contracted by play in Paris, is a *fin de siècle* king. The police official who removes a piece of the skin of the murderer Pranzini after execution and has it tanned and made into a cigar-case, is a *fin de siècle* official. An American wedding ceremony held in a gasworks and the subsequent honeymoon in a balloon is a *fin de siècle* wedding. A schoolboy who, on passing the gaol where his father is imprisoned for embezzlement, remarks to a chum : "Look, that's the governor's school," is a *fin de siècle* son. These are only a few from among innumerable examples illustrating the liveliness of the people of the Nineties to their hour and its characteristics. A further indication of the way in which the phrase permeated the mind of the period is found in its frequent occurrence in the books and essays of the day. It

appears fittingly enough in Oscar Wilde's *The Picture of Dorian Gray*, that typical book of the period, as a reflection upon an epigram afterwards used in *A Woman of No Importance*. Lady Narborough is saying :

" ' If we women did not love you for your defects, where would you all be ? Not one of you would ever be married. You would be a set of unfortunate bachelors. Not, however, that that would alter you much. Nowadays all the married men live like bachelors and all the bachelors like married men ! '

" ' *Fin de siècle*,' murmured Sir Henry.

" ' *Fin du globe*,' answered his hostess.

" 'I wish it were *fin du globe*,' said Dorian, with a sigh. ' Life is a great disappointment.' "

A reviewer of the novel, in *The Speaker* of 5th July 1890, describes Lord Henry Wotton as " an extremely *fin-de-siècle* gentleman." And another book of the period, *Baron Verdigris : A Romance of the Reversed Direction*, by Jocelyn Quilp, issued in 1894, with a frontispiece by Beardsley, is prefaced by the following inscription :—

This Book is Dedicated equally to Fin-de-Sièclcism, the Sensational Novel, and the Conventional Drawing-Room Ballad.

But side by side with the prevailing use of the phrase, and running its popularity very close, came the adjective " new "; it was applied in much the same way to indicate extreme modernity. Like *fin de siècle*, it hailed from France, and, after its original application in the phrase *l'art nouveau* had done considerable service in this country as a prefix to modern pictures, dresses and designs, our publicists discovered that other things were equally worthy of the useful adjective. Grant Allen wrote of " The New Hedonism "; H. D. Traill, of " The New Fiction," opening his essay with the words : " Not to be *new* is, in these days, to be nothing."

In August 1892 William Sharp designed and produced one number, and one only, of *The Pagan Review*, which was written entirely by himself under various pseudonyms, to promote the "New Paganism," described as "a potent leaven in the yeast of the 'younger generation,' and which was concerned only with the *new* presentment of things." And again, in the famous attack on *The Picture of Dorian Gray*, in the *St James's Gazette*, on the first appearance of the novel in the pages of *Lippincott's Monthly Magazine* for July 1890, reference is made to "The New Voluptuousness" which "always leads up to bloodshedding." Oscar Wilde himself wrote on "The New Remorse," in *The Spirit Lamp*, in 1892. The range of the adjective gradually spread until it embraced the ideas of the whole period, and we find innumerable references to the "New Spirit," the "New Humour," the "New Realism," the "New Hedonism," the "New Drama," the "New Unionism," the "New Party," and the "New Woman." The popular, and what we should now call "significant," adjective was adopted by publishers of periodicals, and during the decade there was *The New Age*, a penny weekly with a humanitarian and radical objective, which, after many vicissitudes and various editorial changes, still survives; while William Ernest Henley, coming under the spell of fashion and carrying his modernism from the eighties, translated *The National Observer* into *The New Review*.

A decade which was so conscious of its own novelty and originality must have had some characteristics at least which distinguished it from the immediately preceding decade, if not from all preceding decades. The former is certainly true: the Eighteen Nineties possessed characteristics which were at once distinctive and arresting, but I doubt whether its sense of its own novelty was based in changes which lacked their counterparts in most of the decades of the nineteenth century—pre-eminently a century of change. The period was as certainly a period of decadence as it was a period of renaissance. The decadence was to be seen in a perverse and finicking glorification of the fine arts and mere

artistic virtuosity on the one hand, and a militant commercial movement on the other. The one produced *The Yellow Book* and the literature and art of "fine shades," with their persistent search for the "unique word" and the "brilliant" expression; the other produced the "Yellow Press," the boom in "Kaffirs," the Jameson Raid, the Boer War and the enthronement of the South African plutocrat in Park Lane. But this decadent side of the Nineties must not be looked upon as wholly evil. Its separation from a movement obviously ascendant in spirit is not altogether admissible. The two tendencies worked together, and it is only for the sake of historical analysis that I adopt the method of segregation. Taken thus the decadence reveals qualities which, even if nothing more than "the soul of goodness in things evil," are at times surprisingly excellent. The decadent vision of an Aubrey Beardsley introduced a new sense of rhythm into black and white art, just as the, on the whole, trivial masters of "fine shades," with their peacock phrases, helped us towards a newer, more sensitive and more elastic prose form. The "Yellow Press," with all its extravagances, was at least alive to the desires of the crowd, and the reverse of dull in the presentment of its views; and if it gave Demos the superficial ideas he liked, it was equally prepared to supply a better article when the demand arose. And, withal, a wider publicity was given to thought-provoking ideas and imaginative themes, although adjusted, and often very much adjusted, to the average taste, than had hitherto been possible. As for the "New Park Lane" and the "New" aristocracy, they in their garish abandonment helped us to apply the abstract science of economics to life, thus probably preparing the path for the Super-tax and other so-called "Socialistic" legislation of to-day. But apologies for the decadent side of the period do not complete the story of the renaissance of the Nineties. This latter was more real than the much-advertised decadence, and as time goes on it will prove itself to have been more enduring. The atmosphere of the Eighteen Nineties was alert with new ideas which sought to find expression in the average national life. If

luxury had its art and its traffic, so had a saner and more balanced social consciousness. If the one demanded freedom for an individual expression tending towards degeneration and perversion, the other demanded a freedom which should give the common man opportunities for the redemption of himself and his kind. Side by side with the *poseur* worked the reformer, urged on by the revolutionist. There were demands for culture and social redemption. A wave of transcendentalism swept the country, drawing with it the brighter intelligences of all classes; but it was not remote, it was of the earth and of the common life and hour, seeking the immediate regeneration of society by the abolition of such social evils as poverty and overwork, and the meanness, ugliness, ill-health and commercial rapacity which characterised so much of modern life. The vitality of this awakening of the social consciousness is proved by its extravagances. In the main it worked persistently, cheerfully and with that spirit of compromise dear to the English temperament, as can be seen by a reference to the pages of *The Daily Chronicle*, under the editorship of A. E. Fletcher; *The Star*, under T. P. O'Connor; *The New Age* of the period; Robert Blatchford's *Clarion*, and W. T. Stead's *Review of Reviews*. But now and then the cup of social zeal was too full; it overflowed, and one heard of the bomb of over-zealous anarchist; of the revolt of righteously impatient starvelings among the newly awakened proletariat, and of the purely negative militancy of the "Nonconformist conscience," which used the new-born and enthusiastic London County Council and Mrs Ormiston Chant as the instruments of a moral crusade among West End music halls, then only just discovered as more or less harmless and instructive places of entertainment by those guardians of British respectability—the lower middle classes.

In all these things the Eighteen Nineties were unique only in method and in the emphasis they gave to certain circumstances and ideas. The Eighteen Eighties and the late Seventies had been even more "artistic" than the Nineties, and the preceding decade had also its riots and revolutionary

organisations. Max Beerbohm, in a delightful essay which could only have been written in the Nineties and could only have appeared in *The Yellow Book*, has given us with subtle humour and satire a little history, not entirely free from caricature, of the Eighties. In the essay called " 1880 " he opens, as it were, a window in the house of the Nineties through which we get a fair glimpse of the immediate past. He says :

"Beauty had existed long before 1880. It was Mr Oscar Wilde who managed her début. To study the period is to admit that to him was due no small part of the social vogue that Beauty began to enjoy. Fired by his fervid words, men and women hurled their mahogany into the streets and ransacked the curio-shops for the furniture of Annish days. Dados arose upon every wall, sunflowers and the feathers of peacocks curved in every corner, tea grew quite cold while the guests were praising the Willow Pattern of its cup. A few fashionable women even dressed themselves in sinuous draperies and unheard-of greens. Into whatsoever ballroom you went, you would surely find, among the women in tiaras and the fops and the distinguished foreigners, half a score of comely ragamuffins in velveteen, murmuring sonnets, posturing, waving their hands. Beauty was sought in the most unlikely places. Young painters found her robed in the fogs, and bank clerks, versed in the writings of Mr Hammerton, were heard to declare, as they sped home from the City, that the underground railway was beautiful from London Bridge to Westminster, but not from Sloane Square to Notting Hill Gate. Æstheticism (for so they named the movement) did indeed permeate in a manner all classes. But it was to the *haut monde* that its primary appeal was made. The sacred emblems of Chelsea were sold in the fashionable toy-shops, its reverently chanted creeds became the patter of the *boudoirs*. The old Grosvenor Gallery, that stronghold of the few, was verily invaded. Never was such a fusion of delighted folk as at its private views. There was Robert Browning, the philosopher, doffing his hat with a courtly

sweep to more than one duchess. There, too, was Theo
Marzials, poet and eccentric, and Charles Colnaghi, the hero
of a hundred teafights, and young Brookfield, the comedian,
and many another good fellow. My Lord of Dudley, the
virtuoso, came there, leaning for support upon the arm
of his fair young wife. Disraeli, with the lustreless eyes
and face like some seamed Hebraic parchment, came also,
and whispered behind his hand to the faithful Corry. And
Walter Sickert spread the latest *mot* of 'the Master,' who,
with monocle, cane and tilted hat, flashed through the gay
mob anon."

There is also ample evidence of the social earnestness of
the preceding decade in memories of the dock strike of 1889,
which brought John Burns and Tom Mann to the front as
the "new" labour leaders, and of the riots of 1886, which
culminated in a free speech demonstration in Trafalgar
Square on Sunday, 13th November 1887, when the Life
Guards were called out, and during the clearing of the Square
a young man lost his life. The first British Socialist organ-
isation of any note, the Social Democratic Federation, later
called the Social Democratic Party, and more recently
merged in the British Socialist Party, was formed by Henry
Mayers Hyndman, who had for chief supporter William
Morris, in 1881. Two years later the Fabian Society was
founded, and this organisation drew to its ranks the middle-
class "intellectuals," who were beginning to interest them-
selves in Socialism. These included Sidney Webb, Bernard
Shaw, Sydney Olivier, Graham Wallas, Annie Besant, Hubert
Bland, Frank Podmore, Stewart Headlam and others who
had made, or were about to make, their mark in various
branches of the intellectual life. It was these various
Socialist activities which made the formation of the Inde-
pendent Labour Party a possibility in 1892, and the return
of Keir Hardie, its first representative, to Parliament, in the
same year.

But the chief characteristics of the Eighteen Nineties
proper, although dovetailed into the preceding decade, may

be indicated roughly under three heads. These were the so-called Decadence; the introduction of a Sense of Fact into literature and art; and the development of a Transcendental View of Social Life. But again, it must not be assumed that these characteristics were always separate. To a very considerable extent they overlapped, even where they were not necessarily interdependent. Oscar Wilde, for instance, bridged the chasm between the self-contained individualism of the decadents and the communal aspirations of the more advanced social revolutionaries. His essay, *The Soul of Man under Socialism*, has been acclaimed by recognised upholders of Socialism. And even his earlier æstheticism (which belonged to the Eighties) was an attempt to apply the idea of art to mundane affairs. Bernard Shaw, rational-ist and anti-romantic apostle of the sense of fact, openly used art to provoke thought and to give it a social, as distinct from an individualist, aim; just as other and more direct literary realists, such as Emile Zola and Henrik Ibsen, had done before him, either avowedly or by implication. The more typical realists of the Nineties, George Gissing and George Moore, seem to be devoid of deliberate social purpose, but the pre-valent didacticism of the period is strikingly pronounced in the work of H. G. Wells, who has contrived better than any other writer of his time to introduce reality into his novels without jeopardising romance, to hammer home a theory of morality without delimiting his art. But apart from such obvious resemblances between types of *fin de siècle* genius, the popular idea of the period looked upon one phase of its thought as no less characteristic than another. The adjec-tive "new" as an indicator of popular consciousness of what was happening, was, as we have seen, applied indiffer-ently to all kinds of human activity, from art and morals to humour and Trade Unionism.

There is no clearer example of the intimate relationship between what might have been called the degenerate notions of the period and those which are admittedly regenerate, than a comparison of the Epicurean ideas in such strikingly differ-ent works as Oscar Wilde's *The Picture of Dorian Gray* and

Grant Allen's essay on "The New Hedonism," which appeared in *The Fortnightly Review* of March 1894. Oscar Wilde says :

"Yes : there was to be, as Lord Henry had prophesied, a new Hedonism that was to recreate life, and to save it from that harsh, uncomely Puritanism that is having, in our own day, its curious revival. It was to have its service of the intellect, certainly ; yet it was never to accept any theory or system that would involve the sacrifice of any mode of passionate experience. Its aim, indeed, was to be experience itself, and not the fruits of experience, sweet or bitter as they might be. Of the asceticism that deadens the senses, as of the vulgar profligacy that dulls them, it was to know nothing. But it was to teach man to concentrate himself upon the moments of a life that is itself but a moment."

Here we have a kind of self-culture by the constant variation of experiences, mostly passionate, with little if any reference to the rest of humanity. In a sense it is not a new Hedonism at all, but a Hedonism which had existed from time immemorial, although it found its way into Oscar Wilde's novel by the aid of two modern books. One of these, the *À Rebours* of Joris Karl Huysmans, may be said to contain the apotheosis of the *fin de siècle* spirit ; the other, *The Renaissance*, by Walter Pater, containing a famous passage which became the precious gospel of the Æsthetic Movement of the Seventies and Eighties. It was new, however, in so far as it reacted against the "Nonconformist conscience" of the moment. But that it was not the only "New" Hedonism may be realised by reference to Grant Allen's essay, which is little more than a veiled piece of Socialist propaganda. The central idea of this sociological Hedonism is shown in the following extract :—

"Self-development, on the contrary, is an aim for all—an aim which will make all stronger, and saner, and wiser, and better. To be sound in wind and limb ; to be healthy of body and mind ; to be educated, to be emancipated, to be

free, to be beautiful—these things are ends towards which all should strain, and by attaining which all are happier in themselves, and more useful to others. That is the central idea of the new hedonism. We see clearly that it is good for every man among us that he and every other man should be as tall, as strong, as well knit, as supple, as wholesome, as effective, as free from vice or defect as possible. We see clearly that it is his first duty to make his own muscles, his own organs, his own bodily functions, as perfect as he can make them, and to transmit them in like perfection, unspoiled, to his descendants. We see clearly that it is good for every woman among us that she and every other woman should be as physically developed and as finely equipped for her place as mother as it is possible to make herself. We see that is good for every woman that there should be such men, and for every man that there should be such women. We see it is good for every child that it should be born of such a father and such a mother. We see that to prepare ourselves for the duties of paternity and maternity, by making ourselves as vigorous and healthful as we can be, is a duty we all owe to our children unborn and to one another. We see that to sacrifice ourselves, and inferentially them, is not a thing good in itself, but rather a thing to be avoided where practicable, and only to be recommended in the last resort as an unsatisfactory means of escape from graver evils. We see that each man and each woman holds his virility and her femininity in trust for humanity, and that to play fast and loose with either, at the bidding of priests or the behest of Puritans, is a bad thing in itself, and is fraught with danger for the State and for future generations."

The intellectual, imaginative and spiritual activities of the Eighteen Nineties are concerned mainly with the idea of social life or, if you will, of culture; and the individual and social phases of that culture are broadly represented by the above quotations. For that reason alone the period is interesting apart from any achievements in art or science or statecraft. It is interesting because it was a time when people

went about frankly and cheerfully endeavouring to solve the
question "How to Live." From one point of view such an
employment suggests the bewilderment of a degenerate
world, and it would seem entirely to justify the lamentations
of Max Nordau; but those who lived through the Nineties
as young men and women will remember that this search for
a new mode of life was anything but melancholy or diseased.
The very pursuit was a mode of life sufficiently joyful to
make life worth living. But in addition there was the feeling
of expectancy, born not alone of a mere toying with novel
ideas, but born equally of a determination to taste new
sensation, even at some personal risk, for the sake of life and
growth.

"A great creative period is at hand," wrote William
Sharp, in his preface to *Vistas*; "probably a great dramatic
epoch. But what will for one thing differentiate it from
any predecessor is the new complexity, the new subtlety,
in apprehension, in formative conception, in imaginative
rendering."

It was an era of hope and action. People thought any-
thing might happen; and, for the young, any happening
sufficiently new was good. Little of the older sentimental-
ism survived among the modernists; those who were of the
period desired to be in the movement, and not mere spec-
tators. It was a time of experiment. Dissatisfied with the
long ages of convention and action which arose out of pre-
cedent, many set about testing life for themselves. The new
man wished to be himself, the new woman threatened to live
her own life. The snapping of apron-strings caused con-
sternation in many a decent household, as young men and
maidens were suddenly inspired to develop their own souls
and personalities. Never, indeed, was there a time when the
young were so young or the old so old. No family, were
its record for solid British respectability established on no
matter how secure a basis, was immune from new ideas;
and if the bourgeoisie of the Eighteen Eighties were inspired
to throw their mahogany into the streets, as we have been
assured they were by Max Beerbohm, their successors of the

Eighteen Nineties were barely constrained from doing the same with their most cherished principles. Decadent minor poets sprang up in the most unexpected places. The staidest of Nonconformist circles begot strange, pale youths with abundant hair, whose abandoned thoughts expressed themselves in "purple patches" of prose, and whose sole aim in life was to live "passionately" in a succession of "scarlet moments." Life-tasting was the fashion, and the rising generation felt as though it were stepping out of the cages of convention and custom into a freedom full of tremendous possibilities.

There were misigivings in more directions than one, but these had small effect upon the spirit of the first half of the decade. The experimental life went on in a swirl of song and dialectics. Ideas were in the air. Things were not what they seemed, and there were visions about. The Eighteen Nineties was the decade of a thousand "movements." People said it was a "period of transition," and they were convinced that they were passing not only from one social system to another, but from one morality to another, from one culture to another, and from one religion to a dozen or none! But as a matter of fact there was no concerted action. Everybody, mentally and emotionally, was running about in a hundred different directions. There was so much to think about, so much to discuss, so much to see. "A New Spirit of Pleasure is abroad amongst us," observed Richard Le Gallienne, "and one that blows from no mere coteries of hedonistic philosophers, but comes on the four winds." The old sobriety of mind had left our shores, and we changed from a stolid into a volatile nation. At this time the provinces saw the birth of a new type of music hall, the "Palace of Varieties," with two performances a night, and we began to amuse ourselves.

Our new-found freedom seemed to find just the expression it needed in the abandoned nonsense chorus of *Ta-ra-ra-boom-de-ay!* [1] which, lit at the red skirts of Lottie Collins, spread like a dancing flame through the land, obsessing the

[1] See *A Modern History of the English People*, by R. H. Gretton.

minds of young and old, gay and sedate, until it became a veritable song-pest, provoking satires even upon itself in the music halls of its origin. No song ever took a people in quite the same way ; from 1892 to 1896 it affected the country like an epidemic ; and during those years it would seem to have been the absurd *ça ira* of a generation bent upon kicking over the traces. Even to this day one can hear the song in the streets of Boulogne and Dieppe, where the urchins croak it for the benefit of the English visitor, under the firm conviction that it is the British National Anthem, and in hopes that the patriotic Britishers will reward their efforts with *petit sous.*[1]

The old dim and dowdy chop-houses and taverns also changed with our new mood, and they were replaced by larger and brighter restaurants and " tea shops," daintier food and orchestras, and we extended the habit of dining out, and mixing afternoon tea with shopping.

The " safety " bicycle was invented, and it took its place as an instrument of the " new " freedom as we glided forth in our thousands into the country, accompanied by our sisters and sweethearts and wives, who sometimes abandoned skirts for neat knickerbocker suits. " The world is divided into two classes," said a wit of the period, " those who ride bicycles and those who don't." But the great novelty was the woman cyclist, the New Woman *rampant*, but she was sometimes very charming also, and we immortalised her in our Palaces of Varieties :

> " *Daisy, Daisy, give me your answer do,*
> *I'm half crazy all for the love of you !*
> *It won't be a stylish marriage,*
> *I can't afford a carriage,*
> *But you'll look neat,*
> *Upon the seat*
> *Of a bicycle made for two.*"[1]

[1] This was true in 1913, but now (1922) a new generation of urchins has arisen in Boulogne and other French towns who know not *Ta-ra-ra-boom-de-ay*. This famous ditty has been declassed by *Tipperairie*.

CHAPTER II

PERSONALITIES AND TENDENCIES

SUCH manifestations of liveliness may seem to be of no very great importance to-day, but many minor freedoms now enjoyed by all without question were then the subjects of battle. It is difficult to realise even now how many changes in taste, ideas and habits were crammed into the *fin de siècle* decade. For it has been too readily assumed that the achievement of the Eighteen Nineties is confined to that literary and artistic renaissance described by W. G. Blaikie Murdoch in *The Renaissance of the Nineties*. But such a conclusion is unjust to the period. The fine arts did flourish during the decade, and although many of the results were as ephemeral as they were extraordinary, others represent permanent additions to our store of artistic expression. Still, this habit of looking upon the renaissance as an affair of books and pictures has led too many into the belief that the main current of the artistic movement was solely an extension of the art-for-art's-sake principle ; when, as a matter of fact, the renaissance of the Nineties was far more concerned with art for the sake of life than with art for the sake of art. The men with the larger prodigality of genius were not engaged chiefly with art as art ; for good or ill they were engaged equally with ideas and life. Popular taste also was attracted by the artist-philosopher, as may be seen by its readiness to appreciate the older and more didactic painters and writers—just as in other years it had enjoyed the didacticism of Charles Dickens. Thus George Frederick Watts, Holman Hunt, Ford Madox Brown, Burne-Jones, for instance, though not of the period, received their nearest approach to popularity then ; and the same may be said of William Morris, Walter Crane, and the craftsmen generally

who had evolved out of the Ruskinian gospel of "joy and work" and the Pre-Raphaelite movement.

This obvious taste on the part of the thoughtful public of the *fin de siècle* for art served with ideas found much to its liking in the writers who came into prominence during the time. Oscar Wilde I have already indicated as bridging the Eighties and Nineties, just as his art united the uncompromising artistic sufficiency upheld by Whistler and the art-culture of Pater. But there were in literature, besides, Bernard Shaw and H. G. Wells, using plays and novels for criticising morality and teaching newer modes of social life; Rudyard Kipling and William Ernest Henley using verse to stimulate patriotism; Francis Adams singing revolt; Edward Carpenter, democracy; William Watson, justice; and these were as characteristic of the Eighteen Nineties as the self-centred poets and critics and storytellers who clustered about *The Yellow Book* and *The Savoy*. Even painters, Charles Ricketts and James Pryde and William Nicholson, typical products of the period, turned their genius for a time into the realm of applied art; the first, like William Morris, in the making of beautiful books, and the two latter by becoming, under the pseudonym of the Beggarstaff Brothers, the founders of our modern school of poster designers. And apart from all of these instances of art applied to life, or used to stimulate life, the abundant practical genius of an age which strove always to express itself in the reordering of social conditions, in innumerable activities called "progressive," embracing besides social, commercial, scientific and imperial affairs, supplies sufficient evidence of the breadth and variety of a renaissance which strove to triumph over what was merely artistic.

The movement of the Eighteen Nineties, however, which has most engaged the attention of writers, the movement called "Decadent," or by the names of Oscar Wilde or Aubrey Beardsley, the movement Max Nordau denounced in Europe generally, and recently summed up by *The Times* under the epithet "The Yellow Nineties," does even now dominate the vision as we look backwards. And, indeed,

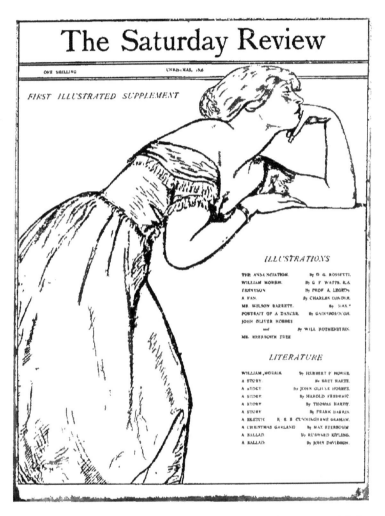

COVER DESIGN OF *THE SATURDAY REVIEW* CHRISTMAS SUPPLEMENT (1896)
By William Rothenstein

though only a part of the renaissance, it was sufficiently "brilliant," to use one of its own *cliches*, to dazzle those capable of being dazzled by the achievements of art and letters for many years to come. For a renaissance of art and ideas which in literature had for exemplars Oscar Wilde (his best books were all published in the Nineties), Bernard Shaw, H. G. Wells, Rudyard Kipling, John Davidson, Hubert Crackenthorpe, W. B. Yeats, J. M. Barrie, Alice Meynell, George Moore, Israel Zangwill, Henry Harland, George Gissing, "John Oliver Hobbes," Grant Allen, Quiller Couch, Max Beerbohm, Cunninghame Graham, Fiona Macleod (William Sharp), Richard Le ·Gallienne, Ernest Dowson, Arthur Symons, Lionel Johnson, and A. B. Walkley; and in pictorial art, James Pryde, William Nicholson, Phil May, William Orpen, Aubrey Beardsley, E. E. Hornel, Wilson Steer, Charles Ricketts, J. J. Shannon, Charles Shannon, John Lavery, John Duncan Fergusson, J. T. Peploe, Charles Conder and William Rothenstein could not have been other than arresting, could not, indeed, be other than important in the history of the arts. For, whatever may be the ultimate place of these workers in literature and painting in the national memory, and whatever value we set upon them then and now, few will deny that even the least of them did not contribute something of lasting or of temporary worth to the sensations and ideas of their age, or its vision of life, and to its conception of spiritual or mental power.

As to what individuals among these writers and painters were the peculiar products of the Eighteen Nineties—that is, those who could not, or might not, have been produced by any other decade—it is not always easy to say. In dealing with the writers the book-lists of John Lane, Elkin Mathews and Leonard Smithers are useful guides in any process of narrowing-down ; and further guidance may be found by a perusal of the files of *The Yellow Book* and *The Savoy*, for these two publications were the favourite lamps around which the most bizarre moths of the Nineties clustered. There were few essential writers of the Nineties who did not contribute to one or the other, and the very fact that Henry

Harland, who edited the former, and Arthur Symons, who edited the latter, were able to gather together so many writers and artists who were at once novel and notable, emphasises the distinction of the artistic activities of the time. But that emphasis should not be taken as indicating merely an awakening of virtuosity during the Nineties ; the many definite artistic movements, embracing both writers and painters and craftsmen, could not have occurred had there not been a considerable receptivity among the people of the time. A renaissance of art depends equally upon artist and public : the one is the complement of the other. The Eighteen Nineties would have been unworthy of special notice had there not been a public capable of responding to its awakening of taste and intelligence.

But doubt is set at rest when we remember how numerous were the excellent periodicals issued with fair evidence of success. No other decade in English history has produced so many distinctive and ambitious publications ; for, apart from *The Yellow Book* and *The Savoy*, there were *The Parade*, *The Pageant*, *The Evergreen*. *The Chameleon*, *The Hobby Horse*, *The Rose Leaf* and, later on, *The Quarto*, *The Dome*, and that able magazine's musical brother, *The Chord*. These periodicals were, of course, the journals which represented the unique qualities in the literature and art of the decade ; they were bone of its bone and flesh of its flesh. But, important as they are, they do not by any means complete the typical and characteristic journalism of the period, for many less exclusive journals, journals making a wider public appeal, must be named—such notable examples of periodical literature and art, for example, as *The Studio*, *The Butterfly*, *The Poster*, *To-Morrow*, *Eureka*, and more popular still, but excellent also in their way, *The Idler*, *To-Day* and *Pick-me-up*. The last, during its best days, and these covered several years, had among its contributors many of the best black-and-white artists of the decade ; Phil May; Raven Hill, A. S. Hartrick, W. T. Manuel, S. H. Sime and Edgar Wilson regularly sent drawings to this sportive publication, which for genius and humour have not been excelled, even by *Punch*.

But although these publications must be named to the credit of the period, many of them, like many of the distinguished writers I have named, might conceivably have been produced at any time during the past forty years. *Pick-me-up*, for example, presented no new point of view ; it was sprightly and humorous in the popular sense—that is to say, it expressed the inconsequent outlook of the *bon viveur* of fiction —and persistently assumed that cosmopolitan Piccadilly Circus-cum-Leicester Square, and the Anglo-American Boulevards des Italiens-cum-Montmartre (after midnight) were the last words in "life." In short, *Pick-me-up* represented the false and altogether absurd "Gay Paree" view of things— and to that extent it was not of a day but of all time. Such an attitude, however, is not inconsistent with a genius for art, and *Pick-me-up* possessed a staff of black-and-white draughtsmen of unequalled ability, and sometimes of rare genius ; and in addition to its native talent it also introduced to this country the work of good foreign draughtsmen, including that of the great French artist Steinlen. Still, an able group of black-and-white artists is by no means a peculiarity of the Nineties. The Sixties had *Once a Week*—and *Punch* has reigned supreme from the Forties till to-day. Phil May and Raven Hill belonged to the artistic eminence of the Nineties, but, individual as they are, they might have happened in any other decade since Charles Keene and John Leech created the modern humorous pen drawing. One *Pick-me-up* artist, and only one, had anything approaching *fin de siècle* tendencies ; that artist was (and is) S. H. Sime : he is an art product of the Nineties, along with Aubrey Beardsley, Charles Conder, Charles Ricketts and Laurence Housman.

The literary movement of the Eighteen Nineties has had full opportunity of insisting upon itself, but had no such opportunity existed the books of the period would have stood out with a certain distinction. In the year 1890 the literary field was so dominated by men whose reputations had long since been established, either with the inner circle of bookish people or the larger public, that any new-comers, especially in poetry, were apt to be labelled "minor." Tennyson was

still alive, and Robert Browning had died only in the previous year ; Philip James Bailey was living, though forgotten, and Martin Tupper, like Browning, had passed away in 1889. William Morris and Algernon Charles Swinburne, although fully recognised as major poets, had still some good work to do, and there were a select few who admired the poetry of Coventry Patmore, and many who thought well of the works of Lewis Morris. And among women singers Jane Ingelow was still living, and Christina Rossetti was yet to publish two more volumes.

John Ruskin and Walter Pater were not only alive, but their æsthetic-social messages were finding ever wider fields of acceptance. "The acute but honourable minority," which hitherto had been George Meredith's way of referring to his own small following, was rapidly becoming a respectable body of supporters, aided not a little by the discerning but whole-hearted trumpeting of a young man from Liverpool, Richard Le Gallienne, who was to become a notability of the Nineties. Thomas Hardy, also, was established, and like Meredith winning to a wider, though not so tardy, popularity ; and he also was heralded by a young poet of the period, Lionel Johnson, in a fine study called *The Art of Thomas Hardy* (1894). John Henry Newman ended his ardent life in 1890, but Cardinal Manning was still living ; so also were the popular Church of England divines, Archdeacon Farrar and Canon Liddon, the equally popular Nonconformist, Charles Spurgeon, and at the antipodes of their faith, James Martineau. In science the great names of Thomas Henry Huxley, John Tyndall, Herbert Spencer, Francis Galton were honoured among living geniuses ; and so was that of Alfred Russel Wallace, who survived until the eve of the Great War. The historian, James Anthony Froude, died in 1894, and W. E. H. Lecky lived through the decade.

Literary reputations beginning in the Seventies and Eighties, and only in a few cases awaiting further buttressing in the Nineties, were numerous ; these, besides those already named, included W. H. Mallock, Edmund Gosse, Andrew Lang, Robert Louis Stevenson, Frederic Harrison, William

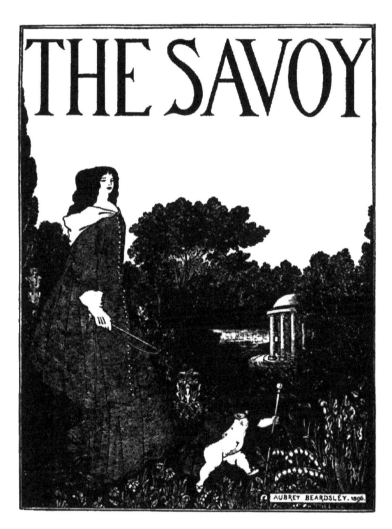

COVER DESIGN OF *THE SAVOY*, VOLUME I
By Aubrey Beardsley

Ernest Henley, John Addington Symonds, Arthur Pinero, Sidney Colvin, Austin Dobson, Edward Dowden, H. D. Traill, Theodore Watts-Dunton, Stopford Brooke, James Payn, Leslie Stephen, Henry James, Grant Allen, William Black, Robert Bridges, Frederick Wedmore, and among more popular writers, Marie Corelli, Rider Haggard, and Hall Caine. Mrs Humphry Ward had become famous on the publication of *Robert Elsmere*, in 1888, but the importance of her work during the succeeding decade places her, as it does also George Moore, Rudyard Kipling and George Gissing, each of whom did good work before 1890, in the newer movement. This latter was not, however, to have its effect on the younger generation alone, it was so irresistible as to inspire even those whose life-work was more or less done to new and modern activities. Thus Thomas Hardy began a new phase of his art in 1891 with *Tess of the D'Urbervilles*, following it with the masterly, and ultra-modern, *Jude the Obscure*, in 1895. He also published his first volume of poems, *Wessex Poems*, in 1898. William Morris published most of his prose romances in the Nineties, including *News from Nowhere*, in 1891, and in quick succession *The Roots of the Mountains*, *The Story of the Glittering Plain*, *The Wood Beyond the World*, and *The Well at the World's End*. *The Water of the Wondrous Isles* and *The Story of the Sundering Flood* were left in manuscript and published after his death. John Addington Symonds, whose chief work, *The History of the Italian Renaissance*, was completed between the years 1875-1886, published *In the Key of Blue*, a book so typical in some ways of the Nineties that it might well have been written by one of the younger generation. Frederick Wedmore, without being *fin de siècle*, published *Renunciations* (a very Eighteen-Ninety title !) in 1893, and *English Episodes*, in 1894, both of these have a freshness of vision quite of the period. Theodore Watts-Danton published his gipsy novel, *Aylwin* (1898). The great veteran of black-and-white art, George du Maurier, suddenly became a popular novelist with the famous *Trilby* in 1894, which had been preceded by *Peter Ibbetson* (1891) and succeeded by *The Martian* (1896) ; and

another veteran artist of great eminence also reasserted himself as a writer of first-rate power during the period, for it was not until 1890 that James McNeill Whistler collected and published in a delightful volume his " Ten O'Clock " lecture, and his various letters to the newspapers, with other Press cuttings, under the appropriate title of *The Gentle Art of Making Enemies*. Grant Allen, besides becoming a journalistic champion of the new school, himself joined the younger generation by the publication of *The Woman Who Did*, in 1895, and Arthur W. Pinero, like Thomas Hardy with his novels, began a new phase as a playwright with the production of *The Second Mrs Tanqueray*, in 1893 ; for, doubtless, both *Tess of the D'Urbervilles* and *The Second Mrs Tanqueray* would have been premature in the Eighties. And, finally, Richard Whiteing, veteran journalist, but unknown to the public by name, suddenly became something like famous by the publication of *No. 5 John Street*, in the last year of the decade.

Further evidence of the stimulating atmosphere of the period is to be found in the number of writers who sprang into existence out of the *Zeitgeist* of the decade, as people in this country were beginning to call the spirit of the times. I do not mean those who were of the period in the narrower sense, but those who, taking that which every writer takes from his time, were sufficiently general in attitude not to have been peculiar to any movement. Among such writers may be named J. M. Barrie, Conan Doyle, Maurice Hewlett, Owen Seaman, Barry Pain, Pett Ridge, Israel Zangwill, Anthony Hope, W. H. Hudson, Joseph Conrad, Jerome K. Jerome, Stanley Weyman, H. A. Vachell, Stephen Phillips, Henry Newbolt, A. E. Housman, Arthur Christopher Benson, William Watson, Allen Upward, and the late G. W. Steevens, all of whom published their first notable work in the Nineties, and in many instances their best work. A qualification is necessary in the case of W. H. Hudson, whose earliest work, *The Purple Land that England Lost*, was born " out of its due time " in 1885, and consequently neglected by critics and public. Had this remarkable book been published ten years later, under its abridged title, *The Purple Land*, such a fate

might not have befallen it ; the Nineties almost certainly would have accorded it that recognition for which it had to await twice ten years. Robert Hichens should also appear in the above list, but the fact that he wrote in‚ The Green Carnation (1894) the most notable satire of the period brings him into the more exclusive movement.

The writers most imbued with the spirit of the time, direct outcome of circumstances peculiar to the fin de siècle, will be more fully considered in other chapters of this book. Suffice it to say here that they fall roughly into groups which express ideas and tendencies then prevalent and, if not always taking the form of designed movements, indicating the existence of very definite though subconscious movements in the psychology of the age. Delightful among fin de siècle writers were those masters of a new urbanity, which, although in the direct tradition of Addison and Steele, of Dr Johnson and Charles Lamb, possessed a flair of its own, a whimsical perversity, a "brilliance," quite new to English letters. First and most eminent of these urbane essayists, for like their earlier prototypes they practised mainly the essayist's art, comes Max Beerbohm, who considered himself outmoded at the age of twenty-four and celebrated the discovery by collecting his essays in a slim, red volume with paper label and uncut edges, and publishing them at the sign of The Bodley Head, in 1896, under the title of The Works of Max Beerbohm. From the same publishing house came fascinating volumes by G. S. Street, who satirised suburbans, talked charmingly of books, art and persons, and in The Autobiography of a Boy revealed the irony of the youth who wanted to be himself, and to live his own scarlet life, without having any particular self to become or any definite life to live, save that of matching his silk dressing-gown with the furniture of his room. There were also Charles Whibley, who wrote able studies of scoundrels and dandies ; Richard Le Gallienne, who made a fine art of praise and, besides reviving the picaresque novel of flirtation in The Quest of the Golden Girl, became a sort of fin de siècle Leigh Hunt ; John Davidson, who wrote the Fleet Street Eclogues and some curiously urbane novels, but

who was more poet than essayist, and, latterly, was so much
interested in ideas that he became a philosopher using litera-
ture as his medium ; and Arthur Symons, poet of the music
hall, the café and the *demi-monde*, literary impressionist of
towns, and penetrating critic of the writers and ideas of the
decadence in France and England.

Another group of writers distinctly associated with the
period received its inspiration from the Celtic revival. Its
chief figure was William Butler Yeats, the Irish poet and
dramatist, whose earliest volumes of distinction, *The Countess
Kathleen* and *The Celtic Twilight*, were published in 1892 and
1893. With him were Dr Douglas Hyde, George Russell
(A.E.), John Eglinton, Lady Gregory, and others, who
together made up the Irish Literary Movement which
eventually established the Irish National Theatre in Abbey
Street, Dublin, and produced the greatest of modern Irish
dramatists, John Millington Synge. Wales also had its
movement, with Ernest Rhys as its chief figure ; and in
Scotland there was a more effective revival, which clustered
about Professor Patrick Geddes in Edinburgh and produced
four numbers of a handsome quarterly magazine, called *The
Evergreen*, in 1895, among its contributors being both "Fiona
Macleod" and William Sharp (then supposed to be two
separate persons). This Scottish movement was not entirely
artistic in aim, but, like so many activities of the Nineties, it
sought to link art and ideas with life, and so became actually
a social movement with a Socialistic tendency. Next to
W. B. Yeats the most prominent figure of the Celtic revival
was Fiona Macleod, whose first book, *Pharais, A Romance of
the Isles*, appeared in 1894. There was also another Scottish
movement, very widely appreciated on this side of the border.
It was called the "Kail Yard School," and included the
popular dialect fiction of J. M. Barrie, S. R. Crockett and
"Ian Maclaren."

The importation of realism from France began in the pre-
ceding decade, with translations of the novels of Emile Zola,
for which the translator and publisher, Ernest Vizetelly,
suffered imprisonment, and with the realistic novels of George

Moore during the same period. That writer's vivid piece of realism, *Esther Waters* (1894), made history also by being the first notable novel to be banned by the libraries and placed on the *Index Expurgatorius* of Messrs W. H. Smith & Son. In the same year a new realist arrived, in the person of Arthur Morrison, with *Tales of Mean Streets*, which was followed by *A Child of the Jago*, in 1896. These striking sketches of slum life were new in so far as they depicted slum life as a thing in itself at a time when people still looked upon the slums, much as they had done in the time of Dickens, as a subject for romantic philanthropy. W. Somerset Maugham published a slum novel, *Liza of Lambeth*, in 1897, which had some considerable vogue, and in 1899 Richard Whiteing's *No. 5 John Street* joined the same class. But there never could be more than a passing fancy for such sectional realism ; slums were rapidly becoming the affair of the sociologist. Readers of books, and also those people who rarely read books, turned to the more stimulating realism, which by the way was not free of romance, of Rudyard Kipling, who had hitherto appeared in the blue-grey, paper-backed pamphlets issued, for Anglo-Indian consumption, by Wheeler of Allahabad. In 1890 their growing fame forced them upon the home booksellers, and when they were published in this country they aroused so great an interest that instead of remaining curiosities of Anglo-Indian publishing they became the chief modern literature of the English-speaking world. There were realists, too, like Cunninghame Graham, who savoured also of the new romance, whose first book appeared in 1895, and in the same year Frank Harris published his first volume of short stories, *Elder Conklin and Other Stories*. But neither of them achieved popularity. Cold also was the reception given to the personal experience of poverty which George Gissing put into his novels ; although *The New Grub Street* (1891) was at least the first of this unfortunate author's works to receive anything like popular recognition.

I have pointed out more than once that the renaissance of the Nineties was largely social, and much of its literature reveals this spirit. There were many writers who made

literature of their social zeal, more particularly among Socialists. Some of the realists, indeed, were avowed Socialists. Richard Whiteing, Cunninghame Graham, Frank Harris and Grant Allen were all of that faith. George Bernard Shaw and Robert Blatchford persistently used their literary skill in the propagation of social theories, and only less directly was the same thing done at that time by H. G. Wells, who has since passed through a phase of deliberate Socialist propaganda. George Bernard Shaw's first really characteristic book, *The Quintessence of Ibsenism*, appeared in 1891, his first play, *Widowers' Houses*, in 1892, and his earliest collected plays, *Plays Pleasant and Unpleasant*, in 1898. Throughout the Nineties he was a busy journalist, criticising music, art, drama, life, anything in fact that anybody would print, for he had views to express, and determination to express them, on all phases of our social life.

Robert Blatchford published *Merrie England*, a remarkable essay in Socialist special pleading, written for the man-in-the-street in a strong, simple and picturesque manner. The book attracted wide notice, and did much towards consolidating the Socialist movement of the time. Over a million copies were sold, and it has been translated into Welsh, Danish, German, Dutch, Swedish, French, Spanish, Hebrew and Norwegian. Edward Carpenter belongs to this class, for although *Towards Democracy* was published, with several of his other books, in the Eighties, he wrote and lectured much during the Nineties. He was also one of the earliest of English writers to consider problems of sex. And finally, Sidney Webb, the social historian and sociologist, published his first works in the late Eighties and the Nineties : *Socialism in England* (1889), *The London Programme* (1892) and with his wife, Beatrice Webb, *The History of Trades Unionism* and *Industrial Democracy* in 1894 and 1898. The Nineties also saw the beginning of that careful sociological investigation of poverty and industrial conditions which has been the basis of so many recent reforms—the monumental inquiry of Charles Booth into the conditions of the labouring classes of London. This great work was begun in 1892 and

finished in 1903, and is recorded in seventeen volumes, entitled *The Life and Labour of the London People.*

But there is no doubt that the most remarkable phase of the literary movement of the Eighteen Nineties was that which found expression in the work of those writers associated with the high journalism of *The Yellow Book* and *The Savoy* : poets, essayists and storytellers whose books were in most instances published either by Mr John Lane, at the Bodley Head, or by Mr Elkin Mathews, both of whom were established in Vigo Street. At the beginning of the decade they were partners, under the title of Elkin Mathews & John Lane; but the partnership was dissolved, and afterwards the partners carried on separate businesses almost opposite each other in the same street. Other publishers associated with the new literary movement were Henry & Co., Laurence & Bullen and, more intimately, Leonard Smithers, himself a decadent and the friend and associate of many of the leaders of the group. Nearer the new century the Unicorn Press continued some of the traditions of the early Nineties, when the other publishers of the movement had become normal. These last-named publishers, as in the case of so many of the British decadents, passed away with the Nineties or thereabouts. Mr William Heinemann was a notable publisher of the period and in sympathy with the younger generation ; so was Mr Fisher Unwin, who showed his modernism by advertising his books by means of posters designed by Aubrey Beardsley ; and Mr Grant Richards issued several important works of the time, notably Bernard Shaw's *Plays Pleasant and Unpleasant,* and A. E. Housman's *A Shropshire Lad.* The lists of any of these publishers issued during the decade prove interesting reading even to-day, and they reveal sometimes a type of publisher as *fin de siècle* as their literary wares. No one will deny, however, that The Bodley Head was the chief home of the new movement, for not only did *The Yellow Book* issue from that house, but books by Oscar Wilde, John Davidson, Francis Thompson, Max Beerbohm, Richard Le Gallienne, George Egerton, Laurence Binyon, Michael Field, Norman Gale, Kenneth Grahame, Lionel Johnson, Alice

Meynell, William Watson, and G. S. Street. Leonard
Smithers made a unique place for himself as a *fin de siècle*
publisher, and when *The Savoy* (1896) was published by him
he stood courageously for the ideas and art of the decadence
at its darkest hour. With the passing of that excellent but
short-lived quarterly the decadence in England may be said
to have passed away.

The list of contributors to those two periodicals constitute
practically the *dramatis personæ* of the movement—with the
notable exception of Oscar Wilde, not any of whose work
appeared in either. *The Yellow Book* had Henry Harland
for literary editor, and for art editor, Aubrey Beardsley. Its
first four numbers (1894-1895) afford us a clear and compre-
hensive view of the literary movement of the Nineties ; but
after the withdrawal of Aubrey Beardsley, who transferred
his work to *The Savoy* in January 1896, the policy of *The
Yellow Book* seemed to change, and this change proceeded
always more away from the characteristics of the early days,
and, save for its yellow covers, *The Yellow Book* eventually
was hardly to be distinguished from any high-class magazine
in book form. The first number was in the nature of a bomb-
shell thrown into the world of letters. It had not hitherto
occurred to a publisher to give a periodical the dignity of
book form ; and, although literature had before then been
treated as journalism, it was quite a new thing in this country
for a group of lesser-known writers and artists to be glorified
in the regal format of a five-shilling quarterly. But the
experiment was a success even in the commercial sense, a
circumstance aided no doubt by its flaming cover of yellow,
out of which the Aubrey Beardsley woman smirked at the
public for the first time. Nothing like *The Yellow Book* had
been seen before. It was newness *in excelsis* : novelty naked
and unashamed. People were puzzled and shocked and
delighted, and yellow became the colour of the hour, the
symbol of the time-spirit. It was associated with all that
was *bizarre* and queer in art and life, with all that was out-
rageously modern. Richard Le Gallienne wrote a *prose
fancy* on "The Boom in Yellow," in which he pointed out

many applications of the colour with that *fin de siècle* flippancy which was one of his characteristics, without, however, tracing the decorative use of yellow to Whistler, as he should have done. Nevertheless his essay recalls very amusingly the fashion of the moment. "Bill-posters," he says, "are beginning to discover the attractive qualities of the colour. Who can ever forget meeting for the first time upon a hoarding Mr Dudley Hardy's wonderful Yellow Girl, the pretty advance-guard of *To-Day*? But I suppose the honour of the discovery of the colour for advertising purposes rests with Mr Colman; though its recent boom comes from publishers, and particularly from The Bodley Head. *The Yellow Book* with any other colour would hardly have sold as well—the first private edition of Mr Arthur Benson's poems, by the way, came caparisoned in yellow, and with the identical name, *Le Cahier Jaune*; and no doubt it was largely its title that made the success of *The Yellow Aster*."

The first number of *The Yellow Book*, published in April 1894, contained contributions by Richard Le Gallienne, Max Beerbohm, Ella D'Arcy, Arthur Symons, Henry Harland, George Egerton, Hubert Crackenthorpe, John Davidson, John Oliver Hobbes and George Moore, all of whom were in the vanguard of the new movement, and among the newer artists, besides Aubrey Beardsley, who contributed four full drawings, the cover decorations and title-page, there were Walter Sickert, Joseph Pennell, Laurence Housman, Will Rothenstein, and R. Anning Bell. But although *The Yellow Book* was mainly *fin de siècle* it was not exclusively so, for it included contributions by Henry James, Arthur Christopher Benson, William Watson, Arthur Waugh, Richard Garnett and Edmund Gosse, and illustrations by J. T. Nettleship and Charles W. Furse, and, above all, as though to reassure its readers and the British public after the Beardsley cover, and certain contents to match, and to assert its fundamental respectability, it contained a frontispiece by Sir Frederick Leighton, P.R.A. Volume II. had Norman Gale, Alfred Hayes, Dolly Radford and Kenneth Grahame among its new contributors, and P. Wilson Steer, E. J. Sullivan, A. S.

Hartrick and Walter Crane among its illustrators. Volume III.
was more modern than Volume II., for in addition to many
of the younger generation who contributed to the earlier
volumes it introduced into its company Ernest Dowson,
Lionel Johnson, Olive Custance, Theodore Wratislaw and
Charles Dalmon, whilst Max Beerbohm was represented
among the illustrators by his caricature of George IV. The
most notable addition to the contributors of Volume IV. was
Charles Conder, who sent a design for a fan ; and Volume V.
is interesting as it contains an article by G. S. Street, the first
English essay on Anatole France, by the Hon. Maurice
Baring, and the first article by that distinguished French
writer and *savant* ever published in England.

In spite, however, of its novelty, and the excellence of the
contents of its early numbers, *The Yellow Book* was always
inclined not only to compromise in matters of editorial policy,
but its contents were not always chosen according to the
high standard such a work demanded, and this became more
pronounced after the retirement of Beardsley. *The Savoy*
pursued a different policy. Edited by Arthur Symons, it
stood boldly for the modern note without fear and without
any wavering of purpose. Hence it represents the most
ambitious and, if not the most comprehensive, the most
satisfying achievement of *fin de siècle* journalism in this
country. Such a result was inevitable with an editor of rare
critical genius and one who had been profoundly influenced
by the French decadents. If his choice was not always
decadent it was always modern, even when it selected a
drawing of a distant time. This can be seen also among the
literary contributors to *The Savoy*, among whom were Arthur
Symons, W. B. Yeats, Theodore Wratislaw, Ernest Rhys,
Fiona Macleod, George Moore, Edward Carpenter, Ford
Madox Hueffer and Lionel Johnson. All are *fin de siècle*
writers, though differing in type and aim, and such writers
could hardly do otherwise than give the periodical a decidedly
modern expression, in spite of a challenging Editorial Note
prefaced to No. 1 (dictated, it would seem, by dissatisfaction
with the uneven editing, *fin de siècle* pose with apparent

readiness to compromise of *The Yellow Book*), which disavowed a definite modernist intent :

"It is hoped that THE SAVOY will be a periodical of an exclusively literary and artistic kind. To present Literature in the shape of its letterpress, Art in the form of its illustrations, will be its aim. For the attainment of that aim we can but rely on our best endeavours and on the logic of our belief that good writers and artists will care to see their work in company with the work of good writers and artists. Readers who look to a new periodical for only very well-known or only very obscure names must permit themselves to be disappointed. We have no objection to a celebrity who deserves to be celebrated, or to an unknown person who has not been seen often enough to be recognised in passing. All we ask from our contributors is good work, and good work is all we offer our readers. This we offer with some confidence. We have no formulas, and we desire no false unity of form or matter. We have not invented a new point of view. We are not Realists, or Romanticists, or Decadents. For us, all art is good which is good art. We hope to appeal to the tastes of the intelligent by not being original for originality's sake, or audacious for the sake of advertisement, or timid for the convenience of the elderly-minded. We intend to print no verse which has not some close relationship with poetry, no fiction which has not a certain sense of what is finest in living fact, no criticism which has not some knowledge, discernment and sincerity in its judgment. We could scarcely say more, and we are content to think we can scarcely say less."

The Savoy lived for twelve months, and during that time it went far towards realising its editor's ideal. It did realise that ideal to the extent of not admitting anything to its pages which could not be recommended alone on artistic grounds, and it never for a moment stepped beneath its high intent for the sake of financial gain or any of the other snares and pitfalls of even well-meaning editors. Among contributors

D

who were modern without being decadent were Bernard Shaw, who is represented in the first number by his most essay-like essay, "On Going to Church"; Havelock Ellis, who contributed one of the earliest articles in English on Friedrich Nietzsche; Frederick Wedmore, Edmund Gosse, Selwyn Image, Mathilde Blind and Joseph Conrad. Besides these *The Savoy* contained translations from Paul Verlaine, Emil Verhaeren and Cesare Lombroso. The illustrations were always modern, and always distinguished, and included, in addition to the last and, in many instances, best of Aubrey Beardsley's drawings, examples of the work of Charles Conder, Will Rothenstein, C. H. Shannon, Max Beerbohm, Joseph Pennell, William T. Horton, Walter Sickert and Phil May. It also reveals Aubrey Beardsley as a writer in both prose and poetry, the former taking the shape of his aggressively modern romance, *Under the Hill*. *The Savoy* was admittedly an art-for-art's-sake publication, and its failure in twelve months through lack of support proves that there was at the time no public for such a publication, even though the half-a-crown charged for each issue was not only half the price of *The Yellow Book*, but well within the reach of a fairly numerous cultured class. That class proved unequal to the demand of a decadent periodical of a fine type. Neither did the fact of a number being banned by Messrs W. H. Smith & Son, because it contained a reproduction of one of William Blake's pictures, have any appreciable effect on its circulation; and, finally, funds reached so low an ebb that Arthur Symons was forced to write the whole of the last number himself, and in his epilogue to his readers on the last page of that number he confessed to the pessimistic belief that "Comparatively few people care for art at all, and most of these care for it because they mistake it for something else," which in a way is true, but not necessarily unwise on the part of the majority, for art, as the Nineties were beginning to learn, was less important than life. But that does not invalidate the excellence of *The Savoy*.

A final attempt was made to produce a good periodical by the publication of *The Dome*, described as "A Quarterly

containing examples of all the Arts," at the price of one shilling, in 1898, two years after the death of *The Savoy*. But this quarterly never attempted to do more than represent the various arts ; it had no guiding theory save excellence, with the result that it was less definite than either of its forerunners. It admitted good work of the past as well as the present, and reprinted many fine examples of ancient and modern wood-engraving. Notable among its modern illustrators were Gordon Craig and Althea Giles ; and among its writers, Laurence Binyon, W. B. Yeats, C. J. Holmes, Laurence Housman, T. W. H. Crosland, Stephen Phillips, Fiona Macleod, John F. Runciman, T. Sturge Moore, Francis Thompson, Wilfrid Wilson Gibson, Gordon Bottomley, Arthur Symons, Roger Fry, "Israfel," and there was also a translation of one of Maurice Macterlinck's earliest stories, *The Massacre of the Innocents*.

It will be seen from the foregoing that the art movement of the Eighteen Nineties found one of its most characteristic expressions in *belles lettres*. It was largely a literary renaissance, exemplifying itself in poetry, drama, fiction and the essay. Books became once again respected for their own sakes ; publishers, led by John Lane, Elkin Mathews and, later, by J. M. Dent, competed as much in beauty and daintiness of production as in names and contents, and this bookish reverence reached its highest expression in a veritable apotheosis of the book at the hands of William Morris of the Kelmscott Press and Hacon & Ricketts of the Vale Press. But this branch of the fine arts, although still remote from the average national life, was no longer remote in the old sense ; it did not desire academic honours, and those who promoted the renaissance had no idea of establishing a corner in culture. An air of freedom surrounded the movement ; old ideals were not the only things that suffered at the hands of the iconoclasts, but, as we have seen, old barriers and boundaries were broken down and pitched aside ; a new right-of-way was proclaimed, and invitations to take to it were scattered broadcast. It was not entirely a democratic movement, however, and in some of its more intense moments

it was not at all democratic. What really happened in the
Nineties was that doors were thrown open and people might
enter and pass through into whatever lay beyond if they
would or could, and whether they were invited or not. To
that extent the period was democratic. Such an attitude
was a more or less intuitive recognition of a very obvious
awakening of intelligence which represented the first mental
crop of the movement towards popular education. The
Board Schools were bearing fruit; Secondary Education
and University Extension culture were producing a new
inquisitiveness. Ibsen's younger generation was knocking
at the door. The growing demand for culture was partially
satisfied, in the case of those who could expect no further aid
from the educational system, by popular reprints of the
classics, as could be seen by the ever-growing demand for
the volumes of *The Scott Library*, *The Canterbury Poets* and
The Temple Classics. The mental and imaginative stimulus
thus obtained created a hunger in many for still newer
sensations, and many of these passed through the doors
of the decadents or the realists into stranger realms. The
remainder, unable to appreciate the bizarre atmosphere of
The Yellow Book, turned with avidity to the new romantic
literature of the Yellow Press.

The Eighteen Nineties were to no small extent the battle-
ground of these two types of culture—the one represented by
The Yellow Book, the other by the Yellow Press. The one
was unique, individual, a little weird, often exotic, demand-
ing the right to *be*—in its own way even to waywardness ;
but this was really an abnormal minority, and in no sense
national. The other was broad, general popular ; it was
the majority, the man-in-the-street awaiting a new medium
of expression. In the great fight the latter won. *The Yellow
Book*, with all its " new " hopes and hectic aspirations, has
passed away, and *The Daily Mail*, established two years
later, flourishes. In a deeper sense, also, these two publica-
tions represent the two phases of the times. The character-
istic excitability and hunger for sensation are exemplified in
the one as much as the other, for what after all was the

"brilliance" of Vigo Street but the "sensationalism" of Fleet Street seen from the cultured side ? Both were the outcome of a society which had absorbed a bigger idea of life than it knew how to put into practice, and it is not surprising to those who look back upon the period to find that both tendencies, in so far as they were divorced from the social revolution of the Nineties, were nihilistic, the one finding its Moscow at the Old Bailey, in 1895, the other in South Africa, in 1899.

I use both terms and dates symbolically, for I am neither blind to the element of injustice in the condemnation of Oscar Wilde nor to the soul of goodness in the South African War. But at the moment I am dealing with main tendencies, and trying to give an idea-picture of a period, which was self-contained even in its disasters. The first half was remarkable for a literary and artistic renaissance, degenerating into decadence ; the second for a new sense of patriotism degenerating into jingoism. The former was in the ascendant during the first five years. In 1895 the literary outlook in England had never been brighter ; an engaging and promising novelty full of high vitality pervaded the Press and the publishers' lists, and it was even commencing to invade the stage, when with the arrest of Oscar Wilde the whole renaissance suffered a sudden collapse as if it had been no more than a gaily coloured balloon. "The crash of the fall certainly affected the whole spirit of this year," says R. H. Gretton, in his *Modern History of the English People.* "There were few great houses in London where he was not known ; fewer still where there was not among the younger generation an aggressive, irresponsible intolerance which had some relation, however vague, to his brilliant figure. Even athleticism rejoiced at this date to dissociate itself from anything that might have been in danger of easy approval from an older generation, by being too æsthetic ; captains of university football teams had been seen with long hair. There was too much of real revolt in the movement to allow the fate of one man to hold it lastingly in check ; but a certain silence, almost, if not quite, shamefaced, settled for

the moment on much of the social life of the country." Two
of Oscar Wilde's plays were being performed at the time, and
they were immediately suppressed. Outside of the smoking-
room that writer's name was scarcely whispered; it was
suppressed entirely in the newspapers. His books were
allowed to go out of print, and unauthorised publishers
pirated them, and were allowed for a time to thrive upon
the *succès de scandale* attained by the books because of the
misfortune of their author.

With the arresting of the art movement of the Nineties
came the chance of the man-in-the-street, whose new in-
tellectual needs found a new caterer in Alfred Harmsworth.
The political prejudices of the average man and his need for
romance by proxy were exploited with phenomenal success
by the audacious genius of the great newspaper adminis-
trator who has since won a world-wide reputation as Lord
Northcliffe. *The Daily Mail* openly fanned the Jingo flame,
already beginning to leap aloft under the inspiration of
Joseph Chamberlain and Cecil Rhodes, and the melodram-
atic Jameson Raid of December 1895. Then came the
Jubilee of 1897, when pride of race reached so unseemly a
pitch that Rudyard Kipling even, the acknowledged poet of
Imperialism, as the new patriotism was called, was moved to
rebuke his compatriots:

> " *If, drunk with sight of power, we loose*
> *Wild tongues that have not Thee in awe,*
> *Such boastings as the Gentiles use,*
> *Of lesser breeds without the Law.*
> *Lord God of Hosts, be with us yet,*
> *Lest we forget—lest we forget !* " [1]

But there was no turning back. Bitten by an unseeing
pride, expressing itself in a strangely inorganic patriotism,
the nation forgot art and letters and social regeneration, in
the indulgence of blatant aspirations which reached their
apotheosis in the orgy of Mafeking Night.

CHAPTER III

THE DECADENCE

NO English writer has a better claim to recognition as an interpreter of the decadence in recent English literature than Arthur Symons. He of all the critics in the Eighteen Nineties was sufficiently intimate with the modern movement to hold, and sufficiently removed from it in his later attitude to express, an opinion which should be at once sympathetic and reasonably balanced without pretending to colourless impartiality. But during the earlier phase his vision of the decadent idea was certainly clearer than it was some years later, when he strove to differentiate decadence and symbolism.

"The most representative literature of the day," he wrote in 1893, "the writing which appeals to, which has done so much to form, the younger generation, is certainly not classic, nor has it any relation to that old antithesis of the classic, the romantic. After a fashion it is no doubt a decadence; it has all the qualities that mark the end of great periods, the qualities that we find in the Greek, the Latin, decadence; an intense self-consciousness, a restless curiosity in research, an over-subtilising refinement upon refinement, a spiritual and moral perversity. If what we call the classic is indeed the supreme art—those qualities of perfect simplicity, perfect sanity, perfect proportion, the supreme qualities—then this representative literature of to-day, interesting, beautiful, novel as it is, is really a new and beautiful and interesting disease." [1]

Six years later Arthur Symons, like so many of the writers of the period, was beginning to turn his eyes from the " new

[1] " The Decadent Movement in Literature." By Arthur Symons. *Harper's New Monthly Magazine*, November 1893.

and beautiful and interesting disease," and to look inwardly
for spiritual consolation. In the "Dedication" to *The
Symbolist Movement in Literature* he told W. B. Yeats that
he was "uncertainly but inevitably" finding his way towards
that mystical acceptation of reality which had always been
the attitude of the Irish poet. And further on in the same
book, as though forgetting the very definite interpretation of
decadence given by him in the article of 1893, he writes of it
as "something which is vaguely called Decadence," a term,
he said, used as a reproach or a defiance :

"It pleased some young men in various countries to call
themselves Decadents, with all the thrill of unsatisfied virtue
masquerading as uncomprehended vice. As a matter of
fact, the term is in its place only when applied to style, to
that ingenious deformation of the language, in Mallarmé, for
instance, which can be compared with what we are accus-
tomed to call the Greek and Latin of the Decadence. No
doubt perversity of form and perversity of matter are often
found together, and, among the lesser men especially, experi-
ment was carried far, not only in the direction of style. But
a movement which in this sense might be called Decadent
could but have been a straying aside from the main road
of literature. . . . The interlude, half a mock-interlude, of
Decadence, diverted the attention of the critics while some-
thing more serious was in preparation. That something
more serious has crystallised, for the time, under the form of
Symbolism, in which art returns to the one pathway, leading
through beautiful things to the eternal beauty."

In the earlier essay he certainly saw more in decadence than
mere novelty of style, and rightly so, for style can no more
be separated from idea than from personality. The truth of
the matter, however, lies probably between the two views.
What was really decadent in the Eighteen Nineties did seem
to weed itself out into mere tricks of style and idiosyncrasies
of sensation ; and whilst doing so it was pleased to adopt the
term decadence, originally used as a term of reproach, as a

badge. But with the passing of time the term has come to
stand for a definite phase of artistic consciousness, and that
phase is precisely what Arthur Symons described it to be in
his earlier article, an endeavour "to fix the last fine shade,
the quintessence of things; to fix it fleetingly; to be a dis-
embodied voice, and yet the voice of a human soul; that is
the ideal of Decadence."

The decadent movement in English art was the final out-
come of the romantic movement which began near the dawn
of the nineteenth century. It was the mortal ripening of
that flower which blossomed upon the ruins of the French
Revolution, heralding not only the rights of man, which was
an abstraction savouring more of the classic ideal, but the
rights of personality, of unique, varied and varying men.
The French romanticists, led by Victor Hugo, recognised
this in their glorification of Napoleon; but fear and hatred
of the great Emperor generated in the hearts of the ruling
classes in this country and propagated among the people
prevented the idea from gaining acceptance here. At the
same time decadence was neither romantic nor classic; its
existence in so far as it was dependent upon either of those
art traditions was dependent upon both. The decadents
were romantic in their antagonism to current forms, but they
were classic in their insistence upon new. And it must not
be forgotten that far from being nihilistic in aim they always
clung, at times with desperation, to one already established
art-form or another. The French artists of the first revolu-
tionary period depended as much upon the traditions of re-
publican Greece and Rome as those of the revolution of July,
and the poets of Britain, led by Walter Scott and Byron,
depended upon the traditions of mediæval feudalism.
Romanticism was a reshuffling of ideals and ideas and a re-
creation of forms; it was renascent and novel. It could be
both degenerate and regenerate, and contain at the same
time many more contradictions, because at bottom it was
a revolt of the spirit against formal subservience to mere
reason. It is true that there is ultimately an explanation
for all things, a reason for everything, but it was left for

romance to discover a reason for unreason. It was the romantic spirit in the art of Sir Walter Scott which saw no inconsistency between the folk-soul and the ideals of chivalry and nobility ; that taught Wordsworth to reveal simplicity as, in Oscar Wilde's words, " the last refuge of complexity " ; that inspired John Keats with a new classicism in *Endymion* brighter than anything since *A Midsummer Night's Dream*, and *Comus*, and a new mediævalism in *The Eve of St Agnes* fairer than "all Olympus' faded hierarchy." It taught Shelley that the most strenuous and the most exalted individual emphasis was not necessarily antagonistic to a balanced communal feeling, and that the heart of Dionysos could throb and burn in the form of Apollo ; and above all it taught Samuel Taylor Coleridge that mystery lurked in common things and that mysticism was not merely a cloistral property.

Though all of these tendencies of thought and expression went to the making of the decadence in England, the influence, with the exception of that of Keats, was indirect and foreign. In that it was native the impulsion came directly from the Pre-Raphaelites, and more particularly from the poetry of Dante Gabriel Rossetti and Swinburne. But the chief influences came from France, and partially for that reason the English decadents always remained spiritual foreigners in our midst ; they were not a product of England but of cosmopolitan London. It is certain Oscar Wilde (hounded out of England to die in Paris), Aubrey Beardsley (admittedly more at home in the *brasserie* of the Café Royale than elsewhere in London) and Ernest Dowson (who spent so much of his time in Soho) would each have felt more at home in Paris or Dieppe than, say, in Leeds or Margate. The modern decadence in England was an echo of the French movement which began with Théophile Gautier (who was really the bridge between the romanticists of the Victor Hugo school and the decadents who received their inspiration from Edmond and Jules de Goncourt), Paul Verlaine and Joris Karl Huysmans. In short, Gautier, favourite disciple of Victor Hugo, represented the consummation of the old romanticism, and he did this by inaugurating that new

romanticism, which had for apostles the Parnassiens, Symbolists and Decadents. French romanticism begins with *Hernani*, and ends with *Mademoiselle de Maupin*. Decadence properly begins with *Mademoiselle de Maupin* and closes with *À Rebours*. In England it began by accident with Walter Pater's Studies in Art and Poetry, *The Renaissance*, which was not entirely decadent, and it ended with Oscar Wilde's *Picture of Dorian Gray* and Aubrey Beardsley's romance, *Under the Hill*, which were nothing if not decadent.

The accident by which Pater became a decadent influence in English literature was due to a misapprehension of the precise meaning of the famous "Conclusion" to the first edition of the volume originally issued in 1873, which led the author to omit the chapter from the second edition (1877). "I conceived it might possibly mislead some of those young men into whose hands it might fall," he wrote, when he reintroduced it with some slight modifications, bringing it closer to his original meaning, into the third edition of the book, in 1888. Nevertheless there was sufficient material in the revised version to stimulate certain minds in a direction only very remotely connected with that austere philosophy of sensations briefly referred to in *The Renaissance* and afterwards developed by Walter Pater under the idea of a "New Cyrenaicism" in *Marius the Epicurean* (1885). To those seeking a native sanction for their decadence, passages even in *Marius* read like invitations. "With the Cyrenaics of all ages, he would at least fill up the measure of that present with vivid sensations, and such intellectual apprehensions as, in strength and directness and their immediately realised values at the bar of an actual experience, are most like sensations." Such passages seemed in the eyes of the decadents to give a perverse twist to the æsthetic Puritanism of the intellectual evolution of Marius, and to fill with a new naughtiness that high discipline of exquisite taste to which the young pagan subjected himself. It is not surprising then to find even the revised version of the famous "Conclusion" acting as a spark to the tinder of the new acceptance of life.

"The service of philosophy, of speculative culture, towards the human spirit is to rouse, to startle it into sharp and eager observation. Every moment some form grows perfect in hand or face ; some tone on the hills or the sea is choicer than the rest ; some mood of passion or insight or intellectual excitement is irresistibly real and attractive for us,—for that moment only. Not the fruit of experience, but experience itself, is the end. A counted number of pulses only is given to us of a variegated, dramatic life. How may we see in them all that is to be seen in them by the finest senses ? How shall we pass most swiftly from point to point, and be present always at the focus where the greatest number of vital forces unite in their purest energy ? To burn always with this hard, gemlike flame, to maintain this ecstasy, is success in life. In a sense it might even be said that our failure is to form habits ; for, after all, habit is relative to a stereotyped world, and meantime it is only the roughness of the eye that makes any two persons, things, situations, seem alike. While all melts under our feet, we may well catch at any exquisite passion, or any contribution to knowledge that seems by a lifted horizon to set the spirit free for a moment, or any stirring of the senses, strange dyes, strange colours and curious odours, or work of the artist's hands, or the face of one's friend. Not to discriminate every moment some passionate attitude in those about us, and in the brilliancy of their gifts some tragic dividing of forces on their ways, is, on this short day of frost and sun, to sleep before evening. With this sense of the splendour of our experience and of its awful brevity, gathering all we are into one desperate effort to see and touch, we shall hardly have time to make theories about the things we see and touch. What we have to do is to be for ever curiously testing new opinions and courting new impressions, never acquiescing in a facile orthodoxy of Comte, or of Hegel, or of our own. Philosophical theories or ideas, as points of view, instruments of criticism, may help us to gather up what might otherwise pass unregarded by us. 'Philosophy is the microscope of thought.' The theory or idea or system which requires of us the sacrifice of any part

of this experience, in consideration of some interest into which
we cannot enter, or some abstract theory we have not identi-
fied with ourselves, or what is only conventional, has no real
claim upon us."

But misappropriation of the teaching of Walter Pater was
only an incident in the progress of decadence in England.
By the dawn of the last decade of the century susceptible
thought had reverted to the original French path of decadent
evolution which manifested itself from Théophile Gautier
and Charles Baudelaire through the brothers Goncourt, Paul
Verlaine, Arthur Rimbaud, Stéphane Mallarmé, to Huysmans,
with a growing tendency towards little secret raids over the
German frontier where the aristocratic philosophy of Fried-
rich Nietzsche was looted and made to flash approval of in-
tentions and ideas which that philosopher, like Pater, had
lived and worked to supersede. The publication of *The
Picture of Dorian Gray* in 1891 revealed the main influence
quite definitely, for, apart from the fact that Wilde's novel
bears many obvious echoes of the most remarkable of French
decadent novels, the *À Rebours* of J. K. Huysmans, which
Arthur Symons has called "the breviary of the decadence,"
it contains the following passage which, although *À Rebours*
is not named, is generally understood to refer to that book,
even if the fact were not otherwise obvious :—

"His eyes fell on the yellow book that Lord Henry had
sent him. What was it, he wondered. He went towards
the little pearl-coloured octagonal stand, that had always
looked to him like the work of some strange Egyptian bees
that wrought in silver, and taking up the volume, flung him-
self into an arm-chair, and began to turn over the leaves.
After a few minutes he became absorbed.

"It was the strangest book he had ever read. It seemed
to him that in exquisite raiment, and to the delicate sound
of flutes, the sins of the world were passing in dumb show
before him. Things that he had dimly dreamed of were
suddenly made real to him. Things of which he had never
dreamed were gradually revealed.

"It was a novel without a plot, and with only one character, being, indeed, simply a psychological study of a certain young Parisian who spent his life trying to realise in the nineteenth century all the passions and modes of thought that belonged to every century except his own, and to sum up, as it were, in himself the various moods through which the world-spirit had ever passed, loving for their mere artificiality those renunciations that men have unwisely called virtue as much as those natural rebellions that wise men still call sin. The style in which it was written was that curious jewelled style, vivid and obscure at once, full of *argot* and of archaisms, of technical expressions and of elaborate paraphrases, that characterises the work of some of the finest artists of the French school of symbolists. There were in it metaphors as monstrous as orchids and as evil in colour. The life of the senses was described in the terms of mystical philosophy. One hardly knew at times whether one was reading the spiritual ecstasies of some mediæval saint or the morbid confessions of a modern sinner. It was a poisonous book. The heavy odour of incense seemed to cling about its pages and to trouble the brain. The mere cadence of the sentences, the subtle monotony of their music, so full as it was of complex refrains and movements elaborately repeated, produced in the mind of the lad, as he passed from chapter to chapter, a form of reverie, a malady of dreaming, that made him unconscious of the falling day and the creeping shadows."

This book so revealed Dorian Gray to himself that he became frankly the Duc Jean des Esseintes of English literature. There are differences, to be sure, and the sensations and ideas of Dorian Gray are not elaborated so scientifically as those of des Esseintes, but there is something more than coincidence in the resemblance of their attitudes towards life.

Jean des Esseintes and Dorian Gray are the authentic decadent types. Extreme they are, as a matter of course, but their prototypes did exist in real life, and minus those incidents wherein extreme decadence expresses itself in serious

crime, such as murder or incitement to murder, those prototypes had recognisable corporeal being.

In the Eighteen Nineties two such types were Oscar Wilde and Aubrey Beardsley, each of whom approximated, if not in action, then in mind and idea to des Esseintes and Dorian Gray. There was in both a typical perversity of thought, which in Wilde's case led to a contravention of morality evoking the revenge of society and a tragic ending to a radiant career. Both preferred the artificial to the natural. "The first duty in life is to be as artificial as possible," said Oscar Wilde, adding, "what the second duty is no one has as yet discovered." The business of art as he understood it was to put Nature in her proper place. To be natural was to be obvious, and to be obvious was to be inartistic. Aubrey Beardsley invented a new artificiality in black and white art, and in his romance, *Under the Hill*, only a carefully expurgated edition of which has been made generally accessible to the public, he created an *À Rebours* of sexuality. And both possessed an exaggerated curiosity as to emotional and other experiences combined with that precocity which is characteristic of all decadents. The curiosity and precocity of the decadence were revealed in an English writer before the Eighteen Nineties by the publication, in 1886, of the *Confessions of a Young Man*, by George Moore; but apart from the fact that the author who shocked the moral susceptibilities of the people who control lending libraries, with *Esther Waters*, loved the limelight and passed through enthusiasms for all modern art movements, he was as far removed from the typical decadent as the latter is removed from the average smoking-room citizen who satisfies an agelong taste for forbidden fruit with a *risqué* story. George Moore played at decadence for a little while, but the real influences of his life were Flaubert and the naturalists on the one side, and their corollaries in the graphic arts, Manet and the impressionists, on the other. For the rest he insisted upon England accepting the impressionists; abandoned realism; introduced into this country the work of Verlaine and Rimbaud, and the autobiography of indiscretion; flirted

with the Irish Literary Movement, and its vague mysticism
—and remained George Moore.

The chief characteristics of the decadence were (1) Per-
versity, (2) Artificiality, (3) Egoism and (4) Curiosity,
and these characteristics are not at all inconsistent with a
sincere desire "to find the last fine shade, the quintessence
of things; to fix it fleetingly; to be a disembodied voice,
and yet the voice of a human soul." Indeed, when wrought
into the metal of a soul impelled to adventure at whatever
hazard, for sheer love of expanding the boundaries of human
experience and knowledge and power, these characteristics
become, as it were, the senses by which the soul may test
the flavour and determine the quality of its progress. In that
light they are not decadent at all, they are at one with all
great endeavour since the dawn of human consciousness.
What, after all, is human consciousness when compared with
Nature but a perversity—the self turning from Nature to
contemplate itself? And is not civilisation artifice's con-
spiracy against what is uncivilised and natural? As for
egoism, we ought to have learnt by this time that it is not
sufficient for a being to say "I am." He is not a factor in
life until he can add to that primal affirmation a consum-
mating "I will." "To be" and "to will" exercised
together necessitate action, which in turn involves experi-
ence, and experience, not innocence, is the mother of curiosity.
Not even a child has curiosity until it has experienced some-
thing; all inquisitiveness is in the nature of life asking for
more, and all so-called decadence is civilisation rejecting,
through certain specialised persons, the accumulated experi-
ences and sensations of the race. It is a demand for wider
ranges, newer emotional and spiritual territories, fresh woods
and pastures new for the soul. If you will, it is a form of
imperialism of the spirit, ambitious, arrogant, aggressive,
waving the flag of human power over an ever wider and
wider territory. And it is interesting to recollect that de-
cadent art periods have often coincided with such waves of
imperial patriotism as passed over the British Empire and
various European countries during the Eighteen Nineties.

It is, of course, permissible to say that such outbreaks of curiosity and expansion are the result of decay, a sign of a world grown *blasé*, tired, played-out; but it should not be forgotten that the effort demanded by even the most ill-directed phases of decadent action suggests a liveliness of energy which is quite contrary to the traditions of senile decay. During the Eighteen Nineties such liveliness was obvious to all, and even in its decadent phases the period possessed tonic qualities. But the common-sense of the matter is that where the so-called decadence made for a fuller and brighter life, demanding ever more and more power and keener sensibilities from its units, it was not decadent. The decadence was decadent only when it removed energy from the common life and set its eyes in the ends of the earth whether those ends were pictures, blue and white china, or colonies. True decadence was therefore degeneration arising not out of senility, for there is nothing old under the sun, but out of surfeit, out of the ease with which life was maintained and desires satisfied. To kill a desire, as you can, by satisfying it, is to create a new desire. The decadents always did that, with the result that they demanded of life not repetition of old but opportunities for new experiences. The whole attitude of the decadence is contained in Ernest Dowson's best-known poem : "Non sum qualis eram bonæ sub regno Cynaræ," with that insatiate demand of a soul surfeited with the food that nourishes not, and finding what relief it can in a rapture of desolation :

> " I cried for madder music and for stronger wine,
> But when the feast is finished, and the lamps expire,
> Then falls thy shadow, Cynara ! the night is thine ;
> And I am desolate and sick of an old passion,
> Yea, hungry for the lips of my desire :
> I have been faithful to thee, Cynara ! in my fashion ! "

In that poem we have a sort of parable of the decadent soul. Cynara is a symbol of the unattained and perhaps unattainable joy and peace which is the eternal dream of man. The decadents of the Nineties, to do them justice, were not so

E

degenerate as either to have lost hope in future joy or to have had full faith in their attainment of it. Coming late in a century of material pressure and scientific attainment they embodied a tired mood, rejected hope, beyond the moment, and took a subtle joy in playing with fire and calling it sin ; in scourging themselves for an unholy delight, in tasting the bitter-sweet of actions potent with remorse. They loved the cleanliness in unclean things, the sweetness in unsavoury alliances ; they did not actually kiss Cynara, they kissed her by the proxy of some " bought red mouth." It was as though they had grown tired of being good, in the old accepted way, they wanted to experience the piquancy of being good after a debauch. They realised that a merited kiss was not half so sweet as a kiss of forgiveness, and this subtle voluptu-ousness eventually taught them that the road called de-cadence also led to Rome. The old romanticism began by being Catholic ; Théophile Gautier strove to make it pagan, and succeeded for a time, but with Huysmans romanticism in the form of decadence reverted to Rome. In England the artists who represented the renaissance of the Nineties were either Catholics like Francis Thompson and Henry Harland or prospective converts to Rome, like Oscar Wilde, Aubrey Beardsley, Lionel Johnson and Ernest Dowson. If Catholicism did not claim them some other form of mysti-cism did, and W. B. Yeats and George Russell (A.E.) became Theosophists. The one who persistently hardened himself against the mystical influences of his period, John Davidson, committed suicide.

The general public first realised the existence of the decadence with the arrest and trial of Oscar Wilde, and, collecting its wits and its memories of *The Yellow Book*, the drawings of Aubrey Beardsley, and the wilful and perverse epigrams of *A Woman of No Importance*, it shook its head knowingly and intimated that this sort of thing must be stopped. And the suddenness with which the de-cadent movement in English literature and art ceased, from that time, proves, if it proves nothing else, the tremendous power of outraged public opinion in this country. But it

also proves that English thought and English morality, however superficial on the one hand and however hypocritical on the other, would neither understand nor tolerate the curious exotic growth which had flowered in its midst.

The passing of the decadence in England had been prepared by the satires of Robert Hichens and G. S. Street, in *The Green Carnation* and *The Autobiography of a Boy*, just as its earlier phase, the Æsthetic Movement, had been laughed out of any popularity it might have won by W. H. Mallock in *The New Republic*, W. S. Gilbert in *Patience*, and by George du Maurier in a famous series of humorous drawings in *Punch*. The weakness of *The Green Carnation* is that satire sails so perilously near reality as, at times, to lose itself in a wave of fact. At times the book reads more like an indiscretion than a satire, but no other writer has realised so well the fatuous side of the " exquisite " and " brilliant " corner in decadence which Oscar Wilde made his own :

" 'Oh ! he has not changed,' said Mr Amarinth. 'That is so wonderful. He never develops at all. He alone understands the beauty of rigidity, the exquisite severity of the statuesque nature. Men always fall into the absurdity of endeavouring to develop the mind, to push it violently forward in this direction or in that. The mind should be receptive, a harp waiting to catch the winds, a pool ready to be ruffled, not a bustling busybody, for ever trotting about on the pavement looking for a new bun shop. It should not deliberately run to seek sensations, but it should never avoid one ; it should never be afraid of one ; it should never put one aside from an absurd sense of right and wrong. Every sensation is valuable. Sensations are the details that build up the stories of our lives.'

" 'But if we do not choose our sensations carefully, the stories may be sad, may even end tragically,' said Lady Locke.

" 'Oh ! I don't think that matters at all, do you, Mrs Windsor ? ' said Reggie. 'If we choose carefully, we become deliberate at once ; and nothing is so fatal to personality

as deliberation. When I am good, it is my mood to be good ; when I am what is called wicked, it is my mood to be evil. I never know what I shall be at a particular moment. Sometimes I like to sit at home after dinner and read *The Dream of Gerontius.* I love lentils and cold water. At other times I must drink absinthe, and hang the night hours with scarlet embroideries. I must have music, and the sins that march to music. There are moments when I desire squalor, sinister, mean surroundings, dreariness and misery. The great unwashed mood is upon me. Then I go out from luxury. The mind has its West End and its Whitechapel. The thoughts sit in the park sometimes, but sometimes they go slumming. They enter narrow courts and rookeries. They rest in unimaginable dens seeking contrast, and they like the ruffians whom they meet there, and they hate the notion of policemen keeping order. The mind governs the body. I never know how I shall spend an evening till the evening has come. I wait for my mood.' "

There is satire so guarded, and lacking just so very dainty a touch of humour, that the uninitiated might miss the point. But that cannot be said of the more humorous touch of the author of *The Autobiography of a Boy*. Esmé Amarinth and Lord Reginald Hastings are cold, satirical echoes of Lord Henry Wotton and Dorian Gray, or such prototypes as they may have had in actuality ; but the delightful Tubby of the autobiography is an unforgettably comic exaggeration which might laugh the veriest and most convinced of decadents back to sanity. The introduction to the reader is masterly in its sly humour.

" He was expelled from two private and one public school ; but his private tutor gave him an excellent character, proving that the rough and ready methods of schoolmasters' appreciation were unsuited to the fineness of his nature. As a young boy he was not remarkable for distinction of the ordinary sort—at his prescribed studies and at games involving muscular strength and activity. But in very early life

the infinite indulgence of his smile was famous, and as in after years was often misunderstood ; it was even thought by his schoolfellows that its effect at a crisis in his career was largely responsible for the rigour with which he was treated by the authorities ; 'they were not men of the world,' was the harshest comment he himself was ever known to make on them. He spoke with invariable kindness also of the dons at Oxford (who sent him down in his third year), complaining only that they had not absorbed the true atmosphere of the place, which he loved. He was thought eccentric there, and was well known only in a small and very exclusive set. But a certain amount of general popularity was secured to him by the disfavour of the powers, his reputation for wickedness, and the supposed magnitude of his debts. His theory of life also compelled him to be sometimes drunk. In his first year he was a severe ritualist, in his second an anarchist and an atheist, in his third wearily indifferent to all things, in which attitude he remained for the two years since he left the university until now when he is gone from us. His humour of being carried in a sedan chair, swathed in blankets and reading a Latin poet, from his rooms to the Turkish bath, is still remembered in college."

The Autobiography of a Boy is not, like *The Green Carnation*, a satire upon the leaders of the decadence ; it is a satire upon the innumerable hangers-on to the movement—who were perhaps the only real degenerates. Perhaps the Tubby type will be always with us, and so long as we have our dominions beyond the seas, to which irate fathers may pack them, all may be well, especially if they depart with such superbly futile resolves as this Tubby made on the eve of his emigration to Canada. "My father," he writes towards the close of his autobiography, " spoke of an agent whom I was to see on my arrival : I think he wants me to go into a bank out there. But I shall make straight for the forests, or the mountains, or whatever they are, and try to forget. I believe people shoot one another there ; I have never killed a man, and it may be an experience—the lust for slaughter.

They dress picturesquely; probably a red sash will be the keynote of my scheme."

The decadence proper, in this country, was only one of the expressions of the liveliness of the times. It was the mood of a minority, and of a minority, perhaps, that was concerned more about its own moods than about the meaning of life and the use of life. At its worst it was degenerate in the literal sense—that is to say, weak, invalid, hectic, trotting with rather sad joy into the *cul de sac* of conventional wickedness and peacocking itself with fine phrases and professions of whimsical daring. As such it was open to satire; as such it would have suppressed itself sooner or later without the intervention of public opinion. At its best, even when that best was most artificial and most exotic, it realised much, if it accomplished little. True it was a movement of elderly youths who wrote themselves out in a slender volume or so of hot verse or ornate prose, and slipped away to die in taverns or gutters—but some of those verses and that prose are woven into the fabric of English literature. And if it was a movement always being converted, or on the point of being converted, to the most permanent form of Christianity, even though its reasons were æsthetic, or due entirely to a yearning soul-weariness, it succeeded in checking a brazen rationalism which was beginning to haunt art and life with the cold shadow of logic. Ernest Dowson's cry for "Madder music and for stronger wine," Arthur Symons' assertion that "there is no necessary difference in artistic value between a good poem about a flower in the hedge and a good poem about the scent in a sachet," and Oscar Wilde's re-assertion of Gautier's *l'art pour l'art* (with possibilities undreamt of by Gautier) are all something more than mere protests against a stupid philistinism; fundamentally they are expressions not so much of art as of vision, and as such nothing less than a demand for that uniting ecstasy which is the essence of human and every other phase of life. All the cynicisms and petulances and flippancies of the decadence, the febrile self-assertion, the voluptuousness, the perversity were, consciously or unconsciously, efforts towards the rehabilitation

of spiritual power. "I see, indeed," wrote W. B. Yeats, "in the arts of every country those faint lights and faint colours and faint outlines and faint energies which many call 'the decadence,' and which I, because I believe that the arts lie dreaming of things to come, prefer to call the autumn of the body. An Irish poet, whose rhythms are like the cry of a sea-bird in autumn twilight, has told its meaning in the line, 'the very sunlight's weary, and it's time to quit the plough.' Its importance is great because it comes to us at the moment when we are beginning to be interested in many things which positive science, the interpreter of exterior law, has always denied: communion of mind with mind in thought and without words, foreknowledge in dreams and in visions, and the coming among us of the dead, and of much else. We are, it may be, at a crowning crisis of the world, at the moment when man is about to ascend, with the wealth he has been so long gathering upon his shoulders, the stairway he has been descending from the first days." So it may be that this movement, which accepted as a badge the reproach of decadence, is the first hot flush of the only ascendant movement of our times; and that the strange and bizarre artists who lived tragic lives and made tragic end of their lives, are the mad priests of that new romanticism whose aim was the transmutation of vision into personal power.

CHAPTER IV

THE singularity of Oscar Wilde has puzzled writers since his death quite as much as it puzzled the public during the startled years of his wonderful visit' to these glimpses of Philistia; for after all that has been written about him we are no nearer a convincing interpretation of his character than we were during the great silence which immediately followed his trial and imprisonment. Robert H. Sherard's *Oscar Wilde: The Story of an Unhappy Friendship*, throws the clear light of sincerity and eloquence upon his own and his subject's capacity for friendship, but little more than that; André Gide has created a delightful, literary miniature which must always hang on the line in any gallery of studies of Oscar Wilde, but his work is portraiture rather than interpretation. For the rest, we have to be content with such indications of character as may be obtained from the numerous critical essays which have been published during the last few years, notable among them being Arthur Ransome's fine study, and the always wise commentations of Wilde's literary executor and editor, Robert Ross, and the notes and collectanea of Stuart Mason. But whatever ultimate definition his character may assume in future biography, and however difficult such definition may be, it is not so hard to define Oscar Wilde's position and influence during the last decade of the nineteenth century, and what proved to be as well the last decade of his own life.

In the year 1889 Oscar Wilde might have passed away without creating any further comment than that which is accorded an eccentric poet who has succeeded in drawing attention to himself and his work by certain audacities of costume and opinion. His first phase was over, and he had

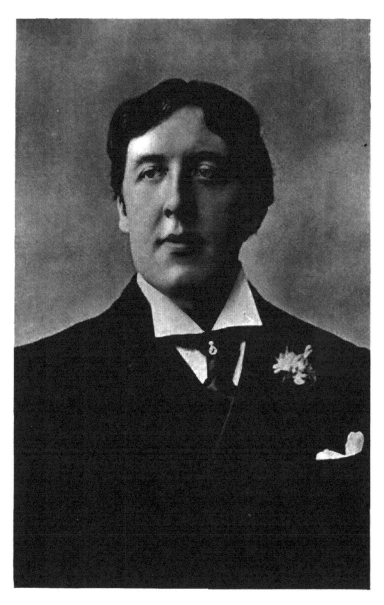

OSCAR WILDE (1895)
From the Photograph by Ellis & Walery

become an out-moded apostle of an æstheticism which had already taken the place of a whimsically remembered fad, a fad which, even then, almost retained its only significance through the medium of Gilbert and Sullivan's satirical opera, *Patience*. He was the man who had evoked merriment by announcing a desire to live up to his blue-and-white china ; he was the man who had created a sort of good-humoured indignation by expressing displeasure with the Atlantic Ocean : " I am not exactly pleased with the Atlantic," he had confessed. "It is not so majestic as I expected "; and whose later dissatisfaction with Niagara Falls convinced the United States of America of his flippancy : " I was disappointed with Niagara. Most people must be disappointed with Niagara. Every American bride is taken there, and the sight of the stupendous waterfall must be one of the earliest if not the keenest disappointments in American married life." These sayings were beginning to be remembered dimly, along with the picturesque memories of a plum-coloured velveteen knickerbocker suit and a famous stroll down Bond Street as a form of æsthetic propaganda by example. This memory also was aided by W. S. Gilbert :

> " If you walk down Piccadilly
> With a poppy or a lily
> In your mediæval hand. . . ."

But certain encounters with Whistler, in which Oscar Wilde felt the sting of the Butterfly, were remembered more distinctly and with more satisfaction, with the result that, besides being outmoded, he became soiled by the charge of plagiarism. " I wish I had said that," he remarked once, approving of one of Whistler's witticisms. " You will, Oscar ; you will ! " was the reply. And still more emphatic, the great painter had said on another occasion : " Oscar has the courage of the opinions . . . of others ! " The fact was that the brilliant Oxford graduate had not yet fulfilled the promise of his youth, of his first book, and of his own witty audacity. He had achieved notoriety without fame, and literary reputation without a sufficient means of livelihood,

and so small was his position in letters that, from 1887 to 1889, we find him eking out a living by editing *The Woman's World* for Messrs Cassell & Co.

His successes during this period were chiefly in the realms of friendship, and of this the public knew nothing. Publicly he was treated with amiable contempt : he was a social jester, an intellectual buffoon, a *poseur* ; food for the self-righteous laughter of the Philistines ; fair quarry for the wits of *Punch*, who did not miss their chance. Yet during the very years he was controlling editorial destinies which were more than foreign to his genius, he was taking the final preparatory steps towards the attractive and sometimes splendid literary outburst of his last decade. During 1885 and 1890 his unripe genius was feeling its way ever surer and surer towards that mastery of technique and increasing thoughtfulness which afterwards displayed themselves. This was a period of transition and co-ordination. Oscar Wilde was evolving out of one *bizarrerie* and passing into another. And in this evolution he was not only shedding plumes borrowed from Walter Pater, Swinburne and Whistler, he was retaining such of them as suited his needs and making them definitely his own. But, further than that, he was shedding his purely British masters and allowing himself to fall more directly under the influence of a new set of masters in France, where he was always at home, and where he had played the " sedulous ape " to Balzac some years earlier. From time to time during these years he had polished and engraved and added to the luxuriant imagery of that masterpiece of baroque poetry, *The Sphinx*, which was published in 1894 in a beautiful format with decorations by Charles Ricketts. Essays like "The Truth of Masks " and "Shakespeare and Stage Costume " appeared in the pages of *The Nineteenth Century* in 1885 ; in other publications appeared such stories as "The Sphinx without a Secret," "The Canterville Ghost " and "Lord Arthur Savile's Crime," and in 1888 he issued *The Happy Prince and Other Tales*. "Pen, Pencil and Poison " appeared in *The Fortnightly Review* in 1889, and in the same year *The Nineteenth Century* published the first of

his two great colloquies, *The Decay of Lying.* In all of these
stories and essays his style was conquering its weaknesses
and achieving the undeniable distinction which made him
the chief force of the renaissance of the early Nineties. In
1890 his finest colloquy, "The Critic as Artist," appeared in
The Nineteenth Century. Several of the above-named essays
and tales went to the making of two of his most important
books, *The House of Pomegranates* and *Intentions*, both of
which appeared in the first year of the Nineties, and in the
same year he published in book form the complete version
of *The Picture of Dorian Gray*, thirteen chapters of which
had appeared serially in *Lippincott's Monthly Magazine* in
the previous year.

Thus, with the dawn of the Eighteen Nineties, Oscar Wilde
came into his own. *The House of Pomegranates* alone was
sufficient to establish his reputation as an artist, but the
insouciant attitude of the paradoxical philosopher revealed
in *The Picture of Dorian Gray* and *Intentions* stung waning
interest in the whilom apostle of beauty to renewed activity.
Shaking off the astonishing reputation which had won him
early notoriety as the posturing advertiser of himself by
virtue of the ideas of others, he arose co-ordinate and re-
splendent, an individual and an influence. He translated
himself out of a subject for anecdote into a subject for dis-
cussion. And whilst not entirely abandoning that art of
personality which had brought him notoriety as a conversa-
tionalist and dandy in *salon* and drawing-room and at the
dinner-table, he transmuted the personality thus cultivated
into the more enduring art of literature, and that brought
him fame of which notoriety is but the base metal. For
many years he had looked to the theatre as a further means
of expression and financial gain, and he had tried his 'prentice
hand on the drama with *Vera : or the Nihilists* in 1882, which
was produced unsuccessfully in America in 1883, and with
The Duchess of Padua, written for Mary Anderson and re-
jected by her about the same time, and produced without
encouraging results in New York in 1891. There were also
two other early plays, *A Florentine Tragedy*, a fragment only

of which remains, and *The Woman Covered with Jewels,* which seems to have been entirely lost. The failure of these works to make any sort of impression involves no reflection on the public, as they are the veriest stuff of the beginner and imitator; echoes of Sardou and Scribe; romantic costume plays inspired by the theatre rather than by life, and possessing none of the signs of that skilled craftsmanship upon which the merely stage-carpentered play must necessarily depend. But with that change in the whole trend of his genius which heralded the first year of the Nineties came a change also in his skill as a playwright. In 1891 he wrote *Salomé* in French, afterwards translated into English by Lord Alfred Douglas and published by the Bodley Head, with illustrations by Aubrey Beardsley, in 1894. This play would have been produced at the Palace Theatre in 1892 with Madame Sarah Bernhardt in the cast, had not the censor intervened. Oscar Wilde achieved his first dramatic success with *Lady Windermere's Fan,* produced by George Alexander at the St James's Theatre, on 20th February 1892. The success was immediate. Next year Herbert Beerbohm Tree produced *A Woman of No Importance* at the Haymarket Theatre before even more enthusiastic audiences. In 1895 *An Ideal Husband* was produced at the same theatre in January, and, in February, *The Importance of Being Earnest* was produced at the St James's.

Oscar Wilde had now reached the age of forty-one and the height of his fame and power. "The man who can dominate a London dinner-table can dominate the world," he had said. He had dominated many a London dinner-table; he now dominated the London stage. He was a monarch in his own sphere, rich, famous, popular; looked up to as a master by the younger generation, courted by the fashionable world, loaded with commissions by theatrical managers, interviewed, paragraphed and pictured by the Press, and envied by the envious and the incompetent. All the flattery and luxury of success were his, and his luxuriant and applause-loving nature appeared to revel in the glittering surf of conquest like a joyous bather in a sunny sea. But it was only

a partial victory. The apparent capitulation of the upper and middle classes was illusory, and even the man in the street who heard about him and wondered was moved by an uneasy suspicion that all was not well. For, in spite of the flattery and the amusement, Oscar Wilde never succeeded in winning popular respect. His intellectual playfulness destroyed popular faith in his sincerity, and the British people have still to learn that one can be as serious in one's play with ideas as in one's play with a football. The danger of his position was all the more serious because those who were ready to laugh with him were never tired of laughing at him. This showed that lack of confidence which is the most fertile ground of suspicion, and Wilde was always suspected in this country even before the rumours which culminated in his trial and imprisonment began to filter through the higher strata of society to the lower. It sufficed that he was strange and clever and seemingly happy and indifferent to public opinion. This popular suspicion is summarised clearly, and with the sort of disrespect from which he never escaped even in his hour of triumph, in an article in *Pearson's Weekly* for 27th May 1893, written immediately after the success of *Lady Windermere's Fan* and *A Woman of No Importance* :

"Where he does excel is in affectation. His mode of life, his manner of speech, his dress, his views, his work, are all masses of affectation. Affectation has become a second nature to him, and it would probably now be utterly impossible for him to revert to the original Oscar that lies beneath it all. In fact, probably none of his friends have ever had an opportunity of finding out what manner of man the real Oscar is. . . . So long as he remains an amiable eccentricity and the producer of amusing trifles, however, one cannot be seriously angry with him. So far, it has never occurred to any reasonable person to take him seriously, and the storms of ridicule to which he has exposed himself have prevented his becoming a real nuisance. For the present, however, we may content ourselves with the reflection that

there is no serious danger to be apprehended to the State from the vagaries of a butterfly."

The above may be taken as a fair example of the attitude of the popular Press towards Oscar Wilde, and the same sentiments were expressed, varying only in degrees of literary polish, in many directions, even at a time when the new spirit of comedy he had introduced into the British theatre was giving unbounded delight to a vast throng of fashionable playgoers ; for these plays had not to create audiences for themselves, like the plays of Bernard Shaw ; they were immediately acclaimed, and Wilde at once took rank with popular playwrights like Sydney Grundy and Pinero.

There were of course many who admired him ; and he always inspired friendship among his intimates. All who have written of him during his earlier period and during the early days of his triumph refer to his joyous and resplendent personality, his fine scholarship, his splendid manners and conversational gifts, his good humour and his lavish generosity. André Gide gives us many glimpses of Wilde both before and after his downfall, one of which reveals him as table-talker :

"I had heard him talked about at Stephane Mallarmé's house, where he was described as a brilliant conversationalist, and I expressed a wish to know him, little hoping that I should ever do so. A happy chance, or rather a friend, gave me the opportunity, and to him I made known my desire. Wilde was invited to dinner. It was at a restaurant. We were a party of four, but three of us were content to listen. Wilde did not converse—he told tales. During the whole meal he hardly stopped. He spoke in a slow, musical tone, and his very voice was wonderful. He knew French almost perfectly, but pretended, now and then, to hesitate for a word to which he wanted to call our attention. He had scarcely any accent, at least only what it pleased him to affect when it might give a somewhat new or strange appearance to a word—for instance, he used purposely to pronounce *scepticisme* as *skepticisme*. The stories he told us without a break that evening were not of his best. Uncertain

of his audience, he was testing us, for, in his wisdom, or
perhaps in his folly, he never betrayed himself into saying
anything which he thought would not be to the taste of his
hearers; so he doled out food to each according to his appe-
tite. Those who expected nothing from him got nothing, or
only a little light froth, and as at first he used to give himself
up to the task of amusing, many of those who thought they
knew him will have known him only as the amuser."

With the progress of his triumph as a successful playwright,
his friends observed a coarsening of his appearance and
character, and he lost his powers of conversation. Robert H.
Sherard met him during the Christmas season of 1894 and
described his appearance as bloated. His face seemed to
have lost its spiritual beauty, and he was oozing with material
prosperity. At this time serious rumours about his private
life and habits became more persistent in both London and
Paris, and countenance was lent to them by the publication
of *The Green Carnation*, which, although making no direct
charge, hinted at strange sins. Oscar Wilde knew that his
conduct must lead to catastrophe, although many of his
friends believed in his innocence to the end. André Gide
met him in Algiers just before the catastrophe happened.
Wilde explained that he was fleeing from art :

"He spoke of returning to London, as a well-known peer
was insulting him, challenging him, and taunting him with
running away.

"'But if you go back what will happen ? ' I asked him.
'Do you know the risk you are running ? '

"'It is best never to know,' he answered. 'My friends
are extraordinary—they beg me to be careful. Careful ?
But how can I be careful ? That would be a backward step.
I must go on as far as possible. I cannot go much further.
Something is bound to happen . . . something else.'

"Here he broke off, and the next day he left for England."

Almost immediately after his arrival he brought an action
for criminal libel against the Marquis of Queensberry and,

upon losing the case, was arrested, and charged under the 11th Section of the Criminal Law Amendment Act, and sentenced to two years' penal servitude. During his imprisonment he wrote *De Profundis*, in the form of a long letter, addressed but not delivered, to Lord Alfred Douglas, a part of which was published in 1905, and after his release he wrote *The Ballad of Reading Gaol*, published, under a pseudonym, " C. 3. 3." (his prison number), by Leonard Smithers, and he contributed two letters on the conditions of prison life, "The Cruelties of Prison Life," and "Don't Read this if you Want to be Happy To-day," to *The Daily Chronicle* in 1897 and 1898. These·were his last writings.

After leaving prison he lived for a while, under the assumed name of " Sebastian Melmoth," at the Hôtel de la Plage, and later at the Villa Bourget, Berneval-sur-Mer, near Dieppe, where he wrote *The Ballad of Reading Gaol*, and the prison letters, and where he contemplated writing a play called *Ahab and Jezebel*. This play he hoped would be his passport to the world again. But a new restlessness overcame him, and all his good resolutions turned to dust. For a while he travelled, visiting Italy, the south of France and Switzerland, eventually settling in Paris, where he died, in poverty and a penitent Catholic, on 30th November 1900. He was buried in the Bagneux Cemetery, but on 20th July 1909 his remains were removed to Père Lachaise.

It is too soon, perhaps, even now, to set a final value upon the work of Oscar Wilde. Time, although not an infallible critic, is already winnowing the chaff from the grain, and almost with the passing of each year we are better able to recognise the more permanent essences of his literary remains. It is inevitable in his case, where the glamour of personality added so significantly to the character of his work, that Time should insist upon being something more than a casual arbiter. In proof of this the recollection of so much futile criticism of Wilde cannot be overlooked. Both the man and his work have suffered depreciations which amount to defamation, and appraisals which can only be described as silly. But finally he would seem in many

instances to have suffered more at the hands of his friends than his enemies. There have been, to be sure, several wise estimations of his genius, even in this country, notably those of Arthur Ransome and the not altogether unprovocative essay of Arthur Symons, entitled " An Artist in Attitudes " ; and the various prefaces and notes contributed by Robert Ross to certain of the volumes in the complete edition of the works are, of course, of great value. But, as the incidents associated with the life and times of Wilde recede further into the background of the mental picture which inevitably forms itself about any judgment of his work, we shall be able to obtain a less biased view. Even then, our perspective may be wrong, for this difficulty of personality is not only dominant, but it may be essential.

The personality of Oscar Wilde, luxuriant, piquant and insolent as it was, is sufficiently emphatic to compel attention so long as interest in his ideas or his works survives. Indeed, it may never be quite possible to separate such a man from such work. It is certainly impossible to do so now. With many writers, perhaps the majority, it requires no effort to forget the author in the book, because literature has effectually absorbed personality, or all that was distinctive of the author's personality. With Oscar Wilde it is otherwise. His books can never be the abstract and brief chronicles of himself ; for, admittedly on his part, and recognisably on the part of others, he put even more distinction into his life than he did into his art. Not always the worthier part of himself ; for that often, and more often in his last phase, was reserved for his books. But there is little doubt that the complete Oscar Wilde was the living and bewildering personality which rounded itself off and blotted itself out in a tragedy which was all the more nihilistic because of its abortive attempt at recuperation—an attempt which immortalised itself in the repentant sincerity of *De Profundis,* but almost immediately fell forward into an anticlimax of tragedy more pitiful than the first.

So far as we are able to judge, and with the aid of winnowing Time, it is already possible to single out the small

contribution made by Oscar Wilde to poetry. The bulk of his poetry is negligible. It represents little more than the ardent outpourings of a young man still deeply indebted to his masters. One or two lyrics will certainly survive in the anthologies of the future, but if Wilde were dependent upon his verses for future acceptance his place would be among the minor poets. There is, however, a reservation to be made even here, as there is in almost every generalisation about this elusive personality ; he wrote three poems, two towards the close of his earlier period, *The Harlot's House* and *The Sphinx*, and one near the close of his life, *The Ballad of Reading Gaol*, which bear every indication of permanence. The two former will appeal to those who respond to strange and exotic emotions, the latter to those who are moved by the broader current of average human feeling. His last poem, and last work, does not reveal merely Oscar Wilde's acceptance of a realistic attitude, it reveals what might have been, had he lived to pursue the matter further, conversion to a natural and human acceptation of life. The sense of simplicity in art which previously he had been content to use as a refuge for the deliberately complex, as a sort of intensive culture for modern bewilderment, is now used with even greater effect in the cause of the most obvious of human emotions—pity :

" I never saw a man who looked
 With such a wistful eye
Upon that little tent of blue
 Which prisoners call the sky,
And at every drifting cloud that went
 With sails of silver by.

I walked, with other souls in pain,
 Within another ring,
And was wondering if the man had done
 A great or little thing,
When a voice behind me whispered low,
 ' *That fellow's got to swing.*' "

There is none of the old earnest insincerity in this poem, and only occasionally does the poet fall back into the old

bizarrerie. Had *The Ballad of Reading Gaol* been written a hundred years ago, it would have been printed as a broadside and sold in the streets by the balladmongers ; it is so common as that, and so great as that. But there is nothing common, and nothing great, in the universal sense, about the two earlier poems. These are distinguished only as the expressions of unusual vision and unusual mood ; they are decadent in so far as they express emotions that are sterile and perverse. They are decadent in the sense that Baudelaire was decadent, from whom they inherit almost everything save the English in which they are framed. But few will doubt their claim to a place in a curious artistic niche. *The Sphinx,* a masterly fantasy of bemused artificiality, is really a poetic design, an arabesque depending for effect upon hidden rhymes and upon strange fancies, expressing sensations which have hitherto been enshrined in art rather than in life :

" Your eyes are like fantastic moons that shiver in some stagnant
 lake,
 Your tongue is like some scarlet snake that dances to fantastic tunes,

 Your pulse makes poisonous melodies, and your black throat is like
 the hole
 Left by some torch or burning coal on Saracenic tapestries.''

Similarly, *The Harlot's House* interprets a mood that is so sinister and impish and unusual as to express disease rather than health :

" Sometimes a horrible marionette
 Came out, and smoked its cigarette
 Upon the steps like a live thing.

 Then turning to my love, I said,
 ' The dead are dancing with the dead,
 The dust is whirling with the dust.'

 But she—she heard the violin,
 And left my side, and entered in :
 Love passed into the house of lust.''

Wilde developed this abnormal attitude towards life in
The Picture of Dorian Gray and in *Salomé*, and in each of
these prose works he endeavours, often with success, to
stimulate feelings that are usually suppressed, by means of
what is strange and rare in art and luxury. It is not the
plot that you think about whilst reading *Salomé*, but the
obvious desire of the author to tune the senses and the mind
to a preposterous key :

"I have jewels hidden in this place—jewels that your
mother even has never seen ; jewels that are marvellous. I
have a collar of pearls, set in four rows. They are like unto
moons chained with rays of silver. They are like fifty moons
caught in a golden net. On the ivory of her breast a queen
has worn it. Thou shalt be as fair as a queen when thou
wearest it. I have amethysts of two kinds, one that is black
like wine, and one that is red like wine which has been
coloured with water. I have topazes yellow as are the eyes
of tigers, and topazes that are pink as the eyes of a wood-
pigeon, and green topazes that are as the eyes of cats. I
have opals that burn always, with an icelike flame, opals
that make sad men's minds, and are fearful of the shadows.
I have onyxes like the eyeballs of a dead woman. I have
moonstones that change when the moon changes, and are
wan when they see the sun. I have sapphires big like eggs,
and as blue as blue flowers. The sea wanders within them
and the moon comes never to trouble the blue of their waves.
I have chrysolites and beryls and chrysoprases and rubies.
I have sardonyx and hyacinth stones, and stones of chalce-
dony, and I will give them all to you, all, and other things
will I add to them. The King of the Indies has but even
now sent me four fans fashioned from the feathers of parrots,
and the King of Numidia a garment of ostrich feathers. I
have a crystal, into which it is not lawful for a woman to
look, nor may young men behold it until they have been
beaten with rods. In a coffer of nacre I have three wondrous
turquoises. He who wears them on his forehead can imagine
things which are not, and he who carries them in his hand

can make women sterile. These are great treasures above all price. They are treasures without price. But this is not all. In an ebony coffer I have two cups of amber, that are like apples of gold. If an enemy pour poison into these cups they become like an apple of silver. In a coffer encrusted with amber I have sandals encrusted with glass. I have mantles that have been brought from the land of the Seres, and bracelets decked about with carbuncles and with jade that came from the city of Euphrates. . . . What desirest thou more than this, Salomé ? Tell me the thing that thou desirest, and I will give it thee. All that thou askest I will give thee, save one thing. I will give thee all that is mine, save one life. I will give the mantle of the High Priest. I will give thee the veil of the sanctuary."

The mere naming of jewels and treasures in a highly wrought prose-poem might in itself be as innocent as one of Walt Whitman's catalogues of implements, but even removed from its context there is something unusual and even sinister about Herod's offerings to Salomé. The whole work is coloured by a hunger for sensation that has all the sterility of an excessive civilisation.

In the essays collected in the book called *Intentions*, Oscar Wilde has let us into the secret which produced these works. That secret is an attempt to push Gautier's idea of art for art's sake, and Whistler's idea of art as Nature's exemplar, to their logical conclusions. He outdoes his masters with the obvious intention of going one better. Throughout the whole of his life he was filled with a boyish enthusiasm which took the form of self-delight. "His attitude was dramatic," says Arthur Symons, "and the whole man was not so much a personality as an attitude. Without being a sage, he maintained the attitude of a sage ; without being a poet, he maintained the attitude of a poet ; without being an artist he maintained the attitude of an artist." It is certainly true that his intellect was dramatic, and it is equally true that he was fond of adopting attitudes, but it is far from true to name three of his favourite attitudes

and to say that these began and ended in the mere posture. For Oscar Wilde was both poet and sage and artist. He may not have been a great poet, he may not have been a great sage, he may not, which is more doubtful, have been a great artist, but the fact remains that the attitudes representing those faculties and adopted by him were the symbols of demonstrable phases of his genius. Whilst always longing to express himself in literary forms, and knowing himself to be capable of doing so, he found it easier to express himself through the living personality. Writing bored him, and those who knew him are agreed that he did not put the best of himself into his work. "It is personalities," he said, "not principles, that move the age."

Throughout the whole of his life he tried to live up, not to his blue-and-white china, but to an idea of personality; and the whole of his philosophy is concerned with an attempt to prove that personality, even though it destroy itself, should be the final work of art. Indeed, in his opinion, art itself was nothing but the medium of personality. His attitudes thus become details in the art of personality. If they had no basis in fact, Oscar Wilde would have been no more than an actor playing a part in a work of art, but although he played, played at intellectual dandy, much as a boy will play at pirates, he was playing a part in the drama of life; and he adopted the attitude of dandy in response to as real an emotion at least as that which inspires a boy to adopt the attitude of pirate. What he seemed to be doing all the time was translating life into art through himself. His books were but incidents in this process. He always valued life more than art, and only appreciated the latter when its reflex action contributed something to his sensations; but because he had thought himself into the position of one who transmutes life into art, he fell into the error of imagining art to be more important than life. And art for him was not only those formal and plastic things which we call the fine arts; it embraced all luxurious artificialities. "All art is quite useless," he said. Such an attitude was in itself artificial; but with Oscar Wilde this artificialism lacked any progressive

element : it was sufficient in itself ; in short, it ended in itself, and not in any addition to personal power. Oscar Wilde never, for instance, dreamt of evolving into a god ; he dreamt of evolving into a master of sensation, a harp responding luxuriously to every impression. This he became, or rather, this he always was, and it explained the many quite consistent charges of plagiarism that were always being brought against him, and it may explain his insensate plunge into forbidden sin, his conversion and his relapse. He lived for the mood, but whatever that mood brought him, whether it was the ideas of others or the perversities of what is impish in life, he made them his own. What he stole from Whistler, Pater, Balzac, Gautier and Baudelaire, whilst remaining recognisably derivative, had added unto them something which their originals did not possess. He mixed pure wines, as it were, and created a new complex beverage, not perhaps for quaffing, but a sort of liqueur, or, rather, a cocktail, with a piquant and original flavour not ashamed of acknowledging the flavours of its constituents.

This, then, was in reality an attitude towards life, and not an empty pose. I do not think that Oscar Wilde had any hope of finding anything absolute ; he was born far too late in the nineteenth century for that. He had no purpose in life save play. He was the playboy of the Nineties ; and, like the hero of John Millington Synge's drama, he was subject to the intimidation of flattery. Naturally inclined to go one better than his master, he was also inclined to please his admirers and astonish his enemies by going one better than himself, and as this one better generally meant in his later life one more extravagance, one further abandonment, it resulted, from the point of view of convention, in his going always one worse. Repetition of this whim turned perversity into a habit, and the growing taunt of those who knew or suspected his serious perversions drove him into the final perversion of deliberately courting tragedy, much as the mouse is charmed back into the clutches of the cat after it has apparently been given a loophole of retreat. It would not have been cowardice if Oscar Wilde had escaped while

he had the chance, and it was not bravery that made him blind to that chance ; he was bemused by his own attitude. Afterwards, he learnt the meaning of pain, and he arrived at a conclusion similar to that of Nietzsche. But it was not until afterwards. And although he found consolation in Christian mysticism whilst in prison, and again on his death-bed, we shall never know with what subtle joy he permitted his own destruction during the intervening period. Looked at from such a point of view, his books help in explaining the man. The best of them, *Intentions, The House of Pome-granates, The Importance of Being Earnest, The Soul of Man, The Ballad of Reading Gaol, De Profundis,* and a handful of epigrams and short parables which he called *Prose Poems,* must, it seems to me, take a definite place in English litera-ture as the expression and explanation of the type Wilde represented.

This type was not created by Oscar Wilde : it was very general throughout Europe at the close of the last century, and he represented only one version of it. Probably to him-self he imagined himself to approximate somewhat to the cynical idlers of his plays : Lord Goring in *An Ideal Husband,* Lord Darlington in *Lady Windermere's Fan,* Lord Illingworth in *A Woman of No Importance* and Algernon Moncrieff in *The Importance of Being Earnest* may be partial portraits of the sort of personal impression their author imagined he was creating in the fashionable world. But he drew fuller por-traits of himself in his novel. Lord Henry Wotton and Dorian Gray represent two sides of Oscar Wilde ; they are both experimenters in life, both epicureans and both seeking salvation by testing life even to destruction. *The Picture of Dorian Gray* is really a moral tale, and that also is character-istic of the genius of Oscar Wilde, for at no period of his life had he the courage of his amorality. He was always haunted by the still small voice which broke bounds and expressed itself freely in *De Profundis.* And whilst reading his books, or listening to his plays, one cannot help feeling that their very playfulness is but the cloak of tragedy. The decadent, weary with known joys and yearning for new sensations,

perpetually being rebuked by the clammy hand of exhausted desire, must needs laugh. Oscar Wilde laughed, and made us laugh, not by his wit so much as by his humour, that humour which dances over his plays and epigrams with the flutter of sheet lightning, compelling response where response is possible, but always inconsequent and always defying analysis. It reached its height in *The Importance of Being Earnest,* a comedy so novel, so irresistibly amusing and so perfect in its way that discussion of it ends in futility, like an attempt to explain the bouquet of old Cognac or the iridescence of opals. It is the moonshine of genius. The still small voice in him, of which his lambent humour is the mask, is stronger in *The Soul of Man* and *The Ballad of Reading Gaol,* and it is quite possible that had he lived the even life that he began to live on the bleak coast of Normandy after his release from prison, this underlying strain in his character would have turned him into a social reformer. His harrowing letters on prison conditions point to some such destiny especially when associated with his philosophic dash into the realm of Socialism. As it was, such humane zeal as he possessed ended on the one side in sublime pity and on the other in the dream of a Utopia for dandies.

Dandy of intellect, dandy of manners, dandy of dress, Oscar Wilde strutted through the first half of the Nineties and staggered through the last. So pleased was he with himself, so interested was he in the pageant of life, that he devoted his genius, in so far as it could be public, to telling people all about it. His genius expressed itself best in stories and conversation, and he was always the centre of each. The best things in his plays are the conversations: the flippancies of dandies and the garrulities of delightful shameless dowagers. His best essays are colloquies; those that are not depend for effect upon epigrams and aphorisms, originally dropped by himself in the dining-rooms and *salons* of London and Paris. When he was not conversing he was telling stories, and these stories, perhaps, the *Prose Poems, The House of Pomegranates* and *The Happy Prince,* will outlive even his wittiest paradox. *Salomé* is more a story, a

" prose-poem," than a play, and it is more, to use for once the method of inversion in which he delighted, an epigram than a story. One can imagine the glee with which Oscar Wilde worked up to the anti-climax, to the moment after Salomé has kissed the dead mouth of Jokanaan, and Herod has turned round and said : " Kill that woman." One can taste his own delight whilst writing the final stage instruction : " The soldiers run forward and crush beneath their shields Salomé, daughter of Herodias, Princess of Judæa." But more easily still can one imagine this remarkable man for ever telling himself an eternal tale in which he himself is hero.

CHAPTER V

THE appearance of Aubrey Beardsley in 1893 was the most extraordinary event in English art since the appearance of William Blake a little more than a hundred years earlier. With that, however, or almost so, the resemblance ends. Blake was born " out of his due time," not alone because he baffled the understanding of his age, but because his age scarcely knew of his existence. Beardsley, on the other hand, was born into an age of easy publicity; and that circumstance, combined with the fact that he was so peculiarly of his period, instantly made him a centre of discussion, a subject for regard and reprehension. Temporally he was so appropriate that an earlier appearance would have been as premature as a later would have been tardy. It was inevitable that he should have come with *The Yellow Book* and gone with *The Savoy*. The times demanded his presence. He was as necessary a corner-stone of the Temple of the Perverse as Oscar Wilde, but, unlike that great literary figure of the decadence in England, his singularity makes him a prisoner for ever in those Eighteen Nineties of which he was so inevitable an expression. He alone of all the interesting figures of those years is almost as sterile in art as he is local in point of time. Oscar Wilde added delicate raillery and novel lightness to drama, and a new accent to conversation; Francis Thompson reintroduced Christian mysticism into English poetry; Ernest Dowson linked an eternal and bitter anguish of the soul with modern emotion; and Arthur Symons, Max Beerbohm, John Davidson, G. S. Street and Richard Le Gallienne reasserted the significance of urbane things; all revealed something that was universal—if only the universality of

91

taverns and courtesans. But Aubrey Beardsley is the unique
expression of the most unique mood of the Nineties, a mood
which was so limited that his art would have been untrue
had it been either imitable or universal. As a matter of
fact, it is neither ; all who have called Beardsley master
have destroyed themselves, and his work was archaic even
before he died.

As a man, or rather as a boy—for although Beardsley
reached manhood in years he hardly lost a certain boyish
attitude towards life—he was admired for his gaiety of heart,
unabashed joy in his work, and good-fellowship. He was
born at Brighton on 21st August 1872, and died of tuber-
culosis in 1898. From his seventh year his health was
delicate, and pulmonary troubles began to be feared as early
as 1881. He had passed through the first stages of education
before this, first at a kindergarten at Brighton, and then at
a preparatory school at Hurstpierpoint. But with the
appearance of lung trouble he was removed to Epsom. The
first artistic influence of his early life was music, and so pro-
ficient did he become as an executant that, in 1883, he joined
his family in London, and appeared on the concert platform
with his sister (Miss Mabel Beardsley, who became an actress)
as an infant prodigy. His real tastes, however, were liter-
ary, and, although as a child almost he could talk with some-
thing like authority upon music, he preferred to read books
and dream in words and phrases. In 1884 he and his sister
were living in Brighton again, and he began to attend the
Brighton Grammar School as a day boy. Although his
tastes ran in the direction of books, he had innate skill with
the pencil, and was influenced by the drawings of Kate
Greenaway. When quite young he made a little money by
decorating menu and invitation cards, but his drawing first
attracted particular attention at the Grammar School, where
the masters were interested and amused by his caricatures
of themselves, and his earliest work thus came to appear in
Past and Present, the magazine of that school. In 1888 he
entered an architect's office in London, but apparently re-
mained there for no great length of time, for in 1889 he was

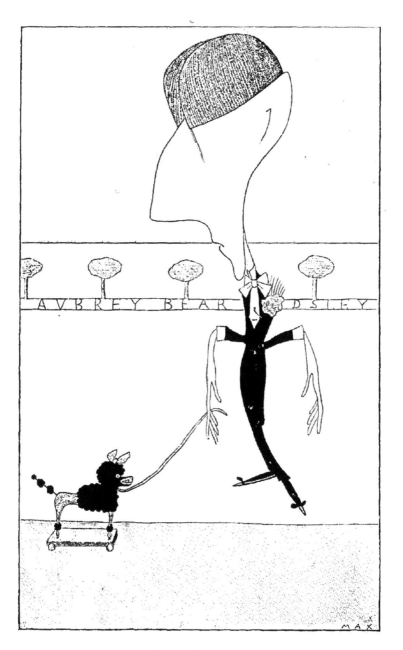

AUBREY BEARDSLEY
By Max Beerbohm

employed as a clerk in the Guardian Life & Fire Assurance Company. Whilst in that office he devoted his spare time to reading and drawing, and his passion for books led him, as it has led many another city clerk of literary tastes, to the well-known bookshop of Messrs Jones & Evans, in Queen Street, Cheapside, and here he made the acquaintance of Mr Frederick H. Evans, whose enthusiasm for his drawings was the herald of Beardsley's fame. Thus with the dawn of the Nineties came whispers of the appearance of a new and remarkable artist.

Through the intervention of Mr Evans, Aubrey Beardsley came into contact with the publishing world, and Mr J. M. Dent commissioned him to illustrate the now famous two-volume edition of the *Morte d'Arthur*, the publication of which in monthly parts, beginning June 1893, was Beardsley's debut as a book illustrator. About this time he met Joseph Pennell, who introduced him to the public in an enthusiastic article, illustrated by several characteristic drawings, in the first number of *The Studio* (April 1893), the cover of which was also designed by Beardsley. Interest in the new artist was immediate and clamorous; and his work began to appear in many books. Messrs Dent & Company, Messrs Elkin Mathews & John Lane, Messrs Longmans & Company and Mr David Nutt, all published books decorated by him. In 1894 he was appointed art editor of *The Yellow Book*, and then the "Beardsley Craze" began in earnest. Beardsley posters appeared on the hoardings, and the man-in-the-street became further acquainted with the work of this marvellous boy through the columns of the popular newspapers and magazines. The "Beardsley Woman" was an absorbing topic; and the young artist was belauded and belittled to exasperation.

Never before did artist achieve such immediate fame. He himself appreciated it all with unabashed delight, and worked harder and harder to meet the increasing demands upon his genius. Conscious, as John Keats had been, that "mortality weighed heavy upon him," he yet clung to life with the fatal hopefulness of the consumptive. He is said also to have

worked feverishly, as though conscious of pending doom, but, although fully aware of his fatal disease, it was not until the last year of his life that he realised the nearness of death. As late as September 1897, when he had actually got as far as France on what proved to be his funeral journey to the south, he was buoyed up by the hope of a complete recovery. " Dr P. has just put me through a very careful examination," he wrote to the Rev. John Gray. "He thinks I have made quite a marvellous improvement since he saw me at the Windsor Hotel, and that if I continue to take care I shall get quite well and have a new life before me."

A little more than seven months before, Aubrey Beardsley had been received into the Church of Rome, and his published letters, covering the period of preparation before his conversion, and closing a little less than three weeks before his death, are full of a sweetness which is heroic in so passionate a lover of life. In the introduction to *The Last Letters of Aubrey Beardsley*, those " noted letters " in which, as Arthur Symons has said, " we see a man die," Father Gray says : " Aubrey Beardsley might, had he lived, have risen, whether through his art or otherwise, spiritually to a height from which he could command the horizon he was created to scan. As it was, the long anguish, the increasing bodily helplessness, the extreme necessity in which someone else raises one's hand, turns one's head, showed the slowly dying man things he had not seen before. He came face to face with the old riddle of life and death ; the accustomed supports and resources of his being were removed ; his soul, thus denuded, discovered needs unstable desires had hitherto obscured ; he submitted, like Watteau his master, to the Catholic Church." He was buried after a Mass at the cathedral at Mentone, in the hillside Catholic cemetery of that town ; his grave on the edge of the hill is hewn out of the rock ; " a true sepulchre, with an arched opening and a stone closing it."

It is recorded that Aubrey Beardsley was greatly impressed by the wordless play, *L'Enfant Prodigue*, which delighted the playgoers of the Nineties, and one can well imagine how

the youthful artist found in the spacious silences of that novel production an echo of himself. Doubtless he saw in it something of his own vision of life translated into another form, but doubtless he felt also, but this time subconsciously, a response to that Pierrot note in his own soul which has been indicated by Arthur Symons. But Beardsley was something more than that, something more purposeful, although his early death left his purpose unrealised. His youth made him the infant prodigy of the decadence; and the Pierrot in him was an attitude, and even then it was a bigger attitude than that of its namesake. Innocence always frustrated the desires of Pierrot and left him desolate, but Aubrey Beardsley introduced into art the desolation of experience, the *ennui* of sin. It required the intensity of youth to express such an attitude, although the attitude savours not of the conventional idea of youth, but of the conventional idea of experienced age. Perhaps it is only the young who are ever really morbid, for youth more than age regrets that " spring should vanish with the rose." But youth that has heard the beatings of the wings of death, as Beardsley must have done, grows so hungry for the joys and beauties of spring that it becomes aged by the very intensity of desire. Keats, like Aubrey Beardsley, suffered such hunger, because, like Beardsley, whom he resembles so much temperamentally, he loved as he said "the mighty abstract idea of Beauty in all things." And with both poet and artist there was acute consciousness of the evanescence of Beauty :

> " Beauty that must die ;
> And Joy, whose hand is ever at his lips
> Bidding adieu, and aching Pleasure nigh,
> Turning to poison while the bee-mouth sips."

But that reality is not only the attitude of hypersensitive youth towards life ; it is the attitude of self-conscious civilisation. And how like modern civilisation is Max Beerbohm's summary of Aubrey Beardsley's temperament ? "He knew that life was short, and so he loved every hour of it with a kind of jealous intensity. He had that absolute power of

'living in the moment' which is given only to the doomed man—that kind of self-conscious happiness, the delight in still clinging to the thing whose worth you have only realised through the knowledge that it will soon be taken from you. For him, as for the schoolboy whose holidays are near their close, every hour—every minute, even—had its value. His drawing, his compositions in prose and in verse, his reading —these things were not enough to satisfy his strenuous demands on life. He was himself an accomplished musician, he was a great frequenter of concerts, and seldom, when he was in London, did he miss a 'Wagner night' at Covent Garden. He loved dining out, and, in fact, gaiety of any kind. His restlessness was, I suppose, one of the symptoms of his malady. He was always most content where there was the greatest noise and bustle, the largest number of people, and the most brilliant light." That is a picture of the age as well as of its epitome, Aubrey Beardsley.

In spite, however, of this hunger for life, this restless desire for more and more vitality, he contrived to retain a natural sweetness in his dealings with his fellow-men which has left many happy memories, some of which have been recorded. When Robert Ross first met Beardsley in 1892 he was so overcome by his " strange and fascinating originality " that he neglected the portfolio of drawings which the young artist had with him. "He was an intellectual Marcellus suddenly matured," says this chronicler. · "His rather long brown hair, instead of being *ébouriffé*, as the ordinary genius is expected to wear it, was brushed smoothly and flatly on his head and over part of his immensely high and narrow brow. His face even then was terribly drawn and emaciated. Except in his manner, I do not think his general appearance altered very much in spite of his ill-health and suffering, borne with such unparalleled resignation and fortitude ; he always had a most delightful smile, both for friends and strangers."

Arthur Symons suggests that any eccentricities or difficulties of character possessed by Beardsley were easily for-

gotten in his personal charm: "He seemed to have read everything, and had his preferences as adroitly in order, as wittily in evidence, as almost any man of letters; indeed, he seemed to know more, and was a sounder critic, of books than of pictures; with perhaps a deeper feeling for music than for either. His conversation had a peculiar kind of brilliance, different in order but scarcely inferior in quality to that of any other contemporary master of that art; a salt, whimsical dogmatism, equally full of convinced egoism and of imperturbable keen-sightedness. Generally choosing to be paradoxical and vehement on behalf of any enthusiasm of the mind, he was the dupe of none of his own statements, or indeed of his own enthusiasms, and, really, very coldly impartial. I scarcely accept even his own judgment of himself, in spite of his petulant, amusing self-assertion, so full of the childishness of genius. He thought, and was right in thinking, very highly of himself; he admired himself enormously; but his intellect would never allow itself to be deceived even about his own accomplishments." "I remember that when I first saw him," says Max Beerbohm, "I thought I had never seen so utterly frail a creature—he looked more like a ghost than a living man. He was then, I believe, already in an advanced stage of pulmonary consumption. When I came to know him better, I realised that it was only by sheer force of nerves that he contrived to sustain himself. He was always, whenever one saw him, in the highest spirits, full of fun and of fresh theories about life and art. But one could not help feeling that as soon as he were alone he would sink down, fatigued and listless, with all the spirit gone out of him. One felt that his gaiety resulted from a kind of pride, and was only assumed, as one should say in company." Another friend of the artist, H. C. Marillier, writes: "Poor Beardsley! His death has removed a quaint and amiable personality from among us; a butterfly who played at being serious, and yet a busy worker who played at being a butterfly. Outwardly, he lived in the sunshine, airing bright wings. Inwardly no one can tell how he suffered or strove. It is well to avoid

G

self-righteousness in judging him. As the wise pastrycook says in *Cyrano*,

" ' fourmi n'insulte pas ces divines cigales.' "

But there is little doubt that Aubrey Beardsley did take his work very seriously, boyish as he was, dandy as he was, butterfly as he was. He loved praise and approbation as all men do ; but when he won the frank appreciation of an acknowledged master, such as Whistler, as eventually he did, Beardsley showed his own sincerity and earnestness by tears. The story is told very simply and very beautifully by Elizabeth and Joseph Pennell in *The Life of James McNeill Whistler* :

" Whistler met Beardsley and got to like not only him, as everybody did, but his work. One night when Whistler was with us, Beardsley turned up, as always when he went to see anyone, with his portfolio of his latest work under his arm. This time it held the illustrations for *The Rape of the Lock*, which he had just made. Whistler, who always saw everything that was being done, had seen *The Yellow Book*, started in 1894, and he disliked it as much as he then disliked Beardsley, who was the art editor ; but he had also seen the illustrations to *Salomé*, disliking them too, probably because of Oscar Wilde ; he knew many of the other drawings, one of which, whether intentionally or unintentionally, was more or less a reminiscence of Mrs Whistler, and he no doubt knew that Beardsley had made a caricature of him which a follower carefully left in a cab. When Beardsley opened the portfolio, and began to show us *The Rape of the Lock*, Whistler looked at them first indifferently, then with interest, then with delight. And then he said slowly : ' Aubrey, I have made a very great mistake—you are a very great artist.' And the boy burst out crying. All Whistler could say, when he could say anything, was ' I mean it—I mean it—I mean it.' "

Leaving aside the prodigious elements in the life and work of Aubrey Beardsley, his youth and early death, the sudden

THE RAPE OF THE LOCK
By Aubrey Beardsley

ripening of uninstructed genius, and the brilliant productive-
ness of those last six disease-ridden years, his best drawings
stand out from the general level of British art with such
sheer audacity as to compel attention. It may be true that
more than half of this distinction is comprised of the inso-
lence of originality or of mere difference, but even then his
novelties and differences are so remarkable as to be things
in themselves. Most artists are generally normal in their
work, departing only into the margin of the page of art by
means of a mannerism or so upon which neither they nor
their admirers insist overmuch. Aubrey Beardsley was all
mannerism ; his genius all whim. That is the explanation
of its suddenness ; its surprise. But it does not explain the
extraordinary vision of humanity associated with his work.

An interviewer once asked him whether he used models.
" All humanity inspires me. Every passer-by is my uncon-
scious sitter," Beardsley replied, " and," he added, " strange
as it may seem, I really draw folk as I see them. Surely it is
not my fault that they fall into certain lines and angles."
Contradictions of actuality as each of these statements may
be, they yet throw light on Beardsley's attitude. Those who
know his work, eclectic as it is, know that " all humanity "
did not inspire it ; that " every passer-by " was not an
" unconscious sitter " ; that his confession of drawing folk
as he saw them was merely the art-cant of the hour, which
he tacitly admits by the suggestion that such a confession is
strange, in the light of his own drawings and what he and the
interviewer knew to be actually true. It was not, of course,
his fault that these folk under his pencil fell into " certain
lines and angles," it was the natural outcome of his genius.
But that genius was never pictorial in the realistic sense.
Beardsley was not an Impressionist, like Manet or Renoir,
drawing the thing as he *saw* it ; he was not a visionary, like
William Blake, drawing the thing as he *dreamt* it ; he was an
intellectual, like George Frederick Watts, drawing the thing
as he *thought* it. Aubrey Beardsley is the most literary of
all modern artists ; his drawings are rarely the outcome of
pure observation—they are largely the outcome of thought ;

they are thoughts become pictures. And even then they are
rarely if ever the blossoming of thought derived from ex-
perience ; they are the hot-house growths of thought derived
from books, pictures and music. Beardsley always worked
indoors, without models and by artificial, generally candle,
light. On those rare occasions when he did go to life for
inspiration he went to life in its more artificial form—to
theatres and *salons,* to the Domino Room at the Café Royal,
to the Pavilion at Brighton and the Casino at Dieppe.

The rococo in art and life appealed to him and influenced
him in his finest creative moments. Other influences are
certainly obvious in much of his work ; something of the
Japanese, but not so much as some critics have imagined,
much of Watteau, and a great deal of Burne-Jones, who early
expressed approval of the new artist—perchance, as Tenny-
son said of Prince Albert and King Arthur in *The Idylls of
the King,* "Perchance in finding there, unconsciously, some
image of himself," although the "Beardsley woman," that
sardonic creature, who looks as if she were aways hungering
for the sensation after next, might well have been, as she
probably was, at her inception, a caricature of the wraith-like
women of Burne-Jones. The wan and saintly amorousness
of the figures in the *Romaunt of the Rose* become cadaver-
ous with sin, and fat with luxury in the figures of Aubrey
Beardsley. But wherever the influence of Japanese or
English æstheticism asserts itself in Beardsley's drawings, it
does so to their detriment, as in the case of the illustrations
and decorations of the *Morte d'Arthur* and the "Procession
of Joan of Arc," although the influence behind the decora-
tions in the former work is obviously more that of William
Morris than of Burne-Jones. The only pictorial influence
which had a creative effect upon the work of Beardsley was
that of Watteau, under whose spell, born of deep sympathy
with the old master's sophisticated period, Beardsley pro-
duced some of his most satisfying pictures.

Save for two months in an art school, Beardsley had no
art training. He was self-taught, and the so-called influ-
ences require another name to describe them precisely.

MERLIN AND
NIMVE

PAGE DECORATION FROM THE *MORTE D'ARTHUR*
By *Aubrey Beardsley*

They were studies in technique; he used them much as the average art student uses his models—to teach himself the use of his materials, and they were dropped with the development of mastery. Throughout his short and astonishing art life, Beardsley was thus shedding those artistic influences which appeared to dominate him. But all the time he added himself to his masters : he was never dominated. The rapt and languorous spirituality of Burne-Jones was translated into grotesque and leering fleshliness—if languorous at all, languorous with sin. The frozen realities of Japan became torrid reflections of occidental passion expressed in crisp shadows and sweeps of line in black and white, suggesting colours undreamt of even in the rainbow East. But apart from all this, and during the earlier transition period, Aubrey Beardsley had actually discovered himself. At a time when he had barely ceased turning out poor echoes of Burne-Jones for his friends, he was drawing such daringly original things as "The Wagnerians," "The Fat Woman," "The Kiss of Judas," and "Of a Neophyte, and how the Black Art was revealed unto him by the Fiend Asomuel." From such work he passed on to the decorations for *Salomé*, which consummate magnificently his first period, and to those of *The Rape of the Lock*, which gave formal art a new meaning and Beardsley immortality.

The only real and lasting influence in the art of Aubrey Beardsley was literature. All who have written about him concur as to his amazing booklore. He himself admitted to having been influenced by the writers of the eighteenth century. "Works like Congreve's plays appeal far more vividly to my imagination than do those belonging to the age of Pericles," he said, in the interview already quoted. He was well versed in the literature of the decadence, and was fond of adventuring in strange and forbidden bookish realms of any and every age. The romance, *Under the Hill*, especially in its unexpurgated form, suggests deep knowledge of that literature generally classed under *facetiæ* and *erotica* by the booksellers, and there are passages which read like romanticised excerpts from the *Psychopathia Sexualis* of

Krafft-Ebing. *The Last Letters of Aubrey Beardsley* reveal
on almost every page an extraordinary interest in books,
equalled only by the keenness of his insight into literature.
They reveal also how he was gradually being drawn from the
literature of time to that of eternity. "Heine," he writes,
"certainly cuts a poor figure beside Pascal. If Heine is
the great warning, Pascal is the great example to all artists
and thinkers. He understood that to become a Christian the
man of letters must sacrifice his gifts, just as Magdalen must
sacrifice her beauty." And in the last letter in the volume,
less than three weeks before his death, he wrote : "I have
been reading a good deal of S. Alphonsus Liguori ; no one
dispels depression more than he. Reading his loving ex-
clamations, so lovingly reiterated, it is impossible to remain
dull and sullen."

In his literary predilections, more even than in his art,
you can see the mind of Aubrey Beardsley. All the rest-
lessness, all the changefulness of modernity were there. His
art was constantly changing, as Oscar Wilde's was, not
necessarily progressing, for, properly understood, Beardsley
said his say in "The Fat Woman," just as the essence of
Wilde is in *The Harlot's House*. All afterwards was repeti-
tion, restatement, intensification and elaboration. As with
all the work of the decadence, Aubrey Beardsley's repre-
sented a consistent search after new and more satisfying
experiences : the soul-ship seeking harbourage. But unlike
so many decadents he possessed humour. You hear the
laugh, often enough satyric, behind his most sinister design ;
and there is something in Max Beerbohm's belief that many
of his earlier drawings, which seemed morbid and horrible,
were the outcome of a very natural boyish desire to shock
conventional folk. But that does not explain away his
undeniable interest in all phases of sexual experience.
In normal youth, this tendency generally satisfies itself by
absorbing the current and colloquial variants of, say, the
stories of the *Decameron*. But Beardsley loved the abnormal
and he invented a sort of phallic symbolism to express his
interest in passionate perversities. His prose work, *Under*

the Hill, is an uncompleted study in the art of aberration.
He is seldom frankly ribald, after the manner of youth,
although, strangely enough, the most masterly of all his
drawings, the illustrations to the *Lysistrata*, if it were not for
their impish cynicism, are sufficiently Rabelaisian to satiate
the crudest appetite for indecencies. It has been urged
that Beardsley was engaged with such matters as a satirist,
that his designs had the ultimate moral objective of all satire.
Such apologies would make of him an English Felicien Rops.
But there is little genuine evidence to support the contention,
and what there is fades away in the light of an unpublished
letter, written after his conversation during his very last
days, imploring his friends in a few tragic, repentant words
to destroy all indecent drawings. "I implore you," he
wrote, "to destroy *all* copies of *Lysistrata* and bawdy
drawings. Show this to —— and conjure him to do same.
By all that is holy *all* obscene drawings." And the words,
"In my death agony," were added after the signature.

Aubrey Beardsley, although he died a saint, represents
a diabolonian incident in British art. He was essentially a
decorator ; but with the perversity of one phase of his genera-
tion he made decoration a thing in itself. None of the books
he illustrated are illustrated or decorated in the best sense.
His designs overpower the text—not because they are
greater but because they are inappropriate, sometimes even
impertinent. The diabolical thumb-nail notes in the "Bon
Mot " series have nothing whatever to do with the texts.
Where the designs for the *Morte d'Arthur* approximate to
the work of William Morris and Burne-Jones they serve
their purpose, but where they reveal the true Beardsley they
miss the point ; the *Salomé* drawings seem to sneer at Oscar
Wilde rather than interpret the play. *The Rape of the Lock*
is eclipsed, not explained, by Beardsley. But, outrageous
as his decorative comments on the *Lysistrata* may be, they
are at least logical commentations on the text of the play ;
as are also the illustrations to his own *Under the Hill*. "No
book ever gets well illustrated once it becomes a classic,"
wrote Beardsley, but that does not explain his own failure

as an illustrator. He failed as an illustrator because his art was decoration in the abstract: it lacked the rhythm of relationship—just as he himself lacked obvious relationship with the decades that preceded and followed him. He is entombed in his period as his own design is absorbed in its own firm lines.

But Beardsley as a fact is the significant thing, not Beardsley as an artist. It does not matter how or where he stands in art, for he represents not art so much as an idea, not an accomplishment so much as a mood. The restless, inquisitive, impudent mood of the Nineties called him forth, and he obeyed and served and repented.

TAIL-PIECE FROM SALOME
By Aubrey Beardsley

CHAPTER VI

THE NEW DANDYISM

"The future belongs to the dandy. It is the exquisites who are going to rule."—OSCAR WILDE.

LOVE of town is a human passion which may not be suppressed by advocates of the Simple Life and the Return to Nature, even though they bedeck their propaganda with words of flame. Such enthusiasts can never be more than apostles of a marginal gospel, attracting the few and, perhaps, the ill-starred. To the average man they will be nothing but curious folk, a little unbalanced—what are called cranks. For human life gravitates townwards; even when it emigrates, and settles in lands of prairie and forest, cities spring up about it; nothing, indeed, is more certain than the fact that, at the touch of humanity, the wilderness blossoms with the town. Normal man has, however, always loved to toy with the idea of the country, with its whispers of romance and health. But during the Eighteen Nineties, as in one or two other periods in history, art threw a glamour over the town, and all the artificial things conjured up by that word. Poets, it is true, did not abandon the pastoral mood, but they added to it an enthusiasm for what was urban. Where, in the past, they found romance only in wild and remote places, among what are called natural things, they now found romance in streets and theatres, in taverns and restaurants, in bricks and mortar and the creations of artificers. Poets no longer sought inspiration in solitude, they invoked the Muses in Fleet Street and the Strand. And whilst not entirely abandoning, as I say, the old themes which they have always and will always sing, they discovered a fresh delight in more sophisticated matters. These poets sang not only to "Corinna's going

a-maying," but they found a subtle joy in acclaiming "Nora
of the Pavement." It were unkind to say that they ceased
hearing the morning stars singing together, but they certainly
heard also, and with equal delight, the "Stars" of the music
halls. Richard Le Gallienne, for instance, ceased for a while
his consideration of the lilies of the field to consider "the
Iron Lilies of the Strand"; John Davidson, with his
Eclogues, became the Virgil of Fleet Street; and Arthur
Symons became the Herrick of the Theatre of Varieties.

In all this awakening interest in urban things, it is not
surprising to learn that London inspired a renaissance of
wonder, one phase of which found sympathetic expression in
Richard Le Gallienne's

> " London, London, our delight,
> Great flower that opens but at night,
> Great city of the midnight sun,
> Whose day begins when day is done.
>
> Lamp after lamp against the sky
> Opens a sudden beaming eye,
> Leaping a light on either hand,
> The iron lilies of the Strand."

Not that the wonder of London was in any sense a new
thing, even in literature. The capital city had inspired
many a song, and many a purple patch of prose. But the
men of the Nineties certainly added a new meaning to their
worship of the great town. They reasserted the romance of
London as an incident in their new-found love of the artificial.
This adoration extended from streets as abstract and ador-
able things separately to the houses of the streets, and even,
with a characteristically delicious thrill of wickedness, to the
women of the streets, and, with the remorseless logic of
the period, to the patchouli, the rouge and the peroxide
of hydrogen which are among the media of the craft of that
ancient sisterhood. In short, it was a characteristic of the
decadence not to sing the bloom of Nature but the bloom of
cosmetics, and, likewise, town was adored for its artificial
rather than its natural characteristics.

This new sophistication of the artistic temperament was again no sudden thing; it was linked by many correspond- ences with the urbane spirit of all times, although it favoured such remote forbears as Catullus and Petronius rather than the nearer and more domesticated ancestors, Charles Lamb, Samuel Johnson and Charles Dickens. It was Whistler who taught the modern world how to appreciate the beauty and wizardry of cities. He taught them by pictures and he taught them by magical and unforgettable words: "And when the evening mist clothes the riverside with poetry, as with a veil, the poor buildings lose themselves in the dim sky, and the tall chimneys become campanili, and the ware- houses are palaces in the night, and the whole city hangs in the heavens, and fairy-land is before us. . . ." But Whistler's revelation was not for the sake of the town, it was for the sake of art. It was Oscar Wilde, taking his cue from Whistler, who turned the idea of the beauty of art against natural beauty, into the artificial against the natural. He learnt from Whistler that trick of thought which placed Nature under an obligation to Art. Whistler's whimsical sayings about "foolish" sunsets and "Nature catching up to Art" set Oscar Wilde's nimble wit dancing down the corridors of paradox. "What art really reveals to us is Nature's lack of design," he says; "her curious crudities, her extraordinary monotony, her absolutely unfinished condition. Nature has good intentions, of course, but, as Aristotle once said, she cannot carry them out. When I look at a landscape I cannot help seeing all its defects. It is fortunate for us, however, that Nature is so imperfect, as otherwise we should have had no art at all. Art is our spirited protest, our gallant attempt to teach Nature her proper place. . . . All bad art comes from returning to Life and Nature, and elevating them into ideals. Life and Nature may sometimes be used as part of Art's rough material, but before they are of any real service to Art they must be trans- lated into artistic conventions. . . . Life imitates Art far more than Art imitates Life. This results not merely from Life's imitative instinct but from the fact that the self-

conscious aim of Life is to find expression, and that **Art offers** it certain beautiful forms through which it may realise that energy." But Wilde was not alone in upholding such ideas : they were in the air of the time, and found many exponents in what became a conscious if tentative revolt against Nature. "For behold ! " cried Max Beerbohm in, if not the ablest, one of the most convincing of his satires, " the Victorian era comes to its end and the day of *sancta simplicitas* is quite ended. The old signs are here and the portents warn the seer of life that we are ripe for a new epoch of artifice. Are not men rattling the dice-box and ladies dipping their fingers in the rouge-pot ? " And history was induced to pay tribute to the mood by Richard Le Gallienne, who reminded his age that the bravest of men had worn corsets.

Romance—or, at least, romance in its old obvious sense of wonder attuned to awe—was not, then, the final essence of this new interest in town life ; although the older romance had also its exponents during the *fin de siècle* renaissance. The *London Voluntaries* of William Ernest Henley set an older and more virile romanticism to a new music, and in no poem was his vigorous music more vigorous or more inspired than in the lines beginning "Down through the ancient Strand," which close with a pæan of ardent appreciation, if without quite achieving real ecstasy :

> " For earth and sky and air,
> Are golden everywhere,
> And golden with a gold so suave and fine
> The looking on it lifts the heart like wine.
> Trafalgar Square
> (The fountains volleying golden glaze)
> Gleams like an angel market. High aloft
> Over his couchant Lions in a haze
> Shimmering and bland and soft,
> A dust of chrysoprase,
> Our Sailor takes the golden gaze
> Of the saluting sun, and flames superb
> As once he flamed it on his ocean round.
> The dingy dreariness of the picture-place,
> Turned very nearly bright,

Takes on a luminous transciency of grace,
And shows no more a scandal to the ground.
The very blind man pottering on the kerb,
Among the posies and the ostrich feathers
And the rude voices touched with all the weathers
Of the long, varying year,
Shares in the universal alms of light,
The windows, with their fleeting, flickering fires,
The height and spread of frontage shining sheer,
The quiring signs, the rejoicing roofs and spires—
'Tis El Dorado—El Dorado plain,
The Golden City ! And when a girl goes by,
Look ! as she turns her glancing head,
A call of gold is floated from her ear !
Golden, all golden ! In a golden glory,
Long lapsing down a golden coasted sky,
The day not dies but seems
Dispersed in wafts and drifts of gold, and shed
Upon a past of golden song and story
And memories of gold and golden dreams.''

But Henley was not blind to the scamy side of London
life, to the grey and bitter tragedy of a great city, as he
proved on more than one occasion, and, especially, in the
poem beginning "Out of the poisonous East." Among the
notable poets who sang of the romance of London after
Henley came Laurence Binyon, with his *London Visions*,
which were inspired by a quieter and more reflective muse,
but voicing none the less the peculiar qualities of the London
enthusiasm of the time :

" Hazily blue the air, heavy with dews
The wind ; and before me the cries and the crowd,
And the sleepless murmur of wheels ; not loud,
For a magical softness all imbrues.
The softness estranges my sense : I see and I hear,
But know 'tis a vision intangible, shapes that seem.
All is unreal ; the sound of the falling of feet,
Coming figures, and far-off hum of the street ;
A dream, the gliding hurry, the endless lights,
Houses and sky, a dream, a dream ! ''

The newer and more peculiar sense of London was less
general in its expression. It sprang more out of the

intimacies of life, and appealed less to well-explored emotions of wonder and mystery than to more unique poetic moods of fewer but by no means rare individuals. It was more precisely a striving after reality through the medium of temperament. This intimate romanticism of the new urbanity tended always towards the artificial. Perhaps it was almost too real to be romantic, as it was too romantic to be real. It was less the artistic expression of a phase of life than the expression of a phase of art. It was really the art of posing, using the term intellectually to indicate what was certainly a state of mind rather than a conceit, for there is no reason why a pose need be other than sincere. The artificiality of the period which thus expressed itself by means of the personal pose was essentially a form of dandyism, not the dandyism which might or could express itself merely in clothing, but that dandyism of the temperament which found a true philosopher in Barbey D'Aurevilly and, perhaps, a truer in Charles Baudelaire. The dandyism of Baudelaire only expressed itself incidentally in the clothing of the body. It strove tragically enough to achieve soul-sufficiency, not by tasting, as the old mystics did, all the stars and all the heavens in a crust of bread, but by experiencing purgatory in every sensation. He and his followers were dandies of the spirit; but acute consciousness of sin bade them resist not evil, in contradistinction to the older mystics who became dandies of the spirit because they resisted evil. The desire of Baudelaire, as of all those who are in any way akin to him, was to discover in life that ecstasy which is eternity.

Dandyism may, and generally does, express itself in clothes; it did in the Eighteen Nineties express itself in the apparel of many a self-conscious "masher." But, whether it expresses itself in the clothing of the body or in the clothing of the mind, it is generally the outcome of similar causes. The chief of these, as Barbey D'Aurevilly saw, is boredom. Dandyism is thus a protest against the lassitude of soul which follows lapse of interest in the life of the hour. "Like those philosophers," says D'Aurevilly, "who raised up an

obligation superior to the law, so the dandies of their own
authority make rules that shall dominate the most aristo-
cratic, the most conservative sets, and with the help of wit,
which is an acid, and of grace, which is a dissolvent, they
manage to ensure the acceptance of their changeable rules,
though these are in fact nothing but the outcome of their
own audacious personalities. Such a result is curious, and
flows from the nature of things. In vain does society
refuse to bend, in vain do aristocracies admit only received
opinions ; one day Caprice arises and makes its way through
those seemingly impenetrable grades, which were really
undermined by boredom." The revolt against Nature in
England was in reality a revolt against the ennui of con-
ventions which in operation acted as checks upon the free
movements of personalities and ideas. D'Aurevilly has
observed that dandyism in recent times was an English
product, but also that it was introduced into this country
originally by the gallants of the Restoration who had lived
in France during the time England was under the heel of
the Puritan : it was, in fact, the Pagan's reply to Puritanism.
Dandyism has always been in the nature of such a reply.
But it is interesting to note that the new romanticism which
found expression in the decadence was also derived from
France, as was also its immediate ancestor, that romantic
movement to which D'Aurevilly belonged.

Dandyism of the intellect was as much a characteristic of
Théophile Gautier, Charles Baudelaire and Barbey D'Aure-
villy as it was of Whistler, Oscar Wilde and Aubrey Beards-
ley, and it is worth noting that these three English-speaking
artists were dandies also in the sartorial sense. But the
resemblance to the innate dandyism of D'Aurevilly is even
more marked when we remember his theory that dandyism
always produced the unexpected—" that which could not
logically be anticipated by those accustomed to the yoke of
rules." Unexpectedness was the secret of half the originality
of the Eighteen Nineties ; it was the salt of its philosophy,
and the charm of its most characteristic art. "To expect
the unexpected shows a thoroughly modern intellect," said

Oscar Wilde in his *Phrases and Philosophies for the Use of the Young*, a little work which is a veritable philosophy of dandyism. Literature in the Nineties ran to epigram, that poseur of syntax, and to paradox, that dandified juggler of ideas. Habits played blind man's buff with convention; and so determined was the fashion of the hour to be "out of fashion" that, with those who were *dans le mouvement* heterodoxy took the sting out of its own tail by becoming a form of orthodoxy. So remarkable was this spread of intellectual vanity that it was quite possible to have at one and the same time such variations as Oscar Wilde and Aubrey Beardsley surprising by their neo-paganism and its glorification of the artificial; Max Beerbohm and G. S. Street surprising by their satires of the former and, above all, by their very conservatism in an age of revolt; and, at the other extreme, such a complete and versatile revolutionary surprise packet of vanity as Bernard Shaw, who added to the general astonishment by insisting upon the Puritanical basis of his own theory of life. Equally surprising and unexpected to all but the most patient observers of intellectual revolutions, was the completion of the somersault of ideas at the very dawn of the twentieth century, when intellectual consciousness landed on its feet, as it were, becoming wildly English and frankly Christian in the genius of G. K. Chesterton.

Whilst the essential dandyism of the decade lasted it needed an urban background. Town was its natural element, pastoral dandyism being as yet unborn, though pastoral romance was as old as the hills. The very idyll of love literally assumed a new complexion. It was not fashionable for poets to sing of shepherd who told

> "his tale
> Under the hawthorn in the dale."

It was the fashion to sing, as Arthur Symons did, of

> "The chance romances of the streets,
> The Juliet of a night";

and poets, far from protesting overmuch of eternal fidelity, unblushingly confessed their lack of amorous concentration :

> " I too have sought on many a breast
> The ecstasy of love's unrest,
> I too have had my dreams and met
> (Ah me !) how many a Juliet."[11]

Such poems are in many instances artificial to the extent that they are obviously the result of deliberately cultivated moods; they and their kind are the green carnations of song; and they are unnatural only to the extent that they represent a peculiarly civilised, as distinct from a peculiarly barbarian, form of life. These differences reveal themselves more clearly in Arthur Symons' defence of his own early poems, which a reviewer had called "unwholesome " because, he said, they had "a faint smell of patchouli about them." The name of that scent was used more or less symbolically, and the poet accepts it as such and sums up an eloquent defence of his position as follows :—

"Patchouli ! Well, why not Patchouli ? Is there any 'reason in nature ' why we should write exclusively about the natural blush, if the delicately acquired blush of rouge has any attraction for us ? Both exist; both, I think, are charming in their way ; and the latter as a subject has, at all events, more novelty. If you prefer your 'new mown hay ' in the hayfield, and I, it may be, in a scent bottle, why may not my individual caprice be allowed to find expression as well as yours ? Probably I enjoy the hayfield as much as you do, but I enjoy quite other scents and sensations just as well and I take the former for granted and write my poem, for a change, about the latter. There is no necessary difference in artistic value between a good poem about a flower in the hedge, and a good poem about the scent in a sachet. I am always charmed to read beautiful poems about nature in the country. Only, personally, I prefer town to country ; and in the town we have to find for ourselves, as best we may, the *décor* which is the town equivalent of the great natural *décor* of fields and hills. Here it is that artificiality comes in;

H

and if anyone sees no beauty in the effects of artificial light in all the variable, most human, and yet most factitious town landscape, I can only pity him, and go on my own way."

The above passage does something more than defend with sound logic the artificial attitude of the decadence : it throws a very useful light upon the whole of that phase of the art and life of the period. Arthur Symons in his own personality substantiates Barbey D'Aurevilly's theory that the dandy is the product of boredom ; Symons having been nurtured in Nonconformity represents literally a Pagan revolt against Puritanism. His use of such words as " novelty," " change " and " caprice " further reveal the existence of a temperament which, having grown restive under the constraints of custom and recognised procedure, seeks reality in the conscious exploitation of mood and whim. It was only the very young and the very limited in vision who imagined that novelty, caprice and change, associated with sensation, held in themselves any satisfying food for the soul ; and, if they did imagine such a thing, disillusion was ever waiting for the chance to offer them her cold companionship. As for the whim of artificiality, that child of decadent inquisitiveness, neither in life nor in art was it other than limited and exotic. Even the hints of the existence of perversions like homosexuality were more or less exaggerated : they would be more appropriate to the London of to-day than to the London immediately preceding the trial of Oscar Wilde.

Aubrey Beardsley was the supreme example of the revolt against Nature, but it is probable that even his revolt was more artistic than actual. In his art he realised Oscar Wilde's dictum that " The first duty in life is to be as artificial as possible." His pictures are at the antipodes of naturalism, and his unfinished romance, *Under the Hill,* is a mosaic of artificiality. Life is never left to its own unaided devices for a moment in this strange work, which seems at times, by the very heaped-up deliberation of its artifice, to satirise all the weaknesses of the decadence, by pressing them to their logical conclusion in the negation of all spontaneous desire save desire for the gratification of perverse sensations.

It creates life out of cosmetics and aberrations ; and Nature never appears except in the form of an abnormality. Could anything more artificial be imagined, outside of a picture by Beardsley, than this description of the toilet of Venus ? " Before a toilet that shone like the altar of Notre Dame des Victoires, Venus was seated in a little dressing-gown of black and heliotrope. The coiffeur Cosmé was caring for her scented chevelure, and with tiny silver tongs, warm from the caresses of the flame, made delicious intelligent curls that fell as lightly as a breath about her forehead, and over her eyebrows, and clustered like tendrils about her neck. Her three favourite girls, Papplarde, Blanchemains and Loreyne, waited immediately upon her with perfume and powder in delicate flaçons and frail cassolettes, and held in porcelain jars the ravishing paints prepared by Châteline for those cheeks and lips that had grown a little pale with anguish of exile. Her three favourite boys, Claude, Clair and Sarrasine, stood amorously about with salver, fan and napkin. Millarmant held a slight tray of slippers, Minette some tender gloves, La Popelinière, mistress of the robes, was ready with a frock of yellow and yellow. La Zambinella bore the jewels, Florizel some flowers, Amadour a box of various pins, and Vadius a box of sweets. Her doves, ever in attendance, walked about the room that was panelled with gallant paintings of Jean Baptiste Dorat, and some dwarfs and doubtful creatures sat here and there, lolling out their tongues, pinching each other, and behaving oddly enough."

In spite of all this artificiality, the revolt against Nature was not organised, but it was very real and very self-conscious for all that. An artificial and half-hearted attempt was made to revive the literary tavern, and literary discussions were actually heard once again in so unpromising a quarter as Fleet Street, as they once had been heard in the days of Samuel Johnson. The Rhymers' Club foregathered at the Cheshire Cheese, and members read their poems to one another and discussed the great business of poetry and life. This revival of the town did not last long ; a new charmer

appeared upon the scene, and even poets fell before the seductions of suburban life. They became victims of our national love of compromise, and the exodus began. " Who knows but that Artifice is in truth at our gates and that soon she may pass through our streets ? " asked Max Beerbohm, in 1894. The new queen was more than at our gates : she had entered the city ; but she was never really enthroned. On the eve of her accession fear struck the hearts of *les jeunes ecrivains* ; fear, or disillusion, or the birth-pangs of middle age, and Queen Artifice was denied by her whilom courtiers from villa retreats without the city walls. The only artifice which actually survived was that which, like the romance in Kipling's poem, was already " printed and bound in little books." The chance romances of the streets were abandoned for the reputedly more certain realities of home life. Bohemians cut their locks, shed their soft collars and fell back upon Suburbia. No more songs about Nora of the Pavement, no more rhapsodies about the glamour of the footlights, no more rhetoric about passionate and scarlet lives ; even dandyism of thought and word disappeared ; for, once you live in a suburb, there is nothing left but to become ordinary.

The decadence suffered early from fatty degeneration of its naughtiness and found sanctuary in the suburbs. Even Max Beerbohm, during his " first year at Oxford," saw it coming, as he thought of " the lurid verses written by young men who, in real life, know no haunt more lurid than a literary public-house."

CHAPTER VII

THE New Urbanity had no finer expression than that which was summed up and set forth in the personality and art of Max Beerbohm. It was fine because it was at once normal and unique, sane but inconsequent, sedate without being serious, and mannered without empty severity or formality. Max was the comic spirit of the Nineties, and he took his elegant way without haste or fuss, dropping appropriate remarks about himself apropos of others and vice versa; throwing upon the decadence of his day the critical light of a half-appreciative humour. Without being decadent, this extraordinarily modern personality managed to represent the decadence laughing, or rather smiling, at itself.

Max Beerbohm was born in London, in August 1872, and it is interesting to note that he entered the world three days after his famous contemporary, Aubrey Beardsley, who was born at Brighton during the same week. He was educated at Charterhouse, and Merton College, Oxford, where his critical and satirical gifts revealed themselves in caricatures of masters and dons; in a letter to *The Carthusian*, over the pseudonym, "Diogenes," complaining against the dullness of the school journal, and in a satire in Latin elegiacs, called *Beccarius*, twelve copies of which were privately printed, at the suggestion of his form-master, in the form of a four-page pamphlet. A rough yellow paper was used for the publication, and the year of issue was 1890. The colour and date may be noted; and, still more significant, the title of his first notable essay, "A Defence of Cosmetics," written at Oxford, and published in the first number of *The Yellow Book* in 1894.

117

That year and the two following saw the reputation he had made at Oxford carried to London, and Max, in the second year of manhood, leapt into the front rank of the literary renaissance. During these years he contributed to *The Yellow Book*, in addition to the above-named essay, "A Letter to the Editor," in July 1894, and "A Note on George the Fourth," in October 1894. Later he contributed "Dandies and Dandies," to *Vanity*, New York, February 1895; "Notes on Foppery," to *The Unicorn*, September 1895; "Be it Cosiness," to *The Pageant*, Christmas 1895; "A Good Prince," to *The Savoy*, January 1896; "De Natura Barbatulorum," to *The Chap-Book*, February 1896; and "Poor Romeo!" to *The Yellow Book*, April 1896. These essays were collected, revised and, in some instances, re-named, and published in a little red volume, with white paper label, under the title of *The Works of Max Beerbohm*, in 1896. During the same period he contributed caricatures to *The Sketch, The Pall Mall Budget, Pick-me-up, The Yellow Book, The Octopus* and *The Savoy*. Some of these have been re-issued in volume form, but the majority are buried in the files of those publications.

There is nothing specially remarkable in the amount of work recorded above, but its distinctive quality for a young man still under twenty-four years of age is characteristic of the precocity of the period. More remarkable still, however, is the air of ancient wisdom which pervades the essays. Max Beerbohm gives the impression of having been born grown-up—that is to say, more or less ripe when others would be more or less raw and green. One can well imagine such a youth a few years earlier filling, in a more elegant way, the part of Sir W. S. Gilbert's immortal "Precocious Baby," who was born, it will be remembered, with

> "A pipe in his mouth, and a glass in his eye,
> A hat all awry,
> An octagon tie,
> And a miniature-miniature glass in his eye,"

for he assures us that at school he read *Marius the Epicurean* in bed, and found the book as fascinating as *Midshipman*

Easy. The ripeness of maturity having established itself so early, it is not surprising to find Max Beerbohm announcing his intention of settling down to a cosy dotage at the great age of twenty-five, and, as a step towards this comfortable end, publishing his collected *Works*, with a Bibliography by Mr John Lane of the Bodley Head. "Once again in the delusion that Art," he wrote, in 1895, "loving the recluse, would make his life happy, I wrote a little for a yellow quarterly and had that *succès de fiasco* which is always given to a young writer of talent. But the stress of creation soon overwhelmed me. Only Art with a capital H gives any consolations to her henchman. And I, who crave no knighthood, shall write no more. I shall write no more. Already I feel myself to be a trifle outmoded. I belong to the Beardsley period. Younger men, with months of activity before them, with fresher schemes and notions, with newer enthusiasm, have pressed forward since then. *Cedo junioribus.* Indeed, I stand aside with no regret. For to be outmoded is to be a classic, if one has written well. I have acceded to the hierarchy of good scribes and rather like my niche."

It was an age of poses, and this was one of the most refreshing : all the other young men were frantically striving to cram into their youth the multiple experiences of a generation weary of experiencing anything older than the moment before last. But Max in his undue maturity was not old ; he was merely trying the alleged unruffled calm of elderliness on the palate of waning youth (a period when men feel older than they are, or will be) and, in contradistinction to the hot-house ardency of the hour, he declared it to be good. Actually, Max was that wise thing—a ripe youth. Even now he seems to be immune from the trespassing years, having, doubtless, forestalled them in the Nineties. The elderly by nature do not grow old. So, having terminated his life as a writer in 1896 by the publication of his *Works*, with the whimsical conclusion, "Diminuendo," in which he confessed that he believed himself outmoded, and declared his intention of living a life of meditation in some unfashionable

suburban retreat, he began writing again. His second period
produced a fantastic tale, *The Happy Hypocrite*, and a com-
panion volume to the *Works*, entitled *More*. This book,
published in 1899, is a selection from among a considerable
number of essays contributed to various periodicals, all of
which, with the exception of *To-Morrow*, are in the normal
current of publicity. More recently he has issued a further
volume of essays, *Yet Again* (1909), a novel, *Zuleika Dobson*
(1911), a volume of parodies on modern prose styles, *A
Christmas Garland* (1912), several collections of caricatures,
and a one-act comedy of his has been produced at the Palace
Theatre.

A notable event in his literary life was the succession to
Bernard Shaw as dramatic critic of *The Saturday Review*, in
1898. Just twelve months before Max had written his own
valedictory—"Be it Cosiness," reprinted in the *Works* as
"Diminuendo," Bernard Shaw joined the staff of *The
Saturday Review*, and when ill-health forced him to relinquish
his post he wrote an equally famous " Valedictory," announc-
ing Max as his successor. "The younger generation is
knocking at the door," wrote Shaw, in his generous announce-
ment of the new-comer. "The younger generation is knock-
ing at the door ; and as I open it there steps spritely in the
incomparable Max." Max Beerbohm was not exactly the
younger generation knocking at the door of dramatic criti-
cism. Bernard Shaw was that younger generation. The
incomparable Max had no new axe to grind. He was neither
new nor old, progressive nor reactionary. He brought to
the theatre nothing save his own personality, and advocat-
ing no other cause, and upholding neither this " movement "
nor that, he contented himself by recording his own dramatic
likes and dislikes. And if his penetrating and creative criti-
cism did not always see eye to eye with the upholders of what
was called the "higher drama," it had, in addition to its
independence and insight, the lasting charm of good writing.

There are those even among the appreciators of Max
Beerbohm who seem to take special delight in laying stress
upon what they call his cleverness and brilliance. Such

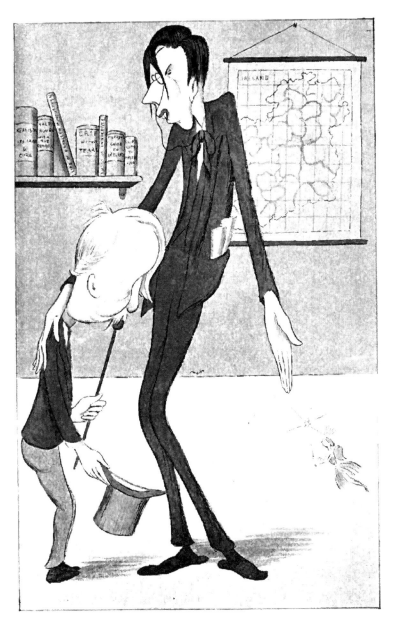

"Mr. W. B. Yeats presenting Mr. George Moore to the
Queen of the Fairies"
By Max Beerbohm

obvious characteristics of his work are not to be denied;
but, when all has been said upon the point, it is only right to
admit that cleverness and brilliance, common enough stock-
in-trade even of the literary huckster, are only a phase, and
a minor phase, of the art of Max Beerbohm. First and fore-
most, he represents a point of view. And, secondly, that
point of view is in no sense a novelty in a civilised society.
Every age has had its representative of a similar attitude
towards life, in one a Horace, in another a Joseph Addison
and, again, a Charles Lamb. In our age it is Max Beerbohm.
He is the spirit of urbanity incarnate ; he is town. He is
civilisation hugging itself with whimsical appreciation for a
conservative end. "A delicate and Tory temperament pre-
cludes me from conversing with Radicals," he says. That
does not preclude him from laughing at institutions and what
might be called institutional persons. But it precludes him
from shouting and arguing loudly, in an age given overmuch
to that sort of thing. He talks the quiet talk of culture,
and his finely balanced essays betray conscious appreciation
of the immemorial traditions of culture on every page.
When he reproves, in either prose or pictures, he reproves
with a smile. His laughter is ever Meredith's laughter of
the mind ; that laughter which the novelist considered a
corrective of civilised foibles because it is based in a love of
civilisation ; the laugh that, in Meredith's own words, "will
be of the order of the smile, finely tempered, showing sun-
light of the mind, mental richness rather than noisy enormity.
Its common aspect is one of unsolicitous observation, as if
surveying a full field and having leisure to dart on its chosen
morsels, without any fluttering eagerness. Men's future
upon earth does not attract it ; their honesty and shapeliness
in the present does ; and whenever they wax out of propor-
tion, overblown, affected, pretentious, bombastical, hypo-
critical, pedantic, fantastically delicate ; whenever it sees
them self-deceived or hoodwinked, given to run riot in
idolatries, drifting into vanities, congregating in absurdities,
planning shortsightedly, plotting dementedly ; whenever
they are at variance with their professions, and violate the

unwritten but perceptible laws binding them in considera-
tion one to another ; whenever they offend sound reason,
fair justice ; are false in humility or mined with conceit,
individually or in the bulk, the Spirit overhead will look
humanely malign and cast an oblique light on them, followed
by volleys of silvery laughter." That benign yet critical
spirit is the comic spirit, and it fathered the urbane essays
and caricatures of Max Beerbohm. But it did not impress
itself upon the genius of Max so as to overwhelm it with
social purpose. It left a fair margin for the play of person-
ality, for playfulness in itself, and even for that essential
egotism whose special flavour captivates by insinuation
rather than by advertisement.

The attitude he adopts in his books is, of course, a pose,
but he himself would not deny the imputation. On the
contrary. His pose is as natural as anything civilised can
be. Civilisation is the master art of the human race, and
Max Beerbohm insists upon his civilised attributes, realising
in his every mood and sensation that the long years of human
development have made him a detail of that master art, just
as a column is a detail of architecture, or rhythm of verse.
He is not, however, an expression of the hardness of even
civilised life ; he is the expression of its delicacy and refine-
ment, one of the points, as it were, wherein the race in its
artificial aspects becomes self-conscious, contemplative,
artistic, meet for Mayfair or St James's. He is a sane mani-
festation of dandyism. There is evidence of this in every
line of his essays—from the careful and inimitable excellence
of his prose to his delight, often satirical, in the use of ornate
and exotic words. You would deduce a dandy from such
essays, but not a D'Orsay, although Max is also an amateur
in portraiture. D'Orsay abandoned himself to personal
display ; he was more a fop than a dandy, and his gorgeous
clothes were flamboyant weeds rather than the nice accentua-
tions of a man and his works. Max is never abandoned, so
you could never deduce a fop from his essays. What you
could deduce would be a person more dignified, less theatrical,
but none the less proud of himself ; and the quiet eccen-

tricity of his clothes would serve as a suitable background for the sly brightness of his wit. For the dandyism of Max is intrinsic ; it is a state of being rather than an assumption ; it is psychological, expressing itself in wit rather than clothes; and wit is the dandyism of the mind.

It does not matter what he writes about : his subjects interest because he is interesting. A good essayist justifies any subject, and Max Beerbohm as an essayist is next in succession to Charles Lamb. His essays, and these are his greatest works, are genial invitations to discuss Max, and you discuss him all the more readily and with fuller relish because they are not too explicit ; indeed, he is often quite prim. "On the banner that I wave is embroidered a device of prunes and prisms," he says. The author of *The Works of Max Beerbohm*, of *More*, and of *Yet Again*, does not tell you all; he pays you a delicate compliment by leaving you something to tell yourself; the end of his ellipsis, as in all the great essayists, is yourself. He is quite frank with you, and properly genial ; but he is too fastidious to rush into friendship with his readers. They must deserve friendship first. He does not gush. In his earlier work he recalled the Wise Youth in *Richard Feverel*, and Whistler of the *Ten O'Clock*. But latterly he has grown more confiding and less artificial. His whimseys have given place to irony—an irony with the flavour of a fully matured wine. But he has not, as yet, achieved great distinction in letters outside the medium in which he has proved himself a master. His departures from the essay, in the form of a short story and a novel, are, in a sense, extensions of his genius as an essayist. *The Happy Hypocrite* is really an essay masquerading as a story, and *Zuleika Dobson*, a wreath of essays (including one exquisite gem on Oxford), aphorisms and detached reflections, hung about a refreshingly extravagant story. The real Max Beerbohm is, I fancy, an essayist pure and simple, the essay being the inevitable medium for the expression of his urbane and civilised genius. There are, he has told us, a few people in England who are interested in repose as an art. He is, undoubtedly, one of them. But he is also interested

in the art of the essay, and his essays are exquisite contributions to that rare art. In them you see revealed the complete Max, interpreting deftly, by means of wit and humour, imagination and scholarship, that "uninterrupted view of my fellow-creatures," to use his own words, which he admits preferable to books, and which, doubtless, he prefers better than any other view in life.

Even his caricatures are essays, and not only in the pictorial sense, for many of them are incomplete in themselves; they depend for their fulness of satire upon the carefully worded descriptions added by the artist. His earlier style of drawing was far simpler than the elaborate pictures which are the delight of so many who love fun with a sting in it, at the now familiar Leicester Gallery exhibitions. His *Caricatures of Twenty-five Gentlemen* (1896) is a volume of drawings in simple black and white, each in the nature of a grotesque comment upon some contemporary personality. There is little of the deeper satire which Max afterwards developed. It was a decade of attitudinising, and caricatures in this early volume are portraits of modern attitudes seen through the lens of a temperament which distorts without malice for the sake of healthy and critical laughter. But, with the exception of the caricature of Aubrey Beardsley, which combines caricature of that artist's personal appearance and his art, plus a clever comment on his exotic and artificial point of view in the introduction of a toy French poodle, there is very little below the surface of these drawings; they lack depth. His later work in caricature is broader as well as deeper, and his keen sense of satirical fun does not hesitate to go hand-in-hand with a sharper form of criticism when face to face with pomposity or the self-sufficiency of our mandarins. The fulness of Max Beerbohm's genius as a caricaturist is to be seen in the volume of coloured drawings called *The Poet's Corner* (1904). Here we have him arousing the laughter of amusement in such drawings as "Omar Khayyám," "Dante in Oxford"; the laughter which is criticism in "Robert Browning taking Tea with the Browning Society," and "Mr Rudyard Kipling

takes a bloomin' Day aht, on the blasted 'Eath, along with Britannia, 'is Gurl "; and the laughter which ceases to be laughter in "Mr W. B. Yeats presenting Mr George Moore to the Queen of the Fairies," and the unforgettable "Mr Tennyson reading *In Memoriam* to his Sovereign "—surely among the great caricatures of all time. Max rarely knots the lash of his satire, but his caricatures of certain aspects of Court life prove him to be capable of inflicting criticisms which might well make their subjects wince. In the main, however, his caricatures suggest an amused impartiality. Most of us are in the habit of making to ourselves sarcastic or whimsical remarks about the people we meet, see or hear about. Max Beerbohm has put such usually silent comment into pictures; and these pictures constitute in themselves a revival of caricature in a country that had practically lost the art of personal satire in pictures—and the taste for it.

CHAPTER VIII

SHOCKING AS A FINE ART

" Thrice I have patted my God on the head that men might call me brave."—
Tomlinson, by RUDYARD KIPLING.

CLOSELY related to the new dandyism and the search for reality by means of mood and sensation in their more sophisticated forms came the gentle art of astonishing the middle class. The one was in the nature of a by-product of the other. Young bloods of the period delighted to *épater le bourgeois,* as the phrase went, and with experience a new kind of art came into vogue : the art of shocking. In a sense the necessity was thrust upon the younger generation by the unimaginative opposition their demand for more life encountered at the hands of the auto-cracy of elderly respectability. It was really a contest be-tween the stupidity of vitality and the vitality of stupidity. For if those in authority had occasional doubts as to their own material importance they had none about their virtue and righteousness. No one, indeed, had ever contested their right to such views, and these views were supported by the full weight of traditional opinion. It was hardly surprising that they should look with suspicion upon the restiveness of the younger generation, because that unrest was not the conventional sowing of wild oats : a custom conventionally recognised from earliest times as the natural safety valve of turbulent youth. It was a far more subtle thing. To let off steam and settle down into the steady and respectable run of life is one thing, and comprehensible to elderly folk who have been through the process, but to let off steam and refuse to settle down seemed serious folly, especially when argu-ments were advanced in defence of what, in the elderly point of view, was nothing less than outrageous conduct. The

bewildered elders of the Nineties were faced with that dilemma.

At the same time, the gospel of *épater le bourgeois* was in the main less an actuality than an idea seeking expression in life and using Art as its advocate. True it had its practical exponents, but these were generally confined to the more literary and artistic circles, and for the general public they became a part of the mythology of the Nineties even during the decade. Rumours of strange wickedness were heard in many directions. Names were mentioned; and certain artists and minor poets gained repute by their alleged association with vice. It was fashionable in "artistic" circles to drink absinthe and to discuss its "cloudy green" suggestiveness; and other hitherto exotic drugs were also called into the service of these dilettanti of sin. Certain drugs seemed to gather about them an atmosphere of romance during these years, and all sorts of stimulants and soporifics, from incense and perfumes to opium, hashish, and various forms of alcohol, were used as means to extend sensation beyond the range of ordinary consciousness, along with numerous well-known and half-known physical aids to passionate experience. The age was extraordinarily sensitive, for instance, to the suggestiveness of sex. The subject was discussed with a new interest and a new frankness in essays and novels and plays; but for one person interested in the medico-legal sides of the questions raised, a dozen must have been drawn to the subject by a craving for forbidden fruit. Thus sex-inquisitiveness awoke slumbering aberrations in some and suggested them to others, with the result that definite perverse practices became associated with the "advanced" movement.

The appearance in literature and art of this new outlook upon life bore with it all the attractiveness of novelty and daring, and the irritation such things arouse among a people who have lived for many years under the impression that morals, and even ideas, were more or less fixed. But the very spirit of the time contested such complaisance. An imp of disquiet was abroad, scattering notes of interrogation

like confetti of fire among cherished principles and customs. The young men enjoyed the fun as they rushed about smashing up the intellectual and moral furniture of their parents. A generation nourished by the high normalities of Tennyson and Browning, which had thought Matthew Arnold (the critic) rather daring, and which had been nearly scared out of its Swinburne and its Rossetti by Robert Buchanan's attack on "The Fleshly School of Poetry," had every reason to be horrified by the appearance of Ibsen and Nietzsche. Many shook their heads ominously and took refuge in *Locksley Hall* :

" Authors—essayist, atheist, novelist, realist, rhymester, play your part,
 Paint the mortal shame of nature with the living hues of Art.

 Rip your brothers' vices open, strip your own foul passions bare ;
 Down with Reticence, down with Reverence—forward—naked—
 let them stare."

Others took the change in better humour, and either joined the dance or became interested spectators.

Influences behind the art of shocking were not entirely French, though the French decadents played their part. Throughout the whole of the period English publishers were issuing excellent translations of modern masterpieces from many European idea-centres, and in this way such writers as Tolstoy, Ibsen, Zola, Nietzsche, D'Annunzio and Turgenev became familiar aids to advanced thought in this country. Hitherto the language barrier had left these writers the property of the cultured classes, as was the case with the French decadents, the chief of whom have not even now been given adequate representation in English. The introduction of such writers was like the opening up of a new country to be immediately settled by ardent colonists. Their ideas were eagerly absorbed and, what is more interesting, used in a vigorous criticism of life. But there is little doubt that the first foreign ethical influence of the period was Henrik Ibsen, whose method of criticising conventional morals by means of drama had a profound effect upon thinking people

and dramatists. Nietzsche was known only to the few who read German at the beginning of the decade, but before the death of the old century the first attempt at a complete edition of the works of Friedrich Nietzsche was made by Henry & Co. The enterprise, however, aroused so little interest that it was abandoned after the production of four volumes. It was not until 1896 that any general interest in Nietzsche's ideas began in this country. In that year Havelock Ellis contributed a study of the German philosopher to *The Savoy*, and there were several other notices and criticisms in the reviews. The earliest reference to Nietzsche in the literature of the period is to be found in George Egerton's *Keynotes* (1892), but there are several pages devoted to his ideas in the *Sentences and Paragraphs* of John Davidson (1893), who seems to have been the only writer of the time to have come directly under the spell of the Nietzschean philosophy. The earliest British journal avowedly upholding an "egoistic philosophy" was started in 1898, under the title of *The Eagle and the Serpent*. It bore beneath its title these words from *Zarathustra* : "The proudest animal under the sun and the wisest animal under the sun have set out to reconnoitre"; and for further explanation the following :—

> "*Dedicated to the Philosophy of Life Enunciated by Nietzsche, Stirner, Thoreau and Goethe*, THE EAGLE AND THE SERPENT *labours for the Recognition of New Ideals in Politics and Sociology, in Ethics and Philosophy, in Literature and Art.*

> A RACE OF ALTRUISTS IS NECESSARILY A RACE OF SLAVES.
> A RACE OF FREEMEN IS NECESSARILY A RACE OF EGOISTS.
> THE GREAT ARE ONLY GREAT BECAUSE WE ARE ON OUR KNEES. LET US RISE ! "

I

This curious and entertaining little paper was published
at first bi-monthly, and then occasionally and fitfully, until
the last number appeared in 1902.

One foreign influence making for frankness of expression
was that of Emile Zola, whose books were issued in a well-
translated, although somewhat expurgated, edition, at a
popular price. Thousands of these were sold and read, thus
preparing the way for the books of our native realists like
George Moore, whose *Esther Waters* gave one of the most
violent shocks of the period ; Arthur Morrison, with his
Tales of Mean Streets and *A Child of the Jago*, and Somerset
Maugham's *Liza of Lambeth*.

Under such influences the art of shocking rattled along
merrily enough, and claimed many devotees. These may
be divided roughly into two classes : the Individual and the
Social. In the former there were the typical men of the
literary movement of the Nineties and their followers,
astonishing either from innate addiction to caprice, irre-
pressibility of whim, love of experiment or, as was often
the case with the rank and file, mere cussedness. Certain
demonstrations in the art of shocking recall the story of the
man who, seeing the father of decadent poetry, remarked to
a friend : " There goes Baudelaire. I wager he is going to
sleep *under* the bed to-night instead of *in* it, just to astonish
it." Among the art products of the more important members
of this class stand the paradoxes of Oscar Wilde, the pictures
of Aubrey Beardsley, the early poems of Arthur Symons and
the satires of Max Beerbohm. But many of the writers who
might have astonished the middle classes by administering
artistic shocks put other qualities into their art and filled
their lives with astonishing incidents. Nothing is more re-
markable in looking back at the Nineties than to note how
Death has gathered to himself so many of the period's
most characteristic and most interesting figures. All of
these men " lived their own lives," and when whim or Fate
led them along perilous paths they suffered the consequences.
Most of them died young, several were scarcely more than
youths ; some died of diseases which might have been

checked or prevented in more careful lives ; some were con-
demned to death at an early age by miserable maladies, and
some were so burdened by the malady of the soul's unrest
that they voluntarily crossed the borderland of life. It
would seem as if these restless and tragic figures thirsted
so much for life, and for the life of the hour, that they put
the cup to their lips and drained it in one deep draught :
perhaps all that was mortal of them felt so essential to the
Nineties that life beyond the decade might have been unbear-
able. Oscar Wilde died in 1900 at the age of forty-four ;
Aubrey Beardsley died in 1898, aged twenty-six ; Ernest
Dowson, in 1900, aged thirty-three ; Charles Conder, in
1909, aged forty-one ; Lionel Johnson, in 1902, aged thirty-
five ; Hubert Crackanthorpe, in 1896, aged thirty-one ;
Henry Harland, in 1905, aged forty-four ; Francis Thomp-
son, in 1907, aged forty-eight ; and John Davidson, in 1909,
aged fifty-two.

The second section of those who astonished the middle
classes was composed of revolutionists and reformers who
shocked by expressing the newly awakened social conscious-
ness which demanded change in the affairs of the State—
wider margins of personal freedom and better opportunities
of life and comfort for all. First among these came Bernard
Shaw, who introduced a new subjective daring into dialectics
and social controversy, avowedly designed to shock, prod
and irritate the social consciousness of the bourgeoisie into
practical moral and economic zeal. Grant Allen wrote *The
Woman Who Did*, also in the same spirit, to draw attention
to the difficulties of our marriage customs. The direct in-
fluence behind this group, although he did not supply it
with all its ideas, was Ibsen. The Norwegian dramatist-
philosopher suggested the attitude of the moral revolt. It
was he, and not Nietzsche, who first taught the Englishman
and Englishwoman to "transvalue their values," to examine
with a critical and restless eye the moral scaffolding of
their civilisation, and to suggest to them where they would
find weaknesses. And the result was that the middle
classes were more shocked by this attack than by any

other astonishing thing of the period—save the fall of Oscar Wilde.

Different in aim and method as these two classes of artists in astonishment may have been, they were each the outcome of the same demand for more freedom, more experience, more sensation, more life. What was happening in England was but the echo of what had been happening in Western Europe for a couple of decades. The idea of self-realisation, as old as Emerson, and older, was at the root of the modern attitude. The younger generation became acutely conscious of parental control. Turgenev had interpreted the attitude in its broader aspects in *Fathers and Children*, which was published in Russia as long ago as 1862. But the nihilism of Turgenev's great creation, Bazarov, was not at the back of the English revolt, except in a common desire of freedom. Nor were the men of the Nineties wholly absorbed in material experiences. Every physical excess of the time went hand in hand with spiritual desire. The soul seemed to be trying the way of the flesh with calamitous desperation. Long years of Puritanism and rationalism had proved the folly of salvation by morality and salvation by reason, so in a fit of despair the unsatisfied spirit of the age sought respite in salvation by sin. The recognition of sin was the beginning of the revolt against rationalism and the beginning of the revival of mysticism. · The latter revealed itself in the Theosophical movement, in the sudden popularity of Maurice Maeterlinck, and in numerous conversions to Rome, the first and last home of Christian mysticism.

The decadence was a form of soul-sickness, and the only cure for the disease was mysticism. But there was also another form of the soul's unrest which sprang more out of excessive vitality straining at the leash of custom. It was the unrest of an age which had grown too big for its boots. New conceptions of life and morality and mankind were demanded. Generations had been brought up in the faith that there were no ideas higher than man and God. Many were reasserting the democratic faith that the voice of the people was the voice of God. But Max Stirner and Henrik Ibsen

were gradually insinuating the idea that the highest of all things was not mankind but the self, the individual ego, and thus preparing the way for Nietzsche, who foretold the supersession of man : "Man is a bridge connecting animal and superman—a bridge thrown across a precipice."

But the Nietzschean idea, as I have pointed out, did not reach this country until the later Nineties. Ibsen was the social stimulus to revolt. His plays were being read and acted, and the idea of a self-centred personality was generally accepted by the "intellectuals." "So to conduct one's life as to realise oneself—this seems to me the highest attainment possible to a human being," Ibsen had written to Björnson ; and again in a letter to George Brandes he had said : "The great thing is not to allow oneself to be frightened by the venerableness of an institution. The state has its roots in Time : it will have its culmination in Time. Greater things than it will fall ; all religion will fall. Neither the conceptions of morality nor those of art are eternal. To how much are we really obliged to pin our faith ? Who will vouch for it that two and two do not make five up in Jupiter ? " Those words were written as far back as 1871, but it took twenty years for their sense as expressed in the plays of Ibsen to be fully appreciated. By the middle of the Nineties the attitude was so much to the taste that many were quite ready to say, and in a way prove, that it was not necessary to go as far as Jupiter to find two and two making five.

In the main, however, the majority were content to prove that two and two made four ; but they insisted upon proving it for themselves ; that the proof was already established and long since taken for granted was quite sufficient to arouse the gravest suspicions. "Whenever people agree with me, I always feel I must be wrong," said Cecil Graham, in *Lady Windermere's Fan*, voicing a characteristic whim. This superior attitude was, of course, far from the general attitude of the masses. They probably knew little of those adventures among ideas and sensations which occupied more leisured and more cultured people. The art of shocking the middle classes existed mainly among members of that class.

It was an internal revolt. "Nothing," said Arthur Symons, "not even conventional virtue, is so provincial as conventional vice; and the desire to 'bewilder the middle classes' is itself middle class": which is perfectly true, but the tendency is not to be belittled for all that. It showed that the bourgeoisie was capable of producing critics of itself, however distasteful these proved to be. The earliest critics of the middle classes had always arisen within the pale even when they had been Socialists, as in the instances of Ferdinand Lassalle, Karl Marx and, in our own time, William Morris, H. M. Hyndman and Bernard Shaw. The conversion to Socialism of that genius of bewilderment, Oscar Wilde, must not be taken too seriously from the Socialistic point of view, as to a large extent, the famous essay on *The Soul of Man under Socialism* was little more than an elaborately shocking admission; for it must not be forgotten that it was a much more daring thing to announce oneself a Socialist then than now—it was almost as daring for a middle-class girl to go out unchaperoned, and shocked almost as much.

Literature was drawn into the firing line of the times. Novels and plays not only became more outspoken, but sentences became more epigrammatic and thoughts more paradoxical. No one could say how the most innocent of sentences might explode in its last word, any more than one could prophesy what somersault one's favourite belief might take in its latest incarnation. Surprises lurked in the most surprising literary places as though to reflect and keep time with the reshuffling of habits and conventions. And just as modern literature has gained in brightness by the experience, so the adventure has familiarised us with the need of variety in personality and of wider margins of freedom for its expression.

CHAPTER IX

PURPLE PATCHES AND FINE PHRASES

"I am going to sit up all night with Reggie, saying mad scarlet things, such as Walter Pater loves, and waking the night with silver silences. . . . Come, Reggie, let us go to the smoking-room, since we are left alone. I will be brilliant for you as I have never been brilliant for my publishers. I will talk to you as no character in my plays has ever talked. Come ! The young Endymion stirs in his dreams, and the pale-souled Selene watches him from her pearly car.

"The shadows on the lawns are violet, and the stars wash the spaces of the sky with primrose and with crimson. The night is old yet. Let me be brilliant, dear boy, or I feel that I shall weep for sheer wittiness, and die, as so many have died, with all my epigrams still in me."—Esmé Amarinth in *The Green Carnation*.

JUST as the personal revolt of the decadence ran to dandyism, so its literature reached the same goal. There were endless discussions about " style," and many were of the opinion that the ultimate form of a thought, its manner of word and syntax, was the thing in itself. Words for words' sake was a kind of gospel, and, following the habit of Dante Gabriel Rossetti, poets and prose-poets would devote long hours to word-hunting. They would search through dictionaries and ancient tomes with the hot enthusiasm of the hunter, tracking down the " unique word," and hoping to capture it alive for exhibition in the gardens of modern literature. Authors with a personal style were cultivated and upheld. The " Purple Patches " in Ruskin, Pater, and in Edward Fitzgerald's *Rubáiyát* of Omar Khay-yám, were relished with voluble delight. Keats came in for a new admiration, and Rossetti's poems satisfied the call of the hour by the suggestive ardency of their " vagueness and utterness,"to use words applied by George Moore to the poems of Verlaine. The strong and deep wit of George Meredith, with its subtle surprises, aroused even greater delight, and the meticulous prose of Robert Louis Stevenson, with its

135

almost feminine echoes of Meredith, enraptured those who
were just inheriting the newer culture. All this concern for
language as language, for the set and balance of words, was
not, however, entirely of native origin. It was, as in the
case of so much that was new and strange, partially derived
from the French decadent movement which was influencing
the whole of Europe.

Many years ago Théophile Gautier described the decadent
style as "ingenious, complex, learned, full of shades of mean-
ing and investigation, always extending the boundaries of
language, borrowing from all the technical vocabularies,
taking colours from all palettes, notes from all keyboards,
forcing literary expression of that which is most ineffable,
and in form the vaguest and most fleeting outlines ; listen-
ing, that it may translate them, to the subtle confidences of
the neuropath, to the avowals of ageing and depraved passion,
and to the singular hallucinations of fixity of idea verging to
madness. This decadent style is the last effort of language
to express everything to the last extremity." Further, he
compares this style with that of the later Roman empire,
when language became "mottled with the greenness of de-
composition," in a word, gamy (*faisandée*). But in England
literary style developed hardly more than a faint flavour of
that *gamy* expression associated with the work of Baudelaire
and Huysmans, and it approximated more nearly to its
French influences in, as might be expected, Oscar Wilde and
Aubrey Beardsley.

One recalls many a wonderful passage in *Dorian Gray*
wherein Oscar Wilde turned the results of his word-hunting
into prose passages entirely new to English literature :

"He would often spend a whole day settling and re-settling
in their cases the various stones that he had collected, such
as the olive-green chrysoberyl that turns red by lamplight,
the cymophane with its wire-like line of silver, the pistachio-
coloured peridot, rose-pink and wine-yellow topazes, car-
buncles of fiery scarlet with tremulous four-rayed stars,
flame-red cinnamon stones, orange and violet spinels, and

amethysts with their alternate layers of ruby and sapphire. He loved the red-gold of the sunstone, and the moonstone's pearly whiteness, and the broken rainbow of the milky opal. He procured from Amsterdam three emeralds of extraordinary size and richness of colour, and had a turquoise *de la vieille roche* that was the envy of all connoisseurs."

Aubrey Beardsley had so keen a sense of verbal deportment that there is conscious style in almost every sentence he wrote. So insistent is this sense of form that the matter of his slight literary achievement, unusual though it is, retires before his manner. So mannered was he at times that one questions his sincerity. It is as though he adopted a decadent prose as a prank and awoke to find the result a masterpiece. His preciosity is so ordered and elegant, and so deliberate in aim and intent, that it becomes something more than a freakish whim. Could prose, for instance, have more grace than the dedicatory epistle of *Under the Hill* ?

"I must crave your forgiveness for addressing you in a language other than the Roman," he writes, "but my small freedom in Latinity forbids me to wander beyond the idiom of my vernacular. I would not for the world that your delicate Southern ear should be offended by a barbarous assault of rude and Gothic words ; but methinks no language is rude that can boast polite writers, and not a few have flourished in this country in times past, bringing our common speech to very great perfection. In the present age, alas ! our pens are ravished by unlettered authors and unmannered critics, that make a havoc rather than a building, a wilderness rather than a garden. But, alack ! what boots it to drop tears upon the preterit ? "

There we have the polite writer of all time, deftly using the "conceit " of his period with a relish appropriate enough in a writer whose literature was a by-product of a graphic art whose every line was fraught with strutting imagery and elegantly laboured poses. "From the point of a precise

toilet," he writes, in the opening paragraph of the romance, "the fingers wandered, quelling the little mutinies of cravat and ruffle." Again he speaks of "taper-time" and the "slender voices of the fairies," and of Venus standing before her mirror, "in a flutter of frilled things," displaying neck and shoulders "so wonderfully drawn" and "little malicious breasts" which were "full of the irritation of loveliness that can never be entirely comprehended, or ever enjoyed to the utmost." Master of the Purple Patch, Beardsley knew also how to weave gorgeous tapestries of words delighting by their very richness :

"The place where he stood waved drowsily with strange flowers heavy with perfume, dripping with odours. Gloomy and nameless weeds not to be found in Mentzelius. Huge moths so richly winged they must have banqueted upon tapestries and royal stuffs, slept on the pillars that flank either side of the gateway, and the eyes of all the moths remained open, and were burning and bursting with a mesh of veins. The pillars were fashioned in some pale stone, and rose up like hymns in the praise of Venus, for, from cap to base, each one was carved with loving sculptures, showing such a cunning invention and such a curious knowledge that Tannhäuser lingered not a little in reviewing them."

In their search for reality, and their desire to extend the boundaries of sensation, the writers of the Eighteen Nineties sought to capture and steep their art in what was sensuous and luscious, in all that was coloured and perfumed. Oscar Wilde never tired of decorating his prose with unfamiliar imagery and incongruous colour words. He mastered every literary fashion of the time, wielding with like skill the methods of purple patch, preciosity, epigram, paradox and conceit. *Dorian Gray* is a piece of literary jewellery ; peacock phrases, glowing periods and verbal surprises embellishing every page. He speaks of the sunlight slipping "over the polished leaves"; of "the green lacquer leaves of the ivy"; and "the blue cloud-shadows" chasing "themselves across the grass like swallows"; of "the stained trumpet of

Tyrian convolvulus." "The green night of its leaves will hold its purple stars," he says of the clematis. An emotional change in a woman gives him a chance of such literary efflorescence as : "A rose shook in her blood, and shadowed her cheeks. Quick breath parted the petals of her lips." And the homogenic love of Michelangelo he describes as being "carved in the coloured marbles of a sonnet-sequence." The following colour phrases are common throughout his works :—"nacre-coloured air," "apricot-coloured light," "rose-coloured joy," "crocus-coloured robe," and "sulphur-coloured roses." "Swinging censers " are compared with "great gilt flowers," and he speaks of the" jade-green piles of vegetables " in Covent Garden.

The keen colour sense of the period manifested itself in many other directions, particularly in certain characteristic book titles, such as *The Yellow Book, Grey Roses, The Green Carnation, A Yellow Aster, Green Fire* and *The Colour of Life.* It would seem as though the Impressionist painters had made the world more conscious of the effects of light, and inspired writers with a desire to seek out colour visions for themselves, although most were content to look at the new prismatic sights through the eyes of Monet and Pissarro. In an earlier chapter I referred to the fashion of yellow, but this colour was not the only fashion. Green had still many devotees. Oscar Wilde had referred to this taste as " that curious love of green which in individuals is always the sign of subtle artistic temperament, and in nations is said to denote a laxity if not a decadence of morals." Richard Le Gallienne, probably taking his cue from the foregoing famous declaration, wrote, in *Prose Fancies* (second series, 1896) : " Green must always have a large following among artists and art lovers ; for, as has been pointed out, an appreciation of it is a sure sign of a subtle artistic temperament. There is something not quite good, something almost sinister, about it—at least, in its more complex forms, though in its simple form, as we find it in outdoor nature, it is innocent enough ; and, indeed, is it not used in colloquial metaphor as an adjective for innocence itself ? Innocence has but two colours, white

or green. But Becky Sharp's eyes also were green, and the green of the æsthete does not suggest innocence. There will always be wearers of the green carnation; but the popular vogue which green has enjoyed for the last ten or fifteen years is probably passing. Even the æsthete himself would seem to be growing a little weary of its indefinitely divided tones, and to be anxious for a colour sensation somewhat more positive than those to be gained from almost imperceptible nuances of green. Jaded with over-refinements and super-subtleties, we seem in many directions to be harking back to the primary colours of life. Blue, crude and unsoftened, and a form of magenta have recently had a short innings; and now the triumph of yellow is imminent. Of course, a love for green implies some regard for yellow, and in our so-called æsthetic renaissance the sunflower went before the green carnation—which is, indeed, the badge of but a small schism of æsthetes, and not worn by the great body of the more catholic lovers of beauty." But an examination of the *belles lettres* of the period proves that neither yellow nor green predominated, but that the average taste seemed to lead towards the sum-total and climax of all colours—white.

White gleamed through the most scarlet desires and the most purple ideas of the decade, just as its experimental vices went hand in hand with virtue. In midmost rapture of abandonment the decadents adored innocence, and the frequent use of the idea of whiteness, with its correlatives, silver, moonlight, starlight, ivory, alabaster and marble, was perhaps more than half-conscious symbolism. It had also a dash of the debauchee's love of virginity.

Walter Pater named a noble chapter in *Marius the Epicurean*, "White Nights," after the name of the house of Marius, with full sense of the symbolic meaning of the word; and he bore out this idea by a quotation from an old German mystic, who said: "The red rose came first, the mystery of so-called *white* things," as being "ever an afterthought—the doubles, or seconds, of real things, and themselves but half-real, half-material—the white queen, the white witch, the

White Mass, which, as the Black Mass is a travesty of the true Mass turned to evil by horrible old witches, is celebrated by young candidates for the priesthood with an unconsecrated host, by way of rehearsal." So the idea of whiteness had relationship in the work of decadent writers with the " so-called mystery of *white* things." No other poet of the period expressed the idea of the mystery of white innocence so immaculately as Alice Meynell :

> " She walks—the lady of my delight—
> A shepherdess of sheep.
> Her flocks are thoughts. She keeps them white ;
> She guards them from the steep.
> She feeds them on the fragrant height,
> And folds them in for sleep."

The same idea found exponents in other poets. Francis Thompson refers to " a fair white silence." Ernest Dowson was dominated by a sense of whiteness. One cannot forget his " dancing to put thy pale lost lilies out of mind," and *The Pierrot of the Minute* is a veritable symphony in white. He calls for " white music," and the Moon Maiden rides through the skies " drawn by a team of milk-white butterflies," and further on in the same poem we have a palace of many rooms :

> " Within the fairest, clad in purity,
> Our mother dwelt immemorially :
> Moon-calm, moon-pale, with moon-stones on her gown,
> The floor she treads with little pearls is sown. . . ."

And in another poem he sings :

> " Mark the day white on which the Fates have smiled."

The recognition and use of the idea of white was, of course, not always mystical, or even symbolical ; in the majority of cases it was frankly sensuous, following in words that delight in whiteness which Whistler had expressed in pictures. W. B. Yeats sings of the " white breast of the dim sea," Lionel Johnson of

> " Cloisters, in moonlight
> Branching dark, or touched with white :

Round old, chill aisles, where moon-smitten
Blanches the *Orate*, written
Under each worn, old-world face
Graven on Death's holy place ! "

Oscar Wilde refers often to white things : "She shook like a white narcissus "; "blue petals of flame rimmed with white fire "; and "white vultures with gilded claws." Nor must we overlook the "milk-white " unicorn in Aubrey Beardsley's romance. Hubert Crackanthorpe's purple patches of travel, *Vignettes*, has a reference to some white thing on almost every page—white towns, white houses, white roads and white churches. One of the most charming of Arthur Symons' more artificial lyrics celebrates whiteness in girlhood :

"White girl, your flesh is lilies
Grown 'neath a frozen moon,
So still is
The rapture of your swoon
Of whiteness, snow or lilies."

And one of Richard Le Gallienne's most "precious " *Prose Fancies* is dedicated, under the title, "White Soul," to the same theme in womanhood. It is prefaced by these lines :

"What is so white in the world, my love,
As thy maiden soul—
The dove that flies
Softly all day within thy eyes,
And nests within thine heart at night ?
Nothing so white."

In the first paragraph of this essay he demands with quaint conceit the whole gamut of whiteness for the glorification of such innocence : "Whitest paper, newest pen, ear sensitive, tremulous ; heart pure and mind open, broad and clear as the blue air for the most delicate gossamer thoughts to wing through ; and snow-white words, lily-white words, words of ivory and pearl, words of silver and alabaster, words white as hawthorn and daisy, words white as morning milk, words 'whiter than Venus' doves, and softer than the down beneath their wings '—virginal, saintlike, nunnery words."

But always the outstanding literary accessory of the Nineties was surprise, in the form of paradox, or often little more than verbal. In the latter surprise found expression in the use of strange words, the result of resurrections from old books or from scientific and technical sources, the jargon of special sections of humanity, and the slang of the streets. French words and phrases were also in great favour. Several of the most striking verbal effects of the time were obtained by the transposition of words from one set of ideas to another, after the manner of Baudelaire's theory of correspondences. Whistler was the earliest to use the method in this country when he named pictures after musical terms, " Symphonies," " Harmonies " and " Arrangements." Henley, imitating Whistler, took the idea a step further by naming the poems in his *London Voluntaries*, " Andante con Moto," "Scherzando," "Largo e Mesto " and "Allegro Maëstoso." From such normal manifestations of the theory it spread through all definitely *fin de siècle* writing from Henry Harland's reference to a young person who " took to rouge and powder, and introduced *falsetto* notes into her toilet "; George Egerton's firelight which picks out "autographs past emotions have traced " on a woman's face ; to Oscar Wilde's already quoted " coloured marble of a sonnet-sequence." Aubrey Beardsley's " décolleté spirits of astonishing conversation," and Richard Le Gallienne's "London spread out beneath us like a huge black velvet flower, and rows of ant-like fire-flies moving in slow zigzag processions along and across its petals."

The use of strange words and bizarre images was but another outcome of the prevalent desire to astonish. At no period in English history had the obvious and the commonplace been in such disrepute. The age felt it was complex and sought to interpret its complexities, not by simplicity, in spite of Oscar Wilde's statement that simplicity was the last refuge of complexity, but by suddenness of epigram and paradox combined with delicate nuances of expression. Literary style resembled more than anything else a dance in quick time gradually resolving itself into the stateliness of

the minuet. So fearful were writers of being convicted of
obviousness that they often convicted themselves of obscurity.
In the same way they admired what were then considered
to be the obscurities of Meredith. Younger writers realised
the need of a suggestive note in literature. They agreed
with Meredith that "the art of the pen is to rouse the inward
vision," and instead of labouring protracted descriptions
they sought to "spring imagination with a word or a phrase."
Literature that had been exposite became apposite. Fine
shades of meaning and niceties of observation slipped into
swift revealing sentences, and for the first time temperament
was studied as a thing in itself. The idea of Impressionism
also dominated style, but the best writers end at intensity,
suggestiveness, reality and, above all, brightness, rather than
novelty, preferring to achieve this last as a by-product.
They strove to create what was called "atmosphere," leav-
ing much to the intelligence of the reader, who, to do him
justice, often proved himself worthy of the compliment.
Such volumes of studies in Impressionism as George
Egerton's *Keynotes*, G. S. Street's *Episodes*, Hubert Crackan-
thorpe's *Wreckage*, George Fleming's *Women's Tragedies*,
Henry Harland's *Mademoiselle Miss* and *The Lady Para-
mount*, John Oliver Hobbes' *Some Emotions and a Moral*,
Vincent O'Sullivan's and—to a lesser degree—the studies of
Ella d'Arcy and H. D. Lowry are steeped in this new spirit.
Whilst Max Beerbohm, Oscar Wilde, Richard Le Gallienne,
Alice Meynell and Vernon Lee distilled their own personality
into essays in the same key. The subtle intensity of this
style may be illustrated by a quotation from *Keynotes*:

"The paleness of some strong feeling tinges her face, a
slight trembling runs through her frame. Her inner soul-
struggle is acting as a strong developing fluid upon a highly
sensitised plate; anger, scorn, pity, contempt chase one
another like shadows across her face. Her eyes rest upon
the empty frame, and the plain white space becomes alive
to her. Her mind's eye fills it with a picture it once held in
its dainty embrace. A rare head amongst the rarest heads

of men, with its crest of hair tossed back from the great brow, its proud poise and the impress of grand confident compelling genius that reveals itself one scarce knows how ; with the brute possibility of an untamed, natural man lurking about the mouth and powerful throat. She feels the subduing smile of eyes that never failed to make her weak as a child under their gaze, and tame as a hungry bird. She stretches out her hands with a pitiful little movement, and then, re-membering, lets them drop and locks them until the knuckles stand out whitely. She shuts her eyes, and one tear after the other starts from beneath her lids, trickles down her cheeks, and drops with a splash into her lap. She does not sob, only cries quietly and she sees, as if she held the letter in her hand, the words that decided her fate."

Alice Meynell in her essays is equally modern with less emotional themes as, for instance, in the opening essay of her volume *The Colour of Life* :

" Red has been praised for its nobility as the colour of life. But the true colour of life is not red. Red is the colour of violence or of life broken, edited and published. Or if red is indeed the colour of life, it is so only on condition that it is not seen. Once fully visible, red is the colour of life violated, and in the act of betrayal and of waste. Red is the secret of life, and not the manifestation thereof. It is one of the things the value of which is secrecy, one of the talents that are to be hidden in a napkin. The true colour of life is the colour of the body, the colour of the covered red, the implicit and not explicit red of the living heart and the pulses. It is the modest colour of the unpublished blood."

The arts of epigram and paradox with their repeated surprises were so commanded by the genius of Oscar Wilde that others who followed in his steps tended to appear like imitators. There is something preposterous and irresistibly funny about his wittiest half truth, and the best of his state-ments were often no more than that. "One of those

K

characteristic British faces that, once seen, are never re-
membered," is a good specimen of Wilde's method, with
such sayings as : "Brute reason is quite unbearable. There
is something unfair about its use. It is hitting below the in-
tellect "; and "Her capacity for family affection is extra-
ordinary. When her third husband died, her hair turned
quite gold from grief," and "In married life three is company
and two is none "; and "Only dull people are brilliant at
breakfast "; and again "One can resist everything except
temptation." The fun of such sayings does not only depend
upon the shock of half truth, they contain also a wild philo-
sophy which is irresistible because it defies immediate re-
futation by sheer brightness. Wilde created a fashion in
such sayings ; the word "brilliant " was appropriately used
to describe them, and their popularity created a widely
practised game of intellectual frivolity. It was not fashion-
able, as the saying went, " to take yourself seriously," and
the verbal cleverness invented by Oscar Wilde was adopted
cheerfully as a mask for the seriousness of life.

One writer whose gifts of wit were at all comparable with
those of Oscar Wilde had the courage to use his brilliance to
throw light on a definite moral purpose. The attitude he
adopted was in the nature of a Puritan reply to the paganism
of Wilde, and he used similar weapons with equal skill, drama
and fiction, conversation and oratory, flashing sharp with
a more solid intention. "Better see rightly on a pound a
week," he said, "than squint on a million." "Freedom,"
he said again, "means responsibility; that's why most
people fear it." There was something more than cleverness
in such sayings, something more than art. Bernard Shaw,
who uttered them, brought with him an atmosphere of con-
viction. That attitude insisted upon art and cleverness
being discontented with themselves; it strove to bring
intellect back once more from the contemplation of itself
to the realisation of a more orderly life.

CHAPTER X

THE DISCOVERY OF THE CELT

"Strange reversals, strange fulfilments may lie on the lap of the gods, but we have no knowledge of these, and hear neither the high laughter nor the far voices. But we front a possible because a spiritual destiny greater than the height of imperial fortunes, and have that which may send our voices further than the trumpets of east and west. Through ages of slow westering, till now we face the sundown seas, we have learned in continual vicissitude that there are secret ways whereon armies cannot march. And this has been given to us, a more ardent longing, a more rapt passion in the things of outward beauty and in the things of spiritual beauty. Nor it seems to me is there any sadness, or only the serene sadness of a great day's end, that, to others, we reveal in our best the genius of a race whose farewell is in a tragic lighting of torches of beauty around its grave."

FIONA MACLEOD.

ERNEST RENAN discovered the Celt somewhere about the year 1856; but in the year 1891 Grant Allen made the far more interesting discovery that there was such a thing as a Celtic movement in English art. In a vivacious article in *The Fortnightly Review* he made it seem as if the Celtic influence dominated the field of artistic activity. "The return wave of Celtic influence over Teutonic or Teutonised England has brought with it many strange things, good, bad, and indifferent." He wrote:

"It has brought with it Home Rule, Land Nationalisation, Socialism, Radicalism, the Reverend Hugh Price Hughes, the Tithes War, the Crofter Question, the Plan of Campaign. It has brought fresh forces into political life—the eloquent young Irishman, the perfervid Highland Scot, the enthusiastic Welshman, the hard-headed Cornish miner : Methodism, Catholicism, the Eisteddfod, the parish priest, New Tipperary, the Hebrides, the Scotland Division of Liverpool; Conybeare, Cunninghame Graham, Michael Davitt, Holyoake; Co-operation, the Dockers, *The Star*, the Fabians. Powers hitherto undreamt of surge up in our

147

parliamentary world in the Sextons, the Healys, the Atherley Joneses, the McDonalds, the O'Briens, the Dillons, the Morgans, the Abrahams ; in our wider public life in the William Morrises, the Annie Besants, the Father Humphreys, the Archbishop Crokes, the General Booths, the Alfred Russel Wallaces, the John Stuart Blackies, the Joseph Arches, the Bernard Shaws, the John Burnses ;` the People's Palace, the Celtic Society of Scotland, the Democratic Federation, the Socialist League. Anybody who looks over any great list of names in any of the leading modern movements in England—from the London County Council to the Lectures at South Place—will see in a moment that the New Radicalism is essentially a Celtic product. The Celt in Britain, like Mr Burne Jones's enchanted princess, has lain silent for ages in an enforced long sleep ; but the spirit of the century, pushing aside the weeds and briars of privilege and caste, has set free the sleeper at last. . . ."

Sufficiently matter-of-fact in his assertions, Grant Allen's enthusiasm was just a little premature. But he was only a year or so too early, and if he had stayed his pen a little while he would have been able to announce the real Celtic revival of the Nineties which received its first strong impetus from the genius of William Butler Yeats.

The Celtic movement as expressed in the various fields of activity named by Grant Allen was at the dawn of the Eighteen Nineties quite free of self-consciousness. It was not really a " movement " at all ; and even where Grant Allen correctly indicates Celtic influence, that influence is the accidental outcome of the fact that those who were responsible for it happened to have been Celts or to have had Celtic blood in their veins. In many of his examples it would have been of equal pertinence to trace Teutonic or Latin influences. The real Celtic revival, as a revival, began with the Irish Literary movement. W. B. Yeats published his first book of poems in Dublin in 1885 ; but it was not until he issued *The Wanderings of Oisin, and Other Poems*, in 1889, that a new voice singing a song as old as time was recognised.

With the publication of *The Countess Kathleen*, in 1892, and the *Celtic Twilight*, in 1893, this new voice was hailed as something more than new; it was hailed as a strong and persuasive voice that was already attracting to itself affinities in the land of its origin. Among these were Dr Douglas Hyde, Lady Gregory, George Russell (A.E.), Lionel Johnson, John Eglinton and, later, and with less certainty from the Celtic standpoint, George Moore. Dr Douglas Hyde and Lady Gregory were devoting their attention to the ancient legends and songs of Ireland, and their studies ultimately resulted in the publication of books such as the *Love Songs of Connacht* and *Gods and Fighting Men*. George Russell and W. B. Yeats linked up the natural mysticism of the Celt with Theosophy, besides contributing to the movement poems of rare beauty. John Eglinton worked along lines of philosophic interpretation which he expressed in *Two Essays on the Remnant*, published in 1895. George Moore introduced an equally Celtic sense of fact into a movement which might otherwise have been a record of dreams.

In 1891 W. B. Yeats founded the National Literary Society, which, seven years later, brought into existence the Irish Literary Theatre at Dublin. The object of the Irish Literary Theatre was first and foremost to create a medium for the production of " something better than the ordinary play of commerce," and by so doing to augment the chances of a native Irish dramatic renaissance. The first performances of the society took place in 1899, when two plays, *The Countess Kathleen*, by W. B. Yeats, and *The Heather Field*, by Edward Martyn, were produced at the Antient Concert Rooms, Dublin. Next year the Irish Literary Theatre produced five plays at the Gaiety Theatre, Dublin. These were : *The Bending of the Bough*, by George Moore ; *The Last Feast of the Fraina*, by Alice Milligan ; *Mæve*, by Edward Martyn. In 1901 at the same theatre were produced *Diarmuid and Grania*, by W. B. Yeats and George Moore ; and a Gaelic play, *The Twisting of the Rope*, by Douglas Hyde. These performances closed the first attempt in Ireland to create a national drama. During its brief life, the Irish Literary

Theatre recorded its views and achievements in an occasional publication called *Beltaine* (1899-1900), which was the forerunner of *Samhain*, as the Irish Literary Theatre was of the National Theatre Society Ltd., and its famous playhouse in Abbey Street, Dublin. The dramatic and literary awakening in Ireland found expression in the local Press, *The Daily Express* of Dublin devoting considerable space to the discussion of literature and art, to which most of the young Irish writers contributed.

Side by side with the development of the Celtic revival in Ireland there were Celtic awakenings of a lesser degree in Scotland and Wales. The chief activity of the Scottish revival was at Edinburgh, where Patrick Geddes produced four numbers of a quarterly review called the *Evergreen* in 1895 and 1896. The idea seemed to be to make each number complete in itself and so to arrange the contents that they should serve as comments on art and life apropos the four seasons. Among the literary contributors are found the names of Patrick Geddes, Sir Noel Paton, S. R. Crockett, William Sharp, "Fiona Macleod," Sir George Douglas, Riccardo Stephens and Gabriel Setoun. The French communist, Élisée Reclus, was also a contributor. All the decorations were in black and white, and the artists included Pittendrigh Macgillivray, John Duncan, E. A. Hornel and James Cadenhead.

The most important literary product of the Celtic revival in Scotland was the work of the mysterious personality "Fiona Macleod," whom we now know to have been the novelist and critic, William Sharp. "Fiona Macleod's" first volume, *Pharais ; a Romance of the Isles*, was published by Moray, of Derby, in 1894 ; other works from the same pen, such as *The Washer of the Ford*, were published by Patrick Geddes and Colleagues, at Edinburgh. The work of "Fiona Macleod" possessed all the more pronounced characteristics of Celtic art, with an insistence upon mystical aloofness so deliberate as to suggest a determination to be Celtic at all costs ; a pose carried off successfully only by rare literary skill.

The movement in Wales was far less definite. There was a decided quickening of social consciousness among the Celts, which expressed itself in ardent political activities of a Radical tendency. The extreme section was represented by the Labour leader, "Mabon," but the main current of the national political genius found its fullest expression in the vigorous personality of a rising young politician, Lloyd George, who was later to become the chief protagonist of Joseph Chamberlain during the Jingo outbreak of the final years of the decade. Literary activity was confined to a renewed interest in national myth and tradition, an interest aroused by the magnificent collection of legends made by Lady Charlotte Guest in *The Mabinogian*. But there was no distinctive modern art or literary production. The Welsh poetic renaissance, save for such hints as are to be found in the poems of Ernest Rhys, was unborn, and Wales was still under the impression that all things associated with the theatre were evil ; a view that was not to be altered until well into the present century.

These various expressions of the Celtic renaissance, rather than those indicated by Grant Allen, were in the true tradition of that Celtic spirit first interpreted by Ernest Renan in *The Poetry of the Celtic Races*. Speaking of that race he says :

"Its history is itself one long lament ; it still recalls its exiles, its flights across the seas. If at times it seems to be cheerful, a tear is not slow to glisten behind its smile ; it does not know that strange forgetfulness of human conditions and destinies which is called gaiety. Its songs of joy end as elegies ; there is nothing to equal the delicious sadness of its national melodies. One might call them emanations from on high which, falling drop by drop upon the soul, pass through it like memories of another world. Never have men feasted so long upon these solitary delights of the spirit, these poetic memories which simultaneously intercross all the sensation of life, so vague, so deep, so penetrative, that one might die from them, without being able to say whether it was from bitterness or sweetness. . . . The essential element

of the Celt's poetic life is the *adventure*—that is to say, the pursuit of the unknown, an endless quest after an object ever flying from desire. It was of this that St Brandam dreamed, that Peredur sought with his mystic chivalry, that Knight Owen asked of his subterranean journeyings. This race desires the infinite, it thirsts for it, and pursues it at all costs, beyond the tomb, beyond hell itself."

The most profound and the most effective interpreter of that view of life in modern British literature is W. B. Yeats. It was he who was the chief figure of the Celtic Renaissance of the Eighteen Nineties ; the artists, writers and politicians named by Grant Allen were Celts playing the Teutonic game, and winning. In Yeats we have the fullest expression of the intellectual Celt—poet, mystic and patriot—expressing himself in an imaginative propaganda which has affected the thoughts and won the appreciation of the English-speaking world.

He was born in Dublin in the year 1866, the son of the Irish painter J. B. Yeats, R.H.A. Educated chiefly in the city of his birth, he was probably helped in the ripening of his genius by frequent visits to relatives in County Sligo, where, among a peasantry intimate with ghosts, fairies and demons, he laid the foundations of a wide knowledge of the more remote characteristics and traditions of his country-men. Ireland was his home until 1887. Later, the Yeats family went to London, and during the Nineties he lived partly in the English capital and partly in the Irish. His aim in promoting the Irish Literary movement was the out-come of the idea that for Ireland " a national drama or literature must spring from a native interest in life and its problems, and a strong capacity for life among the people." So by studying and translating the Gaelic legends, rescuing and recording in literary form the folk-tales of the country-side, and inspiring Irish writers and artists to interpret the national individuality rather than that of alien lands, he hoped to crystallise the scattered forces of Gaelic energy, and thus make a literature that would stand towards Ireland as

the literature of the Shakespearean period stands towards England. To make, in short, the literature and art of Ireland both national and quick with a life that might be felt not merely by a select coterie of cultured enthusiasts, but by the whole nation.

Working for this idea, Yeats gathered around him, as we have seen, all that was most hopeful in modern Irish letters. The result to-day is that Ireland is no longer a geographical expression with a clamorous voice ; Ireland to-day stands among the nations as a race with a literature and drama expressing its inmost spiritual, intellectual and social needs. In all save the fact that this literature and drama uses a language which Ireland, with the rest of the British Empire and America, owes to the Anglo-Saxon, it is essentially Irish in aim and expression. And, incidentally, it has gone a long way towards exploding the idea that the genius of Ireland found complete expression in the *Irish Melodies* of Tom Moore and the melodramatic heroes of Dion Boucicault. "Our legends," says W. B. Yeats, "are always associated with places, and not merely every mountain and valley, but every strange stone and little coppice has its legend, preserved in written or unwritten tradition. Our Irish romantic movement has arisen out of this tradition, and should always, even when it makes new legends about traditional people and things, be haunted by people and places. It should make Ireland, as Ireland and all other lands were in ancient times, a holy land to her own people."

Yeats, with Maeterlinck, and other foreign symbolists, filled his song and drama with the possibility of unexpected happenings. These works are steeped in a different atmosphere from that in which we ordinarily move. They dare to be unreasonable ; to go where Caolte "tosses his burning hair," and Niam calls :

> "Away, come away ;
> And brood no more where the fire is bright ;
> Filling thy heart with a mortal dream ;
> For breasts are heaving and eyes a-gleam ;
> Away, come away, to the dim twilight."[1]

In such imaginative abandon there is possibility of discovery and adventure. America was not discovered by Columbus sailing into uncharted seas, but by the imaginative impulse that foretold continents over the rim of the known world. So it is that the Celtic dreaming, made articulate by Yeats and others, contains in its suggestive darknesses more wisdom than subservience to known things and known experiences have contributed to men. The Celts have realised, by intuition rather than by reason, what all people of simple imagination have realised, that life, as Renan says of the Breton, is not a personal adventure undertaken by each man on his own account, but a link in a long chain, a gift received and handed on. In addition to this idea of tradition, the British Celt has realised and reasserted the further idea of experience by individual adventure. W. B. Yeats is distinguished among Celtic writers because of this sense of individuality. His work is not merely pensive and wonder-stricken in the manner of much traditional Celtic art; it is thoughtful and joyful, possessing a strength born of personal happiness and individual wonder. In the retelling of the tales of his nation he has added much of himself to that which "it has taken generations to invent," and he has come nearer towards stimulating the creation of a noble popular literature than anyone in Ireland since the simple tales and legends of Finn and Oisin were the commonplaces of the national mind.

There was a wizardry about his songs quite new to contemporary Ireland. His choice of words was full of a vague glimmering of unknown things, while his rhythm haunted the mind with the peculiar insistence of songs which have stood age-long tests of familiarity. But the matter was strange to customary hearing, it was redolent of

> " The dim wisdoms old and deep
> That God gives unto men in sleep. "

Celtic dependence upon the intimation of the inner consciousness, however, did not draw him away from familiar things and more obvious but none the less profound sensa-

tions. He was engaged quite as often with the simpler concerns of sentiment, with the home and the affections of the more human among human beings, with "the cry of a child by the roadway, the creak of a lumbering cart, the heavy steps of the ploughman, splashing the wintry mould."

His tales, like his verses, are coloured by myth and folklore, mysticism and magic. All the stories in *The Secret Rose* and *The Celtic Twilight* hinge their interest upon something outside mundane experiences. Many are little more than simple records of tales he has been told by the country folk in the more remote districts of Ireland. "I have written down accurately and candidly," he says, in the preface to *The Celtic Twilight*, "as much as I have heard and seen and, except by way of commentary, nothing that I have merely imagined. I have been at no pains to separate my own beliefs from those of the peasantry, but have rather let my men and women, ghouls and faeries, go their way unoffended or defended by any argument of mine. The things a man has heard and seen are threads of life, and if he pulled them carefully from the confused distaff of memory, any who will can weave them into whatever garment of belief please them best." The garment of belief which the poet has woven about these old tales is one of the most successful expressions of the literary renaissance of the Nineties.

Anglo-Saxons are not usually interested in a peasant's vague experiences in the twilight margin of the West, but they are concerned as to the nature of such experiences. They appreciate the unreal in the dullest ghost story. They recognise the thrill in the shallowest yarn of the ghost-seer, even though the cause be no more mysterious than the desire of a domestic animal for human society, or some white-smocked and bibulous peasant mistaking the churchyard for the king's highway. But to hear of the doings of Celtic peasants in the language of W. B. Yeats is to hear something that interests beyond the limits of a mere tale. Some of his stories deal frankly with the mysterious as it appeals to the devotee of magic, and some of them have an imaginative atmosphere recalling Edgar Allan Poe. Such are the stories

of Michael Robartes in *The Secret Rose* and *The Tables of the Law*. In the plays, also, similar themes recur, expressed in the drama's convention of conflict between experience and idea. Here Yeats is more akin to Maeterlinck, although there is always that national note which is nowhere apparent in the work of the Belgian symbolist. *Pelleas and Mélisande* belongs to no country and all countries, but *The Countess Kathleen* belongs first to Ireland—and then to humanity.

CHAPTER XI

THE MINOR POET

THE term "minor poet" is inexact at best, but during the Eighteen Nineties it was used very widely, and a little unnecessarily, to distinguish the younger generation of poets from the generation still represented by Tennyson, Swinburne, William Morris, George Meredith, and from among whom Robert Browning and Dante Gabriel Rossetti were but lately removed. The distinction, like the term "decadent," began as a disparagement and, despite well-meaning protests, it lived on with a difference. Richard Le Gallienne lectured on "The Minor Poet," proving him of importance; and many critics were of the same mind, including William Archer. In the preface to *Poets of the Younger Generation*, a book written in 1899, but not published until 1902, owing to the outbreak of the Boer War, he said: "Criticism has made great play with the supercilious catchword 'minor poet.' No one denies, of course, that there are greater and lesser lights in the firmament of song; but I do most strenuously deny that the lesser lights, if they be stars at all and not mere factitious fireworks, deserve to be spoken of with contempt. Now a shade of contempt has certainly attached of late years to the term 'minor poet,' which has given it a depressing and sterilising effect."

Zeal to stigmatise a calumny has here led to over-statement of its effect. The very book in which the above words appear, with its excellent review of the work of thirty-three poets, disproves at least any suggestion of sterilising results; and, though the survey is both comprehensive and catholic, one might add without much fear of cavil the names of another twelve poets or more to William Archer's hierarchy. The truth of the matter is that the poets so labelled were

157

indifferent to the term ; but less discerning members of the reading public may have suffered by allowing it to prejudice them against new poetry which was certainly in the tradition of the great British bards. Indeed, it is not easy to discover another decade in which English literature possessed so numerous and so meritorious a body of young poets. There were splendid outbursts of song in the Elizabethan and Caroline epochs, and another in the early years of the nineteenth century, when such poetic planets as Wordsworth, Byron, Coleridge, Keats and Shelley swam into human ken, but I know of no other decade with such a variety and ebullience of song as that under review. How much of it will survive the test of the passing years no critical judgment can say ; nor is that our concern. The future will have its own tastes and its own criteria. It is our business to recognise that, according to existing standards and modern predilections, the Nineties were prodigal of poets and distinguished in poems.

Already several of the so-called minor poets of the time have won something like the indisputableness of classics. Every survey of recent poetry takes willing and serious account of Francis Thompson, Ernest Dowson, Lionel Johnson and John Davidson ; and for greater reasons than that these poets are no longer living. Unhesitating also is the recognition of William Watson, Alice Meynell, A. E. Housman, Henry Newbolt and W. B. Yeats. There may be some who would still withhold the bays from Rudyard Kipling, as there are others who deal niggardly justice to Stephen Phillips, whose poetic achievement is higher than the valuation of the moment, if lower than that of the time when he gave us *Christ in Hades*, *Marpessa*, and *Paolo and Francesca* : poems surely destined to outlive detraction and neglect.

But the natural acceptance of such poets only touches the fringe of the *fin de siècle* fabric of song. The second decade of the new century sustains a lively interest in many poets who might well have been considered local to the last decade of the old. Some of them, though lacking nothing in individuality, sing with an accent so much in tune with the

"divine average" of culture and experience that some sort of permanence is assured to their work in special fanes of poesy, if not in the broader avenues of popular acceptance. Among such poets may be named Laurence Binyon, H. C. Beeching, F. B. Money-Coutts, E. Nesbit, Laurence Housman, Herbert Trench, Margaret L. Woods, "Michael Field," Sturge Moore, Charles Dalmon, Selwyn Image, Dollie Radford, Ernest Radford, Norman Gale, George Santayana and Rosamund Marriott-Watson. And finally there remain those poets who give expression to moods more attuned to end-of-the-century emotions, but who will command a select group of admirers in most periods. In this class are Arthur Symons, Richard Le Gallienne, John Gray, Lord Alfred Douglas, Theodore Wratislaw and Olive Custance.

In spite, however, of what has been said, the term "minor" applied to poetry came to be something more than a formal expression of contempt. The contempt it expressed was associated with the prevailing, though half-amused, antagonism of the middle classes towards the decadent movement in art and life. Calling the new poetry "minor" was, from the point of view of literary criticism, hitting below the belt, for the term really conveyed a moral meaning beneath a literary demonstration of force. Opposition to the younger poets may at times have taken the form of genuine literary criticism, but the voice of disapproval at its loudest lay in ethics rather than letters. Owen Seaman made exquisite fun of the younger generation of poets, particularly of

> "A precious few, the heirs of utter godlihead,
> Who wear the yellow flower of blameless bodlihead ! "

in *The Battle of the Bays*, and in a satirical poem, "To a Boy-Poet of the Decadence," he indicates precisely the type of poet who came to be regarded as minor, and the sort of objection he aroused :

> "The erotic affairs that you fiddle aloud
> Are as vulgar as coin of the mint ;
> And you merely distinguish yourself from the crowd
> By the fact that you put 'em in print.
>

> For your dull little vices we don't care a fig,
> It is *this* that we deeply deplore :
> You were cast for a common or usual pig,
> But you play the invincible bore."

Here there are direct inferences of erotic tendencies in the younger poets, as though such things were so unusual in youthful verse as to be startling, instead of being recognised as characteristics of all adolescent poetry. Be that as it may, " erotic affairs " may or may not be vulgar or dull. In the hands of a Baudelaire or a Gautier, a Swinburne or a Rossetti, they may offend—but not necessarily by vulgarity or dullness. Neither were the best of the minor poets vulgar or dull. Their eroticism may have been irritating, disturbing, offensive or disgusting, but it was often unique, and always sufficiently juvenescent and impudent to be bright. But the younger poets did not all err on the side of eroticism, and some of those who had·other enthusiasms were ready enough to criticise and repudiate their fellows in song. Richard Le Gallienne, who, himself, was usually, and unjustly, classed with the degenerates, showed small sympathy with that type in "The Decadent to his Soul." In the course of this poem he defines very clearly the attitude adopted by at least one poet of the time towards what was conventionally decadent :

> " Then from that day, he used his soul
> As bitters to the over dulcet sins,
> As olives to the fatness of the feast—
> She made those dear heart-breaking ecstasies
> Of minor chords amid the Phrygian flutes,
> She sauced his sins with splendid memories,
> Starry regrets and infinite hopes and fears ;
> His holy youth and his first love
> Made pearly background to strange-coloured vice."

And Lionel Johnson, who was neither decadent nor minor, contributed a prose satire on the same subject to the first number of *The Pageant*. It is called "Incurable," and deals rather heavily with that phase of youthful introspection which tends to brood on love and suicide. But his decadent

poet is better represented by examples of the work attributed
to him. Here is a faithful imitation of the minor mode with
satire so well concealed that, in the Nineties, it might easily
have passed for the real thing :

> " Sometimes, in very joy of shame,
> Our flesh becomes one living flame :
> And she and I
> Are no more,separate, but the same.
>
> Ardour and agony unite ;
> Desire, delirium, delight :
> And I and she
> Faint in the fierce and fevered night.
>
> Her body music is : and ah !
> The accords of lute and viola,
> When she and I
> Play on live limbs love's opera."

There were poets, I say, who might well have been repre-
sented by the above parody. Arthur Symons (in his earlier
phase too often a Restoration poet *malgré lui*) played the
part of minor poet of the minute with something like
desperation :

> " Her cheeks are hot, her cheeks are white ;
> The white girl hardly breathes to-night,
> So faint the pulses come and go,
> That waken to a smouldering glow
> The morbid faintness of her white.
>
> What drowsing heats of sense, desire
> Longing and languorous, the fire
> Of what white ashes, subtly mesh
> The fascinations of her flesh
> Into a breathing web of fire ?
>
> Only her eyes, only her mouth,
> Live, in the agony of drouth,
> Athirst for that which may not be :
> The desert of virginity
> Aches in the hotness of her mouth."

And among all his earlier poems you can find innumerable
manifestations of the decadent reversion to artificiality, as
in the lines :

" Divinely rosy rogued, your face
 Smiles, with its painted little mouth,
 Half tearfully, a quaint grimace ;
 The charm and pathos of your youth
 Mock the mock roses of your face."

Such variations upon love were by no means new to poetry
even in this country. Swinburne and Rossetti had been
roundly trounced by Robert Buchanan for venturing as far
but no farther, and the minor poets of the Nineties suffered
similar attacks from their own outraged contemporaries.
Generally speaking, this erotic verse lacked the magic of fine
poetry, and to that extent it was minor or, rather, not poetry
at all. It was verse, and often, let it be admitted, very good
verse, but only in the work of Ernest Dowson did it possess
the high-wrought intensity and indefinable glamour of poetry.

The veritable minor note of the poetry of these years was
not, strangely enough, that sought out for denunciation and
satire by the bourgeoisie. The eroticism which became so
prevalent in the verse of the younger poets was minor because
it was little more than a pose ; not because it was erotic. It
was minor because it was the swan song of the Fleshly School
of the Seventies and Eighties. It did not ring true : for one
reason because it was an affectation, and for another because
it was perhaps a little too much like the life the decadents
were trying to live. Only a respectable person, like Swin-
burne, could write a really profound decadent love poem.

Where the minor poets were both minor and poets was in
that curious lisping note which many of them managed to
introduce into their poems. This was a new note in poetry,
corresponding with the minor key in music. It was not polish
or style, nor metrical, nor alliterative trick or experiment.
Neither was it entirely that fashionable sensitiveness,
which, in its ultimate search for unknown, unexperienced
reality, often resulted in a sterile perversity. It approxi-
mated more to that ultra-refinement of feeling, that
fastidiousness of thought which, in its over-nice concern for
fine shades and precious meanings, becomes bleak and cheap.
There was an unusual femininity about it ; not the femininity

of women, nor yet the feminine primness of men ; it was more a mingling of what is effeminate in both sexes. This was the genuine minor note, and it was abnormal—a form of hermaphroditism. But it has left no single poem as a monument to itself. It was never so near corporeality as that. It was a passing mood which gave the poetry of the hour a hothouse fragrance ; a perfume faint yet unmistakable and strange. And now, as then, it lives only in stray "gillyflowers of speech," recording, perchance, "a bruisèd daffodil of last night's sin," to borrow phrases from the early poems of Richard Le Gallienne, who affected these mincing measures as thoroughly as he has since followed a more virile muse.

Again, when the minor poet was most minor, he always contrived to clothe his verse in gracious language which had full power to charm by its ingenuity and beauty. If the minor mode forbade its devotees to trespass far beyond the borders of fancy ; if it prevented prettiness becoming beauty, we need not complain. Fancy and Prettiness never sought to dethrone Imagination and Beauty, but to support and serve them like good courtiers, and so the minor poets of the Nineties served Art and Life.

Yet so myopic was the literary vision that ephemeral verses were classed as minor with the strong and normal lyricism of William Watson's :

> " Let me go forth, and share
> The overflowing Sun
> With one wise friend, or one
> Better than wise, being fair,
> Where the peewit wheels and dips
> On heights of bracken and ling,
> And Earth, unto her finger tips,
> Tingles with the Spring."

Or with the wistful beauty of W. B. Yeats'

> " When you are old and grey and full of sleep
> And nodding by the fire, take down this book,
> And slowly read, and dream of the soft look
> Your eyes had once, and of their shadows deep ;

How many loved your moments of glad grace,
 And loved your beauty with love false and true ;
 But one man loved the pilgrim soul in you,
And loved the sorrows of your changing face.

And bending down beside the glowing bars,
 Murmur, a little sadly, how love fled
 And paced upon the mountains overhead,
And hid his face amid a crowd of stars."

Or Richard Le Gallienne's beautiful lines :

 " She's somewhere in the sunlight strong,
 Her tears are in the falling rain,
 She calls me in the wind's soft song,
 And with the flowers she comes again."

Or with some such happy song as Norman Gale's

 " All the lanes are lyric
 All the bushes sing,
 You are at your kissing,
 Spring ! "

Or the more tragic theme of Francis Money-Coutts :

 " Oft in the lapses of the night,
 When dead things live and live things die,
 I touch you with a wild affright
 Lest you have ceased in sleep to sigh."

And later even with Stephen Phillips' *Christ in Hades* :

 " It is the time of tender, opening things.
 Above my head the fields murmur and wave,
 And breezes are just moving the clear heat.
 O the mid-noon is trembling on the corn,
 On cattle calm, and trees in perfect sleep,
 And hast thou empty come ? Hast thou not brought
 Even a blossom with the noise of rain
 And smell of earth about it, that we all
 Might gather round and whisper over it ?
 At one wet blossom all the dead would feel ! "

And the higher and deeper simplicity of A. E. Housman :

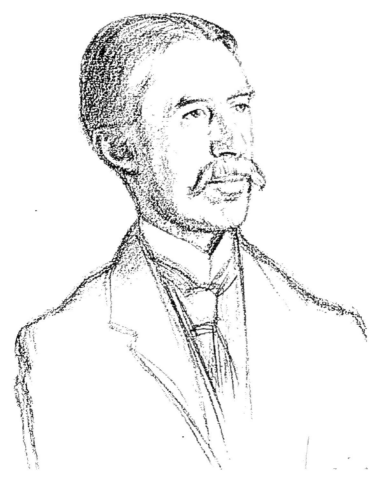

A. E. HOUSMAN
From a Drawing by William Rothenstein

" With rue my heart is laden
 For golden friends I had,
For many a rose-lipt maiden
 And many a lightfoot lad.

By brooks too broad for leaping
 The lightfoot boys are laid ;
The rose-lipt girls are sleeping
 In fields where roses fade."

All these were classed as lesser poems—and so they are,
beside the best of Shakespeare, Milton, Shelley, Keats and
the best work of those few other high lords of song ; but with
the rest they may claim kin, and ever remain in goodly
company.

CHAPTER XII

THE wave of Catholicism which swept over the art world of the closing years of the nineteenth century reached its poetic fulness in the work of Francis Thompson. Contemporary with him were Ernest Dowson, Lionel Johnson and John Gray, and, although each was inspired by the same spiritual forces to reassert in song their faith in traditional Christianity, none of them had his bigness of vision. Few poets, indeed, of any time, have surpassed his technical skill or the prodigality of his literary inventiveness ; but, beyond that, the spirit of the hour breathed into his verse a new avowal of mysticism, and it informed his orthodoxy with so sweet and beautiful a sense of life that those who were old in the convention of Rome must have marvelled at the beauty of their inheritance.

Francis Thompson, product as he is of the poetic impulsion of the Nineties, cannot be located there, as one can locate so many of the poets of the time. He is not estranged from neighbouring decades, like Ernest Dowson and John Gray, by a fortuitous decadence of mood, but rather does he partake of the endless current of the years and of the eternal normalities. Those who care to discover obvious resemblances among poets have compared him, fittingly enough, with Crashaw, Vaughan and Herbert, and other seventeenth-century mystical singers, and sometimes as though he had been influenced by them. Yet it is known that he resembled such poets before he had made himself acquainted with their works. Francis Thompson is, of course, just one more manifestation of the eternal mystery of faith, and in his greatness he is of no time and all time. Those resemblances with the past have no more to do with the average magnificence of his

166

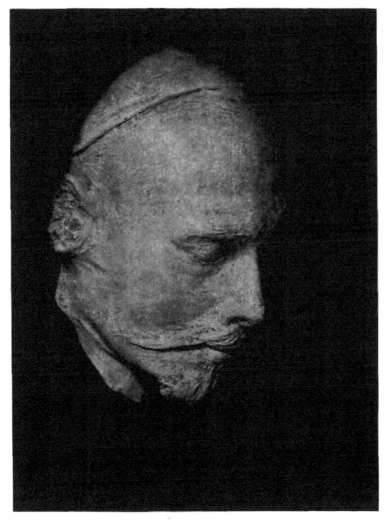

FRANCIS THOMPSON (LIFE MASK, 1905)
From the Photograph by Sherril Schell

genius and his work than the minor novelties of thought and
expression which may remind us of his corporeal moment.
To the latter I must refer, and with more excuse than that
demanded by the scope of this book, for there is much in
his life and art which links him with, without confining him
to, his period.

The son of a doctor, Francis Thompson was born at Preston
on 18th December 1859. His father and mother, and two
paternal uncles, were converts to the Roman Catholic
religion ; both uncles were associated with letters, one as
professor of English literature at the Catholic University,
Dublin, and later as sub-editor of *The Dublin Review*, and
author of several devotional tracts, and the other as the
author of a volume of poems. Francis was educated in the
Catholic faith, and sent to Ushaw College with some idea
of ultimate priesthood ; but that intention must have been
abandoned, for at the age of seventeen he was a reluctant
student of medicine at Owens College, Manchester. Six
years were devoted to this work when, repeated attempts
to take a degree proving abortive, a medical career was
abandoned. He expressed no desire to live by writing,
although he was an ardent student of literature, with a
particular affection for Æschylus, William Blake and De
Quincey. Several unsuccessful attempts were made by him
to earn a living in various employments, but in 1885, stung
by his father's reproaches, Thompson left Preston and walked
to London. For three years he lived unknown, generally
in degrees of poverty and destitution. He was employed
variously and at odd times ; once as a bootmaker's assistant
in Leicester Square, again as a publisher's " collector." In
1888 he sent two poems, " The Passion of Mary " and
" Dream Tryst," and a prose essay, " Paganism Old and
New," copied out on ragged scraps of paper, to *Merry
England*. This act proved a turning-point in his career, for
the editor, Wilfrid Meynell, recognising the extraordinary
quality of the work submitted to him, not only published
it, but sought out the author, who had given the vague ad-
dress of Charing Cross Post Office ; and, having found him,

became his lifelong friend and, in course of time, his literary
executor and the far-seeing guardian of his fame.

So poor was Francis Thompson during his early London
days that even writing materials were beyond his means,
and some old half-used account-books, given to him by the
Leicester Square bootmaker, were a windfall, enabling him
to translate to more enduring form something of the richness
of his mind. But he was not a writer in the ordinary sense.
His desire to harvest his dreams was intermittent at best,
and, in after years, friendly editors were at great pains to
extract commissioned work from him. At the same time
he did make some attempt at publicity, as the sending of
manuscripts to Mr Wilfrid Meynell would prove. The results
were not, however, always so fortunate, for in the following
year his essay on "Shelley" was rejected by *The Dublin
Review*. Nearly twenty years later the essay was discovered
among the poet's papers by his literary executor, and, as we
know, *The Dublin Review* was enabled to make amends.
During his own life Thompson published three volumes :
Poems (1893), *Sister Songs* (1895) and *New Poems* (1897).
He contributed poems and reviews to several publications,
notably to *The Academy*, under the editorship of Lewis Hind,
who was one of the earliest to give practical recognition to
his genius.

It was not easy to befriend such a man as Francis Thomp-
son. For years he had taken opium, which set up a paralysis
of the social will and made him tragically indifferent to the
most elementary amenities of life. His friends induced him,
especially when he was too ill to resist their kind offices, to
leave the estranged city ways, and thus there are oases in his
sordid outer life—in hospitals ; at the house of Wilfrid and
Alice Meynell ; at Storrington, in Sussex, where he wrote
most of the poems in his first volume ; and, later, near the
Franciscan monastery at Pantasaph, North Wales, where he
wrote the greater part of those in his last. After this he did
little work of first quality. His own soul, rather than the
world, made fateful and fatal demands of him. This strange
being, with brain of wondrous imagery and cleanest thoughts,

this gentle poetic genius, voluntarily, it would seem, chose destitution and desolation as his lot—if one dare apply such terms to a being whose inner life was so rich with vision. But opium and privation are exacting mistresses and eventually they wrecked his never-too-robust body. Unfamiliar and unkempt, this wayward child of the magical soul, this decadent Shelley who "dabbled his fingers in the day-fall," preferred to haunt the Embankment, the cavernous arches of Charing Cross and the bleak and dusty colonnades of Covent Garden, like any lonely and friendless human outcast, until disease drove him to take shelter in a hospital at St John's Wood, where he died, on 13th November 1907.

Among the many eloquent and whole-hearted tributes to his memory, that by Wilfred Whitten stands out for its vivid word portraiture of the man in his latter days. Mr Whitten first met Francis Thompson at the office of *The Academy*, Chancery Lane, in 1897, "the year in which, with his *New Poems*, he took farewell of poetry and began," he says, "to look on life as so much dead lift, so much needless postscript to his finished epistle. Thompson came frequently to the office to receive books for review, and to bring in his 'copy.' Every visit meant a talk, which was never curtailed by Thompson. This singer, who had soared to themes too dazzling for all but the rarest minds ; this poet of the broken wing and the renounced lyre had not become moody or taciturn. At his best he was a fluent talker, who talked straight from his knowledge and convictions, yet never for victory. He weighed his words, and would not hurt a controversial fly. On great subjects he was slow or silent ; on trifles he became grotesquely tedious. This dreamer seemed to be surprised into a kind of exhilaration at finding himself in contact with small realities. And then the fountains of memory would be broken up, or some quaint corner of his *amour propre* would be touched. He would explain nine times what was clear, and talk about snuff or indigestion or the posting of a letter until the room swam round us."

Following this comes a picture of the poet as he appeared in his pilgrimage through the London streets : "A stranger

figure than Thompson's was not to be seen in London.
Gentle in looks, half-wild in externals, his face worn by pain
and the fierce reactions of laudanum, his hair and straggling
beard neglected, he had yet a distinction and an aloofness of
bearing that marked him in the crowd ; and when he opened
his lips he spoke as a gentleman and a scholar. A cleaner
mind, a more naïvely courteous manner, were not to be found.
It was impossible and unnecessary to think always of the
tragic side of his life. He still had to live and work, in his
fashion, and his entries and exits became our most cheerful
institution. His great brown cape, which he would wear on
the hottest days, his disastrous hat, and his dozen neglects
and makeshifts were only the insignia of our ' Francis ' and
of the ripest literary talent on the paper. No money (and
in his later years Thompson suffered more from the possession
of money than from the lack of it) could keep him in a decent
suit of clothes for long. Yet he was never ' seedy.' From
a newness too dazzling to last, and seldom achieved at that,
he passed at once into a picturesque nondescript garb that
was all his own and made him resemble some weird pedlar or
packman in an etching by Ostade. This impression of him
was helped by the strange object—his fish-basket, we called
it—which he wore slung round his shoulders by a strap. It
had occurred to him that such a basket would be a con-
venient receptacle for the books which he took away for
review, and he added this touch to an outward appearance
which already detached him from millions."

Stranger or more inspired being has never before slipped
through the indifferent metropolitan throng, transmuting,
by his indifference to earthly things, tragic moments into
joyous conquests.

Having mentioned the difficulties of friendly intention to-
wards such a man, it is necessary to quote here a more recent
tribute to Thompson's earliest friend, Wilfrid Meynell, con-
tributed in a letter to *The Nation* by Lewis Hind, in reply to
a poem "To Francis Thompson," by William H. Davies.
There were lines in this poem, such as " No window kept a
light for thee," and " No pilot thought thee worth his pains,"

which might have led the ill-informed to imagine Thompson a friendless and neglected genius. The contrary is made quite clear for all time :

"Now [says Lewis Hind] it is a matter of history that there was a man who, through sheer love of great verse, and through kindness, piloted Francis Thompson all the years of his London life from the late eighties until his death. That man was Wilfrid Meynell. There was a window always alight for the poet—the window of the Meynell home. And if this is not made very clear in the forthcoming *Life of Francis Thompson*, by Everard Meynell, the reason will be the family shrinking from making their good deeds known. I speak from knowledge. Long ago (it must have been about 1889), on the occasion of my first meeting with Wilfrid Meynell (my initial call at that hospitable house, drawn thither by an essay from Mrs Meynell's pen that made me eager to meet the author), Mr Meynell asked me if I had ever heard of a Francis Thompson who had submitted to him for *Merry England* an astonishing poem from the vague address of Charing Cross Post Office. Later, he tracked the poet, and from that day until Thompson's death Wilfrid Meynell was pilot, friend, purse, anything, everything, to the poet. From the material world Francis Thompson wanted nothing. It did not interest him. It did not exist for him. His body, that wretched structure ordained to house, as it best might, his ardent spirit, he, shall I say, despised. Comfort, a home, provision for the future were to him unrealities. His only realities were spiritual ; his only adventures were in the land of visions. The Meynell household was his true parental home, and he, a child in all worldly matters, was as incurious as a child as to the whence and why of the necessaries of life. For a time I was happily instrumental in relieving my friend, Wilfrid Meynell, of the financial burden of piloting a poet. That was during the days of my editorship of *The Academy*, when for three or four years Thompson was our most valued and most difficult contributor. I soon realised the folly of sending him a cheque in payment of contributions. Either

he would never open the letter, or, likely enough, he would light his obstreperous pipe with the cheque, apparently never dreaming that it might be useful in paying his landlady. No ; I sent him no cheques after the first month. A cheque was despatched to his landlady each week for board and lodging, and a few shillings were placed in the poet's hand, periodically, for pocket money, which he accepted with detachment, his flow of conversation (it was his wont often to talk about nothing at exasperating length) uninterrupted. *The Academy* would never have received his fine ' Ode on the Death of Cecil Rhodes ' (a commission : completed in fifteen hours) had he not been in want that day of pocket money—not for collars, not for cabs—for laudanum."

Tragedy there was in the life of Francis Thompson, but there was nothing pitiful. It was a life too deep for pathos. He was one of those who were marked by the quickening spirit of the times for test of tribulation. The search for reality in the Nineties produced many such who were impelled by the unknown forces of the moment to follow life to the very frontier of experience. Consciously or unconsciously, as we have seen, men were experimenting with life, and it would seem also as if life were experimenting with men. It was a revolution precipitated by the Time Spirit. Francis Thompson represented the revolt against the world. He did not, as many had done, defy the world ; he denied it, and; by placing his condition beneath contempt, he conquered it. That, at least, was the effect of his curious life, and in that he was unique even in a period of spiritual and intellectual insurrection and suffering. The probability that he took to poverty as he took to opium, as a sedative for the malady of spirit, does not invalidate this view, and the record of his pilgrimage and his faith is actually epitomised in the most popular and most remarkable of his poems, *The Hound of Heaven*, a work which well might serve as a symbol of the spiritual unrest of the whole nineteenth century. But whilst every thinker and dreamer of the *fin de siècle* decade was seeking a fuller life through art, or experience, or sensation,

or reform, or revolt, or possessions, Francis Thompson was finding it in the negation of all these. Whilst others acquired for themselves treasures of one kind or another, or sought for themselves wonders and achievements of one kind or another, he remained both poor and unmoved by his poverty. If mind ever was kingdom to man, Francis Thompson's mind a kingdom was to him ; nay, it was the kingdom of God.

In this great lyric the mystical idea of God as the Hound of Heaven eternally pursuing the pilgrims of life until they return to Him is autobiographical of a man and an age. What better epitome of the mind of the modern world could be imagined than the opening stanza ?

> " I fled Him, down the nights and down the days ;
> I fled Him down the arches of the years ;
> I fled Him, down the labyrinthine ways
> Of my own mind ; and in the mist of tears
> I hid from Him, and under running laughter.
> Up vistaed hopes, I sped ;
> And shot, precipitated,
> Adown Titanic glooms of chasmed fears,
> From those strong Feet that followed, followed after. "

There we have the whole desolation of man—the seeker who findeth not, for what he seeks seeketh him ; the hunter of God hunted by God—and as the poem proceeds we see the eternal malady of the spirit, now satiated, now insatiable, in the age-long quest for peace and joy in things known and seen :

> " To all swift things for swiftness did I sue ;
> Clung to the whistling mane of every wind.
> But whether they swept, smoothly fleet,
> The long savannahs of the blue ;
> Or whether, Thunder-driven,
> They clanged His chariot 'thwart a heaven
> Plashy with flying lightnings round the spurn o' their feet :—
> Fear wist not to evade as Love wist to pursue. "

Francis Thompson took a delight in simple things which recalls Wordsworth's attitude and sometimes that poet's accent, particularly in the lines called "Daisy," wherein,

after the manner, also, of the Nineties, he celebrates his meeting with Innocence in the person of a young girl on the Sussex hills near Storrington :

> " She looked a little wistfully,
> Then went her sunshine way :—
> The sea's eye had a mist on it,
> And the leaves fell from the day.
>
> She went her unremembering way,
> She went, and left in me
> The pang of all the partings gone,
> And partings yet to be.
>
> She left me marvelling why my soul
> Was sad that she was glad ;
> At all the sadness in the sweet,
> The sweetness in the sad."

Indeed, it would be easier to find resemblances between Francis Thompson and poets so diverse as Wordsworth and Shelley than between him and the mystic poets of the seventeenth century. He had the quietism of Wordsworth and the exalted sensuousness of Shelley, and he had the fundamental saintliness of both. A life of sordid self-inflicted disaster could no more affect the strength and cleanliness of his spirit than a life of passionate wilfulness could touch the purity of the soul of Shelley. But there are definite points of divergence between Thompson and the two earlier poets. He goes further with Shelley than with Wordsworth : Thompson and Shelley were more akin. The spirituality of Wordsworth was, ultimately, moral ; that of Shelley, mystic. Had the spirit of Wordsworth been reborn in 1891 it might have been rationalistic and ethical : the pride of Nonconformity. But the spirit of Shelley reborn at the same time might have been—Francis Thompson. Shelley, it is true, sought an unknown God in materialism, and some of his prose might easily have been inspired by that Secular Society which post-dated him by half-a-century, but his most rationalistic moment in song has all the passionate mysticism of William Blake. The paganism of Shelley seems to span

the years with majestic courage until, weary of the endless show of things, it joins forces with Thompson and Christianity.

The modern poet knew and understood Shelley as few have done. For him no "bright but ineffectual angel," this soaring creature of enraptured song, but a child with the whole universe for toy-box : "He dabbles his fingers in the day-fall. He is gold-dusty with tumbling amidst the stars. He makes bright mischief with the moon. The meteors nuzzle their noses in his hand. He teases into growling the kennelled thunder, and laughs at the shaking of its fiery chain. He dances in and out of the gates of heaven : its floor is littered with his broken fancies. He runs wild over the fields of ether. He chases the rolling world. He gets between the feet of the horses of the sun. He stands in the lap of patient Nature, and twines her loosened tresses after a hundred wilful fashions, to see how she will look nicest in his song." And in this description of Shelley, Thompson goes far towards describing himself, but he did not stand " in the lap of patient Nature "; Francis Thompson, childlike also, rested in the lap of God.

This kinship with Shelley in a common Pantheism is realised more than elsewhere in Francis Thompson's *Anthem of Earth*, a luxuriant poem in which he retraces with depth and beauty, and an added richness, the image he had summoned to his aid in the essay on his kin-poet :

> " Then what wild Dionysia I, young Bacchanal,
> Danced in thy lap ! Ah for the gravity !
> Then, O Earth, thou rang'st beneath me,
> Rocked to Eastward, rocked to Westward,
> Even with the shifted
> Poise and footing of my thought !
> I brake through thy doors of sunset,
> Ran before the hooves of sunrise,
> Shook thy matron tresses down in fancies
> Wild and wilful
> As a poet's hand could twine them ;
> Caught in my fantasy's crystal chalice
> The Bow, as its cataract of colours
> Plashed to thee downward ;
> Then when thy circuit swung to nightward,

Night the abhorrèd, night was a new dawning,
Celestial dawning
Over the ultimate marges of the soul ;
Dusk grew turbulent with fire before me,
And like a windy arras waved with dreams.
Sleep I took not for my bedfellow,
Who could waken
To a revel, an inexhaustible
Wassail of orgiac imageries ;
Then while I wore thy sore insignia
In a little joy, O Earth, in a little joy ;
Loving thy beauty in all creatures born of thee,
Children, and the sweet-essenced body of women ;
Feeling not yet upon my neck thy foot,
But breathing warm of thee as infants breathe
New from their mother's morning bosom.[11]

Such earth-love is Pagan rather than Christian, yet it was
not foreign to the Christianity of Francis Thompson, whose
orthodoxy did not curtail his worship of Life in many of her
manifestations—in the stars and the winds, in the flowers
and children, and in pure womanhood. There was hardly
anything abnormal about his taste, but everything he wor-
shipped became distinguished and strange by the wonder-
maiden imagery of his genius. The foregoing lines are richly
diapered with luxurious phrases. No other poet of his time
possessed such jewelled endowment, and few of any other
time equal him in this gift. Nowhere in English song are
there poems so heavily freighted with decoration of such
magnificence ; and no poems approaching, however remotely,
their regal splendour have the power of suggesting such
absolute simplicity. Sometimes his "wassail of orgiac
imageries" becomes the light conceit of his time, but never
for long. Francis Thompson soared high above literary
flightiness. His very luxuriance of expression was austere ;
it was not the young delight of a Keats in sheer physical
beauty ; it was the transmutation of sense into spirit by the
refinement of sense in vision.

THE Eighteen Nineties had no more remarkable mind and no more distinctive poet than John Davidson. From the beginning he was both an expression of and a protest against the decadent movement, and in his personality as well as in his tragic end he represented the struggle and defeat of his day in the cause of a bigger sense of life and a greater power over personality and destiny. At the dawn of the period he had reached middle age, having been born at Barrhead, Renfrewshire, on 11th April 1857. But curiously enough, as in the case of so many of those who gained distinction in art during the period, John Davidson did not show any distinctive *fin de siècle* characteristics until he produced his novel, *Perfervid*, in 1890 ; and between that time and 1899 he remained an artist in the approved Whistlerian sense, content in the main to express life in the traditional artistic manner, without any overweening desire to preach a particular doctrine. With the close of the decade his mental attitude seems to have undergone a revolution, which translated him from an artist pure and simple into a philosophic missioner using literature as a means of propaganda.

He was the son of Alexander Davidson, a minister of the Evangelical Union, and Helen, daughter of Alexander Crockett of Elgin. His education began at the Highlanders' Academy, Greenock, and continued until he was thirteen years of age, when he was sent to work in the chemical laboratory of a sugar manufacturer at Greenock, and in the following year he became an assistant to the town analyst. In 1872 he returned to the Highlanders' Academy as a pupil teacher, and remained there for four years, afterwards

spending a year at Edinburgh University. In 1877 he became a tutor at Alexander's Charity, Glasgow, and during the next six years he held similar scholastic posts at Perth and Paisley. During 1884-1885 he was a clerk in a Glasgow thread firm, but returned to the scholastic profession in the latter year, teaching in Morrison's Academy, Crieff, and in a private school at Greenock. During these years he devoted much time to literary work, the drama claiming a considerable amount of his attention, and in 1886 his first work, *Bruce: A Drama*, was published in Glasgow. In 1888 he published *Smith, a Tragic Farce*; in 1889 *An Unhistorical Pastoral, A Romantic Farce* and *Scaramouch in Naxos*. All of these were issued in Scotland during his period of scholastic employment, but this he abandoned in the year 1889, when he departed for London with the object of earning his living as a writer.

Then began a period of literary struggle mitigated somewhat by the rewards of artistic recognition. In the midst of much journalistic work, which included contributions to *The Glasgow Herald, The Speaker* and *The Yellow Book*, he produced poems and novels and short stories; he also translated François Coppée's play, *Pour la Couronne*, which was produced by Forbes Robertson at the Lyceum Theatre under the title of *For the Crown*, and Victor Hugo's *Ruy Blas*, produced at the Imperial Theatre as *A Queen's Romance*.

It was his poetry which first won for him a place among his contemporaries. *In a Music Hall and Other Poems* was published in 1891, and during the decade he issued at short intervals eight further volumes of poetry, followed by two others in the new century. These volumes were *Fleet Street Eclogues* (1893), *Ballads and Songs* (1894), *Fleet Street Eclogues*, second series (1896), *New Ballads* (1897), *The Last Ballad* (1899), *Holiday and Other Poems* (1906), and *Fleet Street and Other Poems* (1909). In this body of work Davidson is represented at his highest as an artist, though he himself set more store by the remarkable series of " testaments " and philosophical plays and poems which engaged his genius during his last phase. In the period covered by his poetic

activity he published various prose works, such as *Sentences and Paragraphs* (1893), an early volume revealing the scientific and philosophical interests of his mind, and above all his early appreciation of the teaching of Friedrich Nietzsche; *A Random Itinerary* (1894), and several novels, including *Baptist Lake* (1894) and *The Wonderful Mission of Earl Lavender* (1895), published with Beardsley's frontispiece illustrating one of the incidents of the book.

The books of his last phase are a designed attempt to co-ordinate and restate his ideas upon life and art. They begin with the first three of his four "testaments": *The Testament of a Vivisector* (1901), *The Testament of a Man Forbid* (1901), and *The Testament of an Empire Builder* (1902). He brooded long and deeply over the views expressed in these works, which reveal a revolutionism transcending all familiar attacks upon institutions, secular or religious, for the poet lashes with high and passionate seriousness the tyrannies not of man, but those also of nature and of fate. Next in order of these philosophical works came *The Theatrocrat: A Tragic Play of Church and State* (1905). Later he devised a dramatic trilogy, further to embody his philosophical gospel, under the title "God and Mammon"; but only two of the projected plays were written: *The Triumph of Mammon* (1907), and *Mammon and his Message* (1908). Finally, he concluded his message to humanity fittingly enough with *The Testament of John Davidson* (1908). His attitude towards these works is made clear in his prefaces and other notes, and in the dedication to the last volume he describes the books as "The Prologue to a Literature that is to be," a literature, he adds, "already begun in my Testaments and Tragedies."

Depression rather than disappointment dogged the life of John Davidson. It is true that he did not reach fortune by his works, but even he could hardly have expected such a reward. He did, however, and with justice in the light of so much industry, expect to earn a living by his pen, but this expectation had but meagre fulfilment. As in the case of many other artists he had to pot-boil. This hurt him both

in performance and result, for regular income did not spring
out of the sacrifice. "Nine-tenths of my time," he wrote,
on his fiftieth birthday, "and that which is more precious,
have been wasted in the endeavour to earn a livelihood. In
a world of my own making I should have been writing only
what should have been written." These words were written
in 1907, and the year before he had been awarded a Civil List
pension of one hundred pounds, but this came too late, how-
ever, to arouse hope in a temperament which long years of
struggle with adversity had steeped in a settled gloom. In
1908 the poet left London with his family for Penzance, and
on 23rd March 1909 he left his home never to return. Nearly
six months afterwards his body was discovered by some
fishermen in Mount's Bay, and, in accordance with his known
wishes, was buried at sea. Such a death is not a surprising
end to one who adopted or possessed Davidson's attitude
towards life. He resented the unknown and loathed all
forms of weakness. He could not accept life as he found it,
and his philosophy reflects his objection to circumstance and
fate, actuality and condition, in a passionate claim for control
over destiny and power, and over life itself. There was no
reality for him without omnipotence; he repudiated life on
any other terms. That was at the root of his depression, as
it was the basis of his philosophy.

The assumption that he took his own life is consistent
with what is known of his temperament and his ideas. In
The Testament of John Davidson, published the year before
his death, he anticipates this fate:

> "None should outlive his power. . . . Who kills
> Himself subdues the conqueror of kings:
> Exempt from death is he who takes his life:
> My time has come."

And further on in the same poem he gives suicide a philo-
sophic basis which has, perhaps, more frankness than novelty:

> "By my own will alone
> The ethereal substance, which I am, attained,
> And now by my own sovereign will, forgoes,
> Self-consciousness; and thus are men supreme:

No other living thing can choose to die.
This franchise and this high prerogative
I show the world :—Men are the Universe
Aware at last, and must not live in fear,
Slaves of the seasons, padded, bolstered up,
Clystered and drenched and dieted and drugged ;
Or hateful victims of senility,
Toothless and like an infant checked and schooled ;
Or in the dungeon of a sick room drained
By some tabescent horror in their prime ;
But when the tide of life begins to turn,
Before the treason of the ebbing wave
Divulges refuse and the barren shore,
Upon the very period of the flood,
Stand out to sea and bend our weathered sail,
Against the sunset, valiantly resolved
To win the heaven of eternal night."

The poetry of John Davidson reveals on most pages a keen
sense of life in its various manifestations struggling for power
of one kind or another. His imagination is essentially
dramatic, but his sense of conflict is often philosophic, his
artistic sense always showing a tendency to give way to the
imp of reflection which, through his imagination, was ever
seeking to turn drama into philosophy and philosophy into
science. Yet he was not immune from a certain whimsi-
cality, particularly in his early prose works, in the fantastic
novels, *Perfervid*, *Earl Lavender*, and *Baptist Lake*, and still
more certainly, with a surer touch of genius, in his panto-
mime *Scaramouch in Naxos*. In the "Prologue" to this play,
spoken by Silenus, Davidson goes far towards summing up
his own peculiar attitude. The speaker alludes to a fondness
for pantomimes, and proceeds to say : "I don't know
whether I like this one so well as those which I witnessed
when I was a boy. It is too pretentious, I think ; too
anxious to be more than a Pantomime—this play in which I
am about to perform. True *Pantomime* is a good-natured
nightmare. Our sense of humour is titillated and strummed,
and kicked and oiled, and fustigated and stroked, and ex-
alted and bedevilled, and, on the whole, severely handled
by this self-same harmless incubus ; and our intellects are

scoffed at. The audience, in fact, is, intellectually, a panta-
loon, on whom the Harlequin-pantomime has no mercy. It
is frivolity whipping its schoolmaster, common-sense ; the
drama on its apex ; art, unsexed, and without a conscience ;
the reflection of the world in a green, knotted glass. Now, I
talked to the author and showed him that there was a certain
absence from his work of this kind of thing ; but he put his
thumbs in his arm-pits, and replied with some disdain,
'Which of the various dramatic forms of the time may one
conceive as likeliest to shoot up in the fabulous manner
of the beanstalk, bearing on its branches things of earth
and heaven undreamt of in philosophy ? The sensational
dramas ? Perhaps from them some new development of
tragic art ; but Pantomime seems to be of best hope. It
contains in crude forms, humour, poetry, and romance. It
is childhood of a new poetical comedy.' Then I saw where
he was and said, 'God be with you,' and washed my hands
of him." Here we have Davidson, as early as 1888, con-
cerned about something new in art, something elastic enough
to contain a big expression of modernity, of that modernity
which in the Eighteen Nineties, and in John Davidson more
than in any other British writer of the time, was more than
half reminiscent of the classical Greek idea of eternal conflict.

But with Davidson and the moderns, led philosophically
by Nietzsche, Davidson's earliest master, the eternal conflict
was not regarded with Greek resignation. It was looked
upon as a thing which might be directed by the will of man.
The modern idea was to make conflict a means of growth to-
wards power : the stone upon which man might sharpen the
metal of his will until he could literally storm high heaven
by his own might. Such an idea, often vague and chaotic
enough, inspired the hour, making philosophers of artists
and artists of philosophers, and seekers after a new elixir of
life of all who were sufficiently alive to be modern. This
idea, more than any other, informed the moods of the
moment with restless curiosity and revolt. It filled the
optimist with the conviction that he lived in a glorious
period of transition which might at any moment end in

Utopia, and the pessimist with the equally romantic notion that the times were so much out of joint that nothing short of their evacuation for the past or the future would avail. As Davidson sang :

> "The Present is a dungeon dark
> Of social problems. Break the gaol !
> Get out into the splendid Past
> Or bid the splendid Future hail."

This resentment of the present was always Davidson's weakness despite an intellectual courage in which he had few equals in his time.

He could face with heroic fortitude the necessity of re-valuing ideas, just as he could face the necessity of revaluing his own life by suicide. But he could not face the slings and arrows of outrageous fortune. He never realised that a man and his age were identical, or that tragedy was an essential of life to be courted even by the powerful. ("Deep tragedy," said Napoleon, "is the school of great men.") Instead of that he murmured against that which thwarted and checked him, regretting the absence of might to mould the world for his own convenience. That was his contribution to the decadence. The bigness of him, unknown to himself, was the fact that he did fight for the integrity of his own personality and ideas, and he did accomplish their conservation, even to rounding off his own life-work with a final "testament." But when one has said all one is forced to admit that the irregularities and incongruities of his genius were nothing less than the expression and mark of his time.

It is as a poet that Davidson must ultimately stand or fall, although the philosophy he expressed in his later volumes will doubtless attract far more attention than that which greeted its inception. At first glance his poetry suggests a limited outlook, and even a limited technique ; but on closer acquaintance this view cannot be maintained. John Davidson is as varied as he is excellent, and as charming in moments of light-heartedness as he is noble in his tragic moods. Time probably will favour his ballads, but it will by no means neglect the magic poetry of his eclogues, nor the

grandeur of certain passages in his poetic dramas. And it is
not easy to believe that the delicate lyricism of some of his
shorter poems will ever pass out of the favour of those who
love great verse. Such a poem is "In Romney Marsh,"
finely balanced in phrase and image, and rising to a magnifi-
cent climax of metaphorical description in the two last verses :

> " Night sank : like flakes of silver fire
> The stars in one great shower came down ;
> Shrill blew the wind ; and shrill the wire
> Rang out from Hythe to Romney town.
>
> The darkly shining salt sea drops
> Streamed as the waves clashed on the shore ;
> The beach, with all its organ stops
> Pealing again, prolonged the roar."

Even in his last volume of verse, when ideas rather than
imaginative inventions crowded his mind, he proved in many
a poem the invincibility of his lyrical gift. The title-poem
itself, "Holiday," equals any of his earlier lyrics, and com-
pares well with even the best of his ballads. And he has
wrought a solemn grandeur into the short crisp lines of the
impassioned and deeply felt poem called "The Last Song" :

> " Death is but a trance :
> Life, but now begun !
> Welcome change and chance :
> Though my days are done,
> Let the planets dance
> Lightly round the sun !
> Morn and evening clasp
> Earth with loving hands—
> In a ruddy grasp
> All the pleasant lands !
>
> Now I hear the deep
> Bourdon of the bee,
> Like a sound asleep
> Wandering o'er the lea ;
> While the song-birds keep
> Urging nature's plea.
> Hark ! The violets pray
> Swooning in the sun !
> Hush ! the roses say
> Love and death are one ! "

It does not need a very wide acquaintance with Davidson's poetry to realise how he was affected by the natural life of his native countryside and the country places of his residence. He saw the phenomena of field and hedgerow and woodland with clear eye and appreciative exactitude. But he did not immolate his personality at the shrine of Nature after the manner of Wordsworth or Shelley. His appreciation was in the main sensuous and æsthetic, serving to supply the poet with some of the fanciful materials of his art, for use in the more buoyant moments of his muse.

Throughout the whole of his poems passages abound in which Nature has thus been made to render the sort of tribute Keats demanded of her, as for instance in the following passage from one of the earlier eclogues :—

> " At early dawn through London you must go
> Until you come where long black hedgerows grow,
> With pink buds pearled, with here and there a tree,
> And gates and stiles ; and watch good country folk ;
> And scent the spicy smoke
> Of withered weeds that burn where gardens be ;
> And in a ditch perhaps a primrose see.
> The rooks shall stalk the plough, larks mount the skies,
> Blackbirds and speckled thrushes sing aloud,
> Hid in the warm white cloud
> Mantling the thorn, and far away shall rise
> The milky low of cows and farmyard cries.
> From windy heavens the climbing sun shall shine,
> And February greet you like a maid
> In russet-cloak arrayed ;
> And you shall take her for your mistress fine,
> And pluck a crocus for her valentine."

This keen sense of country sights and sounds reaches its highest in "A Runnable Stag," a lyric which stands alone among English poems for its musical realism and its vividly suggested but unstated sentiment :

> " When the pods went pop on the broom, green broom,
> And apples began to be golden-skinned,
> We harboured a stag in the Priory comb,
> And we feathered his trail up-wind, up-wind,
> We feathered his trail up-wind—

A stag of warrant, a stag, a stag,
A runnable stag, a kingly crop,
Brow, bay and tray and three on top,
A stag, a runnable stag.[11]

The subject brings to mind the callous stag-hunting chapter in Richard Jefferies' book, *Red Deer*, but different are the sentiments underlying poem and essay—in the former human feeling colours realism with pity at the stag harried to death in the sea, when

" Three hundred gentlemen, able to ride,
 Three hundred horses as gallant and free,
Beheld him escape on the evening tide,
 Far out till he sank in the Severn Sea,
 Till he sank in the depths of the sea—
 The stag, the buoyant stag, the stag
 That slept at last in a jewelled bed
 Under the sheltering oceans spread,
 The stag, the runnable stag."[1]

Davidson without comment reveals the pity of it all, but Richard Jefferies is capable of describing a similar incident in the passionless terms of photography.

Sympathy with pain, oftener of the spirit than of the flesh, links John Davidson with the Humanist movement of his time and ours, but it does not imprison him in a specific category. Labels cannot be attached to him. He was not associated with any coterie or organisation. He was as strange to the Rhymers' Club as he was to the Fabian Society or the Humanitarian League, and although circumstances brought him into the Bodley Head group of writers, giving some of his books decorations by Beardsley, and his portrait, by Will Rothenstein, to *The Yellow Book*, the facts must be set down to Mr John Lane's sense of what was new and strong in literature rather than to any feeling of kinship on Davidson's part. Kinsman of modernity in the big sense, he was not, then, in the brotherhood of any clique or special group of modernists, and although his works were as modern in the smaller topical aspect as they are part of a larger and more

notable awakening of thought and imagination, they never
achieved even a small measure of the popularity usually
accorded topical writings. Davidson's work, even in what
may be considered its most popular form, in his great
ballads, was esteemed by a few rather than accepted by
many. It is conceivable that in due time "The Ballad
of a Nun," "The Ballad of an Artist's Wife" and "The
Ballad of Hell" will enter into the familiar poetry of the
nation, as they have taken their places in the realm of
good poetry recognised by the cultured. But that time
is not yet; a higher average of culture must come about
before such verses could supplant "Christmas Day in the
Workhouse," or even Rudyard Kipling's ballad of "The
Mary Glocester" or "Gunga Din."

Davidson himself eventually rejected in some measure his
own lyric verse. He came to look upon rhyme as a symptom
of decadence, although he knew that "decadence in any art
is always the manure and root of a higher manifestation of
that art." He sought therefore to discover in the art of
poetry, as he sought also in life, a newer and more apt means
of expression. This he found in English blank verse. And
he associated his discovery with the final profundity of his
passionately asserted vision of life as matter seeking ever
finer and more effective manifestations. "Matter says its
will in poetry; above all, in English blank verse, and often,
as in the case of Milton, entirely against the conscious inten-
tion of the poet." In this verse form, "the subtlest, most
powerful, and most various organ of utterance articulate
faculty has produced," he saw the latest emanation of what
he calls the "concrete mystery Matter," created, "like folk,
or flowers, or cholera, or war, or lightning, or light," by an
evolutionary process involving all activities and states of
consciousness, until it produced that powerful human race
which "poured into England instinctively as into the womb
of the future, and having fought there together for centuries
. . . wrestling together for the mastery, and producing in
the struggle the blended breed of men we know : so tried
and welded, so tempered and damascened, this English race

having thrown off the fetters of a worn-out creed, having obtained the kingdom of the sea and begun to lay hands as by right on the new world, burst out into blank verse without premeditation, and earth thrilled to its centre with delight that Matter had found a voice at last." Poetry for him was thus no scholarly accomplishment, no mere decoration or bauble, but the very instrument of thought and imagination, emotion and passion, the finely tempered weapon of a nationalism which he linked up with Nature and endowed with her fierceness, mastery and power.

His sense of the high mission of poetry found ample expression in the prefaces and appendices of his later books, and in his "testaments." But in earlier days he heard himself speaking of the meaning and object of his own poetry in "A Ballad of Heaven," where the musician announces the completion of the masterpiece which "signed the sentence of the sun " and crowned "the great eternal age " :

> " The slow adagio begins ;
> The winding-sheets are ravelled out
> That swathe the minds of men, the sins
> That wrap their rotting souls about.
>
> The dead are heralded along ;
> With silver trumps and golden drums,
> And flutes and oboes, keen and strong,
> My brave andante singing comes.
>
> Then like a python's sumptuous dress
> The frame of things is cast away,
> And out of Time's obscure distress,
> The thundering scherzo crashes Day."[1]

Davidson's self-imposed mission was to thunder news of a new dawn. He repudiated the past ("The insane past of mankind is the incubus," he said), and, whilst insisting upon the importance of the present, he heralded the new day to come with an ardour equalled only by the Futurists of Milan, who followed him, and are his nearest intellectual kin. Had John Davidson lived to-day he must have hailed Marinetti

brother. "Undo the past!" he cried, in *The Testament of a Man Forbid* :

> " Undo the past !
> The rainbow reaches Asgard now no more ;
> Olympus stands untenanted ; the dead
> Have their serene abode in earth itself,
> Our womb, our nurture and our sepulchre.
> Expel the sweet imaginings, profound
> Humanities and golden legends, forms
> Heroic, beauties, tripping shades, embalmed
> Through hallowed ages in the fragrant hearts
> And generous blood of men ; the climbing thoughts
> Whose roots ethereal grope among the stars,
> Whose passion-flowers perfume eternity,
> Weed out and tear, scatter and tread them down ;
> Dismantle and dilapidate high heaven."

Being a poet, and Davidson never made any other claim, he would use poetry to help undo the past. "The statement of the present and the creation of the future," he said, "are the very body and soul of poetry." Of his later intentions he declared, "I begin definitely in my Testaments and Tragedies to destroy this unfit world and make it over again in my own image." He was never weary of asserting the novelty of his aim and method, and although he admitted that there was no language for what he had to say, he was convinced that what he had said was both new in form and idea. "It is a new poetry I bring, a new poetry for the first time in a thousand years." He called this new poetry "an abiding-place for man as matter-of-fact," and his own purpose in writing it, "to say that which is, to speak for the universe." And the ultimate aim of such work was, again in his own words, "to change the mood of the world."

Nor was he less precise, nor less frank, in stating the new mood he would establish in the place of the old. In the *fin de siècle* search for reality few possessed his diligence, fewer his intellectual courage. The terrible and powerful poem, "A Woman and Her Son," recalls something of his own

unrelenting criticism of life ; his own determination at all costs to face facts and re-value ideas :

> " These are times
> When all must to the crucible—no thought,
> Practice, or use, or custom sacro-sanct
> But shall be violable now." [11]

Early association with the ideas of Nietzsche had directed Davidson's innate pessimism into channels of creative inquisitiveness and speculation. He learnt more from Nietzsche than did any other poet of his time, but he never became a disciple. He learnt of that philosophical courage which Nietzsche called "hardness," and used it Nietzsche-wise in his continual questioning and re-valuing of accepted ideas. He was imbued also with the German philosopher's reverence for power. But he did not accept the Superman doctrine. This he repudiated equally with the Darwinian idea of sexual selection ; both stood condemned by him because of their anthropomorphism—what in fact Nietzsche condemned in other directions as being "human-all-too-human." Against the idea of evolution by sexual selection, with the ultimates man and then superman, he set the idea of chemical selection, with the ultimate object of complete self-consciousness. Beyond self-consciousness he saw nothing ; that in his view was the highest possible achievement of life. The essence of his teaching is based in the idea of Matter as the final manifestation of ether seeking, first, consciousness, which it has long since attained, and next, self-consciousness, which it has attained more recently in man. This last form of consciousness, according to Davidson, is capable of the highest ecstasy and all knowledge. He denies the inconceivability of eternity, the existence at any time of chaos, and the presence at any time of spirit. All is Matter, even the ether and the lightning are forms of Matter. And on this basis he works out a conception of sin as courage, heaven and hell as "memories of processes of evolution struggling into consciousness," and God as ether, from which man came and to which he will return.

In announcing this theory of the universe he does not ask for scientific judgment or acceptance. He bases his claim for recognition on imaginative grounds and on the fact that he is a poet. "The world," he wrote, "is in danger of a new fanaticism, of a scientific instead of a religious tyranny. This is my protest. In the course of many ages the mind of man may be able to grasp the world scientifically : in the meantime we can know it only poetically ; science is still a valley of dead bones till imagination breathes upon it." It was his desire as a poet to fill the conceptions of science, the world of atoms and electrons, of gases and electricity, of ether and matter, with the light of imagination, as a substitute for the dead rationalism of middle nineteenth-century culture. "Art knows very well that the world comes to an end when it is purged of Imagination. Rationalism was only a stage in the process. For the old conception of a created Universe, with the fall of man, an atonement, and a heaven and hell, the form and substance of the imagination of Christendom, Rationalism had no substitute. Science was not ready, but how can poetry wait ? Science is synonymous with patience ; poetry is impatience incarnate. If you take away the symbol of the Universe in which, since the Christian era began, poetry and all great art lived and had their being, I, for one, decline to continue the eviscerated Life-in-Death of Rationalism. I devour, digest, and assimilate the Universe ; make for myself in my Testaments and Tragedies a new form and substance of Imagination ; and by poetic power certify the semi-certitudes of science."

In the Eighteen Nineties John Davidson strove always for the utterance of such feelings and ideas as absorbed his mind during his last years ; but in the earlier period he was less conscious of definite aim, and his best work took the form of poetry and the place of great poetry. His ballads and eclogues, a few of his lyrics and passages in his poetic tragedies are already graven on the scroll of immortal verse. His "testaments" belonged to another realm as they belong also to another period. They lack the old fine flavour of the poetry of his less purposeful days, and they hardly fulfil his

own promise of a new poetry. They are in the main arrested poetry. The strife of the poet for a new expression, a new poetic value, is too evident, and you lay these later works down baffled and unconvinced, but reverent before the courage and honesty of a mind valiantly beating itself to destruction against the locked and barred door of an unknown and perhaps non-existent reality.

CHAPTER XIV

ENTER—G.B.S.

MOST of the distinguished personalities of the Eighteen Nineties challenged somebody or something. George Bernard Shaw challenged everybody and everything. He began the period as one entering the lists, and he has tilted more or less successfully ever since. No other man of the time broke so many lances as he, and looking backwards one is filled with amazement at his prodigality of ideas and wit, his persistent audacity and unfailing cheerfulness. Yet these very qualities limited his effectiveness, for it took even "the intellectuals," whose high priest he became, twenty years to realise that he was in earnest and a genius. G.B.S. was Challenge incarnate—a rampant note of interrogation, eternally asking us uncomfortable questions about our most cherished habits. Why, for instance, we ate meat ? Why we vivisected animals ? Why we owned property ? Why we tolerated such a brainless drama—such unimaginative art—such low wages—such long hours of labour—such inconvenient houses—such adulteration—such dirty cities—such illogical morals—such dead religions—in short, such a chaotic civilisation ? And he did not wait for us to answer his innumerable questions ; he answered them himself, or provoking a defence by a process of irritation, he smashed our replies with the nicest of dialectical art ; tempting us in the pauses of our bewilderment with a new vision of life.

In the year 1890 Bernard Shaw was hardly a name to those who were outside of convinced Socialist and revolutionary circles, although his articles on music, over the pseudonym *Corno di Bassetto*, in *The Star* (1888-1890), afterwards continued in *The World* from 1890-1894, made him

the subject of discussion in musical circles. Socialists knew him as a tireless and effective propagandist of the collectivism upheld by the Fabian Society, of which organisation he was one of the most able members, and as the editor of the famous *Fabian Essays in Socialism* (1889), which contained two essays by himself, one of which had been delivered before the Economic Section at the Bath Meeting of the British Association, in the preceding year. He was also known in the inner circles of Socialism as a persistent enemy of the Marxian theory of value, which he attacked on every possible occasion. He was introduced to a wider public as a result of the first production of Ibsen's plays in London. *Rosmersholm, Ghosts* and *Hedda Gabler* had been performed by the Stage Society, and the astonishment of the dramatic critics had expressed hopeless bewilderment and surprise in a venomous Press attack. The year before Shaw had lectured upon Henrik Ibsen before the Fabian Society at the St James' Restaurant, and this lecture, rewritten in the form of a reply to the critics, was produced as a book in 1891, under the title of *The Quintessence of Ibsenism*. And in 1892 he followed up this defence of the modern drama with a play of his own, *Widowers' Houses*, which was produced by Mr J. T. Grein at the Royalty Theatre and published in book form during the same year.

Between 1879 and 1883 Bernard Shaw began his literary career by writing five novels. The results were not encouraging from the publishing side, four only, after many vicissitudes, achieving print, and one only, *Cashel Byron's Profession*, receiving anything approaching recognition from Press or public. So, checked but undismayed, he turned, like more than one unsuccessful novelist, to the sister art of drama. The rest of the decade was devoted to laying the foundation of that reputation which has placed him in the forefront of the modern dramatic movement. Between 1892 and 1896 he wrote, besides *Widowers' Houses* :—*The Philanderer : A Topical Comedy* ; *Mrs Warren's Profession : A Play* ; *Arms and the Man : A Comedy* ; *Candida : A Mystery* ; *The Man of Destiny : A Trifle* ; and *You Never*

Can Tell: A Comedy. These were afterwards collected and published in 1898 in two volumes called *Plays: Pleasant and Unpleasant*, prefaced by one of those essays which are his favourite medium for the interpretation of himself and his ideas to a shy-witted public. Three other plays, *The Devil's Disciple, Cæsar and Cleopatra,* and *Captain Brassbound's Conversion*, followed, and were published, in the volume called *Three Plays for Puritans*, in 1901. Public performances of most of the plays were given, but it was not until the dawn of the new century and the historic Vedrenne-Barker repertoire season at the Court Theatre (1904-1907) that the general playgoing public was convinced of even the entertainment value of these remarkable dramas. But lack of public appreciation sat lightly on the shoulders of Bernard Shaw. Seemingly possessed of exhaustless energy, and quite indifferent to neglect, he went on with his work, putting his ideas and arguments into such essays as the *Impossibilities of Anarchism* (1893); *The Perfect Wagnerite* (1898); *Fabianism and the Empire* (1900); and into the long series of dramatic criticisms contributed to *The Saturday Review* between 1895 and 1898. Whenever occasion offered he carried his warfare into current polemics by means of letters to the Press, and one of these, attacking Max Nordau's *Degeneration*, published in the American Anarchist paper *Liberty* (27th July 1895), probably forms a record of its kind, for it fills practically the whole of that issue of the paper, and has since been published in a volume entitled *The Sanity of Art.* He also associated himself with the more typical literary movement of the period by contributing an essay "On Going to Church" to *The Savoy.*

In all this work Bernard Shaw assumed the rôle of critic. The newly awakened social conscience found in him a willing and effective instrument, and despite his unabashed and often self-announced cleverness, the intellectual vice of the time, mere "brilliance," critical or otherwise, was rarely for him an end in itself, as was the wit of Oscar Wilde and Max Beerbohm. His cleverness subserved a creative end, an end which looked forward towards a new and resplendent

civilisation. It was the sharp edge of the sword of purpose.
He did not scruple to enlist the forces of art in his service,
and his plays, therefore, are invariably didactic, though
relieved from dullness by abundant wit, much humour and
vivid flashes of characterisation. ' Such plays, for instance,
as *Widowers' Houses* and *Mrs Warren's Profession* are pure
sociology i n the form of drama, or rather melodrama, for
Shaw is the melodramatist of the intellect. He seeks to do
for the head what Charles Reade sought to do for the heart,
and there is no fundamental difference between the inspira-
tion at the back of *Widowers' Houses* and *It's Never Too Late
to Mend* : both are dramatised tracts.

Art for art's sake had come to its logical conclusion in de-
cadence, and Bernard Shaw joined issue with the ascendant
spirit of the times, whose more recent devotees have adopted
the expressive phrase : art for life's sake. It is probable
that the decadents meant much the same thing, but they
saw life as intensive and individual, whereas the later view
is universal in scope. It roams extensively over humanity,
realising the collective soul. The decadent art idea stood
for individuals, and saw humanity only as a panoramic back-
ground. The ascendant view promotes the background to a
front place ; it sees life communally and sees it whole, and
refuses to allow individual encroachments. Bernard Shaw
upheld this vision of life, and strove to square it with his own
inborn and emphatic individuality. He considered it legiti-
mate to use art to establish and extend his ideas. "Fine
art," he said, "is the subtlest, the most seductive, the most
effective means of moral propagandism in the world, except-
ing only the example of personal conduct ; and I waive even
this exception in favour of the art of the stage, because it
works by exhibiting examples of personal conduct made in-
telligible and moving to crowds of unobservant, unreflecting
people to whom real life means nothing." In the epistolary
essay to *Liberty* he emphasised and detailed his sense of the
moral value of art, revealing his divergence from the Ruskin-
Morris view of art as joyful work, as well as from the views
of Gautier and Baudelaire :

"The claim of art to our respect must stand or fall with the validity of its pretension to cultivate and refine our senses and faculties until seeing, hearing, feeling, smelling and tasting become highly conscious and critical acts with us, protesting vehemently against ugliness, noise, discordant speech, frowsy clothing and foul air, and taking keen interest and pleasure in beauty, in music, and in the open air, besides making us insist, as necessary for comfort and decency, on clean, wholesome, handsome fabrics to wear, and utensils of fine material and elegant workmanship to handle. Further, art should refine our sense of character and conduct, of justice and sympathy, greatly heightening our self-knowledge, self-control, precision of action, and considerateness, and making us intolerant of baseness, cruelty, injustice and intellectual superficiality or vulgarity. The worthy artist or craftsman is he who responds to this cultivation of the physical or moral senses by feeding them with pictures, musical compositions, pleasant houses and gardens, good clothes and fine implements, poems, fictions, essays and dramas, which call the heightened senses and ennobled faculties into pleasurable activity. The greatest artist is he who goes a step beyond the demand, and, by supplying works of a higher beauty and a higher interest than have yet been perceived, succeeds, after a brief struggle with its strangeness, in adding this fresh extension of sense to the heritage of the race. This is why we value art: this is why we feel that the iconoclast and the Puritan are attacking something made holier, by solid usefulness, than their own theories of purity; this is why art has won the privileges of religion; so that London shopkeepers who would fiercely resent a compulsory church rate, who do not know 'Yankee Doodle' from 'God save the Queen,' and who are more interested in the photograph of the latest celebrity than in the Velasquez portraits in the National Gallery, tamely allow the London County Council to spend their money on bands, on municipal art inspectors, and on plaster casts from the antique."

Bernard Shaw strove to add to the heritage of the race a keener sense of reality. He called it "the sense of fact." And it was in pursuit of this idea that he defended the art of the French Impressionists and Richard Wagner and Henrik Ibsen. Much of his humour is based on the portrayal of the incongruity between those who see things clearly and those who don't; between the faculty of seeing life and experiencing life with frank individual conviction, and the habit of seeing and living by the proxies of convention and tradition. His wit is designedly explosive, but only apparently impudent and irreverent, for it seeks to startle a moribund society out of its stultifying habits, duties and ideals. In *The Quintessence of Ibsenism* he upholds realism against idealism, with the plays of Ibsen as text. But his sense of reality does not take reason for its basis. The basis of the new realism is the will. Reason takes the subsidiary place of defender of the will, and will and faith are treated as one. Reason does not indicate direction to the will, it proves that wilfulness is right—after the act. Shaw says, in effect, do what you want to do and then prove you are right. It will thus be seen that anything in the nature of an ideal, a formal duty or a fixed habit must necessarily conflict with the realist attitude. "The realist . . . loses patience with ideals altogether, and sees in them only something to blind us, something to numb us, something whereby instead of resisting death, we can disarm it by committing suicide." He associates his attack upon ideals with the idea of stripping the mask from the face of reality which is life.

Rationalism found a convinced and subtle enemy in this new master of dialectics, for those whose minds could survive the laughter provoked by the humorous presentation of the Shavian doctrine realised quickly enough, and, if they were rationalists, tragically enough, that the moral and religious system rationalism had expended so much energy in attacking was really rationalism triumphant. Shaw announced that civilisation was rational but wrong. Yet in the Eighteen Nineties he had no place for mysticism in his view of life. The rationalists came to grief by reasoning about something,

and Shaw did not think it possible to improve matters by becoming a mystic and "reasoning about nothing." Since then he has modified his view, but now as then his sole aim has been the conquest of reality. This is brought out nowhere so clearly as in the "Interlude" in *Man and Superman*, and in one passage, that in which Don Juan explains his ideas of heaven and hell, we have the quintessence of Shavianism. "Do you suppose heaven is like earth?" Don Juan asks Ana; "where people persuade themselves that what is done can be undone by repentance; that what is spoken can be unspoken by withdrawing it; that what is true can be annihilated by a general agreement to give it the lie? No: heaven is the home of the masters of reality: that is why I am going thither." Ana answers that she has had quite enough reality on earth and that she is going to heaven for happiness. Don Juan advises her to remain in hell for "hell is the home of the unreal and of the seekers for happiness. It is the only refuge from heaven, which is . . . the home of the masters of reality, and from earth which is the home of the slaves of reality." And again he says he would enjoy the contemplation of that which interests him above all things—"namely, Life: the force that ever strives to attain greater power of contemplating itself." The end of this contemplation is to be the creation of a brain capable of wielding an imagination fine enough to help Life in its struggle upward.

With such a conception of life and its purpose Bernard Shaw entered the lists, advocating many causes which might tend towards the realisation of his idea. He managed to combine a firm anti-romantic attitude with convinced humanitarian preferences. Thus he became vegetarian, anti-vaccinationist, anti-vivisectionist and Socialist. His arguments and advocacy were able, and therefore useful to all of these causes, but it was as a Socialist that his genius for propaganda displayed itself to best advantage. Long before the outer public had heard of him, innumerable people whose minds were ripening under social and industrial discontent came under the spell of his eloquence in revolutionary

club rooms, in Trafalgar Square and Hyde Park and other open-air forums of the people, and at the meetings of the Fabian Society. It was at the Fabian Society that he was heard to best advantage, for there he was matched in debate with some of the keenest intelligences and quickest minds in London.

To Socialism, however, he contributed no original thought. He was in the main content to advocate and buttress with eloquence and dialectic the collectivist opportunism of his friend, Sidney Webb. The constitutional methods of Webb and the Fabian Society have indeed seemed at times difficult to square with Bernard Shaw's written views of what ought to be the true attitude of a revolutionist. Particularly is this obvious in such later plays as *Man and Superman* and *Major Barbara*, where there are expressions which it is not easy to construe otherwise than as advocacy of direct action and revolt. Even in his Fabian utterances he has not always taken the orthodox Fabian line, which is always uncompromisingly middle-class, as, for instance, in his insistence on the complete acceptance of the idea of economic equality as the only basis of the Socialist state, and it is conceivable that, if the revolutionary philosophy of Shaw's plays were pushed to its logical conclusion, their author would find himself in the ranks of those Socialists who believe less in parliamentary and legal processes of reform than in active revolt.

Bernard Shaw's original contribution to the intellectual awakening of the Eighteen Nineties was not so much an idea as a new attitude of approaching all ideas and all facts. The approach by criticism is by no means a novel method in itself, but it is always a novelty in the stable mental atmosphere of English and, indeed, Teutonic culture. Anything in the nature of criticism and its correlatives, satire and caricature, are treated by most people in this country as mere irreverence. Shaw has always been considered irreverent, though probably few more earnest and essentially religious men ever existed. But the cumulative effect of his wit has moved a mountain range of indifference, and although the majority of those who go to his plays go to laugh and remain to laugh

(often beyond reason), many remain to laugh and pray. These plays have had a more immediate and more intelligent success in Germany, but they have attracted little attention in France. This is not quite so hard to explain as it might appear at first sight. In England we·could not see the seriousness of Shaw because his critical attack being local hit us before his humour could win home. In Germany a similar mental *milieu* greeted him more readily because his irreverence, apparently the outcome of criticism of British institutions and morals, but really a criticism of modern civilised morality, did not hit Germany so hard, and consequently his wit was free to carry on its subtle trade in philosophy. But in France Shavianism was no new thing. Criticism had been freer in that country for over a century than in any other country in the world. Wit was no rarity; diabolonian humour no uncommon weapon, and idea-play no novelty. France in fact was the birthplace of modernity, and the modernity of Shaw was outmoded there before we began to notice its existence here. Whilst England and Germany were murmuring delightedly "brilliant"—"daring"—"clever"—at each successive Shavian sally, the land of Voltaire and Rousseau, Baudelaire and Zola, Anatole France and Brieux, could only say : "*Vieux jeu!* "—Queen Anne's dead !

Shaw's success in England has not been in any way national. It is at best a class acceptance and generally bourgeois. The mass of the people know him only as a name frequently appearing in the papers, and often enough in connection with some statement or idea which to them seemed incomprehensible or freakish. The reason is not far to seek, for Bernard Shaw is an apostle to the Middle Class, as, indeed, he is a product of that class. He displays all its characteristics in his personality and his art, what are called his eccentricities of thought and expression being often little more than advertisements of his own respectability. Puritanical, economical, methodical, deeply conscious of responsibility and a sound man of affairs, he sums up in his own personality all the virtues of the class satirised by Ibsen

in *The Pillars of Society*. An examination of his most
"advanced" ideas urges the point; for even his dialectic
is bourgeois from its nicest subtleties to its most outrageous
explosions. When he shocks the middle classes, which he
does very often, he shocks them with the sort of squibs
they would let off to shock themselves for fun; and when he
argues with them he uses precisely the kind of argument they
use in defence of the things they already know and like. As
a Socialist he invariably appeals to the bourgeois instinct of
self-interest; and much of his philosophy is a modern varia-
tion of the bourgeois ideals of self-help and self-reliance—
namely, self-assertion. He tells the bourgeoisie that they are,
politically, the neglected and abused class, and advises them
to retaliate upon their oppressors by adopting a Socialism
broad-based in the Utopian dream of a nationalised respect-
ability. And when his interested, but by no means convinced,
hearers stumble over the horrible thought that they may have
to abandon the financial basis of their estate, Bernard Shaw
produces a defence of money which turns consternation into
delight and Socialist philosophy into self-interest.

All of which does not alter the freshness of his gospel nor
the veritability of his unique contribution to modern thought.
As a critic he has made it possible for all who desire to do so
to look at life in their own way, and in doing so to surround
their egoism with a margin of sweet tolerance; he has phil-
osophised common-sense, and made anti-climax a popular
literary, conversational and oratorical trick; and he has
gone far towards reintroducing intelligence to the British
theatre and proving that in some circumstances an intelli-
gent drama is a sound commercial proposition. Above all
he has demonstrated the dramatic possibilities of discussion,
and by so doing linked up the literary drama with Platonic
dialogue, and, at the same time, he has left the theatre free
to develop at the right moment its natural emotional and
imaginative tradition.

If circumstances have forced Bernard Shaw to give to the
middle classes what was meant for humanity, it is consoling
to think that his teaching is big enough and good enough for

the latter. In the essence of things there is nothing in his teaching or his ideas fundamentally opposed to broad human needs. Rightly understood, Shaw's gospel is universal, and none the less so because it is eclectic and has been assimilated and selected by one of the most able and distinguished minds our nation has produced from the thought of the most powerful and original of modern intelligences. Schopenhauer, Richard Wagner, Friedrich Nietzsche, Henrik Ibsen and Samuel Butler have all contributed material to augment that gospel of reality which Shaw has preached with so much original eloquence and wit. The Eighteen Nineties were largely indifferent to the high and bewildering purpose of this teaching, although it is not easy to imagine an atmosphere better suited for its development either on the part of its creator or of his possible followers. It was reserved for the new century to recognise Shaw's great gifts by wide discussion and much protest, and it is certain that protest will die down when the ripe sanity and easy common-sense of his purpose is seen through the satiric *diablerie* of the mask he chooses to wear.

No other modern writer in this country save Samuel Butler, and none in Europe save Tolstoy and Ibsen, have looked at life so frankly as Bernard Shaw. Zola, generally considered an arch-realist, but really a romantic, was so obsessed by the shibboleth of scientific accumulation of evidence that his vision is as blurred as that of Herbert Spencer; Schopenhauer and Nietzsche both looked at life through the distorting glass of theory; Ruskin and Carlyle saw only parts of life. But Tolstoy and Ibsen, Butler and Shaw possessed the faculty of looking at life with photographic vision. Realists of this type are the outcome of that impulsion towards frankness which produced the Impressionists. Manet and Degas are their prototypes in the graphic arts; and just as these artists demanded and accepted with all its consequences the full reality and accent of light, so the artist-philosophers, working in the same spirit, allowed light absolute freedom in the realms of observing intellect and informing imagination.

To look at life until you see it clearly is Bernard Shaw's avowed aim. His concern being with humanity and the fine arts, he has made it his business to see these manifestations of life clearly and deduce his philosophy from them without fear of what has been said or believed or experienced. And although he now sets a higher value on contemplation, in the Nineties he knew that contemplation was not enough in itself. Writing of life, in 1896, he said : "Only by intercourse with men and women can we learn anything about it. This involves an active life, not a contemplative one ; for unless you do something in the world, you can have no real business to transact with men ; and unless you love and are loved, you can have no intimate relations with them. And you must transact business, wirepull politics, discuss religion, give and receive hate, love and friendship, with all sorts of people before you can acquire the sense of humanity. If you are to acquire the sense sufficiently to be a philosopher, you must do all these things unconditionally." Facing life in suchwise himself he has hammered out his own religion of art, activity and contemplation, and this religion finds a voice in all his work, and is summed up in many passages, but in none so intimately and so personally as in a passage in *The Savoy* essay, "On Going to Church ": "Any place where men dwell, village or city, is a reflection of the consciousness of every single man. In my consciousness there is a market, a garden, a dwelling, a workshop, a lovers' walk— above all, a cathedral. My appeal to the master-builder is : Mirror this cathedral for me in enduring stone ; make it with hands ; let it direct its sure and clear appeal to my senses, so that when my spirit is vaguely groping after an elusive mood my eye shall be caught by the skyward tower, showing me where, within the cathedral, I may find my way to the cathedral within me." Reading these words one might have paused, wondering whether Shaw would always believe mysticism to be argument about nothing, and whether his work might not bridge the rationalist gap between the old mysticism and the new.

CHAPTER XV

THE HIGHER DRAMA

" If every manager considers it due to himself to produce nothing cheaper than *The Prisoner of Zenda*, not to mention the splendours of the Lyceum, then good-bye to high dramatic art. The managers will, perhaps, retort that, if high dramatic art means Ibsen, then they ask for nothing better than to get rid of it. I am too polite to reply, bluntly, that high dramatic art *does* mean Ibsen; that Ibsen's plays are at this moment the head of the dramatic body; and that though an actor manager can, and often does, do without a head, dramatic art cannot."—G.B.S. in *The Saturday Review*, 1897.

IF it takes more than two swallows to make a summer, it certainly takes more than two playwrights to make a dramatic renaissance. That being admitted, no one could say that the plays of Oscar Wilde and Bernard Shaw constituted in themselves a " new " drama. Such a definite achievement cannot be credited to the period. But what can be credited to the period is the creation of an atmosphere in which a new drama might flourish at the appointed hour. This was done by the art of criticism, and chiefly by Bernard Shaw, William Archer and J. T. Grein, whose example and ideal was Ibsen. These three critics were more than convinced and ardent Ibsenists ; they were capable and tireless in propagation of the cause, Bernard Shaw as critic and philosopher, William Archer as critic and translator of the Master's plays, and J. T. Grein as critic, producer and founder of the Independent Theatre, the earliest definite home of the Higher Drama. And with them, but not of them, was A. B. Walkley, critic pure and simple, pouring oil upon the waters of revolt with irony and intellectual banter born of a capacity for taking an uncompromising middle attitude, and with a common-sense which amounted in itself to genius.

These critics differed from their kind by an avowedly

personal approach, and they flaunted their apostasy in
the face of those who were content to maintain the old
theatrical methods. The appeal to personal taste might
easily have been ignored by the upholders of convention
had it not been made by critics of undoubted skill and
unanswerable certainty of aim. The new critics accepted
their own view of the state of the drama with as much
deliberation as the old accepted the view of tradition and
convention. They were frankly impressionist and auto-
biographical. Walkley called his first collection of critical
essays *Playhouse Impressions* (1892), and admitted to
adventuring among masterpieces in the approved method
of Anatole France. The diaries of Marie Bashkirtseff were
among the books of the hour, and he coined the verb "to
bashkirtseff," for the purpose, emphasising a method which
had also been defended by Oscar Wilde. Shaw was even
more autobiographical, but prophecy, and purpose other
than the entertainment of a moment or an hour, lurked be-
hind his most indiscreet confession. He did not argue from
precedent, it is true, but he sought all the more energetically
to establish new precedents, chief among which were a drama
of ideas and "a pit of philosophers"—and Ibsen, Ibsen,
Ibsen, *toujours* Ibsen!

The all-or-nothing seriousness of G.B.S. is happily re-
corded in the following passage from Walkley's book, which
purports to describe the author's friend, Euthyphro, but
whose identity is otherwise obvious :—"A universal genius,
a brilliant political economist, a Fabian of the straitest sect
of the Fabians, a critic (of other arts than the dramatic),
comme il y en a peu, he persists, where the stage is concerned,
in crying for the moon, and will not be satisfied, as the rest
of us have learned to be, with the only attainable substitute,
a good wholesome cheese. His standard of taste is as much
too high as Crito's is too low. He asks from the theatre
more than the theatre can give, and quarrels with the
theatre because it is theatrical. He lumps *La Tosca* and
A Man's Shadow together as 'French machine-made plays,'
and, because he is not edified by them, refuses to be merely

amused. Because *The Dead Heart* is not on the level of a Greek tragedy, he is blind to its merits as a pantomime. He refuses to recognise the advance made by Mr Pinero, because . Mr Pinero has not yet advanced as far as Henrik Ibsen. Half a loaf, the wise agree, is better than no bread ; but because it is only half a loaf, Euthyphro complains that they have given him a stone."

More than twenty years have passed since the above words were written, and what A. B. Walkley imagined to be a demand for more than the theatre could give has actually produced a new drama, if not a new theatre, and the succeeding generation, in the person of Gordon Craig, is already making demands which even iconoclasts of the Nineties would have considered impossible.

William Archer is the father of modern dramatic criticism in this country, and he was introducing ideas and an intelligent seriousness into this disappointing and most thankless branch of criticism as far back as the middle eighties, with such books as *About the Theatre* (1886) and *Masks or Faces?* (1888). He shared the honours of being one of the earliest translators of Ibsen with Edmond Gosse, Eleanor Marx Aveling (daughter of Karl Marx), and his own brother, Charles Archer, who collaborated with him in several translations now in the complete English edition.[1]

On 7th June 1889 Charles Charrington began the dramatic renaissance by producing *A Doll's House* at the Novelty Theatre, with Janet Achurch in the part of Nora. The play had been called the *Hernani* of the new dramatic movement in England, and the title has been justified to the full. An interest was aroused such as had not been known in artistic circles since the first performances of Wagner's operas, and the appearance of the Impressionist painters ; and it was increased a thousandfold by the production of *Ghosts* and

[1] The work of bringing together the complete edition of Ibsen in English was begun in 1888, but long before a complete translation of the works had been dreamt of there was much interest in Ibsen's plays in this country, and *Emperor and Galilean* was the first of the plays to be translated into English, by Catherine Ray, in 1876.

Hedda Gabler, in 1891, when the new manifestation of drama turned the opposition of the older critics into indignation and reduced their criticism to a wild display of invective and vituperation. It was, as William Archer said at the time, "probably the most obstinate and rancorous prejudice recorded in the history of the stage." Bernard Shaw's account of Clement Scott's criticism of *Ghosts* in *The Daily Telegraph*, and the famous leading article in the same issue (14th March 1891), recalls the anxiety of the older generation when confronted with this frank drama. The leading article, he wrote, compared the play to an open drain, a loathsome sore unbandaged, a dirty act done publicly, or a lazar-house with all its doors and windows open. Bestial, cynical, disgusting, poisonous, sickly, delirious, indecent, loathsome, fetid, literary carrion, crapulous stuff, clinical confessions : all these epithets were used in the article as descriptions of Ibsen's work. One passage in the same leader said : "Realism is one thing ; but the nostrils of the audience must not be visibly held before a play can be stamped as true to nature. It is difficult to expose in decorous words," the writer continued, "the gross and almost putrid indecorum of this play." And as more than one critic called upon the law to protect the players against such dramas, some idea may be formed of the righteous indignation aroused at the inception of the new drama.

After the first experiment with *A Doll's House*, Charles Charrington took his company on a world tour, and Janet Achurch played the part of Nora over one hundred and fifty times in Australia, New Zealand, India and Egypt. This tour took something like three years, and when the pioneers returned to London they found Ibsen engaging the interest of all the more thoughtful playgoers. *A Doll's House* was therefore revived at the Avenue Theatre (now the Playhouse) on 19th April 1892, and the same year saw the first stage performance of plays by Oscar Wilde and Bernard Shaw. The following year, however, was more memorable in the dramatic renaissance, for it saw the production of no

less than six plays by Ibsen—*The Master Builder, Rosmers-holm, Hedda Gabler, Brand* (Fourth Act), *An Enemy of the People,* and *A Doll's House,* and the Independent Theatre produced five modern plays, one adaptation and one translation, and, more important still, three by modern British playwrights : *The Strike at Arlingford,* by George Moore (his first play), *The Black Cat,* by John Todhunter, 'and *A Question of Memory,* by "Michael Field." Besides these came *The Second Mrs Tanqueray,* by Pinero, *A Woman of No Importance,* by Oscar Wilde, and *The Bauble Shop,* by Henry Arthur Jones, all of which were in the modern movement and contributing to the newly awakened intelligent interest in the theatre.

The appetite for a new drama thus created might have encouraged managers and propagandist promoters to venture further afield, but it did nothing of the sort. After 1893, and for practically seven years, there was very little encouragement for those who stood for the higher drama. It is true that plays by advanced foreigners as important as Björnson Björnstjerne, Maurice Maeterlinck, Sudermann and Echegaray, and a number of classical dramas managed to get produced ; but Bernard Shaw could find only occasional chances of production for his own plays, and the younger school, since evolved out of his teaching and criticism, was not yet born. The new drama was in the main an occasional affair, highly experimental, and appealing only to a small and seriously minded group of "intellectuals" in London. They very largely belonged to the literary fringe of the Fabian Society and other reform and revolutionary organisations, and these were practically the sole supporters of the efforts of the Independent Theatre, the Stage Society and the New Century Theatre.

Such a poor result from early efforts towards a new drama ought not to have been, and, in fact, was not, unexpected. The new movement was so radical in its demands that it had first to create conditions in which it could exist. Everything was against rapid progress. It was not a mere question of art, dramatic or theatrical ; it was a question also of

o

economics, of professional interests, and of theatrical habit and public indifference to anything that did not entertain by laughter or tears. The new drama already existed on the Continent in the plays of Ibsen, Hauptmann, Maeterlinck, Sudermann, Strindberg and others ; and both theatres and audiences were coming into existence in support of it. But here, save for Bernard Shaw and Oscar Wilde, we possessed no native plays at all comparable with these foreign ones, and until there was a certainty of such plays being produced few authors could be expected to go on writing them. For that reason the new movement was forced to be mainly critical. Its chief material objects of attack were the dominance of the actor manager and his demand for plays written around himself, and the general theatrical custom of seeking only plays that promised a "long run." These two conditions stood in the way of a new drama because the modern drama, being impressionist and realist, did not see life as an episode dominated by an attractive personality more or less resembling some popular actor manager ; it only offered such eminence by accident, as in the case of Dr Stockmann in *An Enemy of the People*, which was produced with considerable popular success, and the minimum of Ibsenism, by Beerbohm Tree, in 1893. And, secondly, the only chance of promoting variety of plays of the new type, actors in sufficient numbers to perform them, and audiences of sufficient intelligence and sufficient interest to maintain them, was by a return to the repertory system. Abnormal rents for theatres, abnormal salaries for principal actors, and the absence of small and convenient theatres were also among the first obstacles to the realisation of these ambitions.

But these were not all the seemingly insurmountable difficulties ; the greatest stumbling block was the creation of an audience large enough to make the newer plays a financial possibility. This was no easy matter. At no time are there many people in this or perhaps any country who can be relied upon to show much enthusiasm for ideas and psychological and social problems, especially in a theatre

which has for generations been looked upon as a place of idle amusement. The advocates of the higher drama were serious and purposeful persons. With the exception of Bernard Shaw and Oscar Wilde, there was no laughter in them. They and their followers could laugh, but they preferred the mental smile. Their demand was for dramatic literature : dramas which represented a personal point of view, expressed in impressionistic terms revealing the play of temperament in conflict with convention, and will in conflict with circumstance, and always indicating by implication the ideas underlying the theme. Such plays were not only to be playable ; they were to be readable as well—they were to combine the good stage play and the good book. As we know, the higher dramatic movement did produce plays answering these demands. But it was not always so easy to reveal the idea behind the play. Bernard Shaw had to write *The Quintessence of Ibsenism* to show what Ibsen's plays meant, and long prefaces and appendices to show what his own plays meant. Endless were the discussions as to the meaning of *The Master Builder* (Israel Zangwill called it " The Master Bewilderer ") ; and intellectuals of all kinds yearned for the prefaces Ibsen might have written but didn't. But the old Norwegian dramatist let them yearn. With the plays of Shaw the higher drama became a drama of discussion. It was realistic only incidentally ; in inception it was problematic, and in effect argumentative, without any definite conclusion. Ideas were generally left very much in the air until the play was printed, when the author told you all about his aims in a long, idea-laden and entertaining preface. This argumentative tendency developed in his art until the action of his later plays became entirely conversational ; and to prevent any illusions as to his intentions he called these plays discussions.

Out of the discussion of plays and ideas the new drama ultimately came. Translations of good foreign plays began to appear frequently, and they were read by a select but ever-growing public. Interest also was aroused in the older dramatists, and both Henry Irving and Beerbohm Tree drew

large audiences to their highly decorated revivals of Shakespeare; a still more genuine enthusiasm was created by the excellent Shakespearean Repertoire Company of F. R. Benson, in the provinces. But with all this activity the main line of the modernist advance was diverted by a characteristic compromise on the part of the public. Ibsen did not pay; but it was felt that realism in a modern setting, if the themes in themselves were likeable and capable of a sentimental response, might be popular. Obviously, the game would be to hearten realism with a dash of sentimentalism; in short, to water down Ibsen; not to declare that "it is *right to do something hitherto regarded as infamous* " (*vide* G.B.S.), but to treat seriously, in a play with no specific purpose, something hitherto considered as naughty and therefore only deserving of facetious comment, and to call it a "problem play." And if you could provoke a tear at the naughtiness out of which a Labiche would have raised a laugh, so much the better—you would be both modern and popular.

This actually happened. Oscar Wilde did it with *A Woman of No Importance*; Henry Arthur Jones did it with *The Case of Rebellious Susan*, and Arthur Wing Pinero did it with *The Second Mrs Tanqueray*. It is not to be doubted that these playwrights were pioneers of the new movement, but it should not be forgotten that they were pioneers by compromise. Henry Arthur Jones was an upholder of realism, but his plays of this time do not approximate to the realism of Ibsen or Tolstoy or Strindberg; they are realistic only in so far as realism is consistent with the conviction that the artist is an interpreter of dreams, a translator of real life into imaginative concepts. Quite seriously, logically and successfully, Wilde, Pinero and Jones worked along these lines, and by so doing placed themselves in the direct tradition of the established drama, upon which they succeeded in doing little more than graft some new branches. Now Ibsen possessed only the most elementary connection with traditional drama. He was as distinct from the current trend of European drama that had preceded him as Euripides was

from the Greek drama, as Molière was from the French drama, and as Shakespeare was from the English drama, which had preceded them. Ibsen discovered theatrical reality, and he made it so real that half the opposition to his drama was due to the discomfort most people experience when brought face to face with a new revelation of facts or ideas. Those who compromised achieved no such effect; they were merely illusionists, using reality to further illusion, rather than illusion to further reality.

Bernard Shaw was not deceived by this quasi-modernism. In 1895 he wrote: "The unfortunate new dramatist has . . . to write plays so extraordinarily good that, like Mozart's operas, they succeed in spite of inadequate execution. This is all very well for geniuses like Ibsen; but it is rather hard on the ordinary purveyor of the drama. The managers do not seem to me yet to grasp this feature of the situation. If they did, they would only meddle with the strongest specimens of the new drama, instead of timidly going to the old firms and ordering moderate plays cut in the new style. No doubt the success of *The Second Mrs Tanqueray* and *The Case of Rebellious Susan* seemed to support the view that the new style had better be tried cautiously by an old hand. But then *Mrs Tanqueray* had not the faintest touch of the new spirit in it; and recent events suggest that its success was due to a happy cast of the dice by which the play found an actress [1] who doubled its value and had hers doubled by it." William Archer took a more lenient view of the situation. He referred to the play in 1898 as "the one play of what may be called European merit which the modern English stage can yet boast," and he went on to advise Pinero's fellow-craftsmen to follow the lead set by *The Second Mrs Tanqueray*, because Pinero had "inserted the thin end of the wedge," and "I firmly believe," he said, "that not only the ambition but the material interests of our other dramatists will prompt them to follow his lead, and that, therefore, we are indeed on the threshold of a new epoch."

That proved to be true. *The Second Mrs Tanqueray*,

[1] Mrs Patrick Campbell.

although it was not of the "advanced movement," was really a part of the movement. It was the first effect on the English stage of the influence of Ibsen and the propagandists of the modern drama. And even its faults as a play are faults only in comparison with the Ibsen standard. It is a play possessing both intelligent idea and problem, but above all it possesses a masterly stage technique which alone makes it worthy to be considered with the works of great modern masters. There is little doubt again that the modernist plays of Pinero and Henry Arthur Jones, and certain productions of R. C. Carton and Sydney Grundy, did tone up the moribund popular stage, and so aided the revolutionists by teaching the average playgoer to tune his brain to a higher seriousness than had hitherto been his habit.

But the real expression of the new movement, the main tendency, did not find an outlet during the Nineties. That was not possible until the close of the decade, when, in the person of H. Granville Barker, the Stage Society found the medium for the realisation of the decade-old dreams of the leaders of the modern movement. Dramatist, actor and producer, Granville Barker was the man whom the moment and the movement required, and after several successes within the Stage Society he took a daring leap on to the regular stage by engaging, with C. E. Vedrenne as business partner, the Royal Court Theatre, Sloane Square. By doing so he proved that the plays of Bernard Shaw had immense popular and, as a natural outcome, financial possibilities of success ; that it was also possible, within certain limits, to run a repertory theatre, and, perhaps most important of all, that we had a growing native school of modern dramatists of power and distinction. This new school included John Galsworthy, St John Hankin, John Masefield, Frederick Fenn, and Granville Barker himself, whose play, *The Voysey Inheritance*, stands among the finest products of the dramatic renaissance. These plays have since been performed, along with others which follow in the new tradition, at modern repertory theatres in Glasgow, Manchester and Liverpool, and by touring companies appealing to just

such audiences as the men of the Nineties desired to create.

The development of the movement on the regular stage as patronised by the average playgoer is not so marked. But even here the new spirit has had its effect, for though melodrama, facetious comedy and musical farce still maintain preposterously long "runs," showing that their place, as it is bound to be, is as secure as ever, it is no longer impossible to find intelligent entertainment at any time of the year in one or another of the London theatres. The higher dramatic activity born in the last decade of the old century has lived thus far into the new, justifying the energy which supported its inception.

CHAPTER XVI

THE NEW FICTION

THE realist movement spread among novelists and writers of fiction with even more rapidity than it invaded the dramatic realm. With epidemic suddenness writers of all kinds began to be realistic in their fiction. The reading public was not unprepared for the new tendency, for, at about the same time, a cheap edition of the novels of Zola was put upon the market and devoured eagerly without anybody appearing to be more than pleasantly shocked. The edition was expurgated somewhat, but even then passages were left untouched which only a very few years earlier would have aroused the condemnation of the Nonconformist conscience. Still, what a Frenchman might do with impunity did not go without question when repeated, even in a milder way, by native writers. There was a storm-in-a-tea-cup in certain circles, for instance, when Thomas Hardy issued *Jude the Obscure*, and George Moore, *Esther Waters*; and the storm was heightened on the appearance of Grant Allen's *Woman Who Did*, and such realistic studies of slum life as Arthur Morrison's *Tales of Mean Streets* and *A Child of the Jago*. But even this blew over when the newspapers considered their readers had had enough of the subject, and no more serious damage was done than a few suppressions by the autocrats of the popular lending libraries, notably in the cases of *Jude the Obscure* and *Esther Waters*, which prohibitions, as might have been expected, had the result of drawing more than usual attention to these remarkable books. The matter in the end was not settled one way or the other; it simply lapsed, and publishers and authors proceeded to develop from frankness to frankness without either endangering their reputations,

their readers' morals, or, ultimately, of causing surprise or
sustained opposition from any quarter.

It is a curious fact, however, that, whilst the more daring
of the realists aroused a new interest in the art of the novel,
there were still more critics to denounce than to uphold the
new method. Not only was this the fact with reference to
realism, but it was the fact also with reference to the problem
novel, what was called " the novel with a purpose," and also
to the still more modern fiction of temperament and psycho-
logical analysis represented by such writers as George
Egerton and Sarah Grand. Discussions were lengthy and
heated, and many good people of the time, looking backward
at the large geniality and splendid sanity of Charles Dickens,
the high moral purpose of George Eliot, and the fine culture
and unimpeachable respectability of Thackeray, had grave
forebodings for their own times and serious doubts as to the
wisdom of the successors of the accepted masters. They
forgot, of course, that the realism of *Oliver Twist* had been
criticised in its day, and that there were even people who
doubted the wisdom of Thackeray's mild frankness in *Vanity
Fair*.

What the objectors did not realise, and this was perhaps
the most important circumstance of all, was that the new
fiction was big enough and attractive enough to be worth a
fight, and that that in itself was a sign of literary health and
vitality. Discussion is always a characteristic of renascent
periods in art and life. "Art lives upon discussion," avows
Henry James, "upon experiment, upon curiosity, upon
variety of attempt, upon the exchange of views, and the com-
parison of standpoints ; and there is a presumption that the
times when no one has anything particular to say about it,
and has no reason to give for practice or preference, though
they may be times of honour, are not times of development
—are times, possibly, even, a little of dullness." There can
be little doubt that the times under review were times of
creative development, and above all they were far from dull
in any branch of art, particularly in that of the novel.

A new impetus and a wider range of action, amounting to

a new lease of life, had been given to that literary form by the abolition of the old three-volume method of publication, whose unwieldy size and exorbitant price had had the effect of chaining the novel to the circulating libraries. Many authors, notably Hall Caine, worked tirelessly for the abolition of the outmoded three-volume novel, and finally they won a victory more swiftly and more completely than their wildest hopes had anticipated. After a remarkably short fight the publishers capitulated and introduced the now familiar and, until quite recently, omnipresent six-shilling volume. The passing of the old novel format was important because it represented a great deal more than the passing of a mere form of publication. Actually it was the capitulation of a type of novel : the old sentimental lending-library novel of polite romantic atmosphere and crudely happy endings; the novel which was guaranteed to tax no brain by thought and to vex no code of morals by revolutionary suggestions, but by a determined rejection of anything approaching problem or idea, or even psychology, was calculated to produce that drowsy state of mild peacefulness which many people believe to be the end and aim of all good literature. There were few to regret its demise, and even these were ironical in the hour of regret. Chief among them was Rudyard Kipling, who gave the departed three-volume novel poetical honours in some verses called "The Three-Decker":

> " We asked no social questions—we pumped no hidden shame—
> We never talked obstetrics when the Little Stranger came :
> We left the Lord in Heaven, we left the fiends in Hell.
> We weren't exactly Yussufs, but—Zuleika didn't tell."[1]

The new fiction did all these things, and, to its credit be it said, it did them within the limits of the art of the novel and with the ultimate result.of increasing the number of novel readers beyond all bounds.

Some idea of the more reputable body of opinion aroused against the manifestation of realistic tendencies in literature may be gathered from an article, entitled "Reticence in

Literature," contributed by Arthur Waugh to the first
number of *The Yellow Book*. The beginnings of the new
frankness, particularly in its insistence upon sex, is traced
in this article to Swinburne ; but the frankness of the modern
novel had descended directly from the French realists.
Arthur Waugh detected two developments of modern real-
ism ; one towards excess promoted by effeminacy, "by the
want of restraint which starts from enervated sensations " ;
and the other towards "the excess which results from a
certain brutal virility, which proceeds from coarse familiarity
with indulgence." He went on to say that, "The one
whispers, the other shouts ; the one is the language of the
courtesan, the other of the bargee. What we miss in both
alike," he continued, " is that true frankness which springs
from the artistic and moral temperament ; the episodes are
not part of a whole in unity with itself ; the impression they
leave upon the reader is not the impression of Hogarth's
pictures ; in one form they employ all their art to render
vice attractive ; in the other, with absolutely no art at all,
they merely reproduce, with the fidelity of the kodak, scenes
and situations the existence of which we all acknowledge,
while taste prefers to forget them." He then proceeded to
stigmatise the latest development of literary frankness which
he believed to be both inartistic and a danger to art. "A
new school has arisen which combines the characteristics of
effeminacy and brutality. In its effeminate aspect it plays
with the subtler emotions of sensual pleasure, on its brutal
side it has developed into that class of fiction which for want
of a better word I must call chirurgical. In poetry it deals
with very much the same passions as those which we have
placed in the verses to which allusion has been made above [1] ;
but, instead of leaving these refinements of lust to the haunts
to which they are fitted, it has introduced them into the
domestic chamber, and permeated marriage with the ardours
of promiscuous intercourse. In fiction it affects its heroines
with acquired diseases of names unmentionable, and has de-
based the beauty of maternity by analysis of the process of

[1] "Dolores," by Algernon Charles Swinburne.

gestation. Surely the inartistic temperament can scarcely abuse literature further. I own I can conceive nothing less beautiful." Tennyson was quoted in a familiar couplet to buttress this argument, and the critic concluded by advocating reticence and humility in art as being the most necessary equipment for the production of beauty and the achievement of immortality.

The line of defence taken by the upholders of frankness in literature began by repudiating any precise desire for either immortality, beauty or even morality. The modernist was not only frank, he was frankly amoral ; his one concern was to get into his work the quality of life, the sense of reality, irrespective of the presence or absence of moral ideas, leaving beauty and immortality to chance. At that period there was no very particular denial of the idea or necessity of beauty, as there is among the more "advanced" artists of to-day, nor did the writers of the time repudiate immortality. Immortality, they implied, should, like Whistler's idea of art, happen, but as to beauty, they were convinced that what they did sincerely, truthfully and realistically, would ultimately be considered beautiful. And Hubert Crackanthorpe, in a reply to Arthur Waugh, was so convinced of the righteousness of the modern method in fiction that he was able to write : "Let our artistic objector but weary the world sufficiently with his despair concerning the permanence of the cheerlessness of modern realism, and some day a man will arise who will give us a study of human happiness as fine, as vital as anything we owe to Guy de Maupassant or to Ibsen. That man will have accomplished the infinitely difficult, and in admiration and in awe shall we bow down our heads before him." And this youthful and accomplished realist was arrogant enough on the one hand to admit that fiction was a young art "struggling desperately to reach expression, with no great past to guide it," and humble enough, on the other, to admit that it was matter for wonder, not that the new school stumbled into certain pitfalls, but that they did not fall headlong into a hundred more.

But what may be called the artistic defence was not the

only bulwark against the attack of the old school. Fresh
defences were found necessary owing to the nervousness of
moralists who, weary of decrying the artistic value of real-
ism, attacked it on ethical and even pathological lines. The
new fiction, it was said, was calculated to undermine mor-
ality not only because it was immoral, but because it was
"morbid," "neurotic," and "diseased." Havelock Ellis de-
fended Thomas Hardy's *Jude the Obscure* against this line of
attack, in *The Savoy* ; and, in that article, he took the war
into the enemy's camp by saying that, the more exact an
artist's powers of observation became, the more vital and
profound became his art as an instrument of morality.
"The fresher and more intimate his vision of Nature, the
more startling his picture of morals." And in defence of
Hardy's treatment of the passionate experiences of Jude
and Sue against the charge of neurosis, he says : "Jude and
Sue are represented as crushed by a civilisation to which they
were not born, and though civilisation may in some respects
be regarded as a disease and unnatural, in others it may be
said to bring out those finer vibrations of Nature which are
overlaid by rough and bucolic conditions of life. The refine-
ment of sexual sensibility with which this book largely deals
is precisely such a vibration. To treat Jude, who wavers
between two women, and Sue, who finds the laws of marriage
too mighty for her lightly poised organism, as shocking
monstrosities, reveals a curious attitude in the critics who
have committed themselves to that view. Clearly they con-
sider human sexual relationships to be as simple as those of
the farmyard. They are as shocked as a farmer would be to
find that a hen had views of her own concerning the lord of
the harem. If, let us say, you decide that Indian Game and
Plymouth Rock make a good cross, you put your cocks and
hens together, and the matter is settled, and if you decide
that a man and a woman are in love with each other, you
marry them and the matter is likewise settled for the whole
term of their natural lives. I suppose that the farmyard
view is really the view of the ordinary wholesome-minded
novelist—I mean of course in England—and of his ordinary

critic. Indeed, in Europe generally, a distinguished German anthropologist has lately declared, sensible and experienced men still often exhibit a knowledge of sexual matters such as we might expect from a milkmaid. But assuredly the farmyard view corresponds imperfectly to the facts of human life in our time. Such things as *Jude* is made of are, in our time at all events, life, and life is still worthy of her muse.''

And Vincent O'Sullivan, a modern of the moderns, in a plea which made hash of the old sentimental library novel, wrote : "It is more easy—if more degrading—to write a certain kind of novel. To take a fanciful instance, it is more easy to write the history of Miss Perfect ; how, upon the death of her parents, she comes to reside in the village, and lives there mildly and sedately ; and how one day, in the course of her walk abroad, she is noticed by the squire's lady, who straightway transports her to the Hall. And, of course, she soon becomes mighty well with the family, and the squire's son becomes enamoured of her. Then the clouds must gather : and a villain lord comes on the scene to bombard her virtue with clumsy artillery. Finding after months that her virtue dwells in an impregnable citadel, he turns to, and jibes and goads the young squire to the fighting point. And, presto ! there they are, hard at it with bare steel, on the Norman beach, of a drizzling morning ; and the squire who is just pressing hot upon my lord, when—it's hey ! for the old love and ho ! for the new—out rushes Miss Perfect to our great amazement, and falls between the swords down on the stinging sands in the sight of the toiling sea. Now I maintain, that a novel woven of these meagre threads, and set out in three volumes and a brave binding, would put up a good front at Mudie's ; would become, it too, after a while, morality packed in a box. For nowadays we seem to nourish our morals with the thinnest milk and water, with a good dose of sugar added, and not a suspicion of lemon at all.'' The need of such a plea for frank record of personal impression, even though it led writers to "go out in the black night and follow their own sullen will-o'-the-wisps," is all the more remarkable because it came at a time when

realism had fought the good fight and was near upon winning.

It is not necessary at this date to defend the realism of the Nineties, for franknesses then considered shocking are now accepted as commonplaces of fiction. That does not mean that the merely silly novel of shallow romance has passed away; not even the Eighteen Nineties could bring about so complete a revolution as that. But it does mean that, since the *fin de siècle* battle was fought between reticence and frankness, the bounds of literary expression have been so broadened as to make it possible for readers of all types, even those who can survive a considerable demand upon their thinking powers, to find fiction to suit their needs. The popular novel of the past, and to some extent of the present, ended more or less happily with the sound of wedding bells. The new novel very often began there. It was realised by the modern school of novelists that married life provided a whole realm of sensations and experiences hitherto neglected by their art or but partially exploited. Into this realm they plunged with enthusiasm, and so distinct were the results, when put into the form of fiction, that readers who had been familiar with them in real life were so amazed with this revelation of truth that, almost in self-defence, they were forced to conclude that the new fiction was scandalous when it was not morbid.

But although realistic and introspective fiction was the chief contribution of the period to this form of literary art, all kinds of fiction seemed to receive an impetus, which resulted in a general improvement in style, imagination and thoughtfulness. The influence of Meredith, Hardy and, to a lesser extent, Henry James was apparent in much of the work of the younger writers; whilst French fiction writers, such as Flaubert, Huysmans and Guy de 'Maupassant, were having a profound effect upon other imaginations. The realistic school produced George Moore, Hubert Crackanthorpe, Arthur Morrison, George Gissing, as more or less acknowledged disciples, and it influenced the birth of occasional novels from writers who were not definitely realistic,

or specifically novelists, but who were impelled by the mood of the moment to produce works in key with the realistic mood. Among such novels may be named *The Woman Who Did*, by Grant Allen, *No. 5 John Street*, by Richard Whiteing, and *Liza of Lambeth*, by Somerset Maugham. Another important contribution to the fiction of the period was made by a group of women novelists who showed remarkable powers of psychological analysis and observation, and in several instances the faculty of expressing that modern revolt of women which found a voice in Olive Schreiner's *Story of an African Farm* (1881). Among these writers were Sarah Grand, "George Egerton" (Mrs Golding Bright), "John Oliver Hobbes" (Mrs Craigie), "Iota" (Mrs Mannington Caffyn), Mrs W. K. Clifford, Menie Muriel Dowie, Emma Frances Brooke, Beatrice Harraden and Elizabeth Robins. Mrs Humphry Ward must also be reckoned among the women novelists of the period, although she, as I have noted in an earlier chapter, had an established reputation as the author of *Robert Elsmere*, written in 1888. Equally characteristic of the period were the writers of comedy-fiction. Some of the early novels of H. G. Wells, such as *The Wonderful Visit* (1895), and *The Wheels of Chance* (1896), are in this class, as are also the witty works of John Oliver Hobbes, particularly *The Sinner's Comedy* (1892), *A Study in Temptations* (1893) and *The School for Saints* (1897). But the most characteristic writers of comedy-fiction were: Henry Harland, E. F. Benson, G. S. Street and Frederick Wedmore.

It was during the Nineties also that the use of dialect in fiction delighted an ever-growing number of novel readers. First among writers in this manner stands J. M. Barrie, whose studies in Scottish life were a revelation and a delight to a vast number of people on both sides of the Tweed, and elsewhere. The first of these, *Auld Licht Idylls* and *A Window in Thrums*, were published respectively in 1888 and 1889. Then followed *The Little Minister*, in 1891, and *Sentimental Tommy* and *Margaret Ogilvy*, in 1896. Inspired by the success of these works, S. R. Crockett produced many Scottish

studies, beginning with *The Stickit Minister*, in 1893, and " Ian Maclaren " published the phenomenally successful *Beside the Bonnie Brier Bush*, in 1894. Jane Barlow did something of the same service for Ireland in her *Bogland Studies* (1892); and the discovery by novelists of the value of local colour doubtless made for the success of Israel Zangwill's fine studies of Jewish life, *Children of the Ghetto* (1892), *Ghetto Tragedies* (1893), and *The King of the Schnorrers* (1894); and also to the same interest must be attributed the revival of the Cockney dialect in fiction, set to a tragic theme by realists like Arthur Morrison and Somerset Maugham, but given a delightfully humorous turn by Barry Pain, Pett Ridge and Edwin Pugh.

Romantic fiction once more became distinguished during the period, and in some of its finest results it owed its renaissance to Science which, almost a century before, Keats had said would clip the wings of Romance. This new romance produced two of the most gifted of modern writers : Rudyard Kipling and H. G. Wells. The first of that series of scientific romances which has made the name of H. G. Wells famous throughout the world, *The Time Machine*, was published in 1895, and in 1898 and 1899 he published *The War of the Worlds* and *When the Sleeper Wakes*. But the spirit of romance not only breathed life into the facts of science ; once more taking its cue from the realists it revivified the spirit of adventure in the modern world. Robert Louis Stevenson had shown the way, and during the Nineties he was writing in collaboration with his son-in-law, Lloyd Osbourne, tales, like *The Wrecker* and *The Ebb Tide*, which made the old feel young again and the young desire to live more adventurously. But in the year 1895 came a new master with a book called *Almayer's Folly*. He was a sailor by profession, a Pole by birth, but he wrote in English, a strange, strong and arresting English, and his name was Joseph Conrad. In 1896 he published *An Outcast of the Islands*, and in the two succeeding years *The Nigger of the Narcissus* and *Tales of Unrest*. Conrad was not alone in his mastery of the art of turning experience into romance, for with him were Louis Becke, Frank T. Bullen, Morley Roberts,

P

R. B. Cunninghame Graham, Henry Seton Merriman and Frank Harris, all of whom published their earliest books during the decade. The old romance found a new and subtle exponent in Maurice Hewlett, for *The Forest Lovers* was issued in 1898, *Little Novels from Italy* in 1899, and *Richard Yea and Nay* in 1900, whilst in such writers as Conan Doyle, who published *The White Company* in 1891, *Sherlock Holmes* in 1892, and *Rodney Stone* in 1896; Anthony Hope, who published *The Prisoner of Zenda* in 1894; Stanley J. Weyman, E. W. Hornung and Quiller Couch, popular romance found inspired representatives. Even the romance of powerful and widespread human interest rose again into distinction with Hall Caine, whose best works, if *The Deemster*, published in 1887, be excepted, appeared during these extraordinarily productive years. And the name of Marie Corelli became still further associated with that species of sensationalism which she had already made her own.

So active was the romantic spirit of the period that it did not scruple about using many mediums for its purpose, hitherto neglected. Thus ideas both spiritual and intellectual were pressed into its service, the former finding striking expression in Harold Frederic's *Illumination* (1896), and in the Celtic romances of "Fiona Macleod"; and the latter in the bookish but always charming romances of Richard Le Gallienne. Type of his period, Le Gallienne infused into the old form of the Picaresque romance a great deal of the buoyant gaiety of the time as it inspired young people to prance about among books, ideas, conventions and dreams. In *The Book Bills of Narcissus* (1891) he has caught this joyous intellectuality in full flight, with all its hopes and enthusiasms; and later, when he, greatly daring, ventured into the realm of Laurence Sterne with a new *Sentimental Journey*, called *The Quest of the Golden Girl* (1896). The result was interesting, for with delicate indelicacy he translated the emotional unrest of the hour into a fancifully impossible romance which future generations will read for delight or for a truthful, though not impartial, picture of a certain corner of the age. In 1895 George du Maurier revived, in *Trilby*, the romance of Bohemianism as

discovered by Henri Murger, and Arthur Machen, in *The Great God Pan* (1894), took romance once more into the abode of terror in a manner as startling as it was elementally true. It is not unnatural to find that a period so bent on discovering— or rediscovering—romance in many things and experiences did not overlook the romance of childhood. This enchanted land had been discovered, as we know, by Lewis Carroll and Robert Louis Stevenson, but a new realm was explored with happy results by Kenneth Grahame, who with *The Golden Age* (1896) and *Dream Days* (1898) created a new delight by introducing us into a delectable kingdom whose existence we had only imagined.

Last in this long gallery of writers of fiction, but none the less valued on that account, came the humorists. Although H. D. Traill was convinced that "The New Humour" turned out to be simply the Old Buffoonery "writ small," there was a New Humour which, in the amusing tales of Jerome K. Jerome, W. W. Jacobs, Israel Zangwill, J. M. Barrie, Pett Ridge and Barry Pain, was as much a characteristic of the Nineties as the problem novel. For it certainly made a departure from tradition, although the laughter it raised was the same as all laughter—of Eternity rather than of Time. It probably differed from the old humour in that it was more self-conscious and less capable of laughing at itself. The New Humour when it was *new* was perhaps a little inhuman, and it reached its highest expression not in any of the works deliberately written with an eye on laughter, but in works like the plays of Bernard Shaw, which provoked laughter out of more serious business.

The novels and stories of the period, however, did not revolutionise so much as extend established methods.

It would not be easy to point to another decade in which English literature produced so many varieties of fiction, possessing the attractions of novelty or artistic distinction, or both. These works have at least one thing in common: they all represent more than ordinary ability within their own spheres. Some of them are now admitted to the first class of English fiction. And so balanced is the expression

of the majority that they can be said to stand for many generations rather than for a special period. Few of these works are peculiar to their period after the manner of much of the poetry written in the decade. Oscar Wilde's *Dorian Gray*, Richard Le Gallienne's *Quest of the Golden Girl* and Aubrey Beardsley's *Under the Hill* have each of them characteristics which would have made their appearance irrelevant before or after the decade in which they were published, and so, for the same reason, have the satires upon those authors and their works : *The Green Carnation, The Autobiography of a Boy* and *The Quest of the Gilt-Edged Girl*. But for the rest, novelties of thought and utterance are sufficiently balanced by normal vision to defy many trespassing years to come. In the main, the best fiction of the decade achieved that thoughtfulness and that freedom of expression for which the upholders of the higher drama were still fighting. The native-born realistic play had yet to come, and its arrival was still a matter of anticipation and conjecture. But the realistic novel came complete with *Esther Waters* and *Jude the Obscure*.

Nothing essentially English was added to the novel as such. What was new was the result of outside influence. But in a less popular form of fiction, the short story, a mastery was achieved hitherto unknown in this country. So successful a contributor to this class of fiction as H. G. Wells has referred[1] to the short-story harvest of the Nineties, in comparison with a later decade, in the following terms :

"The Nineties was a good and stimulating period for a short-story writer. Mr Kipling had made his astonishing advent with a series of little blue-grey books, whose covers opened like window-shutters to reveal the dusty sun-glare and blazing colours of the East ; Mr Barrie had demonstrated what could be done in a little space through the panes of his *Window in Thrums*. *The National Observer* was at the climax of its career of heroic insistence upon lyrical brevity and a vivid finish, and Mr Frank Harris was not only printing good short stories by other people, but writing still better ones

[1] *The Country of the Blind and Other Stories*, by H. G. Wells (1912).

himself in the dignified pages of *The Fortnightly Review*. *Longmans' Magazine*, too, represented a *clientèle* of apprecia- tive short-story readers that is now scattered. Then came the generous opportunities of *The Yellow Book*, and *The National Observer* died only to give birth to *The New Review*. No short story of the slightest distinction went for long unrecognised. The sixpenny popular magazines had still to deaden down the conception of what a short story might be to the imaginative limitation of the common reader—and a maximum length of six thousand words. Short stories broke out everywhere. Kipling was writing short stories; Barrie, Stevenson, Frank Harris; Max Beerbohm wrote at least one perfect one, *The Happy Hypocrite*; Henry James pursued his wonderful and inimitable bent; and among other names that occur to me, like a mixed handful of jewels drawn from a bag, are George Street, Morley Roberts, George Gissing, Ella D'Arcy, Murray Gilchrist, E. Nesbit, Stephen Crane, Joseph Conrad, Edwin Pugh, Jerome K. Jerome, Kenneth Grahame, Arthur Morrison, Marriott Watson, George Moore, Grant Allen, George Egerton, Henry Harland, Pett Ridge, W. W. Jacobs (who alone seems inexhaustible). . . . I do not think the present decade can produce any parallel to this list, or what is more remarkable, that the later achievements in this field of any of the survivors from that time, with the sole exception of Joseph Conrad, can compare with the work they did before 1900. It seems to me this outburst of short stories came not only as a phase in literary development, but also as a phase in the development of the individual writers concerned."

In both the novel and the short story the sane tradition of English fiction by which a delicate balance was maintained between realism and romance rarely broke down. Even the traditional sentimentalism of the English novel was main- tained for those who continued to desire it. However, the modernists who were caught in the impulsion towards French realism soon saw the insufficiency of the most carefully observed facts unless they were clothed with the stuff of the imagination and the soul. What happened to George Moore

may be taken as symbolical of the return to romance. In one masterpiece, *Esther Waters*, he gave us reality with a frankness hitherto unknown in this country. He wrote a novel in which he revealed the pilgrimage of a human being as a physical entity. That was very well in its way, especially when that way was the way of a master. But when he came to write *Evelyn Innes* he wrote the epic of a soul's pilgrimage with all his experience as a realist ready to his hand. In that novel romanticism and realism met, co-ordinating much that was tentative and whimsical in the period in one finished and enduring work of art.

IN the year 1890 people in this country were beginning to tell each other about, and to ask each other about, a young Anglo-Indian storyteller whose works were to be found in a series of pamphlets published by Messrs A. H. Wheeler & Co., of Allahabad, in "The Indian Railway Library." On inquiry also it was discovered that this same storyteller was the son of an Anglo-Indian official, and that he himself was engaged in the Indian Civil Service, that he had become the laureate of Governmental circles, and that his clever verses had been collected in a volume called *Departmental Ditties*. The demand to know more about this remarkable young man grew until it was found necessary to publish his stories in England.

It was in the year 1890 that the short stories of Rudyard Kipling became accessible to English readers through the normal channels of publication. Thus came to us, bringing with them the scent and heat, the colour and passion of the East in all its splendours and seductiveness, the now world-famous series of short stories, beginning with *Plain Tales from the Hills*, in which we were introduced to the vitriolic Mrs Hawksbee, and *Soldiers Three*, with Privates Stanley Ortheris, John Learoyd and the immortal Terence Mulvaney. These people immediately entered into our consciousness, taking their place beside the great comic figures of fiction, those characters whom we all know so much better than many people we meet in real life. Of a sudden we found ourselves enjoying a largess of short stories such as the English language had not known before. The mere recital of the titles of the little genius-laden volumes issued during that year recalls artistic experiences little short of thrilling—*The Story of the Gadsbys, In Black and White, Under the*

Deodars, The Phantom 'Rickshaw, Wee Willie Winkie, The Courting of Dinah Shadd and *The City of Dreadful Night.* Then came a long story, *The Light that Failed,* and we realised that this new writer had in him the making of a novelist as well as a great storyteller; a promise, however, not yet achieved. But none who read the *Departmental Ditties* could have foretold a poet, although the appearance in the Press of occasional verses over the name of Kipling was beginning to make us realise that very shortly it would be necessary to consider some of the new author's metrical work in the light of poetry; and when, in 1892, a volume called *Barrack Room Ballads and Other Verses* made its appearance it was as though a bombshell had burst among the seats of literary judgment, and, amidst stimulating shouts of approval, academic criticism was faced with the necessity of revising its idea of poetry, and ultimately of making room for a new poet.

The versatility of Rudyard Kipling did not end there. He proved with such books as *Many Inventions* (1893), *The Jungle Book* (1894), *The Second Jungle Book* (1895), *The Seven Seas* (1896), *Captains Courageous* (1897), *The Day's Work* (1898), *Stalky & Co.* (1899), and a novel, *The Naulahka* (1892), written in conjunction with Wolcot Balestier, that he could enter into the minds of sailors and schoolboys and animals, besides giving something very like consciousness to machines, with as much facility as he could enter into the minds of soldiers, Hindoos, and the members of Anglo-Indian Society. Nor did his surprising genius and versatility stop there, for with *Kim* (1901) he has given us a prose epic of Indian life, and with the *Just-So Stories for Little Children* (1902) he has entered into the wonder spirit of childhood, just as in *Puck of Pook's Hill* (1906), and those remarkable short stories "The Brushwood Boy," "They," and the "Finest Story in the World," he has proved that his genius is equally at home in the realm of fancy and on the borderland of human experience.

Everybody felt that a new force in a double sense had come into literature. It was a new voice, a new accent, in many

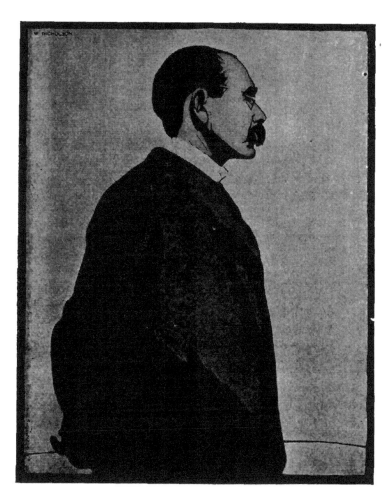

RUDYARD KIPLING
By William Nicholson

ways a new language, and in every way forceful even to
creating an atmosphere of physical violence. Rudyard
Kipling was a realist with a difference. He had no ante-
cedents. The critics found it impossible to locate him, even
when they admitted that he had earned a definite place in
the hierarchy of art. They felt without admitting it, and
showed without intending it, that they were, to use that
language of the street which Kipling turned into literature,
up against a new game. There was over-praise and half-
praise, as well as right-down opposition; in short, all the
phenomena of the arrival of undoubted genius. Even those
in the vanguard of the new movement were lost when they
came to consider his work, for as he had no antecedents,
so he belonged to no definite movement, neither did he
frequent, even when he came to live in England, the places
where literary men congregate.

Yet, as we can see now, he was a bigger figure in the vital
modernist movement of the Nineties than many who were
fonder of using labels to define their position. His was a
definite expression of the modern movement towards the
revaluation of ideas and life; and, although his temperament
was essentially conservative, his interpretation of what finally
is a traditional view of life was so fresh and personal that
it created the illusion of a revolution. He reasserted the
claims of virility and actuality, and, if you like, of vulgarity
—that underlying grossness of life which is Nature's safe-
guard. In that respect Kipling might well be considered a
realist. But his realism never, as in the case of the French
realists, looked upon mere frankness as an end in itself. He
was never a realist for realism's sake: he faced facts only
because he recognised in them the essentials of romance.
When he told a story it was not the outcome of any notion
about being an artist, it was the outcome of the oldest of
literary traditions, the desire of one man to tell another what
he has seen, heard or experienced, and to tell it in the most
effective way. His stories, therefore, read like the verbatim
reports of the achievements of a gifted raconteur in club or
smoking-room, or any other place where men swap yarns;

and these stories are equally masculine. They bring the modern clubroom into literature.

His poems sing the song of ordinary healthy manhood in much the same way as folk-songs sang the life of the folk, or, better, as soldier songs, student songs or sailor chanties tell the desires, whims and gossip of men who are thrown together by common circumstances. You feel all the while that the love of the masculine life which is the keynote of *The Light That Failed* is the underlying and impelling influence of Kipling's attitude. Whilst Bernard Shaw was using Ibsen to decry the fixed ideals of "the manly man" and "the womanly woman," Rudyard Kipling was interpreting a new vision of the manly man in some of the most masculine poems that have ever been written, wherein every reference to woman bears the stamp of the oldest attitude of manliness towards womanliness. And in this respect Kipling was nearer the most modern philosophy of the time, that of Nietzsche, than Bernard Shaw. He was no believer in the equality of the sexes; on the contrary, the pugnacious philosophy of Kipling, with its insistence upon clean health and a courageous and dangerous life would make men more like men and women more like women.

Rudyard Kipling was undeniably a protest also against the artistic intellectualism of the time, with its tendency to enclose life in the conservatory of culture; and he was all the more effective as he used his protagonists' favourite weapons. He knew what he thought and said what he thought in his own way, with as little apology to precedent or convention as the most ultra-realist or impressionist. Everything he did was impressionist, and like all the great figures of his period he did not scruple, when occasion served, to use art as a means of teaching or preaching. He used his art to preach a new imperialistic patriotism as deliberately as Bernard Shaw used art to preach socialism, or John David-son that gospel of philosophic science to which he devoted his last energies.

As an artist, then, Kipling won his spurs at the outset by writing a cycle of short stories unsurpassed in our literature,

and finding their only parallel for bulk of output and high achievement in the stories of Guy de Maupassant. But he differs from the French storyteller in that sex plays only a secondary part in his work. In a period whose artists were over-engaged with the aspects and problems of sex, it was a virtue to show that life had other interests than the way of a man with a maid ; and it was no small achievement at such a time to be able to write stories on other subjects which should prove both stimulating and interesting. It was not as though Rudyard Kipling were not conscious of the problem of sex ; he knew all about it, but he did not treat it as a problem, he recognised it as a mystery : an inspiration— and a warning. And into the poem called "The Vampire " he put his idea of the tragedy of sexual abandonment :

> " A fool there was and he made his prayer
> (Even as you and I !)
> To a rag and a bone and a hank of hair
> (We called her the woman who did not care)
> But the fool he called her his lady fair—
> (Even as you and I !) [1]

And one cannot help feeling that Rudyard Kipling has finally stated, through the medium of one of his own soldiers, the average, and perhaps eternal, view of the sex problem, with all its cheerful fatalism, in "The Ladies " :

> " I've taken my fun where I've found it,
> An' now I must pay for my fun,
> For the more you 'ave known o' the others
> The less you will settle to one ;
> An' the end of it's settin' and thinkin'
> An' dreamin' Hell-fires to see ;
> So be warned by my lot (which I know you will not)
> An' learn about women from me." [1]

With the concluding dictum that—

> " . . . the Colonel's Lady an' Judy O'Grady
> Are sisters under their skins ! "

It was one of Kipling's chief distinctions to have been able to see and feel romance without the aid of antiquity. He

had no patience with antiquarian romanticism, and he satirised those who upheld the old against the new in "The King," giving the laments of Cave-men and Lake-folk at the changes which were killing romance in their times, of the soldier who saw the death of romance in the substitution of the gun for the sword, and of the sailor who saw romance again disappearing when steam took the place of sails ; and he brings us down to our own times with the modern season ticket-holder repining for the old romantic days of the stage coach, when—

> ". . . all unseen
> Romance brought up the nine-fifteen.
> His hand was on the lever laid,
> His oil-can soothed the worrying cranks,
> His whistle waked the snowbound grade,
> His foghorn cut the reeking banks ;
> By dock and deep and mine and mill
> The Boy-god reckless laboured still ! "

And this idea of romance he wove into all his finest work. He took things as he found them, the men who worked at manly crafts like soldiering and sailoring and engine-driving and, later, aviation, and showed us how fearful and wonderful were their days, turning what had hitherto been considered a humdrum modern world into an Arabian Night's Entertainment. In many a tale he has made machinery speak as eloquently as Tommy Atkins or Mowgli, or Toomai of the Elephants. He has taken us out on to the banks of New-foundland and shown us the hardness and joyousness of the cod fisheries and the way they have in the making of a man. And in the Jungle Books he has taken us into the wild, and woven a spell of romance more fascinating than the romantic life of men, and more natural than natural history. When he goes among the machines one feels that he loves them as his own "Stiff-necked, Glasgow beggar," the engineer M'Andrews, loved them, and that the reply of the engineer to the passenger who had asked him, "Don't you think steam spoils romance at sea ? " would be Kipling's own reply in the same circumstances, to those who failed to see the romance of the modern world :

" Damed ijit ! I'd been doon that morn' to see what ailed the throws,
Manholin', on my back—the cranks three inches off my nose.
Romance ! Those first-class passengers they like it very well,
Printed an' bound in little books ; but why don't poets tell ?
I'm sick of all their quirks an' turns—the loves an' doves they dream.
Lord, send a man like Robbie Burns to sing the Song o' Steam ! "

Rudyard Kipling did not wait, as we have seen, for some-
one else to fulfil this demand of his own creating. He
stepped into the breach himself, and if not exactly as a new
Burns singing the song of steam, as one who had vision
enough to express that vision in a language strong to compel
the attention of his fellow-men.

Kipling was far from inclined to rest after discovering
nought common on the earth. He wanted to share this dis-
covery with his fellow-men ; and he wanted his compatriots
to realise their obligations to an Empire which embraced so
much of the good earth. Before him our poets were insular ;
they had no consciousness of Empire, or when they had they
associated the Empire with England. Kipling took the
opposite attitude—he associated England with the Empire.
" What do they know of England who only England know ? "
he asked. And his question came at a moment when cir-
cumstances had made a hitherto indifferent people acutely
conscious of the world-circling colonies their race had
founded. At the Jubilee of 1887 they had been told that
Queen Victoria reigned over an Empire upon which the sun
never set. The image had filled the popular imagination.
Gladstone's failure to settle the Soudan, and his more recent
attempt to give Ireland Home Rule, thus creating an illusion
of Imperial dismemberment, had each contributed to the
larger patriotism of Empire. So when Kitchener " avenged "
the death of Gordon, and obliterated the failures of Wolseley
in Egypt, by defeating the Mahdi at Omdurman, and re-
taking Khartoum, slumbering Imperialism awoke with a
strange and arrogant light in its eyes.

The spark which eventually set the country ablaze with
warlike patriotism was the Outlander question in the Trans-
vaal, following the gold boom and the discovery of diamonds

in South Africa. The great force in Cape Colony was Cecil
Rhodes ; he had gone there in the early Seventies as a young
man, consolidated the diamond interests in the De Beers
Company, worked at the early organisation of the gold in-
dustry, settled the native unrest in Matabeleland, Bechuana-
land, Basutoland and Mashonaland, brought about unity of
purpose between British and Dutch in the south, and founded
the British South Africa Company, which was granted a
royal charter in 1889, and whose vast realm is now known as
Rhodesia. Rhodes was a man of action and a dreamer, a
practical visionary, and from his early days in the colony
he dreamt of a United South Africa, with railway and tele-
graphic communication from the Cape to Cairo. In 1890
he became Prime Minister of Cape Colony, and the events
which followed this appointment were the final causes of
that new patriotism of which Rudyard Kipling became the
bard. Rhodes had been hampered in his schemes in the
north by the national and non-progressive policy of Paul
Kruger, President of the South African Republic, and Cape
Town politics eventually centred around the question of
the enfranchisement of British settlers in the Transvaal.
Rhodes found a sympathetic supporter of his ideals in this
country in Joseph Chamberlain, who had joined the Marquess
of Salisbury's ministry as Secretary of State for Colonial
Affairs in 1895. Weary of political negotiations, the resi-
dents of Johannesburg were becoming restive, and they
began arming themselves against Boer rule ; and a climax
was reached when, acting upon this knowledge, on the 29th
December in the same year, Dr Jameson, the Administrator
of Mashonaland, invaded the Transvaal with a small body
of troops. He was defeated and captured, but the romantic
side of the Jameson Raid appealed to popular sentiment and
the new romance became the new patriotism. The sequel
to the Raid was the Boer War (1899-1902), and the realisation
of Cecil Rhodes' dream of a United South Africa under the
British flag.
 Never before had this country been mixed up in a great
issue which combined so inextricably the most sordid and

the most exalted motives. Violent partisanship rent
asunder the British people, and the pro-Boer campaign led
by Lloyd George ended in riots. Cecil Rhodes became an
ogre in the eyes of the Peace Party, whose members also
looked upon Joseph Chamberlain as the political instrument
of the ring of cosmopolitan financiers who controlled the
South African mining industry. Even now it is impossible
to separate finance from patriotism in that fierce struggle.
Two things, however, seem certain : firstly, that Cecil
Rhodes was not wholly inspired by sordid motives, and that
he used his own wealth as much as he used the Rand financiers
and British politicians, as instruments towards the realisa-
tion of an Imperial idea ; and secondly, that Rudyard
Kipling as prophet and bard of Empire was high above all
pettiness, and inspired by a genuine romantic passion far
removed from that jingoism which did nothing but add the
verb " to maffick " to our language.

It was easier to mistake the gospel of Kipling, and the
crowd did mistake it, because his most popular songs were
set to a banjo melody. Before him bardic prophets had
been content with the lyre ; but with fine insolence he re-
jected that ancient instrument, and sought to inspire the
most commonplace of all musical instruments with an ex-
alted message. He saw in the banjo " the war-drum of the
white man round the world." But not all those who heard
and liked his tunes realised their underlying demand upon
character. They mistook his patriotism for jingoism, and
he was forced to pray,

> " Lord God of Hosts, be with us yet—
> Lest we forget—lest we forget ! "

They waved flags when he sang of Empire—but showed
more inclination for cricket and football than for fighting or
empire-building : and the banjo snapped out its derision of
" the flannelled fools at the wicket " and " the muddied oafs
at the goal "—

> " Given to strong delusion, wholly believing a lie,
> Ye saw that the land lay fenceless, and ye let the months go by

Waiting some easy wonder : hoping some saving sign—
Idle—openly idle—in the lee of the forespent Line.
Idle—except for your boasting—and what is your boasting worth
If ye grudge a year of service to the lordliest life on earth ? [14]

Obviously Kipling and the man-in-the-street, who began
to become a specially designated quantity at about this time,
were at cross-purposes. There was an austerity about his
demand which did not appeal to what he called "a poor little
street-bred people." Perhaps his song was a little foreign—
as the Empire was a little foreign ; and the masses were
hardly prepared for his fierce Old Testament faith in a God
of Battles and of Hosts. The people had his confident faith
in their race. The Jews in Egypt were not more confident
that they were the Chosen People. But our democracy did
not want to prove their title ; they were quite content to let
others prove it for them or to take it on faith. Kipling
narrowed down the Imperial idea to ancient tribal propor-
tions plus conscription and the modern ideal of efficiency in
organisation :

" Keep ye the Law—be swift in all obedience—
Clear the land of evil, drive the road and bridge the ford.
 Make ye sure to each his own
 That he reap where he hath sown ;
By the peace among Our peoples let men know we serve the Lord ! " [14]

With this love of a modern and masterful people he
associated the traditions of the race and its achievements
in science and discovery and adventure ; and particularly in
that restlessness which had pitted the English against nature
and barbarism in the ends of the earth : "there's never a
wave of all her waves but marks our English dead," he sang.
Not alone of successful enterprise of soldier or sailor does he
sing ; but he is fully conscious of the pioneer who makes
tracks into the unknown without reward, favour or success ;
the

" . . . legion that never was 'listed,
 That carries no colour or crest,
 But split in a thousand detachments,
 Is breaking the way for the rest." [15]

And his romanticism naturally takes under its wing the spirit of youth in its hunger for life ; he loves all who respond to the call of the Red Gods and who dare to test their naked souls against the rough uncivilised world :

" Who hath smelt wood-smoke at twilight ? Who hath heard the birch-log burning ?
Who is quick to read the noises of the night ?
Let him follow with the others, for the Young Men's feet are turning
To the camps of proved desire and known delight ! "

Rudyard Kipling's song, whatever its immediate subject, is always the song of intrepid man. It is the revolt against book-culture and a fresh demand for the old culture of experience. He was not always rude in thought or form, and proved his power as a more conventional poet in "Sussex," "The Flowers," and in the most orthodox of all his poems he has come even nearer academic poetry in the expression of his own idea of human, and his own, worthiness :

" One stone the more swings to her place
In that dread Temple of Thy Worth—
It is enough that through Thy grace
I saw nought common on Thy earth.

Take not that vision from my ken ;
Oh, whatsoe'er may spoil or speed,
Help me to need no aid from men
That I may help such men as need."

And it is only natural also that the poem in his own manner which rises nearest to what we have come to regard as poetry is the "L'Envoi " to the *Barrack Room Ballads*, in which he sings of the return to the trail of " proved desire and known delight." But there is little doubt that Kipling's most original and inevitable verse is to be found in his soldier songs. These chanties of military life are unique, and in them he has transcended the art of effective dialect verse by turning slang into poetry. Such ballads as " Fuzzy-Wuzzy " and "Mandalay " are as peculiar in their way, and as separate from the rest of English poetry, as the designs of Aubrey Beardsley are separate things in English pictorial art.

Another class of verse Kipling also made his own : those verses into which he has put his more personal views upon questions of art and conduct. But in these, as well as in some of his more recent patriotic songs, although he has succeeded in achieving eloquent and vigorous expression, with, in addition, that piquancy which is peculiar to all his work, he has strayed furthest from the path of poetry. Sometimes he has fallen into verses which are incredibly lacking even in the most ordinary characteristics of poetry ; and whatever one may find in such compositions as "The Conundrum of the Workshops," "In the Neolithic Age," "Cleared," or "Tomlinson," one only finds poetry by accident, as one finds it in prose. Still, among these are works which are their own reward, and in some of them their author has defended himself and his method of contravening the customs of polite art :

> " Here's my wisdom for your use, as I learned it where the moose
> And the reindeer roared where Paris roars to-night :—
> There are nine and sixty ways of constructing tribal lays,
> And—every—single—one—of—them—is—right."¹

There is perhaps more in this sweeping assertion than art disputants will be ready to admit. However, the selective processes of time would seem to be on the side of Kipling, who has added another admission in justification of his methods in a familiar set of quaint verses introducing the second series of *Barrack Room Ballads* in " The Seven Seas " :

> " When 'Omer smote 'is bloomin' lyre,
> He'd 'eard men sing by land an' sea ;
> An¹ what he thought 'e might require,
> 'E went and took—the same as me ! "²

Rudyard Kipling has helped himself variedly at the tables of art and life, and it is not surprising, therefore, that he has produced unusual results. But strip from his output every weed, every unworthy production, and there will remain not one masterpiece, but a dozen, and in most branches of literature—novel, short story, ballad, lyric, dialogue and descrip-

tive essay. And if his teaching at times seemed unnecessarily blatant it possessed an undercurrent of courageous wisdom as far removed from blatant jingoism as jingoism is from the Imperial or patriotic idea. Wonder was reborn in him ; but it was not the wonder of childhood. It was the wonder of the grown man who had known and observed life and become illusion-proof—but wondered still and was thankful always :

> " For to admire an' for to see,
> For to be'old this world so wide—
> It never done no good to me,
> But I can't drop it if I tried ! "

He can forgive all faults of passion or ambition ; but he has no place in his system for the characterless nonentity who is neither good for something nor bad for anything. He has revealed the type in " Tomlinson," and name and man have entered into our conception of life. This poet and visionary, who has helped by his song to weld a world-ring of colonies into an Empire, came into the Nineties telling people to have done with the gods of printed books and life by proxy—in short, to have done with anything in the nature of that Tomlinson who was not good enough for Heaven or bad enough for Hell, and who was finally rejected by the devil and sent back to earth with the admonition :

> "Go back to Earth with a lip unsealed—go back with an open eye,
> And carry my word to the Sons of Men or ever ye come to die :
> That the sin they do by two and two they must pay for one by
> one—
> And . . . the God that you took from a printed book be with you,
> Tomlinson ! "

CHAPTER XVIII

ART AND LIFE

IN an earlier chapter I have pointed out that the art movements of the period took in the main two more or less diverse paths, paths which may be differentiated as the scientific and the traditional. The first aimed at reality of statement based upon close observation of life, the second depended upon the recapture of past tendencies in art and their definite association with the life of the day. The former was an exotic growth, having its antecedents in the work of the French Impressionists in painting, and the Realists and Symbolists in literature. The second was native, going back to the Middle Ages when art was definitely allied with utility. The former had for its outcome the development of the Fine Arts, and the latter that of what are known as the Applied Arts. In the preceding decade the Applied Art movement had the misfortune of becoming implicated in the æsthetic propaganda of Oscar Wilde, and although its underlying principles were as sound then as they are now, it suffered in repute when accumulated ridicule finally drove out the æsthetes. The movement sprang directly from the teaching of John Ruskin and it received considerable impetus from the Pre-Raphaelite Brotherhood. It is doubtful, however, whether the enthusiasm of a group of artists and enthusiasts for good craftsmanship would have developed into anything approaching the proportions of a national movement had it not been for the practical genius of William Morris. He gave a fresh turn to the teaching of Ruskin, demonstrating in things real what was at the time little more than a pious opinion in peril of being lost in the rhetoric of an impressive prose.

For years a battle had been fought between the Impres-

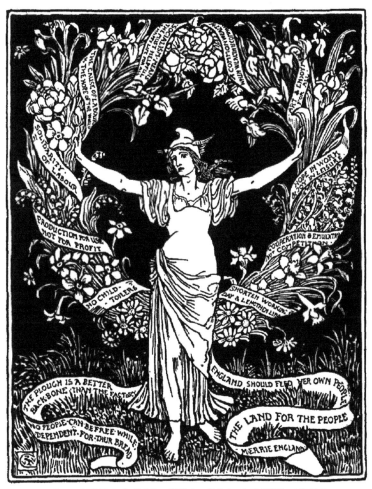

·A·GARLAND·FOR·MAY·DAY·1895·
· DEDICATED·TO·THE·WORKERS·BY·WALTER·CRANE ·

sionists and the Traditionalists, and the long series of wordy
engagements had culminated in the Law Courts when
Whistler brought his famous action against Ruskin. The
result was a Pyrrhic victory for Whistler. This did little
more than throw the contending parties into more definitely
hostile camps without giving any hope of ultimate peace.
William Morris, naturally on the side of Ruskin, did not
make Ruskin's mistake of under-estimating or decrying
the realistic movement. Being a craftsman himself, and
knowing good craftsmanship when he saw it, he realised that
the Impressionists were sincere artists, equally with himself ;
though, from his point of view, wrong-headed ; and, after
granting so much, he was content with stating his differences.
"Now it seems to me," he said, in the preface to *Arts and
Crafts Essays* (1893), "that this impulse in men of certain
minds and moods towards certain forms of art, this genuine
eclecticism, is all that we can expect under modern civilisa-
tion ; that we can expect no *general* impulse towards the
fine arts till civilisation has been transformed into some other
condition of life, the details of which we cannot foresee. Let
us then make the best of it, and admit that those who practise
art must nowadays be conscious of that practice ; conscious
I mean that they are either adding a certain amount of
artistic beauty and interest to a piece of goods which would,
if produced in the ordinary way, have no beauty or artistic
interest, or that they are producing something which has no
other reason for existence than its beauty and artistic interest.
But having made the admission let us accept the consequence
of it, and understand that it is our business as artists, since
we desire to produce works of art, to supply the lack of
tradition by diligently cultivating in ourselves the sense of
beauty (*pace* the Impressionists), skill of hand and niceness
of observation, without which only a *makeshift* of art can be
got ; and also, so far as we can, to call the attention of the
public to the fact that there are a few persons who are doing
this, and even earning a livelihood by so doing, and that
therefore, in spite of the destructive tradition of our immedi-
ate past, in spite of the great revolution in the production of

wares, which this century only has seen on the road to com-
pletion, and which on the face of it, and perhaps essentially,
is hostile to art, in spite of all difficulties which the evolution
of the later days of society has thrown in the way of that side
of human pleasure which is called art, there is still a minority
with a good deal of life in it which is not content with what
is called utilitarianism, which, being interpreted, means the
reckless waste of life in the pursuit of the means of life."
Morris himself endeavoured to put his theories into practice
in a variety of ways, and finally by the control of his own
workshops at Merton Abbey and the sale of his goods at the
historic shop in Oxford Street.

The idea of bringing together art and craft possessed Morris
throughout his life, but it is a curious fact in the history of
the Arts and Crafts movement that he neither initiated the
idea of the handicraft workshop, of which he became pro-
prietor, nor the Arts and Crafts Society, of which he became
chief figure. The former was suggested in the first instance
by Ford Madox Brown, and the latter was a chance result of
an abortive revolt on the part of a number of young artists,
chiefly members of the new English Art Club, against the
methods of the Hanging Committee of the Royal Academy
Exhibition. . This rising occurred in 1886, and, upon its
proving ineffective, the craftsmen and decorative artists who
had thrown in their lot with the revolutionaries were led by
Walter Crane into a new camp, which two years later became
the Arts and Crafts Exhibition Society. This was the first
organisation to give general publicity to the aims of a move-
ment which had received the benediction of the craftsmen
who founded the Art Workers' Guild in 1884. William
Morris was one of the earliest members of the Guild, and
he eventually became a Guild Master. No one denies the
supremacy of his influence in the handicrafts movement ;
just as he never denied, in fact was always ready to admit,
the influence of Ruskin on his own work and ideas. In 1892
he wrote a preface to a popular reprint of the chapter from
The Stones of Venice, called " The Nature of Gothic," in the
course of which he said that he believed that chapter to be

one of the most important things written by Ruskin, and that in future days it would be considered "as one of the very few necessary and inevitable utterances of the century." And in the same preface he upheld Ruskin's teaching that art was the expression of man's joy in his work, and laid it down as a fervent conviction that "the hallowing of labour by art" was the one aim for artists and craftsmen of the time. More than any other man of his day he lived for that purpose and devoted to it an energy and a variety of gifts without equal since the days of the Italian Renaissance.

In the Eighteen Nineties there were those, even as there are to-day, who persisted in looking upon this unique crafts-man as a poet and *belles lettrist*, and upon his craftsmanship and his Socialism as the whims of an otherwise responsible genius. The writing of poetry was, of course, one of the many arts in which he was a master. Yet he never placed himself on a poetical pedestal, and he had no high opinion of those who made poetry the sole business of a lifetime. Poetry was only one of the many incidents in his extraordinarily varied career. He not only practised many crafts, but so wide was his vision, and so tremendous his store of energy, that he would practise several crafts, including the writing of poetry, literally at one and the same time. Those who worked with him remember how he could work at a design, a poem, an essay and a piece of tapestry, and produce good work in each during, say, the course of a single morning. First he might be working at his loom, and all the while he would be mumbling to himself, and humming aloud as if he were trying a tune over in his head and testing it by sound ; then he would jump up from the loom, sit down at a table, and scribble very rapidly the verse of a poem ; immediately afterwards he would add something to the manuscript of an essay that would probably be delivered as a lecture, returning anon to his loom to throw the shuttle for a while, before taking up an unfinished design for printed fabrics, stained glass or book decoration.

In the midst of this apparently scattered activity Morris not only finished a great amount of work, but he knew

precisely what he was doing and had constantly before his mind the ideal towards which he aimed. "The aim of art," he said, "is to increase the happiness of men by giving them beauty and interest in incident to amuse their leisure, and prevent their wearying even of rest, and by giving them hope and bodily pleasure in their work; or, shortly, to make man's work happy and his rest fruitful." He himself rested only when he went to bed. Somebody once criticised the discomfort of a chair he had designed, and the reply of William Morris was: "If you want to be comfortable, go to bed." That explains the man. He loved his work; every expression of energy in the whole of that busy life was an expression of joy. He knew that what he was doing was art, but he made no more fuss about it than he fussed about his poetry; because he knew also that what he was doing was useful work.

William Morris had the imagination to see life in the form of design and the skill to express this sense of design in the materials of his art. That is the keynote of his genius and of his teaching. You can best understand his poetry, his romances, his stained glass and tapestries and chintzes, the books of the Kelmscott Press, as well as his Socialism, by an appeal to design—not an appeal merely to the technical relationship of lines and spaces and colours in patterns, or of rhymes and rhythms in a poem, but design as the relationship of idea and action, the relationship of art and purpose. William Morris always had at the back of his mind the dream of a Perfect State. Always busy in the visible world, he was still busier in the Utopia of his fancy. The beautiful things he made were imported to this world from that Utopia, and their very importation was an act of propaganda. They were the real *News from Nowhere*. And he did not bring them here to make lovers of the fine arts content with modern civilisation; he brought them here deliberately to lure the people of his day from their ugly surroundings into the better land of his dreams. Everything he created was a lure to Utopia, an invitation to follow him into a new world.

He remarked once in a lecture: "I must remind you,

though I, and better men than I, have said it over and over
again, that once every man that made anything made it a
work of art besides a useful piece of goods, whereas now only
a very few things have even the most distant claims to be
considered works of art. I beg you to consider that most
carefully and seriously, and to try to think what it means.
But first, lest any of you doubt it, let me ask you what forms
the great mass of the objects that fill our museums, setting
aside positive lectures and sculpture ? Is it not just the
common household goods that pass time ? True it is that
some people may look upon them simply as curiosities, but
you and I have been taught most properly to look upon them
as priceless treasures that can teach us all sorts of things,
and yet, I repeat, they are for the most part common house-
hold goods wrought by common fellows, as people say now,
without any cultivation, men who thought the sun went
round the earth and that Jerusalem was exactly in the middle
of the world." William Morris was not defending museums,
he was advocating conditions that would make it possible
for the common people of to-day to create after their own
manner beautiful, useful things, just as the common people
of other times created such things after their manner. Such
treasures were for him incentives to good artistic conduct,
which for him again was nothing less than good citizenship.

Good craftsmanship as understood by William Morris and
his fellow-craftsmen, although they talked much of beauty,
was in the main a demand for quality in material, execution
and taste allied with the idea of a change in social life, as
without that these three things would be impossible. The
main tendency of the handicraft revival was therefore social
when it was not actually Socialist. It was rarely individual
and private after the manner of the old fine arts and the new.
"The decline of art," wrote Walter Crane, "corresponds
with its conversion into portable forms of private property,
or material or commercial speculation. Its aims under such
conditions become entirely different. All really great works
of art are public works—monumental, collective, generic—
expressing the ideas of a race, a community, a united people ;

not the ideas of a class." It was inevitable that the ideas of John Ruskin should have been exploited to the full in a movement which sought thus to bring about the communalisation of art. But these ideas were not the only influence. The prose works of Richard Wagner were printed during the decade, and his doctrine of a folk-art had a sure though less definite effect in many quarters, more especially among those who, with Mary Neal, revived the almost lost art of folk-dance and singing games which became so important a feature of the Esperance Girls' Club and Social Settlement, founded by her with Emmeline Pethick Lawrence in 1895. At the same time the folk-art revival was being strengthened by the researches into folk-song of Broadwood, Baring-Gould, Frank Kidson and Cecil Sharp. The appearance also of Aylmer Maude's translation of Tolstoy's *What is Art?* in 1899 aroused heated discussions and a wide interest among art reformers. All prominent craftsmen agreed with the Wagnerian conception of the artistic as distinct from the financial community, and they looked forward to the time when, in Wagner's own words, " art . . . would become the herald and standard of all future communal institutions." And it was easy for those who held this faith to sympathise with Tolstoy's onslaught upon decadence, and to accept the Tolstoyan pronouncement that, "Art is not, as the metaphysicians say, the manifestation of some mysterious Idea of beauty, or God; it is not, as the æsthetical physiologists say, a game in which man lets off his excess of stored-up energy; it is not the expression of man's emotions by external signs; it is not the production of pleasing objects; and, above all, it is not pleasure; but it is a means of union among men, joining them together in the same feeling, and indispensable for the life and progress towards well-being of individuals and of humanity." It will be seen, then, that the two paths of the modern art movement resolved themselves into two very definite and very different aims: the communal and the individual, the public and the private.

But whatever theories about art dominated the intelligence of the members of the Arts and Crafts movement, one thing

is certain, their activities produced a notable effect upon
taste in all matters relating to architecture and the decorative
and useful arts, and permeated more particularly the taste
of the middle classes in Great Britain, spreading from them
to Europe and America. To a large extent propaganda
was carried on by example rather than by precept, and this
was made possible by the existence of so many craftsmen
of ability and repute. William Morris himself might have
made any movement by his capacity for mastering whatever
art or craft appealed to him, and he was known throughout
the world for his skill as a designer, weaver, dyer and printer.
But all branches of craftsmanship had their masters. These
included Walter Crane, designer, painter and illustrator ;
Emery Walker, printer ; T. J. Cobden-Sanderson, and his
pupil, Douglas Cockerell, bookbinders ; William de Morgan,
tilemaker ; May Morris, embroiderer ; Henry Wilson,
W. A. S. Benson and Edmund Spencer, metal-workers ;
Stephen Webb, wood-carver ; and, perhaps most important
of all, the group of architects led by Norman Shaw, and in-
cluding T. G. Jackson, Reginald Blomfield, W. R. Lethaby,
G. F. Bodley, Basil Champneys, Bailey Scott and C. F. A.
Voysey, who together revolutionised our ideas of domestic,
and opened the way to a new era in public, architecture.
Many of these art workers were recognised masters in the
preceding decade, and one or two even before that, but it
remained for the Nineties to give their work a wider and
more general acceptance.

The outward effect of this search for excellence of quality
and utility in art was, however, not so profound as it might
have been. This is explained by the fact that the conditions
under which Morris and his group worked were so far re-
moved from the conditions of the average economic and in-
dustrial life of the time as to appear impractical for general
adoption. They demonstrated, it is true, that it was possible
to produce useful articles of fine quality and good taste even
in an age of debased industry, and scamped and counterfeit
workmanship ; but their demonstration proved also that
unless something like a revolution happened among wage-

earners none but those of ample worldly means could hope
to become possessed of the results of such craftsmanship.
The Arts and Crafts movement was thus checked in its
most highly organised and enthusiastic period by the habit
and necessity of cheapness. It was found possible to educate
taste, for even modern commerce had not succeeded in kill-
ing the fundamental love of excellence in commodities, but
as quickly as taste was improved by exhibitions of modern
craftsmanship, commerce stepped in supplying those who
could not afford the necessarily expensive results with cheap
imitations. The ogre of shoddy stood across the path of
quality, and many who were set upon the high trail of ex-
cellence by the Arts and Crafts movement ended as devotees
of fumed oak furniture, and what began as a great move-
ment was in danger of ending as an empty fashion with the
word " artistic " for shibboleth.

Such negative results did not imply complete failure. The
Arts and Crafts movement never expected immediate
victory, far less would it have been capable of the illusion
that passing fashion and victory were one and the same
thing. They were doing pioneer work, propaganda by
demonstration, and even if all craftsmen were not convinced
of the impossibility of making such work the rule rather
than the exception in a commercial community, they learnt
their lesson very soon, and readily admitted and advocated
some other than the prevailing financial standard of pro-
duction. Still, the work of the craftsmen named represents
so high an achievement that we have to go back many years
before we can find anything in this country to equal it, and
although the Arts and Crafts as an organised movement is
not so apparent to-day, the tradition of good craftsmanship
has been recaptured and its upholders will not readily let it
be lost again.

To have accomplished so much is no little achievement,
but perhaps a more important contribution to the vitality
of the period was the recognition and the interpretation of
the organic relationship between the separate arts and archi-
tecture and between architecture and the building of towns.

The immediate function of art as understood by the Arts and Crafts movement was stated by T. J. Cobden-Sanderson in a lecture at the Arts and Crafts Exhibition in 1896 as the power of doing things in the spirit of an artist and in reference to the whole of life. "Art implies a certain lofty environment," he said, "and is itself an adjustment to that environment, of all that can be done by mankind within it. Art as a great function of human imagination is not the creation of isolated objects of beauty, though isolated objects of beauty may indeed be created by Art, and in themselves resume all that is beautiful, orderly, restful and stable in the artist's conception of that environment. Still less is it, what some may seem to imagine, the objects of beauty themselves. It is something—it is *much*—more. Art is, or should be, alive, alive and a universal stimulus. It is that spirit of order and seemliness, of dignity and sublimity, which, acting in unison with the great perception of natural forces in their own orderly evolution, tends to make out of the chaos of egotistic passions a great power of disinterested social action." And in a lecture on "Beautiful Cities," delivered at the same exhibition, W. R. Lethaby took the idea further and gave it a more practical turn : "Art is not the pride of the eye and the purse, it is a link with the child-spirit and the child-ages of the world. The Greek drama grew up out of the village dance ; the Greek theatre was developed from the stone-paved circles where the dances took place. If we gather the children who now dance at the street corners into some better dancing-ground, might we not hope for a new music, a new drama, and a new architecture ? Unless there is a ground of beauty, vain it is to expect the fruit of beauty. Failing the spirit of Art, it is futile to attempt to leaven this huge mass of ' man styes ' by erecting specimens of architect's architecture, and dumping down statues of people in cocked hats. We should begin on the humblest plane by sweeping the streets better, washing and whitewashing the houses, and taking care that such railings and lamp-posts as are required are good lamp-posts and railings, the work of the best artists attainable." By linking up art with the

city and with common things the Arts and Crafts movement completed the sequence of its ideas, and if it has not as yet succeeded in creating a new Jerusalem, it has indicated a way by pointing out the path for the Town Planning activities of a later date. Many craftsmen-visionaries saw afar off the Promised Land. William Morris set his own vision down in the magical prose of *News from Nowhere* (1891), and there is little doubt that his vision and their craftsmanship helped the ideas of Ebenezer Howard as expressed in *Garden Cities of To-morrow* to such practical manifestations as they have received at Letchworth and Golders Green.

The weakness of the Arts and Crafts movement was a weakness of circumstance rather than ability. Its members did pioneer work, and one of the first tasks was to step back into the past towards fine standards and sound traditions of workmanship before stepping forward into the future with their records and examples, or even, indeed, lauding them in the present. Thus their work, excellent though it is, looks and is archaic. The best craftsmanship of the Eighteen Nineties was outmoded at birth—" born out of its due time." It was sound in workmanship, excellent in design ; at its best, beautiful ; but in the main it was 'prentice work, a lesson rather than an achievement. It bore the stigmata of unrest and yearning instead of the easy gladness of confident and inevitable expression which was at once true to its moment and fit for its purpose.

CHAPTER XIX

THE revival of the art of printing began when Messrs
Charles Whittingham revived Caslon's famous
founts at the Chiswick Press in 1844. The first
volume of the revival was the *Diary of Lady Willoughby*,
printed for Messrs Longmans. Before that date, and for a
period covering something like a century and a half, a pro-
cess of degeneration had been at work in the craft of book-
making, which, towards the close of the eighteenth century,
had reached a degree of positive ugliness as supreme in its
own way as the positive beauty of the books by the great
presses of the past. This is all the more remarkable when
it is remembered that the materials with which the revival
was begun existed so far back as the year 1720, when Caslon
set up his type foundry in London and commenced casting
those " old-faced " alphabets which had been drawn from
the seventeenth-century Elzevirs and Plantins.

But although the revival of printing began so far back as
1844 with the work of the Chiswick Press, the revival of the
personal note in printing did not come about until a half-
century later, when, during the Eighteen Nineties, suddenly,
with few obvious preliminaries, we found ourselves in the
midst of the Golden Age of what may be termed subjective
printing. The revival appeared to be extemporaneous,
but, like all such occurrences, it was founded on a succes-
sion of real if imperceptible circumstances, not least of which
were the existence of ugliness and lack of individuality which
sooner or later will, in any age in which it occurs, provoke
the finer and more impressionable minds to protest. The
protest in this instance took, in the productions of the Vale,
Kelmscott, Eragny, Essex House, and Doves presses, a

255

creative and positive form, as natural as the foliation and fruition of plants. The tastes of such men as William Morris, Emery Walker and Charles Ricketts were revolted at the vulgar, tawdry and expressionless books of the time and, being masters of practical imagination, their protest was creative. They wanted beautiful books, and instead of grumbling with what existed, they set to work and made what they could not buy. They were moved again by that vital form of atavism which, by throwing back to an earlier period, picks up the dropped thread of tradition, and so continues the process of evolution ; their protest therefore became, in the best sense of the word, a revolution : a turning round to the period when craftsmanship, imagination and life were one and indivisible.

In the making of books the first and most essential demand is for legibility. The printing must be readable. To this end must type be fashioned and page built. Charles Ricketts, with those two other masters of the revival of great printing, William Morris and Emery Walker, realised this need, and in their founts they aimed at clarity and utility combined with personal expression. The commercial tradition of the oblong letter, with its false utility, was abandoned, and the dignity of the square and round types of Jenson restored, possible loss of space by such a proceeding being obviated by greater care in the building of the page and in the setting of the lines.

The Arts and Crafts movement had, as we have seen, set people of taste hunting for the lost threads of good craft tradition, and the *fin de siècle* revival of printing as an art-craft was one of the most successful results of its efforts. The study of well-printed books of the past led William Morris and Emery Walker towards what may be called a new ethic of good printing. They set forth their ideas in a joint essay forming one of the *Arts and Crafts Essays* of 1893. "The essential point to remember," they said, "is that the orna-ment, whatever it is, whether picture or pattern-work, should form *part of the page*, should be a part of the whole scheme of the book. Simple as this proposition is, it is

necessary to be stated, because the modern practice is to disregard the relation between the printing and the ornament altogether, so that if the two are helpful to one another it is a mere matter of accident. The due relation of letters to pictures and other ornaments was thoroughly understood by the old printers ; so that, even when the woodcuts are very rude indeed, the proportions of the page still give pleasure by the sense of richness that the cuts and letters together convey. When, as is most often the case, there is actual beauty in the cuts, the books so ornamented are amongst the most delightful works of art that have ever been produced. Therefore, granted well-designed type, due spacing of the lines and words, and proper position of the page on the paper, all books might be at least comely and well-looking ; and if to these good qualities were added really beautiful ornament and pictures, printed books might once again illustrate to the full position of our Society that a work of utility might be also a work of art, if we cared to make it so." This passage contains the germ idea of the return to fine printing.

Still, although so much research and good work was done by William Morris and Emery Walker, the desire to produce books of dignity and beauty inspired more than one group of enthusiasts, and the founders of the Kelmscott Press were not the first in practical results. *The Hobby Horse* (1886-1892), edited by Herbert P. Horne and Selwyn Image, with its carefully built pages, was an earlier intimation of coming developments, and Hacon & Ricketts devised a new typographical beauty by the publication of *The Dial*, in 1889. The revival, however, began to find itself at the Arts and Crafts Exhibition of 1888, when Emery Walker contributed an essay on printing to the catalogue. In the years 1889 and 1890 Morris made a definitely practical move by superintending the printing of three books, *The House of the Wolfings, The Roots of the Mountains* and the *Gunnlang Saga*, at the Chiswick Press. All this time he had been brooding upon the idea of a Press of his own, and he made his first experiments towards the foundation of the Kelmscott Press

R

in 1889 and 1890. "What I wanted," he wrote in the *Note* on his aims in founding the Kelmscott Press, "was letter pure in form ; severe, without needless excrescences ; solid, without the thickening and thinning of the line which is the essential fault of the ordinary modern type, and which makes it difficult to read ; and not compressed laterally, as all later type has grown to be owing to commercial exigencies. There was only one source from which to take examples of this perfected Roman type—to wit, the works of the great Venetian printers of the fifteenth century, of whom Nicholas Jenson produced the completest and most Roman characters from 1470 to 1476. This type I studied with much care, getting it photographed to a big scale, and drawing it over many times before I began designing my own letters.; so that though I think I mastered the essence of it, I did not copy it servilely ; in fact, my Roman type, especially in the lower case, tends rather to the Gothic than does Jenson's." The desire thus embodied in words became a living fact. During 1890 Morris was experimenting with his types, and on the 31st January in the following year the first trial sheet was printed on the Kelmscott Press, which had been set up in a cottage close to Kelmscott House on the Upper Mall, Hammersmith.

The first book printed was Morris's own romance, *The Story of the Glittering Plain* ; it was finished on 4th April, and in the same year *Poems by the Way* was set up and printed. For the next five years, and to the end of the great craftsman's life, books were printed at the rate of about ten each year, and in all fifty-three works were issued during the life of the Press (1891-1897), which together stand unique among books both for honesty of purpose and beauty of accomplishment. The books published naturally reflect Morris's own literary taste. The act of printing was with him an act of reverence, and all of the volumes issued were printed in the spirit of love of fine literature and his own work. Three founts of type were created by Morris. The first, called the "Golden," was a Roman type inspired by Jenson but having a Gothic appearance, which makes it unlike any

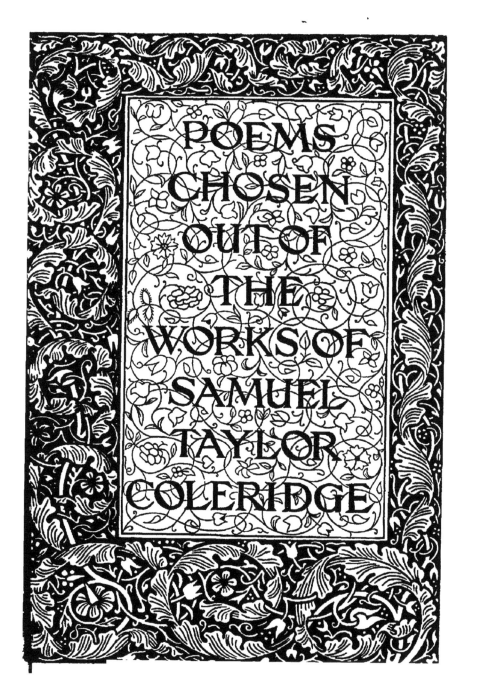

POEMS CHOSEN OUT OF THE WORKS OF SAMUEL TAYLOR COLERIDGE

other type in existence. This fount has extremely beautiful letters, solid and clear, making a page of vivid blackness combined with absolute legibility. The next, called the "Troy," was a large Gothic type, beautiful in its way, and quite legible, but archaic in effect and unsuitable for general printing. The last type to be cast was the "Chaucer "; this was simply the "Troy " type reduced for the purpose of printing the noble folio edition of the works of Geoffrey Chaucer. With these three founts books of several sizes were produced with equally good results. There were delightful 16mo's, such as *The Tale of the Emperor Coustans, The Friendship of Amis and Amile* and Morris's own lecture on *Gothic Architecture,* which was printed by the Kelmscott Press at the Arts and Crafts Exhibition of 1893. The octavos covered a wide field, and included some of the masterpieces of the Press, notably the *Poems* of Coleridge, Tennyson's *Maud, Hand and Soul,* by Dante Gabriel Rossetti, and *The Nature of Gothic,* by Ruskin. The quartos contain several of Morris's own works, notable examples being *News from Nowhere* and *The Wood Beyond the World,* and Caxton's *Historyes of Troye, The Golden Legend* and George Cavendish's *Life of Cardinal Wolsey.* Nine books were issued in folio—namely, *The History of Reynard the Fox* (1892), *The History of Godfrey of Bologne* (1893), *Sidonia the Sorceress,* by William Meinhold, translated by Lady Wilde (1893), *The Story of the Glittering Plain,*[1] by William Morris (1894); *Atalanta in Calydon,* by Swinburne (1894), *The Tale of Beowulf* (1895), *The Life and Death of Jason,* by William Morris (1895), and *The Works of Geoffrey Chaucer* (1896).

Many of the volumes have woodcuts, chiefly from drawings by Burne-Jones, and Morris designed all the elaborate initial letters, borders, title-pages and other decorations. It would not be easy in the ordinary way to single out any book for special notice among so many masterpieces of printing, each possessing characteristics of its own worthy of individual praise, but one book, and as it happens the one that Morris printed with his fullest reverence, does actually

[1] The first Kelmscott issue of this book was in quarto.

stand out from among the rest with distinction. That book
is the noble folio containing the works of Chaucer enshrined
in type cast for the purpose, with Morris's own superb and
appropriate decorations, and eighty-six illustrations by
Burne-Jones. Never was author paid so handsome a tribute
as by this book, and when it is in its complete form, with
Cobden-Sanderson's binding, one is surely in the presence
of the most beautiful and the best designed book the world
has ever seen.

William Morris was essentially a decorator ; he would
have had every one of the fine products of his amazing
vitality burst into flower and leaf, into wondrous device and
every beauty of form. Yet in everything he did the fine
simplicity of his nature was a saving grace. But with the
books designed by Charles Ricketts we find the expression of
an entirely different temperament, or a temperament which
was assertively personal and essentially individual, as against
the democratic and communal sense of Morris. This indi-
viduality is seen in most of the books of the Vale Press, and
in those beautiful volumes, *The Dial* and Oscar Wilde's *The
Sphinx* and *The House of Pomegranates,* which were the
immediate forerunners and first causes of that Press.

Both William Morris and Charles Ricketts, however, were
inspired in their first founts by the classical types of Jenson,
in whom the Roman letter had its consummation, although
the deep-rooted Gothic spirit of Morris was naturally not to
be tied to that particular form. The significance of this
adoption of the Roman type lies in the fact that although
the first movable types were a standardisation of the written
missal of the Middle Ages, and essentially Gothic in char-
acter, lettering itself was of Greek and Roman origin. In-
deed, where the Teutonic designers departed most from the
Roman standard, as they did in their capital letters, they
were not nearly so successful as when they adhered more
strictly to the earlier forms, as they did in their superior
"lower cases." Morris, in spite of his intense love of Gothic,
fully realised this, and although the Kelmscott books in the
mass reveal beauties suggesting Caxton and Wenkyn de

Worde, it will be found on a more intimate acquaintance with them that the Renaissance has contributed in no small way to their final charm.

Just as William Morris, in Charles Ricketts's words, derived inspiration from the "sunny pages of the Renaissance," and finally made books equal to, and in some cases better than, the best books of the Gothic printers, so Ricketts took inspiration from the same source, and although the volumes of the Vale Press never quite resemble the Gothic books, he has admitted the value even to him of the products of the Kelmscott Press. Speaking of the books made under his supervision before the establishment of the Vale Press, he wrote, in his *Defence of the Revival of Printing*: "I regret that I had not then seen *The House of the Wolfings* or *The Roots of the Mountains*, printed for Mr Morris as early as 1888 [1]; these might have initiated me at the time to a better and more severe style, and I am now puzzled that my first impression of *The Glittering Plain*, 1891 (the first Kelmscott book), was one of disappointment."

The earliest of the Ricketts books were inspired but not printed by the founder of the Vale Press. They were and are a standing example of what can be done through the ordinary commercial medium when taste is in command. The illustrations, cover designs, end-papers, and general format of these books were the work of Ricketts; and the type was the best that could be found in some of the more responsible printing houses. The first example of this work is to be found in *The Dial*—a sumptuously printed quarto magazine first published at the Vale, Chelsea, in 1889; No. 2 appeared in February 1892; No. 3 in October 1893; and No. 4, which bore the imprint, "Hacon & Ricketts," in 1896; the fifth and last number appearing in 1897. *The Dial* was issued under the joint editorship of Charles Ricketts and Charles H. Shannon. The first number contained an etching by Ricketts and a lithograph in colours and gold, and twelve other designs by him. The cover was designed by Shannon,

[1] *The House of the Wolfings* was printed in 1889, and *The Roots of the Mountains* in 1890.

but was discarded in subsequent issues, its place being taken by a superior design, cut as well as drawn by Ricketts. In the second number the latter also makes his first appearance as an engraver on wood, one of the main features of the volume being his series of initial letters, ornaments, head-pieces, and *culs-de-lampe*. In No. 4 of *The Dial* appeared two specimen pages of the Vale Press, then being formed.

Before the Press was established, however, other important books had been issued under his supervision. One of the earliest of these, *Silverpoints*, by John Gray, was published by Elkin Mathews and John Lane in 1893. A few of the initials of this uncommon but elegant volume are decorated, but the majority are simple Roman capitals, the text of the volume being in italics. Earlier even than this the two artists had collaborated in the production of Oscar Wilde's *House of Pomegranates*, published by Messrs Osgood, M'Ilvaine & Co. in 1891. The result was less a success than a curious attempt at decorated bookmaking; the most successful parts being the vignettes by Ricketts. Among other books of this period are the *Poems* of Lord de Tabley and *In the Key of Blue*, by John Addington Symonds, the former with illustrations and cover, the latter with cover only, by Ricketts.

All these books were more or less tentative. The road towards perfection was being made; something very like perfection was reached, however, in the *Daphnis and Chloe* (1893), the *Hero and Leander* (1894) and *The Sphinx* (1894)—the two first published by Ricketts & Shannon at the Vale Press, the last by Mr John Lane. The *Daphnis and Chloe* is a quarto volume printed in old-faced pica type and pro-fusely and beautifully illustrated with designs and initial letters from woodcuts. It is said to be "the first book published in modern times with woodcuts by the artist in a page arranged by himself." *Hero and Leander* (Marlowe & Chapman's version) is an octavo; it is conceived in a more restrained key, and the result is altogether more satisfying, in spite of a formal hardness in the setting of the decorations. Theme may have something to do with this, just as it has in

PAGE DECORATIONS FROM JOHN GRAY'S *SPIRITUAL POEMS* (*VALE PRESS*)
By Charles Ricketts

Daphnis and Chloe, where the lightness of the subject carries triumphantly the luxuriance of the decorations. *The Sphinx*, by Oscar Wilde, is the most remarkable of the books of this period. It is a small quarto in ivory-like vellum, with a rich design in gold, printed and decorated throughout in red, green and black. The exotic mind of Wilde is revealed in the decorations of this volume more than in any other : the strange vision of things, the imagination that moulds passionate ideas into figures which are almost ascetic, and into arabesques which are in themselves *glimpses* and revelations of the intricate mystery of life.

The first book printed in the Vale type was *The Early Poems of John Milton*, a quarto decorated with initials and frontispiece, cut by the artist on wood. Speaking of the frontispiece of this volume, H. C. Marillier says : " It is interesting to compare this with one of the Kelmscott frontispieces, in order to realise how completely individual is each case, and how different is the design of the borders. There is nothing in all the flowing tracery of William Morris which remotely resembles the intricate knot-work and geometrical orderliness of the Milton borders." This is true, and a further glance at the Vale Press books reveals also that the inventiveness of Charles Ricketts is much greater than that of William Morris, though it is not so free and, paradoxically, not so formal. But, unlike those of Morris, the Vale designs do not convey a sense of inevitability, a feeling that the design is the unconscious blossoming of the page.

The Kelmscott books not only look as if letter and decoration had grown one out of the other ; they look as if they could go on growing. The Vale Press books, on the other hand, have all the supersensitiveness of things which have been deliberately made according to a fastidious though eclectic taste and a strict formula. It is the difference between naturalness and refinement. Yet at the same time, although Ricketts does not suggest organic growth in his decorated books, he suggests growth by segregation—by a rearrangement of parts which seem to have come together mathematically, or which are built up in counterpoint like a

theme in music. Particularly do we get this effect from the decorations of the Vale Shakespeare and from many of the minor decorated leaves throughout all the volumes. In the use of leaf figures as a kind of super-punctuation, an intellectual process seems to have taken the place of the subtle and indefinable taste which dominates matters of art. The leaves seem to have been *thought* into their places, and the result is not always happy.

The books of the Vale Press have other qualities which distinguish them from those of other similar presses. The Kelmscott Press, in the matter of bindings, for instance, confined itself to vellum and plain grey boards. The Doves Press, established in the next decade, adhered to a fine and peculiar kind of vellum. The Vale Press books made a departure in several instances by appearing in daintily decorated paper boards of various colours, the designs hav- ing a pleasant chintz-like effect, more often to be met with in the end-papers of some modern books, but an obvious development of the Italian decorated paper cover. Again colours, red and sometimes blue and green, play a large part in the pages of the Vale Press books, blending with the black in many cases most satisfactorily. ·

Some fifty books in all were produced, and these covered a wide literary field, including such works as Landor's *Epicurus, Leontion* and *Ternissa*; *Spiritual Poems*, by John Gray; *Fair Rosamund*, by Michael Field; the poems of Sir John Suckling; Shakespeare's *Songs and Sonnets*; *Nym- phidia*, by Michael Drayton; Campion's songs; *Empedocles*, by Matthew Arnold; two volumes of Blake, and two of Keats; Sir Philip Sidney's sonnets; *Dramatic Romances*, by Robert Browning, the *Lyrical Poems* of Shelley; *The Ancient Mariner*, by S. T. Coleridge; *Sonnets from the Portuguese*, by Elizabeth Barrett Browning; *Hand and Soul* and *The Blessed Damozel*, by Dante Gabriel Rossetti. Besides these, certain volumes illustrated by Lucien Pissarro were issued under the imprimatur of the Vale although printed on the artist's own private press, afterwards to be known as the Eragny Press.

The Vale Press books were not presumably the kind of

books destined for an immediate and wide popularity. Yet each issue was speedily taken up by the limited public there is for fine examples of art-work, and the fact that almost immediately, and sometimes before the date of publication, the volumes were being quoted in the book markets at a premium would indicate that the books were not above the taste of everybody. Be this as it may, the demand for such books compared with that of the ordinary commercial volume was, and is at any time, a small one. At the same time, the effect of the Vale Press publications upon the general taste in books has been more pronounced than that of any of the other great presses of the Eighteen Nineties. This is probably due to the fact that Charles Ricketts not only at first worked through the ordinary publisher, but that he had his work done by a good trade firm of printers, Messrs Ballantyne & Hanson, and did not own, as William Morris did, his own presses. In the same way Morris himself had a marked effect upon ordinary straightforward printing, by insisting upon an intelligent use of Caslon's old-faced type when supervising the printing of his own prose works. He knew it was not safe to leave so important a matter to the haphazard of commerce. The supreme result of this concern is to be seen, of course, in the splendid first edition of *The Roots of the Mountains*, issued by Messrs Reeves & Turner and printed at the Chiswick Press. The influence of Charles Ricketts' books is to be seen in many of the early publications of Mr John Lane and Messrs Dent & Co.; and the latter firm attempted deliberately to follow the Kelmscott tradition with Aubrey Beardsley's edition of the *Morte d'Arthur*.

After the death of William Morris and the conclusion of the work of the Kelmscott Press, those who acted as Morris's assistants in the actual work of printing joined C. R. Ashbee of the Guild of Handicraft, who established the Essex House Press, using a fount of type designed by himself. Several well-printed volumes were the result of this enterprise, including the *Treatises of Benvenuto Cellini on Metal Work and Sculpture*, Bunyan's *Pilgrim's Progress*, Shakespeare's *Poems*, Shelley's *Adonais*, and *King Edward VII.'s Prayer Book*, a

noble folio printed in red and black. Some interesting books
were also printed by H. G. Webb at the Caradoc Press ; and
a simple dignity and altogether pleasant result has been
achieved by Miss Elizabeth C. Yeats in the books printed on
the Dun Emer, later called the Cuala Press, at Dundrum near
Dublin.

But the most notable outcome of the revival of printing
since the closing of the Kelmscott and Vale presses is the
Doves Press, established in 1900 by T. J. Cobden-Sanderson
at Hammersmith. A beautiful Roman type was designed by
Emery Walker, whose genius for fine craftsmanship in every-
thing associated with the printing arts made for the further
success of this venture which has to its credit a series of
books of unsurpassable beauty. The Doves Press, although
in the direct line of descent from Morris, was to some extent
a reaction against decorated page, and by adhering strictly
to the formal beauty of well-designed type and a well-built
page it proved that all the requirements of good taste, good
craftsmanship and utility could be achieved. There is
nothing, for instance, quite so effective as the first page of
the Doves Bible, with its great red initial " I " dominating
the left-hand margin of the opening chapter of Genesis like a
symbol of the eternal wisdom and simplicity of the wonderful
Book. Neither foliation nor arabesque could better have
introduced the first verse of the story of the Creation than
this flaming, sword-like initial. This edition of the Bible in
itself represents the last refuge of the complex in the simple,
and stands beside the Kelmscott *Chaucer* without loss by
comparison in beauty or workmanship.

The Doves Press came nearer than the other private presses
towards the realisation of its founder's axiom of the whole
duty of typography, which, he said, was " to communicate
to the imagination, without loss by the way, the thought or
image intended to be communicated by the author."

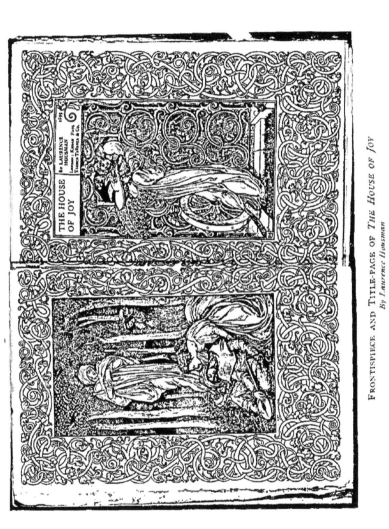

FRONTISPIECE AND TITLE-PAGE OF *THE HOUSE OF JOY*
By Laurence Housman

CHAPTER XX

IN spite of the efforts of the Arts and Crafts movement the average man was still unmoved from his conviction that art was an affair of pictures. He even went so far as to believe that the new art movement was only accidentally derived from pictorial art and would eventually end where it began—in something to hang on a wall. He was supported in this belief by the usual predominance given to picture talk in the discussions of the contending art factions. The Nineties were very fruitful of such discussions, inheriting as they did the still unsettled principles and contentions which survived from the artistic battles of the Eighties. These battles were never more than the British echo of French Impressionism, but they were complicated by the so-called naturalism of the Pre-Raphaelite movement. The latter was largely the affair of the preceding thirty years, and with the dawn of the Nineties Pre-Raphaelitism had become an accepted art convention for those desirous of accepting it, and a subject of indifference for the rest.

Whistler, allied with but apart from the Impressionists, had fought the fight of the open-air school to as conclusive an end as such contests ever reach. And Ruskin's ideas had been almost entirely diverted into their more defensible channels of craftsmanship. George Moore had been for several years holding aloft the banner of French Impressionism with conspicuous success, in *The Speaker* and elsewhere, and William Ernest Henley had fought in *The Scots Observer* an equally vigorous and equally successful battle on behalf of the same ideals, laying stress upon a realism more definitely associated with romance. But in the midst of all this talk about paint and technique and new methods of approaching

Nature, there was a very real undercurrent of philosophic thought which was not afraid of associating pictorial art with social life and action. The old sanity of applied art constantly reasserted itself in the newer movements. Whistler also, when occasion offered, did not scorn applied art, as we know from his enthusiasm over the decoration of the Peacock Room at Sir James Leyland's house, and of his own house in Chelsea. Frank Brangwyn was as much inclined towards mural painting as George Frederick Watts, whilst William Nicholson, James Pryde, Dudley Hardy and Aubrey Beardsley devoted time and talent to the creation of a national school of poster decorators. And the revival of the decorated book gave black and white art a new sphere of expression.

Even so uncompromising an advocate of the framed picture as George Moore was not averse from discussing the value of pictures in relation to national life. Speaking of the practical utility of the Impressionist pictures he said : "They would inspire not only a desire to possess beautiful things, but I can imagine young men and women deriving an extraordinary desire of freedom from the landscapes of Monet and Sisley : Manet, too. Manet, perhaps, more than anyone liberates the mind from conventions, from prejudices. He creates a spirit of revolt against the old ; he inculcates a desire of adventure. Adam standing in Eden looking at the sun rise was no more naked and unashamed than Manet. I believe that a gallery of Impressionist pictures would be more likely than any other pictures to send a man to France, and that is a great point. Everyone must go to France. France is the source of all the arts. Let the truth be told. We go there, every one of us, like rag-pickers, with baskets on our backs, to pick up the things that come in our way, and out of unconsidered trifles fortunes have often been made. We learn in France to appreciate not only art—we learn to appreciate life, to look upon life as an incomparable gift. In some café, in some Nouvelle Athènes, named though it be not in any Baedeker nor marked on any traveller's chart, the young man's soul will

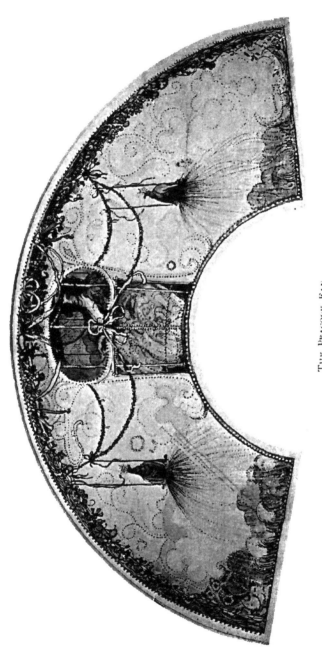

THE PEACOCK FAN
By Charles Conder
In the possession of Mr. Grant Richards

be exalted to praise life. Art is but praise of life, and it is
only through art that we can praise life." Such an attitude
is inseparable from the modern art movement, and it survives
to-day in the development of the decorative arts among the
Post Impressionists.

Conventional pictorial art in this country at the time of
the modern revolt had long suffered from hopeless privacy
and class distinction. Richard Muther says: "English
painting is exclusively an art based on luxury, optimism and
aristocracy; in its neatness, cleanliness and good-breeding
it is exclusively designed to ingratiate itself with English
ideas of comfort. Yet the pictures have to satisfy very
different tastes—the taste of a wealthy middle class which
wishes to have substantial nourishment, and the æsthetic
taste of an *élite* class, which will only tolerate the quint-
essence of art, the most subtle art that can be given. But
all these works are not created for galleries, but for the
drawing-room of a private house, and in subject and treat-
ment they have all to reckon with the ascendant view that
a picture ought, in the first place, to be an attractive article
of furniture for the sitting-room. The traveller, the lover
of antiquity, is pleased by imitation of the ancient style;
the sportsman, the lover of country life, has a delight in little
rustic scenes, and the women are enchanted with feminine
types. And everything must be kept within the bounds of
what is charming, temperate and prosperous, without in any
degree suggesting the struggle for existence. The pictures
have themselves the grace of that mundane refinement from
the midst of which they are beheld." Into some such con-
dition of pictorial art the new men threw themselves, opening
windows, as it were, and allowing the outside world, with all its
rudeness and all its unseen and unrealised beauties, to enter.

The organised revolt took the form of protest by the New
English Art Club against the Royal Academy, and of the
Glasgow School against the conventions of the Royal Scottish
Academy, and as art movements generally begin elsewhere
and end here, the battles they were fighting represented
practically the end of the fight for Impressionism. The

artistic public was gradually becoming used to pictures that were visions of light and atmosphere rather than pictorial anecdotes, and the leaders of the new movement were being absorbed by both academies. Absorption by the old enemy was, however, not the fate of all the revolutionaries, for several, including their earliest leader, Wilson Steer, maintained an attitude of no compromise. Neither did the battle with academic conventions end with the work of the two groups of artists named. It was carried on into the new century and linked up with new movements by the International Society of Painters, Sculptors and Gravers, founded, with Whistler as President and Lavery as Vice-President, in 1898.

The outstanding painters of the Impressionist movement in this country represented all phases of modern art and considerable variety of individual expression. There were Walter Sickert, Maitland and Roussel, who received early inspiration from Whistler; the realists of the Newlyn School led by Stanhope Forbes, and deriving their art from Bastien Lepage; and more individual and, consequently, less easily classified, such painters as George Clausen, John S. Sargent, Wilson Steer, William Rothenstein, Frank Brangwyn, William Nicholson, William Orpen and, later on, Augustus John; whilst standing apart from any particular "movement," but none the less modern, were Charles Conder, Dudley Hardy, Maurice Greiffenhagen, Robert Fowler, Sidney H. Sime, Charles Ricketts and Charles Shannon. The Glasgow School included most of the Scottish painters who became subjects of discussion at the Grosvenor Gallery Exhibition promoted by Sir Coutts Lindsay, on the suggestion of Clausen, in 1890. Among the men from the north who were either associated with the Glasgow group or in sympathy with its bid for freedom were John Lavery, James Guthrie, Arthur Melville, E. A. Hornel, T. Millie Dow, George Henry, James Pryde, D. Y. Cameron, Harrington Mann, W. Y. Macgregor and, at a later date, J. T. Peploe and John Duncan Fergusson.

Out of this wealth of artistic genius it would be idle to

classify or to associate any single painter finally with any definite group of painters, even though he had deliberately allied himself with one or the other schools or coteries. The really big men of the period can only be classified in so indefinite a way as to make such classification almost worthless. The artistic associations of the period are interesting from another point of view. They prove the existence not only of widespread activity in painting, but of a healthy desire for that camaraderie which hitherto, with the exception of the friendships of the Pre-Raphaelite brotherhood, had been almost confined to Paris. But if classification is impossible or unnecessary it is quite permissible to show how remarkably the artists of the time were grouped by the prevailing modern tendency. And it is interesting to note that, although the forward movement in pictorial art absolved itself from all charges of literariness, its very existence was a part of that trend of modern ideas which was affecting all the arts. In literature the tendency was called Realism, in the graphic arts it was called Impressionism. In this book I have called it—the search for reality. That search was the culmination of all the activities and changes of the nineteenth century. And in the last decade of the century it saw the human mind fall back upon individual preference as the surest guide to the fine arts and the bigger and more difficult art of life.

Every painter of the Nineties who stood for modernity strove to use his own personality and his own experience as the test of his art. He may have said that he would paint things as they are, but in his heart he knew that that was an impossible ideal. Those painters of genius who had set out with the intention had ended always by painting their own particular view of things, and modern art-philosophy sought to prove, and succeeded in proving, that such results justified the means. Auguste Rodin, who is the greatest, as well as the most realistic and most personal, of modern sculptors, insisted upon the reverent and exact copying of Nature as a means towards personal expression. And as a further proof that naturalism may produce personal variety,

one has but to remember the Pre-Raphaelites, who were as
devoted in the pursuit of natural exactitude as any of the
Impressionists; but, with the possible exception of Ford
Madox Brown, they never produced a canvas that was not
romantic and literary, and, in spite of the most devoted
attention to Nature, unnatural. The cause of this was
that, whilst talking much of Nature, they were not inspired
by physical reality at all. They were essentially a group of
thinkers and visionaries, and the whole of the movement
was book-inspired. It was the result of life approached by
way of the Arthurian and the Biblical legends, Dante and
Shakespeare, and the observation of natural things always
subserved this literary interest. The Pre-Raphaelites brought
with them a fine æsthetic sense and high purpose, and some
of them could draw, and all of them paint, but, without any
intention of underestimating their achievement, it must be
admitted that they never succeeded in doing more than repre-
sent in paint what had already been realised in literature.

The Impressionists adopted the opposite course. They
treated the art of painting as the medium of actual sight.
What could be seen rather than what could be thought or
imagined was the business of their art. This did not mean
the ultimate eradication of thought from painting, but it did
mean that thought must take second place to vision. Where
thought existed in the artist it was bound to show in his work,
but that work was primarily a view of life arranged in tones
and values of colour and light. As a matter of fact, the Im-
pressionist paintings do actually reveal abundance of thought,
and nowadays it is quite easy to see that the movement was
even more intellectual than Pre-Raphaelitism; but never in
the literary sense. In this country Impressionism did not
reach its logical conclusion. The older English movement
had its uncompromising Holman Hunt, as Impressionism in
France had its Manet, but the modernists of the Nineties in
this country recognised no logic of progress save idiosyncrasy
or circumstance. For that reason the period produced no
convention in painting. It borrowed much from France
and something from Germany, it defended its adopted ideas

with spirit, it compromised where and when it liked, and it argued about the meaning of art, sometimes as if a definition would confirm or compel a renaissance. For the rest, it produced many competent painters, but fewer than might have been expected who could be said to represent the peculiar genius of the age.

The characteristic artists of the period were drawn from no particular school; indeed, in many instances they were quite remote from all definable groups. Aubrey Beardsley, although deriving in some measure from Burne-Jones, might easily have stepped out of eighteenth-century France with Charles Conder; Charles Ricketts and Charles Shannon, Robert Fowler and Maurice Greiffenhagen, although recalling past influences, have each sufficient individuality, to stand as manifestations of the more definite spirit of the period without in any single instance representing all that was modern or strikingly new.

Charles Conder represents perhaps more than any of these artists, except Beardsley, the peculiar artificial mood of the Nineties. His work has the indefinable hot-house atmosphere of the decadence. The drowsiness of a replete civilisation idles through his paintings, and to the innate luxury of his themes he added the material luxury of the silk panels and fans which he loved to decorate. Nothing is decisive about his vision save the voluptuousness of doing nothing. His world is all languorous and dreamful, and there is no movement except the occasional strolling or dancing of stately or delicate persons and the swaying of fans; no sound save the rustle of silk or the music of faintly touched harps or viols; no odours save those of flowers and scented bodies; and for place and boundary there is only colour—colour suggesting form, suggesting all corporeal things, suggesting even itself, for Conder never more than hints at the vivid possibilities of life, more than a hint might waken his puppets from their Laodicean dream. "Conder's women are not timeless," writes Charles Ricketts, "they have forgotten their age; but this, like beauty, is often a mere matter of opinion! We shall find their histories on the

s

stage of Beaumarchais : they have passed into the realms of immortality not in the paintings of Watteau but in the melodies of Mozart. They are 'The Countess,' Susanna, Donna Elvira ; all are anxious to pardon—they are peeping at the moving pageant, for Don Juan was seen but a moment since. But what can have detained Donna Anna ? It is so late, the 'Queen of the Night ' has sung her great aria, the air is close—there are too many roses ! " Too many roses ! Charles Conder's art is in that phrase. It is the art of the privileged, recalling the decadent folk who were the prey of the Morlocks in H. G. Wells' romance. Watteau, Fragonard and Monticelli have each contributed something towards the making of this delicate art, but, as Ricketts points out, "the rest of his art is modern, and was possible only at the time in which it appeared." If the *Fêtes Galantes* of Watteau became literature in Paul Verlaine, they were translated back into painting by Charles Conder; and both he and the poet added to them their own special sense of the world-weariness of modernity.

Equally characteristic of the Nineties, but of a more virile type, were James Pryde and William Nicholson. Pryde took the life about him as his model, the town folk and the country folk, and with power and originality made them live again in paint. Nicholson saw both the countryside and the town with a new vision which combined when transferred to his canvases reticence of colour and power of suggestion. During the period his masterly series of woodcuts in colour were widely known and appreciated at first through the series of portraits in *The New Review*, and later in such volumes as *London Types* and the *Almanack of Twelve Sports*. It was Pryde and Nicholson, under the title of the Beggarstaff Brothers, who gave the poster movement, already well established in France, something like a firm basis in this country. They were not alone in the field, but it was their work which made British genius a factor to be reckoned with in a peculiarly modern branch of art. Each had studied in Paris and had doubtless come under the spell of the striking poster work of Toulouse-Lautrec, but the designs afterwards produced by them were in no sense imitative. Indeed, as

THE ARRIVAL OF PRINCE CHARMING
By Charles Conder
From the picture in the possession of Mr. Grant Richards

Charles Hiatt has pointed out, their posters were intensely English in character. "In their way," he said, "they are as racy of the soil as the caricatures of Rowlandson, the paintings of Morland, or the drawings of Charles Keene." The work of the Beggarstaff Brothers was first seen at the Poster Exhibition held at the Royal Aquarium, Westminster, in 1894. Their exhibit included the masterly *Hamlet*, stencilled in four colours, and a number of sketches and studies for posters of all kinds. The attractive use of simple masses of colour without shading, in fine, the entirely successful application of the idea of the stencil to poster work, made the artists famous at a bound, and their posters became familiar and altogether satisfying features of the street hoardings. It is worth recording, however, that although the Beggarstaff Brothers won so much appreciation, there were people who could see nothing but blotches of paint in the new work. This may be illustrated by a story told of an early adventure of the artists with a client. The Beggarstaff Brothers had been commissioned to produce a poster for the Drury Lane Pantomime, 1895-1896. The result was that classic among posters, the *Cinderella*. But the work did not find favour with Sir Augustus Harris; and the famous manager was supported in his dislike by Dan Leno, who thought the poster looked as though someone had spilt ink down it. The situation was saved by the fortunate arrival of Phil May, who, realising the state of affairs, turned the position by innocently congratulating Sir Augustus on having been so fortunate in obtaining such an effective advertisement.

The chief characteristics of painting in the Nineties were personal courage and adventurous technique. Years of strife with convention had at length cleared a path for free play in both, and, although skirmishing still continued, those who desired to be themselves in paint had at least as much encouragement as their brothers in the literary camp.

The works of painters who thought and dreamt about life were, of course, as numerous as ever, but no exhibition was complete without specimens of the work of those painters

who added to thought and imagination the revived faculty of careful observation. And even modern artists who remained visionaries and dreamers adopted a symbolism of form and colour which possessed a new delicacy and an approximation to observed knowledge in keeping with the tendencies of the period though of earlier inspiration. Ricketts and Charles Shannon achieved rare qualities of imaginative expression with fine technique; Maurice Greiffenhagen and Robert Fowler gave Impressionism a romantic meaning, and symbolism found exponents in these painters and others, and in the work of many black and white artists and pen-draughtsmen. But the final pictorial achievement of the period is not to be found in one artist, but in many; perhaps not in any painter or group of painters, but in the fresh possibilities of vision thrown open by the whole artistic effort of the decade, possibilities which led always to the most modern of all accomplishments—the art of looking at life in one's own way.

It is not easy to single out painters from among the large number contributing to this movement, but a fair idea of the more normal tendencies which have survived from the time may be acquired by a consideration of three typical *fin de siècle* artists whose work has maintained its high quality and distinction down to to-day. These painters are John Lavery, William Rothenstein and Frank Brangwyn. Each of them represents a compromise with Impressionism. They are Impressionists, each in his own way, but the way of each is to add to an essentially realistic idea some personal quality which prevents that idea ever reaching its full logical conclusion. Lavery is in the Velasquez-Whistler descent, and he possesses technical reserves which might, had he been a Frenchman, have urged him into the camp of scientific Impressionism. He preferred to use his modern skill, and all that modernity had taught him in the way of vision, in mating reality with sentiment. He lacks Whistler's decorative sense, and even when he is most realistic he never achieves the frankness of a Manet or a Degas. But taking what he wants from reality, and adding what he pleases from human

sentiment (which is also reality), he has created a series of paintings with some of the technical qualities of Whistler's portraits, but nothing of that profound sense of character which immortalises those works.

William Rothenstein carries Impressionism further than Lavery, and instead of sentiment he adds a remarkably keen sense of reality to thoughtfulness and spirituality. His pictures are interpretations. In all of them intellect plays an important part; but he is too much of an artist ever to allow mind finally to dominate imagination or vision. He recalls George Frederick Watts in his concern for what is lofty in thought and inspiring in idea, although he has never illustrated abstract ideas after the manner of Watts, nor are his pictures didactic. His works impress by quiet profundity of theme and fine qualities of light and colour. His test for art, as expressed in the introductory chapter of his essay on *Goya* (1900), can be applied with success to his own pictures: "For however many reasons men may give for the admiration of masterpieces," he said, "it is in reality the probity and intensity with which the master has carried out his work, by which they are dominated ; and it is his method of overcoming difficulties, not of evading them, which gives style, breadth and becoming mystery to his execution. And this quality of intensity, whether it be the result of curiosity for form, or of a profound imagination for nature, which lives, as it were, upon the surface of a drawing, or of a picture, is the best test we have for what we may consider as art." Rothenstein has many of the characteristics of the Nineties —curiosity about life and thought, personality in vision and statement, and that sincerity of aim which is originality ; but he is never decadent, if only for the reason that he never looked upon art as a thing in itself, but as a means towards the fulfilment of life.

Impressionism and romanticism meet in the art of Frank Brangwyn, as Impressionism and sentiment meet in that of John Lavery, and Impressionism and intellect in Rothenstein. But more than that—a picture by Brangwyn is a bridge between private luxury and public splendour. His

art suggests the big virile world made splendid by the romance of action. His pictures, even his etchings, seem to have small relationship with what are called the fine arts ; they are not to be associated with dainty things : the bric-à-brac of drawing-rooms and the baubles of collectors and connoisseurs. Brangwyn's work has no connection with such things. He is as far removed from them as Walt Whitman is from the writers of drawing-room love lyrics. Everything about his work is large and vigorous. His vivid colours, his heroic masses of form, his bold lighting, even apart from any bigness of canvas, suggest the public place rather than the room. Frank Brangwyn is, in fact, a decorative painter. Impressionism in its less imaginative aspects hardly touched him ; he learnt from it what all artists could learn without endangering imagination or individual genius —the use of light in relation to colour and form. And this knowledge he applied to his own inborn sense of design in the creation of those richly patterned mural paintings which in themselves are little short of an artistic renaissance.

It will be seen from these three examples that the painters of the period were wide-ranged in vision. Yet even they symbolise little more than the broad and normal phases of painting. Such painters, to name but three more, as Walter Sickert, James Pryde and E. A. Hornel, are as different in every way from Lavery, Rothenstein and Brangwyn, as they are from one another. But they also represent the period. Sickert by his mastery over his materials and by the individuality of his outlook ; Pryde by equal mastery and equal individuality in addition to rare insight into character ; and Hornel by his unique sense of decoration and colour. Such variety among painters was hitherto unknown in this country, and apart from the vitality it reveals, it indicates also a complete victory over academic convention, and the creation of such a margin of freedom as would permit of any painter thenceforth expressing himself in his own way. This freedom, subject of battle for several decades, was consummated in the Nineties.

CHAPTER XXI

IN BLACK AND WHITE

IN no other branch of pictorial art was there so much activity during the whole of the period, and, on the whole, so much undisputed excellence, as in the various pen and pencil drawings which blossomed from innumerable books and periodicals. To a considerable extent this remarkable efflorescence of an art which had remained passive for so many years was an offshoot of the renaissance of decorative art. But not entirely was this so, for there were notable developments also among those artists who were content to illustrate a theme in the usual nineteenth-century manner without any regard for the appearance of the printed page. These artists were not concerned with the ultimate balance and proportion of a book as a work of art; their business was interpretative, and their medium, pictures, and they considered it an achievement to make drawings which, whilst serving their immediate illustrative purpose, remained in themselves separate and even independent pictures. The two tendencies in black and white art had existed side by side in the past; generally, however, one was degenerating whilst the other was developing in power. But in the Nineties both achieved a distinction rarely, if ever, attained before, either individually or together. The Italian Renaissance had its great decorated books, and many years later the Victorian period produced a group of ingenious and capable wood-engravers, who often strove to recapture the lost decorative sense, but without much success. Whilst the Renaissance had no illustrators as we understand them, the Victorian period could boast such masterly comic artists in black and white as John Leech, Charles Keene and George du Maurier. But at no other time were there existing in this country such

279

book decorators as William Morris, Walter Crane, Charles Ricketts, Laurence Housman and Aubrey Beardsley, together with such illustrators as Phil May, S. H. Sime, Bernard Partridge, Linley Sambourne, Harry Furniss, Raven Hill and E. J. Sullivan. It was left for the final decade of the nineteenth century to show, in an outburst of ability as prolific as it was varied, the full strength of our native genius for all forms of black and white art, just as earlier in the century we exhibited a similar facility in the art of landscape painting.

The idea of book decoration which developed to so great an extent in the Nineties was, of course, closely related to the Arts and Crafts movement and the revival of good printing. But with the exception of William Morris and Charles Ricketts few designers had facilities for that intimate association with reproductive methods which was considered so essential. The application of photography to pictorial, reproductive processes further aided in widening this breach between designer and producer and helped to create a separate class of decorative book illustrators who were personally independent of the crafts of reproduction. The weaknesses of the decorated books of the period are due rather to this separation of art and craft than to any absence of capacity on either side. The aim of the book decorators, as in the case of the best printers, was to produce designs which should not be beautiful merely in themselves but beautiful in their relationship to the whole of the book—both from the point of view of appearance and idea. "I think," wrote Walter Crane, in *Decorative Illustration* (1896), "that book illustration should be something more than a collection of accidental sketches. Since one cannot ignore the constructive organic element in the formation—the idea of the book itself—it is so far inartistic to leave it out of account in designing work intended to form an essential or integral part of that book. I do not, however, venture to assert that decorative illustration can only be done in *one* way—if so, there would be an end in that direction to originality or individual feeling. There is nothing absolute in art, and one cannot dogmatise,

A VOLUPTUARY

"To rise, to take a little opium, to sleep till lunch, and after again to take a
little opium, and sleep till dinner, *that* is a life of pleasure."

By L. Raven Hill

but it seems to me that in all designs certain conditions must
be acknowledged, and not only acknowledged but accepted
freely, just as one would accept the rules of a game before
attempting to play it." In short, the desire of those il-
lustrators who were at all conscious of any special desire
as designers was for formality within the convention and
circumstances of the printed book.

Throughout the greater part of the century the tradition
of the decorated book had been allowed to lapse. The
actual renaissance of book decoration began when the leaders
of the Pre-Raphaelite Brotherhood, Dante Gabriel Rossetti,
John Everett Millais and Holman Hunt, made their illustra-
tions for the famous edition of Tennyson's *Poems*, published
by Moxon in 1857. This book was not, however, a decorated
book in the true sense, but its illustrations were essentially
designs in spirit. The modern decorated book itself was
not born until 1861, when Rossetti designed the title-page of
his *Early Italian Poets*. No great enthusiasm was shown for
the revived art, and for some years the deliberate arrange-
ment of book illustrations in the form of design was practic-
ally confined to the admirable series of children's books
invented by Kate Greenaway and Walter Crane and, to
some extent, those of Randolph Caldecott. During the late
Eighties and early Nineties *The English Illustrated Magazine*
helped to satisfy a growing taste for formal illustration, and
Herbert Horne and Selwyn Image anticipated somewhat the
future glories of the Kelmscott and Vale presses, in the hand-
some and dignified pages of *The Hobby Horse*. Then came
the books of the presses named, as recorded in an earlier
chapter, and presently publishers were competing with one
another in the production of decorated books, a remarkable
and distinguished number being issued during the years
under review.

It was Walter Crane more than any other artist who
consistently and indomitably carried the torch of book
decoration through the dark days preceding the full revival.
Influenced by Durer and the early German wood-engravers,
he developed mastery and individuality of his own. The

decorative sense is given freedom in his work, with the result that his drawings are always uncompromising designs in strict relation to the book of which they become parts. There are no illustrated books of the Nineties which satisfy the demands of decorative art more eloquently than Crane's *Faerie Queene, Reynard the Fox* and *The Shepherd's Calendar.* In each of these the achievement is greater because the artist succeeds in freeing himself from the convention of the decorated manuscripts by fashioning his design to that of the modern printed page. He thus escaped the archaic tendencies of William Morris and Burne Jones and became more definitely associated with the younger school of draughtsmen who were striving to put the spirit of modernity into their work. His designs were also used in an effective series of Socialist cartoons, notable among which is the fine processional work "The Triumph of Labour," designed to commemorate the International Labour Day, 1st May 1891, and other examples of his black and white drawings are to be found on the covers of books, and in several notable devices for publishing and other trading concerns.

Walter Crane's decorative drawings had a marked effect on the younger men of the period, but the influence stimulated the general decorative movement in regard to illustration rather than imitation of the master.

Book decoration was striving to become modern at the time the Kelmscott Press was started just as vigorously as Morris strove to link it with tradition. There was no set contest between the conflicting ideas and the original Pre-Raphaelite, and Arts and Crafts influences were too recent for the clear definition of any line of demarcation by intrinsically contending factions. The whole of the decorative revival was under the spell of Morris and the group of painters and poets who in turn influenced him. Walter Crane, though so closely associated with William Morris, came less under his influence as a book decorator than might have been expected, and both Charles Ricketts and C. H. Shannon worked out original ideas in design. So modern a designer as Aubrey Beardsley came, however, under the prevailing

Tho, as her manner was on sunny day,
Diana, with her nymphes about her drew
To this sweet spring; where, doffing her array
She bathed her lovely limbs, for love a
 likely pray.

M· VI· XLV·

ILLUSTRATION FROM "*THE FAERIE QUEENE*"
By Walter Crane

influence; and Laurence Housman could hardly have decorated so well had not Morris and Ricketts preceded him. The arabesque borders of William Macdougal were more modern in spirit, though less satisfying in effect, and the happy pictures and head-pieces and tail-pieces of Charles Robinson, as well as the vigorous Japonesque decorations of Edgar Wilson, were altogether novel and appropriate, as were those also of H. Granville Fell. But it was R. Anning Bell who caught the more fanciful decorative spirit of the times with his drawings for *A Midsummer's Nights' Dream* (1895), and other books, including a volume of Keats' *Poems*. In these drawings Anning Bell departed from the luxuriant effects of Morris, Crane, Ricketts and Beardsley, and, working in the realm of fancy, succeeded in producing illustrations which bridged the decorative and the pictorial methods, whilst retaining a designed balance with the printed page.

Whilst the decoration of books was striving for modern expression in this country, the Scottish group of artists, working with Patrick Geddes at Edinburgh, produced many designs which were at once strong and new, although in some instances based in curious and remote arabesques of Runic origin. Symbolism was the aim of these artists, and the clever head-pieces and tail-pieces of *The Evergreen* were faithfully drawn ''after the manner of Celtic ornament.'' Excellent and more illustrative designs were contributed to the same publication by Charles H. Mackie, Robert Burns, Pittendrigh Macgillivray and John Duncan. Later in the period the fantastic work of Jessie M. King came from Scotland, revealing a novel sense of fanciful design based largely upon the Japanese and showing also the influence of Beardsley. Ireland produced no group of Celtic designers, but the work of Althea Giles, with its curiously exotic symbolism, won the enthusiastic appreciation of W. B. Yeats, and the poet's brother, Jack Yeats, began to make those excellent and delightful wood-blocks which have all the qualities of designs without losing any of the characteristics of pictures. Nor had definite symbolism in black and white decorative art many exponents in this

country. The most notable, and he comes hardly within the definition of a decorator, was W. T. Horton, who, with extraordinary economy of materials, the briefest of lines and the flattest masses of black, produced startling revelations of human types in the very few designs he published.

A notable contribution to the ornamental book decorations of the period was made by a group of artists in the Midlands. Originally students at the Birmingham School of Art, these young men and women, inspired by the work and ideals of the elder group of the Arts and Crafts movement, worked diligently within the limits of conventional design. They discountenanced any book illustrations of a realistic type by relegating these to the portfolio or the picture frame. Many books of fairy tales, old romances and poetry were decorated by them, with varying success, and their aims and aspirations were set forth in a magazine of their own, called *The Quest*. William Morris thought so highly of the Birmingham School of decorators that he engaged three of its draughtsmen, E. H. New, C. M. Gere and Arthur Gaskin, to design illustrations for some of the Kelmscott Press books. In the main the artists of this school had little connection with modern life. The bulk of their designs were deliberately archaic, being based upon the work of the fifteenth and sixteenth century wood-engravers, and what modern spirit they possessed was little more than an echo of the Pre-Raphaelite movement and its associates and dependants. Among the more notable members of the group, besides the three artists named above, were Inigo Thomas, Henry Payne, L. Fairfax Muckley, Bernard Sleigh, Mary Newill, Celia Levetus and Mrs Arthur Gaskin. There can be small doubt, however, that the most satisfying and most original draughtsman of the group was E. H. New. His studies of old streets and buildings united the ideas of book decoration and illustration in a successful and altogether pleasing way, and they remain something more than the expressions of a revived method of decoration.

The revival of conventional book decoration did not pass unchallenged, as may be imagined at a time when there were

so many vigorous black and white artists of all types striving
for recognition. One of the most authoritative and most
reasonable pronouncements of the opposition was that made
by Joseph Pennell in the 1897 edition of *Pen Drawing and Pen
Draughtsmen.* "Decoration is appropriateness," he wrote,
"and it really makes no difference whether it is realistic
or conventional, so long as it improves the appearance
of the page. But at the same time I consider the modern
thoroughly developed realistic work in its best form superior
to that of the old men, because it shows most plainly the
advances we have made in knowledge and technique. . . .
Nowhere for the moment will such a statement be questioned,
except in this country. But here, within the last thirty
years, people have been continuously taught to believe that
book decoration, like all other art work, to be artistic must
have a spiritual, moral, social, political, literary or sixteenth-
century value, while beauty of line and perfection of execu-
tion have been subordinated to these qualities ; as a result
the many pay no attention to the real artistic merits or
defects of a drawing, but simply consider it from an entirely
inartistic standpoint. The excuse is the elevation of the
masses and the reformation of the classes. Art will never
accomplish either of these desirable ends, its only function
being to give pleasure, but this pleasure will be obtained
from good work produced in any fashion. If the work is
equally well, or, as usually happens, better done in a modern
style, it will give more pleasure to a greater number simply
because it will be far more widely understood." But the
distinction was not finally between realistic and conventional
decoration ; it was between the ideas of decoration in the
abstract and illustration in the abstract. During the
Nineties there were few naturalistic decorators of books, and
this was due probably to the emphasis which had been laid
upon the independence of all naturalistic art from anything
but its own materials and its own rules of excellence. The
problem of filling the space of a book-page in such a way as
to produce harmony and pleasing proportion was therefore
left to the decorative reformers who, to a man, were inspired

by a mediæval idea. The results are to be seen in the archaic but admirably illustrated books of the time, which, in their own realm of decoration, are sufficient defences against any criticism that has been, or may be, passed upon them.

The other branch of the art was none the less remarkable in its own sphere, and under conditions of almost unlimited personal freedom in choice of method it naturally encouraged originality undreamt of (and seemingly undesired) in the purely decorative schools. Every phase of life found its pictorial exponents, in spite of the serious limitations imposed by the introduction of photography into press and book illustrations. Where the camera could not operate, in for instance the realm of character study and humour, the modern genius for pen drawing produced surprising and masterly results. The most notable of these, and admittedly the finest pen draughtsmanship of the time, were the drawings of Phil May.

This universally appreciated artist, born at New Wortley, Leeds, in 1864, was the son of an engineer. His earliest ambition was to be a jockey, but the wish was not gratified, for when quite a child he was employed as timekeeper in a foundry. There were theatrical associations in the family on his mother's side, and these led to the boy, whose aptitude with the pencil developed early, being employed as an assistant scene painter and odd-job boy at a Leeds theatre. Subsequently he became an actor, playing juvenile parts in a touring company. At the age of fifteen he set out for London and fortune, but hardship drove him back to Leeds, where he practically began his association with pictorial journalism by contributing drawings to a local paper called *Yorkshire Gossip*. He married at the early age of nineteen, and again returned to try his fortune in London, where ill luck greeted him once more. After suffering extreme poverty, a caricature of his, depicting Bancroft, Irving and Toole leaving the Garrick Club, which was published by a print-seller in Charing Cross Road, attracted the attention of Lionel Brough, the actor, who bought the original and introduced May to the editor of *Society*. This led to work and

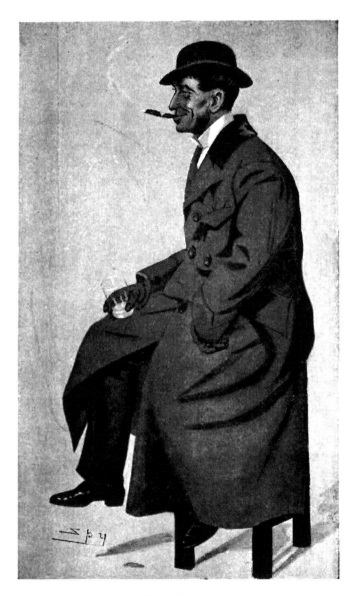

PHIL MAY

opened up avenues for the further development of his career in the pages of *The St Stephen's Review*, where some of the best of his early drawings appeared. But the artist's health broke down, and he was forced to leave England for Australia. There he remained from 1885 to 1888, becoming one of the most popular contributors to *The Sydney Bulletin*. On his return to Europe he studied art for a while in Paris, and from there renewed his connection with *The St Stephen's Review*, contributing his first popularly successful series of drawings, "The Parson and the Painter." This series appeared as a book in 1891. When he returned to London in 1892 he found himself a famous humorous artist, and started the immensely popular *Winter Annuals*, which were published regularly for eleven years. He now contributed drawings to many papers, including *The Graphic, The Daily Graphic. The Pall Mall Budget, The Sketch, Pick-me-up*, and in 1896 he joined the staff of *Punch*. Among his more important separate publications were, *Phil May's Sketch Book* (1895); *Guttersnipes* (1896); *Graphic Pictures* (1897); *Fifty Hitherto Unpublished Pen and Ink Sketches* and *The Phil May Album* (1899). During the greater part of this time Phil May was the undisputed king of pictorial humorists in this country. His sketches were a characteristic of the period, and probably no other black and white artist ever won such ungrudging appreciation from both his brother artists and all classes of the public. So severe a critic as Whistler said: "Modern Black and White Art could be summed up in two words— Phil May." His weekly contributions to *Punch* came to be anticipated and discussed as a pleasurable event of the first order. This high fame was practically achieved and concluded in the Nineties, for Phil May died in 1903, just before entering his fortieth year. After his death several volumes of his drawings were published, including *Sketches from Punch* and *A Phil May Picture Book* (1903); and a *Folio of Caricature Drawings and Sketches* and *Phil May in Australia* (1904).

The two outstanding qualities of Phil May's drawings are their simplicity and their humour. No draughtsman before him had ever succeeded in expressing so much with such

apparent ease and such economy of means. He translated the brevity of wit into black and white art, for although he was fundamentally a humorist, and often a humorist of a very primitive type, the most successful of his drawings are as witty as they are funny. His capacity for wit is also revealed in those early caricatures of his, which, if they had been continued, would have won him fame in another direction. But it is as a humorous artist that he will be remembered and loved. Not since Charles Keene had the distinctive qualities of our native humour been caught with such unerring exactitude and force. At the same time May achieved a far greater versatility than Keene. His mind ranged over every phase of the life of his time, and his amazing skill recorded the funniness of Whitechapel or Mayfair with equal inevitability. The wonderful simplicity of these drawings augmented their popular success, and it provoked as well an equally persistent legend about his art, for it was customary to attribute May's simplicity of line to the belief that whilst he was in Australia he was forced to evolve a simple method of drawing owing to the limitations of local reproductive processes. This illusion had no basis in fact, for the style was as much the man in Phil May's case as in that of any other artist of equal skill. "For May's view of life," wrote his friend and fellow-artist, G. R. Halkett, "with its sharp emphasis of character, and its expression always of the type rather than the individual, an overloading of detail would mean, even in its completeness, a lack of certainty and a halting expression of his idea. In the result, May's work was always that of the brilliant sketcher who records only those essentials which express 'the soul' of the object before him. The accessories he put behind him with no lack of appreciation, and certainly with no lack of study, because he was concerned with deeper things, from which, with unerring instinct, he knew how to discard the merely superfluous."

Next to the directness of his appeal the easy familiarity of his humour made him universally acceptable. It was fundamental, primitive and native humour, reflecting feelings which exist in most adults without respect to class or opinion.

A LECTURE IN STORE

"*Are* you comin' 'ome?"
"I'll do ellythikt you *like* in reason, M'ria—(hic)—but I *won't* come 'ome."
By Phil May

And above all it was easier of acceptance because of its whole-hearted geniality and amiable tolerance of human foibles. It never aroused superior laughter; cynicism was as absent as attempt to score off the inferiorities of others; one could laugh and feel comfortable with him, as one could with, say, Charles Dickens or Dan Leno. Phil May made his appreciators feel as they looked and laughed at one of his quaint or preposterous creations that "there, but for the grace of God, go I." By making you laugh with him at something he had observed or imagined he thus forced you to laugh good-humouredly and with amiable fatalism at yourself. But in spite of all this undoubted geniality the subject of his humour was more often than not fitter for tears than laughter. His "guttersnipes," his ragamuffins, and all the degraded and unfortunate class-less folk he delineated with such genius in all sorts of laughable situations, might just as easily have been the subjects of weeping or, better, of wrath. In some of the finest of these drawings the humour miscarries in the triumph of a tragic realism; and in most of his studies of low life—studies of drunkards, ragged, dirty and half-starved children, inept old men and unkempt women of all ages—the laughter provoked can be little more than the protective covering of merriment against the pains of impotent sympathy. How far Phil May felt this paradox of his own, and, perhaps, all humour, we do not know; but the misfortunes of his own life, due mainly to personal foibles, must have developed in him that kindly and indifferent fatalism which pervades his work.

The best of the new men worked for *Pick-me-up* in its early days, and also for *The Butterfly* and *Eureka*, and in those publications realism, satire, humour, cynicism and caricature flourished with all the spriteliness of a lively age and keen artistic enthusiasm. In many directions one can trace the influence of Phil May both in technique, which is chiefly the concern of the draughtsmen themselves, and in point of view. But many artists developed a *métier* of their own, and most of them had sufficient originality of technique and subject to arouse critical interest. The renaissance of black and

T

white drawing was not, however, confined to the regular artists in that medium, it gained supporters from among painters, many of whom, such as Dudley Hardy, Walter Sickert, Maurice Greiffenhagen and Sidney H. Sime, doing work which held its own among the best work of the regular pen and pencil draughtsmen. And in this connection the long series of lithographic portraits by William Rothenstein [1] must be remembered, and the early line-drawn caricatures of Max Beerbohm. Cecil Aldin was contributing clever animal studies in wash to the popular illustrated journals, and etchers like Joseph Pennell and painter-etchers like Alfonse Legros and William Strang made incursions into the popular realms of black and white illustrations; and even so essential a colourist as Charles Conder came under the same spell.

Variety was a marked characteristic of the black and white art of the Nineties, and it has to be admitted that apart from the two main schools of illustration—the decorative and the illustrative, which correspond with the romantic and realistic schools of painting—little of the work was other than normal, and, save for the circumstances of the moment, possible during any recent decade. Individual talent, of course, had its say in all directions, and every manifestation of genius and skill found appreciators. The list of draughtsmen whose work is distinctive after the critical winnowing of more than fifteen years, and, in some instances, twenty, is still impressive, including, as it does, such names as Raven Hill, C. E. Brock, F. H. Townsend, G. R. Halkett, Frank L. Emanuel, H. R. Millar, E. J. Sullivan, R. Spence, O. Eckhardt, A. S. Hartrick, Gilbert James, J. W. T. Manuel, Hilda Cowham, E. T. Reed, Charles Pears, Patten Wilson and Bernard Partridge, all of whom either published their first work during the decade or produced such good work as to give them repute. And in addition to this varied array of ability newer men were also coming forward. Among these may be named Henry Ospovat, Carton Moore Park, Gordon Craig, Dion Clayton Calthrop and Joseph Simpson, each of whom published

[1] For an account of these lithographs see " The Lithographic Portraits of Will Rothenstein " in the author's *Romance and Reality*.

THE BANKS OF THE STYX
By S. H. Sime

their early work at the close of the period, but whose main work in varied directions belongs to succeeding decades.

All the ideas and "movements" of the time had their devotees among the black and white artists—decadence in Aubrey Beardsley, realism in Phil May, Raven Hill and J. W. T. Manuel; romanticism in Maurice Greiffenhagen, and that urbanity which I have dealt with under the heading of "The New Dandyism," in Max Beerbohm, Dion Clayton Calthrop and others. Besides these phases there were several artists who combined the realistic and romantic points of view in their work, and, in the true spirit of the moment's complex intellectualism, added to it that cynicism and doubt of convention which characterises so much of modern thought. Chief among these artists stands Sydney H. Sime, whose contributions to *Pick-me-up*, *The Butterfly*, *Eureka* and *The Idler* reveal one of the most original and most gifted artists of the time.

All the varieties of *fin de siècle* black and white drawing found a capable and prodigal exponent in this artist, who was equally at home with pen, pencil or brush. Few artists of the time had his versatility, and still fewer his mental range. His line drawings illustrating "Jingle's" theatrical notes in *Pick-me-up* reveal not only a draughtsman of distinction, but an exact observer of life, and a humorist to boot; some of his covers for *Eureka*, particularly the "White-eyed Kaffir," prove that he might have won fame as a poster designer had he wished, whilst his little landscapes in the medium of wash, which appeared from time to time in *The Butterfly*, have all the qualities of fine pastel-work. But the phase of Sime's work which most nearly expresses a distinctive mood of the period is that which reveals him as a sardonic critic of humanity and conventional faith.

From time to time he published drawings in *Pick-me-up*, and elsewhere, which represented a new type of caricature for this country. He could, and did, caricature personality in the traditional manner; but, interesting as these works proved to be, they were not sufficiently distinctive to command more than passing attention. His outstanding work

in caricature was independent of personality. It did not
pass satiric or humorous comment upon this or that man of
note ; it said its say about man as man, and about man's
most cherished ideas and beliefs. Sime once described
caricature as in the nature of a sarcastic remark, and there
is sarcasm enough in these irreverent drawings of his. But
neither sarcasm nor irreverence is their aim or outcome.
They are obviously the work of an artist and thinker, of one
who did not choose to mask his contempt of human weak-
ness. His satires of Heaven and Hell, funny as they are, do
not end as jokes. He sees in these popular conceptions of
the hereafter mere substitutes for thought and imagination
and courageous living, and his attitude resembles that of
Rudyard Kipling in " Tomlinson," which work, significantly
enough, he desired above all things to illustrate, although he
never produced more than two or three drawings towards
that end.

The restless spirit of the time thus found varied expression
in its black and white art. From Phil May's laughter at
tragedy to Sime's laughter at humanity is a far cry ; and it
is still further to Aubrey Beardsley's decorated cynicism.
Yet each point of view is typical of the period, each in its
way an expression of that thirst for reality which character-
ised the whole art work of the decade.

In the work of no single artist was a final interpretation
of reality attained. The art of the time was perhaps too
personal for that ; just as it was too personal for work within
prescribed conventions or formalities. The age favoured
experiment and adventure, and it even looked not unkindly
upon the various whims of the inquisitive, on the assumption
doubtless that discovery was as often the result of accident
as of design. In this large tolerance the spirit of renaissance
worked through mind and imagination inspiring artists with
a new confidence in themselves and courage to take risks.
The results were not always happy ; but that does not make
the spirit in which the risks were taken less admirable, for
those who make great effort contribute to life as well as
those who achieve.

INDEX

About the Theatre, by William Archer, 207
Academy, The, 169-170
Achurch, Janet, 207-208
Adams, Francis, 34
Addison, Joseph, 41, 121
" A.E." (see George Russell)
Æschylus, 167
Æsthetic movement, 28, 67
Ahab and Jezebel, by Oscar Wilde, 80
Albert, Prince, 100
Aldin, Cecil, 290
Allen, Grant, 21, 28-29, 35, 39, 40, 44, 131, 147-148, 151-152, 216
Almanack of Twelve Sports, by W. E. Henley, illustrated by William Nicholson, 274
Almayer's Folly, by Joseph Conrad, 225
" An Artist in Attitudes," 81
Angelo, Michael, 139
Anthem of Earth, by Francis Thompson, 175-176
Archer, Charles, 207
Archer, William, 157-158, 205, 207, 208, 213
À Rebours, by J. K. Huysmans, 28, 59, 61-62
Arms and the Man, by Bernard Shaw, 194
Arnold, Matthew, 128
Art Workers' Guild, 246
Arts and Crafts Essays, 245, 256
Arts and Crafts Exhibition Society, 246
Arts and Crafts Exhibition, 253
Arts and Crafts movement, 244-247, 267, 280, 284
Ashbee, C. R., 265
Auld Licht Idylls, by J. M. Barrie, 224
Autobiography of a Boy, The, by G. S. Street, 41, 67-69, 228
Aveling, Eleanor Marx, 207
Aylwin, by Theodore Watts-Dunton, 39

BAILEY, PHILIP JAMES, 38
Balestier, Wolcot, 232
Ballad of an Artist's Wife, The, by John Davidson, 187
Ballad of a Nun, The, by John Davidson, 187
Ballad of Heaven, A, by John Davidson, 188
Ballad of Hell, The, by John Davidson, 187
Ballad of Reading Gaol, The, by Oscar Wilde, 80, 82-83, 88-89
Ballads and Songs, by John Davidson, 178, 181

Ballantyne & Hanson, 265
Balzac, 74, 87
Baptist Lake, by John Davidson, 178
Baring-Gould, S., 250
Baring, Maurice, 48
Barker, Granville, 214-215
Barlow, Jane, 225
Barrack-Room Ballads, by Rudyard Kipling, 232, 241
Barrie, J. M., 35, 40, 42, 224-225, 227-228
Bashkirtseff, Marie, 206
Battle of the Bays, The, by Owen Seaman, 159
Bauble Shop, The, by Henry Arthur Jones, 209
Baudelaire, Charles, 61, 110, 111, 136, 143, 160, 196, 201
Beardsley, Aubrey, 17, 21, 23, 34, 37, 45, 46, 47, 48, 50, 59, 60, 63, 76, 91-104, 111, 114-115, 117, 130-131, 137-138, 142, 143, 186, 268, 273, 280, 282, 290-292
Beardsley, The Last Letters of Aubrey, 94
Beardsley, Miss Mabel, 92
" Beardsley Craze," 93
Beardsley woman, the, 46, 93
Beccarius, by Max Beerbohm, 117
Becke, Louis, 225
Beeching, H. C., 159
Beerbohm, Max, 17, 20, 25, 30, 35, 41, 45, 48, 50, 97, 102, 108, 112, 116, 117-125, 130, 197, 229, 291
Beerbohm, The Works of Max, 41, 118-120, 123
Beers Company, the De, 238
Beggarstaff Brothers, 34, 274-275
Bell, R. Anning, 47, 283
Beltaine, 150
Bending of the Bough, The, by George Moore, 149
Benson, Arthur Christopher, 40, 47
Benson, E. F., 224
Benson, F. R., 212
Benson, W. A. S., 251
Berneval-sur-Mer, 80
Bernhardt, Sarah, 76
Besant, Annie, 26
Beside the Bonnie Brier Bush, by Ian Maclaren, 225
Binyon, Laurence, 45, 51, 109, 159
Birmingham School of Art, 284-285
Björnson, Björnstjerne, 133, 209
Black, William, 39
Black Cat, The, 209
Blake, William, 50, 91, 99, 167, 174
Bland, Hubert, 26
Blatchford, Robert, 24, 44
Blind, Mathilde, 50
Blomfield, Reginald, 251

2(

Bodley, G. F., 251
Bodley Head, The, 41, 45, 76, 119, 186
Bogland Studies, by Jane Barlow, 225
Book Bills of Narcissus, The, by Richard le Gallienne, 226
" Bon Mot " series, 103
Booth, Charles, 44
Bottomley, Gordon, 51
Brand, by Henrik Ibsen, 209
Brandes, George, 133
Brangwyn, Frank, 268, 270, 276, 277-278
Bridges, Robert, 39
Brieux, Eugene, 201
British South Africa Company, 238
Brock, C. E., 290
Brooke, Emma Frances, 224
Brooke, Stopford, 39
Brown, Ford Madox, 246, 272
Browning, Robert, 25, 38, 128, 157
Bruce : a Drama, by John Davidson, 178
Buchanan, Robert, 128
Bullen, Frank T., 225
Burne-Jones, Sir Edward, 33, 100, 103, 259-260, 273, 282
Burns, John, 26
Burns, Robert, 283
Butler, Samuel, 203
Butterfly, The, 36, 289, 291
Byron, Lord, 57, 158

CADENHEAD, JOHN, 150
Cæsar and Cleopatra, by Bernard Shaw, 195
Café Royale, 58
Caine, Hall, 39, 218, 226
Caldecott, Randolph, 281
Calthrop, Dion Clayton, 290-291
Cameron, D. Y., 270
Campbell, Mrs Patrick, 213
Candida, by Bernard Shaw, 194
Canterbury Poets, 52
Canterville Ghost, The, by Oscar Wilde, 74
Captain Brassbound's Conversion, by Bernard Shaw, 194
Captains Courageous, by Rudyard Kipling, 232
Caricatures of Twenty-five Gentlemen, by Max Beerbohm, 124
Carlyle, Thomas, 203
Carpenter, Edward, 34, 44, 48
Carroll, Lewis, 227
Carthusian, The, 117
Carton, R. C., 214
Case of Rebellious Susan, The, by Henry Arthur Jones, 212
Cashel Byron's Profession, by Ber

Caslon, 255
Caxton, William, 260
Celtic revival, 42, 147-156
Celtic Twilight, The, by W. B. Yeats, 42, 149, 155
Chamberlain, Joseph, 151, 238-239
Chameleon, The, 36
Champneys, Basil, 251
Chant, Mrs Ormiston, 24
Chap-Book, The, 118
Charrington, Charles, 207-208
Chesterton, G. K., 112
Child of the Jago, A, by Arthur Morrison, 43, 130, 216
Children of the Ghetto, by Israel Zangwill, 225
Chiswick Press, 255, 257
Chord, The, 36
Christ in Hades, by Stephen Phillips, 158, 164
Christmas Day in the Workhouse, by G. R. Sims, 187
Christmas Garland, A, by Max Beerbohm, 120
Chronicle, The Daily, 24, 80
City of Dreadful Night, The, by Rudyard Kipling, 232
Clarion, The, 24
Clausen, George, 270
Clifford, Mrs W. K., 224
Cobden-Sanderson, T. J., 251, 253, 260, 266
Cockerell, Douglas, 251
Coleridge, S. T., 58, 158
Collins, Lottie, 31
Colour of Life, The, by Alice Meynell, 139, 145
Colvin, Sydney, 39
Comte, 60
Comus, by John Milton, 58
Conder, Charles, 35, 37, 48, 50, 131, 270, 273-274
Confessions of a Young Man, by George Moore, 63
Conrad, Joseph, 40, 50, 225
Coppée, François, 178
Corelli, Marie, 225
Couch, Arthur Quiller, 35, 225
Countess Kathleen, The, by W. B. Yeats, 41, 149, 156
Courting of Dinah Shadd, The, by Rudyard Kipling, 232
Crackanthorpe, Hubert, 35, 47, 131, 142, 144, 220, 223
Craig, Gordon, 51, 207, 290
Crane, Stephen, 229
Crane, Walter, 33, 48, 251, 280-283
Crashaw, Richard, 166
Critic as Artist, The, by Oscar Wilde, 75

Crockett, S. R., 42, 150, 224
Crosland, T. W. H., 51
Cruelties of Prison Life, by Oscar
· Wilde, 80
Custance, Olive, 48, 159
Cyrenaicism, the New, 59

Daily Express (Dublin), The, 150
Daily Graphic, The, 287
Daily Mail, The, 52
Daily Telegraph, The, 208
Dalmon, Charles, 48, 159
D'Annunzio, Gabriele, 128
Dante, 272
D'Arcy, Ella, 48
Darwinian idea, 190
D'Aurevilly, Barbey, 13, 110-111,
114-115
Davidson, Alexander, 177
Davidson, John, 20, 35, 41, 45, 47,
91, 106, 129, 131, 158, 177-192,
234
Davies, William H., 170
Day's Work, The, by Rudyard
Kipling, 232
Decadents, The, 36
Decameron, The, by Boccaccio, 102
Decay of Lying, The, by Oscar
Wilde, 75
Decorative Illustration, by Walter
Crane, 280
Deemster, The, by Hall Caine, 225
Defence of Cosmetics, A, by Max
Beerbohm, 117
Defence of the Revival of Printing, by
Charles Ricketts, 261
Degas, 203
Degeneration, by Max Nordau, 195
Dent, J. M., 93
Departmental Ditties, by Rudyard
Kipling, 231, 232
De Profundis, by Oscar Wilde,
80-81, 88
De Quincey, Thomas, 167
Devil's Disciple, The, by Bernard
Shaw, 195
Dial, The, 257, 260, 261
Diarmuid and Grania, by W. B.
Yeats and George Moore, 149
Diary of Lady Willoughby, by
Hannah Mary Rathbone, 255
Dickens, Charles, 33, 43, 107, 217,
289
Dionysos, 58
Dobson, Austin, 39
Doll's House, A, by Henrik Ibsen,
208-209
Dome, The, 36, 50-51
"Don't Read This if You Want to
· be Happy To-day," by Oscar
Wilde, 80

D'Orsay, Count, 122
Douglas, Lord Alfred, 76, 159
Douglas, Sir George, 150
Doves Press, 255, 266
Dow, T. Millie, 270
Dowie, Menie Muriel, 224
Dowden, Edward, 39
Dowson, Ernest, 35, 48, 58, 70, 91,
158, 162, 166
Doyle, Arthur Conan, 40, 225
Dream Days, by Kenneth Graham,
227
Dream Tryst, by Francis Thompson,
167
Dublin Review, The, 167-168
Duchess of Padua, The, by Oscar
Wilde, 75
Du Maurier, George, 39, 67, 226, 279
Duncan, John, 150, 283
Durer, Albrecht, 281

Eagle and the Serpent, The, 129-130
Early Italian Poets, by D. G.
Rossetti, 281
Ebb-Tide, The, by Robert Louis
Stevenson and Lloyd Osbourne,
225
Echegaray, 209
Eckhardt, O., 290
Egerton, George, 45, 47, 129, 143,
144, 217, 224
Eglinton, John, 42, 149
Elder Conklin and Other Stories, by
Frank Harris, 43
Eliot, George, 217
Ellis, Havelock, 50, 129, 221
Elsmere, Robert, by Mrs Humphry
Ward, 224
Emanuel, Frank L., 290
Emerson, Ralph Waldo, 132
Emperor and Galilean, by Henrik
Ibsen, 208
Endymion, by John Keats, 58
Enemy of the People, An, by
Henrik Ibsen, 209-210
English Episodes, by Frederick
Wedmore, 39
English Illustrated Magazine, 281
English People, Modern History of,
by R. H. Gretton, 53
Episodes, by G. S. Street, 144
Eragny Press, 255
Esperance Girls' Club, 250
Essex House Press, 255, 265-266
Esther Waters, by George Moore,
43, 63, 130, 216, 228-230
Eureka, 36, 289, 291
Euripides, 212
Evans, Frederick H., 93
Evelyn Innes, by George Moore,
230

Eve of St Agnes, The, by John Keats, 58

Evergreen, The, 36, 43, 150, 283

Fabian Essays in Socialism, 194

Fabianism and the Empire, by Bernard Shaw, 195

Fabian Society, the, 26, 186, 194, 200, 209

Faerie Queene, by Edmund Spenser, 281

Farrar, Archdeacon, 38

Fathers and Children, by Ivan Turgenev, 132

Fat Woman, The, by Aubrey Beardsley, 101-102

Fell, H. Granville, 283

Fenn, Frederick, 214

Fergusson, John Duncan, 35, 270

Feverel, The Ordeal of Richard, by George Meredith, 123

Field, Michael, 45, 159, 209

Fitzgerald, Edward, 135

Fleet Street Eclogues, by John Davidson, 41, 106, 178

Fleet Street Eclogues, by John Davidson (second series), 178

Fleet Street and Other Poems, by John Davidson, 178

Fleming, George, 144

Fleshly School of Poetry, The, by Robert Buchanan, 128

Fortnightly Review, The, 28, 74, 147

Fletcher, A. E., 24

Florentine Tragedy, A, by Oscar Wilde, 75

Forbes, Stanhope, 270

Forest Lovers, The, by Maurice Hewlett, 226

For the Crown, by John Davidson, 178

Fowler, Robert, 270, 273, 276

Fragonard, 274

France, Anatole, 48, 206

Frederic, Harold, 226

French Revolution, 57

Froude, James Anthony, 38

Fry, Roger, 51

Furniss, Harry, 280

Furse, Charles W., 47

Futurists of Milan, 188

GALE, NORMAN, 45

Galsworthy, John, 214

Galton, Francis, 38

Garden Cities of To-morrow, by Ebenezer Howard, 254

Garnett, Richard, 47

Gaskin, Arthur, 284

Gaskin, Mrs Arthur, 284

Gautier, Théophile, 58, 61, 70, 85, 111, 1

Geddes, Patrick, 42, 150, 283

Gentle Art of Making Enemies, The, by James McNeill Whistler, 40

George IV. (caricature of), 48

George, D. Lloyd, 151, 239

Gere, C. M., 284

Gerontius, The Dream of, by John Henry Newman, 68

Ghetto Tragedies, by Israel Zangwill, 225

Ghosts, by Henrik Ibsen, 194, 208

Gide, André, 72, 78-79

Gibson, Wilfred Wilson, 51

Gilbert and Sullivan, 73

Gilbert, W. S., 67, 73, 118

Gilchrist, Murray, 229

Giles, Althea, 51, 283

Gissing, George, 27, 35, 39, 43, 223, 229

Glasgow Herald, The, 178

Glasgow School, 269-270

Gods and Fighting Men, by Lady Gregory, 149

Golden Age, The, by Kenneth Graham, 227

Goncourt, Edmund and Jules de, 58

Gordon, General, 237

Gosse, Edmund, 38, 47, 50, 207

Goya, by W. Rothenstein, 277

Graham, R. B. Cunninghame, 35, 44, 225

Grahame, Kenneth, 45, 47, 227

Grand, Sarah, 217, 224

Graphic, The, 287

Graphic Pictures, by Phil May, 287

Gray, John, 94, 159, 166, 262

Great God Pan, The, by Arthur Machen, 226-227

Greenaway, Kate, 92, 281

Green Carnation, The, by Robert Hichens, 41, 73, 79, 135, 139, 228

Green Fire, by Fiona Macleod, 139

Gregory, Lady, 42, 149

Greiffenhagen, Maurice, 270, 273, 276, 290

Grein, J. T., 194, 205

Gretton, R. H., 31 (footnote), 53

Grey Roses, by Henry Harland, 139

Grosvenor Gallery, 25, 270

Grundy, Sidney, 78, 214

Guest, Lady Charlotte, 151

Guild of Handicraft, 265

Gunga Din, by Rudyard Kipling, 187

Gunnlaug Saga, translated by William Morris, 257

Guthrie, Sir James, 270

Guttersnipes, by Phil May, 287

HACON & RICKETTS, 51, 257

Haggard, Rider, 39

Hankin, St John, 214
Happy Hypocrite, The, by Max Beerbohm, 120, 123, 229
Happy Prince and Other Tales, The, by Oscar Wilde, 54, 89
Hardie, M.P., Keir, 26
Hardy, Dudley, 47, 268, 270, 290
Hardy, Thomas, 38, 40, 216, 221-222, 223
Hardy, The Art of Thomas, by Lionel Johnson, 38
Harland, Henry, 35-36, 46, 47, 131, 143, 144, 224, 229
Harlot's House, The, by Oscar Wilde, 82, 83, 102
Harmsworth, Alfred, 54
Harraden, Beatrice, 224
Harris, Sir Augustus, 275
Harris, Frank, 43, 225, 228-229
Harrison, Frederic, 38
Hartrick, A. S., 36, 47-48, 290
Hayes, Alfred, 47
Headlam, Rev. Stewart, 26
Heather Field, The, by Edward Martyn, 149
Hedda Gabler, by Henrik Ibsen, 194, 208-209
Hedonism, The New, by Grant Allen, 21, 28-29
Heinemann, William, 45
Henley, William Ernest, 34, 38, 108-109, 143, 267
Henry, George, 270
Henry & Co., 45, 129
Herbert, George, 166
Hernani, by Victor Hugo, 39, 207
Hewlett, Maurice, 40, 226
Hiatt, Charles, 274-275
Hichens, Robert, 41, 73
Hill, Raven, 36, 37, 280, 290-291
Hind, C. Lewis, 170-172
Hobbes, John Oliver, 35, 47, 144, 224
Hobby Horse, The, 36, 257, 281
Holiday and Other Poems, by John Davidson, 178, 184
Holmes, C. J., 51
Hope, Anthony, 40
Horace, 121
Horne, Herbert P., 257, 281
Hornel, E. A., 35, 150, 270
Hornung, E. W., 226
Horton, William, T., 50, 284
Hound of Heaven, The, by Francis Thompson, 172-173
House of Pomegranates, The, by Oscar Wilde, 74, 75, 88, 89, 260, 262
House of the Wolfings, The, by William

Housman, A. E., 40, 45, 158, 164-165
Housman, Laurence, 37, 47, 51, 158, 280, 283
Howard, Ebenezer, 254
Hudson, W. H., 40
Hueffer, Ford Madox, 48
Hugo, Victor, 178
Humanitarian League, the, 186
Hunt, Holman, 33, 281
Hunt, Leigh, 41
Huysmans, Joris Karl, 28, 58, 61, 136, 223
Huxley, Thomas Henry, 38
Hyde, Dr Douglas, 42, 149
Hyndman, Henry Mayers, 26, 134

Ibsen, Henrik, 27, 128, 133, 194, 196, 201-203, 205-212, 220
Ibsenism, the Quintessence of, by Bernard Shaw, 44, 194, 198, 211
Ideal Husband, An, by Oscar Wilde, 76, 88
Idler, The, 36
Idylls of the King, The, by Lord Tennyson, 100
Illumination, by Harold Frederic, 226
Image, Selwyn, 50, 159, 257, 281
Importance of Being Earnest, The, by Oscar Wilde, 76, 105-106
Impossibilities of Anarchism, by Bernard Shaw, 195
Impressionists, French, 198, 203, 207, 244, 267-269, 272-273, 276
In a Music Hall, by John Davidson, 178
In Black and White, by Rudyard Kipling, 232
Independent Theatre, the, 205, 209
Industrial Democracy, by Sidney and Beatrice Webb, 44
Ingelow, Jane, 38
Intentions, by Oscar Wilde, 75, 85, 88
In the Key of Blue, by John Addington Symonds, 39, 262
"Iota," 224
Irish Literary movement, 42, 64, 149-150
Irish Melodies, by Thomas Moore, 153
Irish National Theatre, 42, 150
Irving, Sir Henry, 211
"Israfel," 51
It's Never too Late to Mend, by Charles Reade, 196

Jackson, T. G., 251
Jacobs, W. W., 227
James, Gilbert, 290

Jameson, Dr, 238-239
Jameson Raid, the, 23, 233
Jefferies, Richard, 186
Jenson, Nicholas, 256, 258
Jerome, Jerome K., 40, 227
"Jingle," 291
Joan of Arc, The Procession of, by
 Aubrey Beardsley, 100
John, Augustus, 270
Johnson, Lionel, 35, 38, 45, 48, 131,
 141-142, 149, 158, 160-161, 166
Johnson, Samuel, 41, 107, 115
Jones and Evans, 93
Jones, Henry Arthur, 209, 212-213
Jude the Obscure, by Thomas
 Hardy, 39, 216-217, 221
Jungle Books, The, by Rudyard
 Kipling, 232
Just-so Stories, by Rudyard Kip-
 ling, 232

"KAIL YARD SCHOOL," 42
Keats, John, 58, 93, 95, 135, 158,
 165, 176, 185, 225
Keene, Charles, 37, 279
Kelmscott Press, 51, 248, 255-262,
 264-266, 281-284
Kelmscott Press Books, 258-259,
 263, 266
Keynotes, by George Egerton, 129,
 144
Khartoum, Taking of, 237
Khayyám, Omar, 135
Kidson, Frank, 250
Kim, by Rudyard Kipling, 232
King of the Schnorrers, The, by
 Israel Zangwill, 225
King, Jessie M., 283
Kipling, Rudyard, 34, 35, 39, 43,
 54, 126, 158, 187, 218, 225, 231-
 243, 292
Kiss of Judas, The, by Aubrey
 Beardsley, 101
Kitchener, Lord, 237
Krafft-Ebing, 102
Kruger, Paul, 238

LABOUR PARTY, INDEPENDENT, 26
Lady Windermere's Fan, by Oscar
 Wilde, 77, 133
Lamb, Charles, 41, 107, 121, 123
Lane, John, 35, 45, 51, 93, 119, 186,
 262
Lang, Andrew, 38
Lassalle, Ferdinand, 134
Last Ballad, The, by John David-
 son, 178
Last Feast of Fraima, The, by
 Alice Milligan, 140
Lave

Lawrence, Emmeline Pethick, 250
Lecky, W. E. H., 38
Lee, Vernon, 144
Leech, John, 37, 279
Le Gallienne, Richard, 31, 35, 38,
 41, 45, 46, 47, 91, 106, 108, 139,
 142-144, 157, 159, 160, 163-164,
 226-228
Legros, Alfonse, 290
Leighton, Sir Frederick, 47
L'Enfant Prodigue, 94
Leno, Dan, 275, 289
Lepage, Bastien, 270
Lethaby, W. R., 251, 253
Levetus, Celia, 284
Leyland, Sir James, 268
Liberty, 196
Liddon, Canon, 38
Light That Failed, The, by Rud-
 yard Kipling, 232, 234
Lindsay, Sir Coutts, 270
Lippincott's Monthly Magazine, 75
Little Minister, The, by J. M.
 Barrie, 224
Little Novels from Italy, by Maurice
 Hewlett, 226
Liza of Lambeth, by Somerset
 Maugham, 43, 130, 224
Locksley Hall, by Lord Tennyson,
 128
Lombroso, Cesare, 50
*London People, The Life and Labour
 of the,* by Charles Booth, 45
London Programme, The, by Sidney
 Webb, 44
London Types, by W. E. Henley
 and William Nicholson, 274
London Visions, by Laurence
 Binyon, 109-110
London Voluntaries, by W. E.
 Henley, 108-109, 143
Longmans & Co., 93
Lord Arthur Saville's Crime, by
 Oscar Wilde, 74
Love Songs of Connacht, The, by
 Douglas Hyde, 149
Lowry, H. D., 144
Lysistrata, by Aristophanes, 103

Mabinogian, The, translated by
 Lady Charlotte Guest, 151
"Mabon," 151
Macdougal, William, 283
Macgillivray, Pittendrigh, 150, 283
Macgregor, W. Y., 270
Mackie, Charles H., 283
"Maffick," to, 39
Mahdi, the, 237
Maitland, 270

Macleod, Fiona (see also William Sharp), 35, 42, 48, 51, 147, 150, 226
Mademoiselle de Maupin, by Théophile Gautier, 59
Mademoiselle Miss, by Henry Harland, 144
Maeterlinck, Maurice, 51, 132, 153, 209-210
Mœve, by Edward Martyn, 149
Mafeking night, 54
Major Barbara, by Bernard Shaw, 200
Mallarmé, Stéphane, 56, 61, 78
Mallock, W. H., 38, 67
Mammon and His Message, by John Davidson, 179
Man of Destiny, The, by Bernard Shaw, 194
Man and Superman, by Bernard Shaw, 199
Manet, Eduard, 63, 99, 203, 268, 276
Mann, Harrington, 270
Mann, Tom, 26
Manning, Cardinal, 38
Manuel, J. W. T., 36, 290
Margaret Ogilvy, by J. M. Barrie, 224
Marillier, H. C., 97, 263
Marius the Epicurean, by Walter Pater, 118, 140
Marriott-Watson, Rosamund, 159
Marpessa, by Stephen Phillips, 158
Martian, The, by George du Maurier, 39
Martineau, James, 38
Martyn, Edward, 149
Mary Glocester, The, by Rudyard Kipling, 187
Marx, Karl, 134, 207
Marxian theory, 194
Masefield, John, 214
Masks or Faces? by William Archer, 207
Masks, The Truth about, by Oscar Wilde, 74
Massacre of the Innocents, The, by Maurice Maeterlinck, 54
Master Builder, The, by Henrik Ibsen, 209, 211
Mathews, Elkin, 35, 45, 51, 93
Maude, Aylmer, 250
Maugham, W. Somerset, 43, 224, 225
Maupassant, Guy de, 220, 223, 235
May, Phil, 35, 36, 37, 50, 275, 280, 287-292
Melmoth, Sebastian, 80
Melville, Arthur, 270
Meredith, George, 38, 121, 135, 144, 157, 223
Merrie England, by Robert Blatchford, 44

Merriman, Henry Seton, 225
Merry England, 167
Meynell, Alice, 35, 45, 141, 144-145, 158, 168
Meynell, Wilfrid, 168-169
Midshipman Easy, by Captain Marryat, 118
Midsummer Night's Dream, by William Shakespeare, 58
Millais, Sir John Everett, 281
Millar, H. R., 290
Milligan, Alice, 149
Milton, John, 165
Molière, 213
Monet, Claude, 139, 268
Money-Coutts, F. B., 159, 164
Monticelli, 274
Moore, George, 27, 35, 39, 42, 47, 48, 63, 64, 130, 135, 149, 209, 216-217, 223, 229-230, 267-269
Moore, T. Sturge, 51, 159
Moore, Tom, 153
More, by Max Beerbohm, 120
Morgan, William de, 251
Morris, Lewis, 38
Morris, May, 251
Morris, William, 26, 33, 38, 39, 51, 100, 103, 134, 157, 196, 244-254, 256-261, 263-266, 280, 282-284
Morrison, Arthur, 43, 130, 216, 223, 225
Morte d'Arthur, by Malory, illustrated by Aubrey Beardsley, 93
Mrs Warren's Profession, by Bernard Shaw, 194-196
Muckley, L. Fairfax, 284
Murdoch, W. G. Blaikie, 33
Murger, Henri, 226

NAPOLEON, 57, 183
Nation, The, 170
National Observer, The, 22, 228-229
Nature of Gothic, The, by John Ruskin, 246-247
Naulahka, The, by Rudyard Kipling and Wolcot Balestier, 232
Neal, Mary, 250
Nesbit, E., 159
Nettleship, J. T., 47
New, E. H., 284
New Age, The, 22, 24
New Ballads, by John Davidson, 178
Newbolt, Henry, 40, 158
New Century Theatre, 209
New English Art Club, 269
New Grub Street, The, by George Gissing, 43
New Humour, The, 227
Newill, Mary, 284
Newlyn School, 270

New Poems, by Francis Thompson, 169
New Republic, The, by W. H. Mallock, 67
New Review, The, 22
Newman, John Henry, 38
News from Nowhere, by William Morris, 39, 248
Nicholson, William, 34, 35, 268, 270, 274-275
Nietzsche, Friedrich, 50, 61, 88, 128-129, 131-133, 182, 190, 203, 234
Nigger of the Narcissus, The, by Joseph Conrad, 225
Nineteenth Century, The, 75
No. 5 John Street, by Richard Whiteing, 40, 43, 224
"Nonconformist Conscience," 24, 216
Nordau, Max, 19-20, 30, 34, 195
Nutt, David, 93

O'Connor, T. P., 24
Octopus, The, 118
Of a Neophyte, by Aubrey Beardsley, 101
Olivier, Sydney, 26
"On Going to Church," by Bernard Shaw, 50, 204
Once a Week, 37
Orpen, William, 35, 270
Osbourne, Lloyd, 225
Ospovat, Henry, 290
O'Sullivan, Vincent, 144, 222-223
Outcast of the Islands, An, by Joseph Conrad, 225

Pagan Review, The, 22
Pageant, The, 41, 160
Pain, Barry, 40, 225, 227
Palace Theatre, 76, 120
Pall Mall Budget, The, 118, 287
Paolo and Francesca, by Stephen Phillips, 158
Parade, The, 36
Park, Carton Moore, 290
Parnassiens, the, 59
Parson and the Painter, The, by Phil May, 287
Partridge, Bernard, 280, 290
Passion of Mary, The, by Francis Thompson, 167
Pater, Walter, 26, 34, 38, 59, 61, 74, 87, 135, 140
Patience, by W. S. Gilbert, 67, 73
Paton, Sir Noel, 150
Payn, James, 39
Payne, Henry, 284
Peacock Room, the, 268
Pears, Charles, 290
Pearson's Weekly, 77-78

Pelleas and Mélisande, by Maurice Maeterlinck, 156
Pen Drawing and Pen Draughtsmen, by Joseph Pennell, 285
Pen, Pencil and Poison, by Oscar Wilde, 74
Pennell, Joseph, 47, 50, 93, 98, 285, 290
Peploe, J. T., 35, 270
Perfect Wagnerite, The, by Bernard Shaw, 195
Perfervid, by John Davidson, 177, 181
Peter Ibbetson, by George du Maurier, 39
Petronius, 107
Phantom 'Rickshaw, The, by Rudyard Kipling, 232
Pharais, by Fiona Macleod, 42, 150
Philanderer, The, by Bernard Shaw, 194
Phillips, Stephen, 51, 158, 164
Phrases and Philosophies for the Use of the Young, by Oscar Wilde, 112
Pick-me-up, 36, 37, 118, 287, 289-291
Picture of Dorian Gray, The, by Oscar Wilde, 21-22, 27, 59, 62, 63, 68, 75, 84, 88-89, 138, 228
Pierrot of the Minute, The, by Ernest Dowson, 141
Pillars of Society, by Henrik Ibsen, 202
Pinero, Arthur W., 39, 40, 78, 207, 209, 212-213
Pissarro, 139
Plain Tales from the Hills, by Rudyard Kipling, 231
Platonic dialogue, 202
Playhouse Impressions, by A. B. Walkley, 206
Plays Pleasant and Unpleasant, by Bernard Shaw, 44, 45, 195
Podmore, Frank, 26
Poe, Edgar Allan, 155
Poems, by Francis Thompson, 169
Poems by the Way, by William Morris, 258
Poetry of the Celtic Races, The, by Ernest Renan, 151
Poets' Corner, The, by Max Beerbohm, 124
Poets of the Younger Generation, by William Archer, 157-158
Post-Impressionists, 269
Poster, The, 36
Poster Exhibition, 275
Posters, 47
Pour la Couronne, by François Coppée, 178

Pre-Raphaelite movement, 34, 58, 244, 267, 272, 281, 284
Prisoner of Zenda, The, by Anthony Hope, 226
Prose Fancies, by Richard le Gallienne, 139, 142
Prose Poems, by Oscar Wilde, 88, 89
Pryde, James, 34, 35, 268, 270, 274-275
Psychopathia Sexualis, by Krafft-Ebing, 101-102
Puck of Pook's Hill, by Rudyard Kipling, 232
Pugh, Edwin, 225
Punch, 36, 37, 67, 74, 287
Purple Land that England Lost, The, by W. H. Hudson, 40-41

Quarto, The, 36
Queen's Romance, A, by John Davidson, 178
Quest, The, 284
Quest of the Gilt-edged Girl, The, 228
Quest of the Golden Girl, The, by Richard le Gallienne, 41, 226, 228
Question of Memory, A, by Michael Field, 209
Quilp, Jocelyn, 22

RADFORD, DOLLY, 47, 159
Radford, Ernest, 159
Random Itinerary, A, by John Davidson, 179
Ransome, Arthur, 72
Rape of the Lock, The, illustrated by Beardsley, 98, 101, 103
Ray, Catherine, 207
Reade, Charles, 196
Reclus, Élisée, 150
Red Deer, by Richard Jefferies, 186
Reeves and Turner, 265
Renaissance, The, by Walter Pater, 28, 59-60
Renaissance, The History of the Italian, by John Addington Symonds, 39
Renaissance of the Nineties, The, by W. G. Blaikie Murdoch, 33
Renan, Ernest, 147, 151-152, 154
Renoir, 99
Renunciations, by Frederick Wedmore, 39
Review of Reviews, The, 24
Reynard the Fox, 281
Rhodes, Cecil, 54, 238-239
Rhymers, Club, the, 115, 186
Rhys, Ernest, 42, 48
Richard Yea and Nay, by Maurice Hewlett, 226
Richards, Grant, 45

Ricketts, Charles, 34, 35, 37, 74, 256, 260-262, 270, 273-274, 276, 280, 282
Ridge, Pett, 40, 225, 227
Rimbaud, Arthur, 61, 63
Roberts, Morley, 225
Robertson, Forbes, 178
Robins, Elizabeth, 224
Robinson, Charles, 283
Rodin, Auguste, 271
Rodney Stone, by A. Conan Doyle, 226
Romance and Reality, by Holbrook Jackson, 290
Romantic Farce, A, 178
Romantic movement, the, 57
Romaunt of the Rose, 100
Roots of the Mountains, The, by William Morris, 39, 257
Rops, Felicien, 103
Rose Leaf, The, 36
Rosmersholm, by Henrik Ibsen, 194, 209
Ross, Robert, 72, 80-81, 96
Rossetti, Christina, 38
Rossetti, Dante Gabriel, 58, 128, 135, 157, 160, 162, 281
Rothenstein, William, 35, 47, 50, 270, 276-278, 296
Rousseau, Jean-Jacques, 201
Roussel, 270
Royal Academy, 269
Royal Scottish Academy, 269
Runciman, John F., 51
Runnable Stag, A, by John Davidson, 185-186
Ruskin, John, 34, 38, 135, 196, 203, 244-245, 246, 267
Russell ("A. E."), George, 42, 149
Ruy Blas, by Victor Hugo, 178

ST JAMES'S THEATRE, 76
Salisbury, Marquis of, 238
Salomé, by Oscar Wilde, 84-85, 90
Salomé, Beardsley's illustrations to, 103
Sambourne, Linley, 280
Samhain, 150
Sanity of Art, The, by Bernard Shaw, 195
Santayana, George, 159
Sardou, 76
Sargeant, John S., 270
Saturday Review, The, 120, 195, 205
Savoy, The, 17, 34, 35, 36, 45-46, 48-49, 91, 118, 129, 204, 221
Scaramouch in Naxos, by John Davidson, 178, 181
School for Saints, The, by John Oliver Hobbes, 224
Schopenhauer, 203
Schreiner, Olive, 224

Scots Observer, The, 267
Scott, Bailey, 251
Scott, Clement, 208
Scott Library, 52
Scott, Sir Walter, 58
Scribe, 76
Seaman, Owen, 40, 159-160
Second Mrs Tanqueray, The, by Arthur W. Pinero, 40, 209,213-214
Secret Rose, The, by W. B. Yeats, 155-156
Secular Society, the, 174
Sentences and Paragraphs, by John Davidson, 129, 179
Sentimental Journey, by Laurence Sterne, 226
Sentimental Tommy, by J. M. Barrie, 224
Setoun, Gabriel, 150
Seven Seas, The, by Rudyard Kipling, 232, 242-243
Shakespeare, William, 165, 212, 272
Shannon, Charles H., 35, 50, 270, 273-274, 282
Shannon, J. J., 35
Sharp, Cecil, 250
Sharp, William, 22, 30, 42
Shavianism, the quintessence of, 198-201
Shaw, George Bernard, 26, 34, 35, 44, 45, 50, 78, 112, 120, 131, 134, 146, 193-204, 234
Shaw, Norman, 251
Shelley, P. B., 58, 158, 165, 169, 174-175, 185
Shelley, by Francis Thompson, 168
Shepherd's Calendar, The, illustrated by Walter Crane, 282
Sherard, Robert H., 72, 79
Sherlock Holmes, by Arthur Conan Doyle, 226
Shropshire Lad, A, by A. E. Housman, 45
Sickert, Walter, 26, 47, 50, 270, 290
Silverpoints, by John Gray, 262
Sime, S. H., 36, 37, 270, 280, 290, 291-292
Simpson, Joseph, 290
Sinner's Comedy, The, by John Oliver Hobbs, 224
Sister Songs, by Francis Thompson, 168
Sketch, The, 118, 287
Sleigh, Bernard, 284
Smith : a Tragic Farce, by John Davidson, 178
Smithers, Leonard, 35, 45
Social Democratic Federation, 26
Socialism, 247-248
Socialism in England, by Sidney Webb, 44

Socialist Movement, 44
Socialist Party, the British, 26
Soldiers Three, by Rudyard Kipling, 231
Some Emotions and a Moral, by John Oliver Hobbes, 144
Soul of Man, The, by Oscar Wilde, 27, 88, 89, 134
South African War, 53
Speaker, The, 178, 267
Spence, R., 290
Spencer, Herbert, 38, 203
Spenser, Edmund, 251
Sphinx, The, by Oscar Wilde, 74, 82-83, 260, 263
Sphinx without a Secret, The, by Oscar Wilde, 74
Spirit Lamp, The, 22
Spurgeon, Charles, 38
Stage Society, 194, 209, 214
Stalky & Co., by Rudyard Kipling, 232
Star, The, 24, 193
Stead, W. T., 24
Steele, Sir Richard, 41
Steer, Wilson, 35, 47, 270
Steevens, G. W., 40
Stephen, Leslie, 38
Stephens, Riccardo, 150
Stevenson, Robert Louis, 38, 135, 225, 227
Stickit Minister, The, by S. R. Crockett, 224
Stirner, Max, 132
Stones of Venice, The, by John Ruskin, 246
Story of an African Farm, The, by Ralph Iron (Olive Schreiner), 224
Story of the Gadsbys, The, by Rudyard Kipling, 232
Story of the Glittering Plain, The, by William Morris, 39, 258, 259
Story of the Sundering Flood, The, by William Morris, 39
Strang, William, 290
Street, G. S., 41, 46, 48, 68-69, 91, 112, 144
Strike at Arlingford, The, by George Moore, 209
Strindberg, August, 210, 212
Studio, The, 36, 93
Study in Temptations, A, by John Oliver Hobbs, 224
Sudermann, Hermann, 209-210
Sullivan, E. J., 47, 280, 290
Superman, 190
Swinburne, Algernon Charles, 38, 58, 74, 157, 160, 162
Sydney Bulletin, The, 287
Symbolist Movement in Literature, by Arthur Symons, 56

Symbolists, the, 59, 244
Symonds, John Addington, 39, 262
Symons, Arthur, 35, 36, 42, 47, 48, 55-56, 70, 81, 85, 91, 95, 96-97, 106, 112-114, 130, 134, 142, 159, 161-162
Synge, J. M., 42, 87

Tables of the Law, The, by W. B. Yeats, 156
Tabley, Lord de, 262
Tales of Mean Streets, by Arthur Morrison, 43, 130, 216
Tales of Unrest, by Joseph Conrad, 225
Ta-ra-ra-boom-de-ay, 31
Temple Classics, 52
Ten O'Clock, by J. McNeill Whistler, 40, 123
Tennyson, Alfred, Lord, 37, 100, 128, 157, 220, 281
Tess of the D'Urbervilles, by Thomas Hardy, 39, 40
Testament of John Davidson, The, by John Davidson, 179-181
Testament of a Vivisector, The, by John Davidson, 179
Thackeray, William Makepeace, 217
The Testament of a Man Forbid, by John Davidson, 179, 189
The Testament of an Empire Builder, by John Davidson, 179
Theatrocrat, The, by John Davidson, 179
Theosophy, 149
Theosophical movement, 132
Thomas, Inigo, 284
Thompson, Francis, 45, 51, 91, 131, 158, 166-176
Thompson, The Life of Francis, by Everard Meynell, 171
Three Plays for Puritans, by Bernard Shaw, 195
Thus Spake Zarathustra, by Friedrich Nietzsche, 129
Time Machine, The, by H. G. Wells, 225
Times, The, 34
To-Day, 36, 47
Todhunter, John, 209
Tolstoy, Leo, 128, 203, 212, 250
To-morrow, 36, 120
"Tomlinson," by Rudyard Kipling, 292
Toulouse-Lautrec, 274
Towards Democracy, by Edward Carpenter, 44
Town planning, 254
Townsend, F. H., 290
Trades Unionism, The History of, by Sidney and Beatrice Webb, 44

Traill, H. D., 21, 39, 227
Tree, Herbert Beerbohm, 76, 210, 211
Trench, Herbert, 159
Trilby, by George du Maurier, 39, 226
Triumph of Mammon, The, by John Davidson, 179
Tupper, Martin, 38
Turgenev, 128, 132
Twisting of the Rope, The, by Douglas Hyde, 149
Two Essays on the Remnant, by John Eglington, 149
Tyndall, John, 38

Under the Deodars, by Rudyard Kipling, 232
Under the Hill, by Aubrey Beardsley, 50, 59, 63, 101-102, 114-115, 138, 228
Unhistorical Pastoral, An, by John Davidson, 178
Unicorn Press, 45
Unicorn, The, 118
Unwin, Fisher, 45
Upward, Allen, 40

VACHELL, H. A., 40
Vale Press, 51, 255, 261-263, 281
Vampire, The, by Rudyard Kipling, 235
Vanity, 118
Vanity Fair, 217
Vaughan, Henry, 166
Vedrenne-Barker repertoire season, 195, 214-215
Vera : or the Nihilists, by Oscar Wilde, 75
Verdigris, Baron, by Jocelyn Quilp, 21
Verhaeren, Emil, 50
Verlaine, Paul, 50, 58, 61, 63, 135, 274
Victor Hugo, 57, 58
Victoria, Queen, 237
Vignettes, by Hubert Crackanthorpe, 142
Vistas, by William Sharp, 30
Vizetelly, Ernest, 42
Voltaire, 201
Voysey, C. F. A., 251
Voysey Inheritance, The, by Granville Barker, 214

WAGNER, RICHARD, 198, 203
Wagnerians, The, by Aubrey Beardsley, 101
Walker, Emery, 251, 256-257, 266
Walkley, A. B., 35, 206-207
Wallace, Alfred Russel, 38
Wallas, Graham, 26

Wanderings of Oisin, The, by W. B. Yeats, 148
War of the Worlds, The, by H. G. Wells, 225
Ward, Mrs Humphry, 26, 224
Washer of the Ford, The, by " Fiona Macleod," 150
Water of the Wondrous Isles, The, by William Morris, 39
Watson, William, 34, 40, 46, 47, 158, 163
Watteau, 94, 100, 274
Watts, George Frederick, 33, 99, 268, 277
Watts-Dunton, Theodore, 39
Waugh, Arthur, 47, 218-220
Webb, Beatrice, 44
Webb, Sydney, 26, 44, 200
Webb, Stephen, 251
Wedmore, Frederick, 38, 39, 50, 224
Wee Willie Winkie, by Rudyard Kipling, 232
Well at the World's End, The, by William Morris, 39
Wells, H. G., 27, 34, 35, 44, 224, 225, 228-229, 274
Welsh Literary Movement, 42
Wessex Poems, by Thomas Hardy, 39
Weyman, Stanley J., 40, 226
What is Art? by Leo Tolstoy, 250
Wheeler & Co., A. H., 231
Wheels of Chance, The, by H. G. Wells, 224
When the Sleeper Wakes, by H. G. Wells, 225
Whibley, Charles, 41
Whistler, James McNeill, 34, 40, 47, 74, 85, 98, 107, 111, 123, 141, 143, 220, 245, 270, 277, 287
Whistler, The Life of James McNeill, by E. R. and J. Pennell, 98
White Company, The, by A. Conan Doyle, 226
Whiteing, Richard, 40, 43, 44, 224
Whitman, Walt, 85
Whitten, Wilfred, 169
Whittingham, Charles, 255
Widowers' Houses, by Bernard Shaw, 44, 194-196
Wilde, Oscar, 21, 22, 25, 27-28, 34, 45, 53-54, 58, 63, 66-68, 70, 72-90, 91, 98, 120-103, 105, 107-108, 111-112, 114, 131-132, 134, 136-137, 138-139, 142, 143, 144-145, 146, 195, 205-206, 210, 212, 228, 244, 260, 263
Wilde, Oscar, The Story of an Unhappy Friendship, by R. H. Sherard, 72

Wilson, Edgar, 36, 283
Wilson, Henry, 251
Wilson, Patten, 290
Window in Thrums, A, by J. M. Barrie, 224
Wolseley, Viscount, 237
Woman and Her Son, A, by John Davidson, 189
Woman Who Did, The, by Grant Allen, 40, 131, 216
Woman Covered with Jewels, The, by Oscar Wilde, 76
Woman of No Importance, A, by Oscar Wilde, 21, 76, 209, 212
Woman's World, The, 74
Women's Tragedies, by George Fleming, 144
Wonderful Mission of Earl Lavender, The, by John Davidson, 179, 181
Wonderful Visit, The, by H. G. Wells, 224
Wood Beyond the World, The, by William Morris, 39
Woods, Margaret L., 159
Worde, Wenkyn de, 260-261
Wordsworth, William, 58, 158, 174
World, The, 193
Wratislaw, Theodore, 48, 159
Wreckage. By Hubert Crackanthrope, 144
Wrecker, The, by Lloyd Osbourne and Robert Louis Stevenson, 225

YEATS, JACK B., 283
Yeats, R.H.A., J. B., 152
Yeats, William Butler, 35, 42, 48, 51, 56, 71, 141, [149, 150-156, 158, 163-164, 283
Yellow Aster, The, by Iota, 47, 139
Yellow Book, The, 17, 23, 25, 34, 40, 41, 45-46, 49, 52, 91, 93, 98, 118, 139, 178, 186, 219, 228
" Yellow, The Boom in," 46-47
" Yellow Nineties," the, 34
" Yellow Press," the, 23, 52
Yet Again, by Max Beerbohm, 120, 123
You Never Can Tell, by Bernard Shaw, 194

ZANGWILL, ISRAEL, 35, 40, 211, 225, 227
Zola, Emile, 27, 42, 128, 130, 201, 203, 216
Zuleika Dobson. By Max Beerbohm, 120, 123